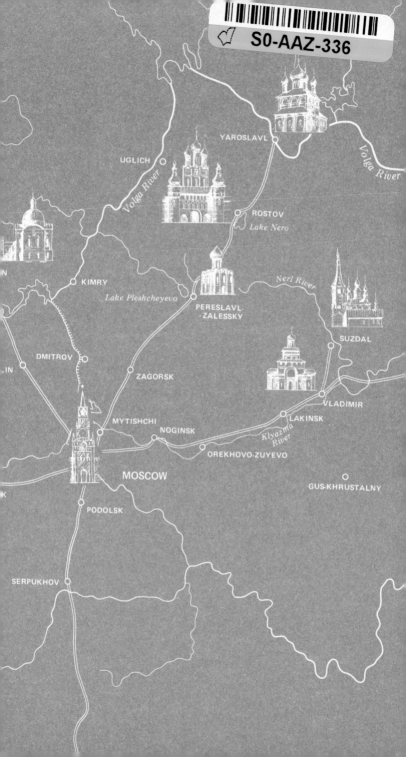

UGLICH

YAROSLAVL

Volga River

ROSTOV
Lake Nero

KIMRY

Lake Pleshcheyevo

PERESLAVL-
-ZALESSKY

Nerl River

SUZDAL

DMITROV

ZAGORSK

VLADIMIR

MYTISHCHI

LAKINSK

NOGINSK

*Klyazma
River*

OREKHOVO-ZUYEVO

MOSCOW

GUS-KHRUSTALNY

PODOLSK

SERPUKHOV

ANCIENT RUSSIAN CITIES

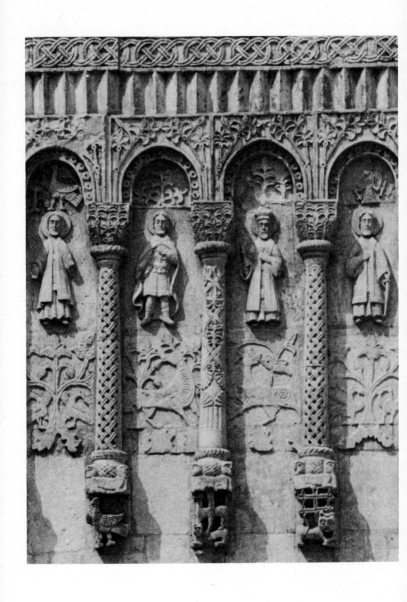

ALEXANDER MILOVSKY

ANCIENT RUSSIAN CITIES

A Travel Guide
to the Historical and Architectural Monuments
and Fine Art Museums

Raduga
Publishers
Moscow

Александр Миловский
ДРЕВНИЕ ГОРОДА РОССИИ
Путеводитель
На английском языке

Translated from the Russian by *Holly Smith*
Editor of the Russian text *Martha Derzhavina*
Editor of the English text *Alexander Kafyrov*
Designed by *Eteri Simanovich*
Art editor *Alexander Kuptsov*
Maps by *Lyubov Cheltsova*
Photos by *U. Abramochkin, V. Chernov, A. Gerasimov,*
A. Kuptsov, A. Milovsky, B. Prikhodko, D. Smirnov, S. Solovyov,
L. Ustinov, V. Zelenova
Layout by *Svetlana Sizova*

$$M\frac{1905040100-177}{0\ 31\ (05)-86}\ 063-85$$

ISBN 5-05-000073-4

Contents

Invitation to a Journey

The vast expanses of Russia are dotted with hundreds of cities, large and small, on which the passing centuries have left their mark. Some of these cities are renowned the world over, and others are known only to experts in ancient architecture. The journey described herein will take the reader to eight of the more interesting cities of Central Russia. These cities are situated roughly in a semi-circle and are but a few hours from Moscow.

Each of the trips described allows the visitor ample time to see Moscow and then go to the nearby cities: Smolensk to the west, Kalinin (formerly Tver) to the northwest, Zagorsk, Pereslavl-Zalessky, Rostov, and Yaroslavl to the north, and Vladimir and Suzdal to the east.

This tour guide does not attempt to describe the sights of Moscow, for that would require a separate, and rather lengthy volume — of which there are several, by the way. We will limit ourselves, therefore, to listing only the spots essential to even the most passing acquaintance with the city. They are, of course, Red Square, the Lenin Mausoleum, the Kremlin with its cathedrals, the Faceted Chamber, Armory Chamber and Diamond Fund of the Kremlin; the Tretyakov Gallery with its outstanding collections of 11th to 20th century art; the Pushkin Fine Arts Museum with its many excellent works of ancient and European art; the Central Lenin Museum; the Bolshoi Theater, and finally, the Exhibition of Economic Achievements, frequently referred to as "the USSR in miniature."

The ancient cities of Russia have much in common: the subdued natural beauty of the central regions of European Russia, in which the dominant colors are the greens of grasslands and trees and the pale blue of the sky; gently rolling plains cut through by meandering rivers which flow unhurriedly through each of the cities (and were once the main arteries of transportation); a thick blanket of snow that covers the cities for five months out of the year; a slow pace of life;

domed churches towering above the other ancient buildings; new residential areas spreading far beyond the historic boundaries of the cities; and broad thoroughfares lined with modern buildings. Architects and city planners have taken care to see that the new structures do not spoil, crowd or block from view the valuable monuments of the past which make these cities unique. In fact, in the Soviet Union, we have a special law on the conservation and use of historical and cultural monuments; these remnants of the past are carefully preserved and restored, often with such excellence that special awards are presented for the work done on particular buildings, architectural complexes, and on occasion, entire cities.

The cities of which we will speak here are so distinctive in style and appearance that they could never be confused with one another. They each have their own varied histories and particular features which are reflected in their present-day appearance. And generally, that which makes each of them so unlike the others is also that which is most interesting to tourists.

Thus, for example, Smolensk is the symbol of the military vigor and courage of the Russian people. Appropriately, it is best known for its remarkable medieval fortress. Kalinin is famed for its distinctive architectural style of Early Russian Classicism. The extremely rare, invaluable works of art – the largest and richest collection in all of Russia – at the Zagorsk monastery are the pride of that town. Pereslavl-Zalessky spreads out along the shores of a beautiful lake and is a town of lovely old monasteries. Rostov boasts a marvelous 17th century Kremlin and a multitude of bells which produce an amazing variety of sounds. Yaroslavl possesses fine 17th century frescoes done at a time when the art of glazed, colored tiles flourished. In Vladimir, rare examples of pre-Mongolian white stone architecture from the 12th to the beginning of the 13th centuries have come down to us. Suzdal, the first city in Russia to be made an architectural preserve, is a 17th-18th century town which has survived intact to the present. But the reader will find each of these particulars dealt with in more detail in the chapters on each of the cities. In the present volume, the author has attempted to present information on the history, geography, traditions, architecture, art and everyday life of these ancient Russian cities. Whenever possible, the common historical and cultural background against which their development took place in various periods is presented. In addition, information on the most interesting and significant monuments which have become an inseparable part of the spirit of the Russian people has been included.

Epochs, Cities, and Styles

Ancient Russian cities... Where should we begin their story? Most likely with Kiev, which celebrated its 1500th anniversary in 1982, although it is not included in this volume. Kiev, presently the capital of Soviet Ukraine, is often referred to in ancient chronicles as "the Mother of Russian Cities", while Kievan Rus – the first early feudal state to spring up in Eastern Europe at the turn of the eighth century – was the seat of the people who evolved into the Russians, Ukrainians, and Byelorussians.

Kievan Rus flourished in the 10th and first half of the 11th centuries during the rule of Prince Vladimir Svyatoslavich, known as Vladimir the Bright Sun (980-1015). During his reign, Rus was christianized in 988-89, and its borders were extended to the Baltic area, the Carpathian Mountains, the steppes near the Black Sea in the South and Lake Onega in the north. Greek architects and icon-painters came to Kiev from Byzantium, and Rus was enriched by its cultural traditions.

At the time of Yaroslav the Wise (1019-54) Rus was a vast feudal state that ranked among the most important in Europe and commanded great respect internationally. Russian speech could be heard in the Balkans and Scandinavia, and the state had extensive political and economic ties with England, France, Germany, Poland, Hungary and Norway.

Under Yaroslav the Wise, an extensive stone building program was carried out in Kiev, and it was during his reign that the cornerstone of St. Sophia's Cathedral, which is still standing today, was laid in 1037. St. Sophia's was the main cathedral of Kievan Rus and testified to the might and greatness of the first ancient Russian state. From the outset, Russian architects tried to achieve creative independence in their search for unique forms and means of expression in which, despite the unavoidable influence of East and West alike, national flavor

was prominent. Originality continued to be characteristic of Russian architecture over the centuries.

Throughout its existence, Kievan Rus was forced to fight for survival in a never-ending struggle against nomadic tribes of Khazars, Pechenegs, and Polovtsy who repeatedly attacked the Russian lands. And thus, whether these ancient Russian cities have survived or were reduced to heaps of rubble centuries ago, they were all forced to defend themselves and became fortresses in the face of a persistent enemy.

These fortresses were built of necessity, but they became centres of culture where energetic, able, talented individuals gathered to engage in trade, crafts, and the arts. Thus, all these ancient cities – and especially the ones dealt with in the present volume – made a contribution to the cultural and artistic development of the country. The buildings erected on their territories were often quite striking and reflected the styles current during the different periods of economic and cultural evolution of Russia.

In the second half of the 12th century, Kievan Rus broke up into a multitude of independent principalities which were weakened by internecine strife. However, while the decline of the Kievan state was disastrous from a military and political point of view, leading to dire consequences during the Tartar invasion, the same cannot be said of the development of culture, art, and architecture. Many new fortresses, stone churches, and palaces continued to be built in the individual principalities. Local schools of art and architecture began to take shape in Chernigov, Novgorod, Smolensk, Polotsk, Vladimir, Suzdal, and other cities. The former ideals of Byzantine and Kievan art and architecture were adapted and reworked in the search for forms more in keeping with new ideas and outlooks. In place of the gigantic, elaborately decorated cathedrals erected during the heyday of Kievan Rus, churches more modest in size and ornamentation were built, reflecting the smaller boundaries of the newly born principalities. Instead of dominating over man, architectural forms became more on a par with him. In place of expensive mosaics of smalt, fresco painting on wet plaster and majolica tiles were employed for decorating. During this period, the level of the applied arts – especially jewellery-making, the plastic arts, and cloisonné work – was extremely high.

The Russian masters of the time achieved a lightness and elegance of line, a striving heavenward which was absent in the earlier Kievan churches. Incidentally, this new form was more in keeping with the tastes of the simple people and the leading members of the ecclesiastical and civil hierarchy alike. A new type of Russian church appeared with a dome towering high above the cubic main body with its inevitable tier of *zakomari* and *kokoshniki*. A marvelous example of this type of church is the Church of the Archangel Michael, described in the chapter on Smolensk.

An outstanding place in the history of Russian architecture belongs to the Vladimir-Suzdal school which enriched our culture with compositional gems noted for their virtuoso stone carvings and the remarkable way in which they

blend with their natural surroundings. The white stone cathedral of Vladimir is the zenith of monumental ancient Russian architecture; it served as the inspiration for generations of Moscow builders.

The Russian principality centered around Vladimir and Suzdal never became the strong, unified state that existed during the reign of Yaroslav the Wise. This was due chiefly to the grave misfortune suffered by the vast Russian lands which, with the exception of Novgorod and Pskov, were conquered by the Tartar hordes in 1237-38. Despite the heroic resistance of the people, the divided lands were unable to turn back the invasion, and the Tartar Yoke thwarted the development of the national economy and culture and slowed down the rate of construction for better than two centuries.

Only after several decades of decline and depression following the invasion of the Golden Horde did the Russian land begin to return quite slowly to a semblance of normal existence. Construction was resumed in the cities on a modest scale. The occupied land lacked the means and man-power for building in stone for quite some time, and thus, only wooden structures were erected throughout the 13th and 14th centuries. Judging by the written records that have come down to us, these buildings achieved a high degree of artistic expression, beautifying the city ensembles with their tall tent roofs.

Along with the gradual reawakening of the people's suppressed talents appeared an upsurge of patriotism which resulted in more wide-scale resistance to the invaders. Their common plight and the ardent desire to throw off the foreign yoke spiritually united the various principalities, which were forced to join together in struggle against the Golden Horde. An ever greater role in this struggle for unity and liberation was played by an obscure fortified city, known since 1147, lost deep in the vast forests of Russia. That small city was Moscow. In the middle of the 14th century, the Moscow princes received the title 'Grand', and then, during the reign of Ivan Kalita, the see of the Metropolitan of Russia was moved from Vladimir to Moscow. The victory of Dmitri Donskoi, Prince of Moscow, over Mamai's hordes at Kulikovo Field in 1380 raised the prestige of the future capital considerably in the eyes of the whole of Russia.

The rallying of the Russian lands around Moscow was opposed by freedom-loving Novgorod, and likewise, by the powerful principalities of Ryazan and Tver, its chief competitors. However, the far-sighted policies of the Moscow princes, the remoteness of Moscow from the usual routes of the Tartar hordes, and its location, which was quite favorable from an economic point of view, led to the city's rapid growth and the consolidation of the liberation movement around it. The formation of a unified, centralized Russian state had begun.

Naturally, these developments had a definite effect on art and architecture as well. By the turn of the 14th century, Moscow had firmly asserted itself as the source of all canons of art and architecture, and thus, during that period, the chief characteristic of church construction was greater attention to the interior of the building, so that no detail of structure or decoration would distract the worshipper from intimate communion with God and so that the eye was immediately

drawn to the iconostasis and the frescoes. The Trinity Cathedral at the Trinity-St. Sergius Monastery in Zagorsk, to be described later, was the very embodiment of the architectural principles of the time.

However, this trend did not result in the elaboration of a single, unified style such as the Gothic in Western Europe. A peculiarity of Russian architecture in general, and during the formation of the Moscow state in particular, was that architects continued to enjoy the freedom to search for new forms of expression and employ new styles so the churches constructed in one and the same place during a given period might all be quite different. The urban, monastery, village, and private churches as well as the cathedrals of metropolitans' sees could vary considerably in construction, according to the official canons of the times and the personal taste of those who commissioned them.

At the beginning of the 15th century, interest in the exterior decoration of the building increased. This interest resulted in keel-shaped portals and *zakomari,* rows of *kokoshniki,* bands of carved ornamentation, and blind arcades decorating the façades, apses and drums, as well as other techniques. Tent-roofed churches make up a special chapter in the history of Russian architecture. The apotheosis of this decorative tradition, which flourished in Russia until the end of the 17th century, is the world famous Cathedral of the Intercession (Pokrovsky Sobor), also known as the Cathedral of St. Basil the Blessed. This building, erected by Barma and Postnik in 1555-61 in Moscow's Red Square, has become a symbol of the Russian architectural tradition as a whole.

By the 1470s, Moscow exercised considerable political influence in the world, and allocated large funds for construction. The fall of the Byzantine Empire to the Turks in 1453 made Moscow the hope and bulwark of the whole Orthodox world. Now, not just the Russian principalities, but the states of Eastern and Central Europe turned their eyes toward Moscow in the face of the threat of Moslem domination. And the fact that Moscow, like the Eternal City and Constantinople, was situated on seven hills, gave rise to the legend that this recently obscure city would be the "third Rome". Finally, in 1480, Rus threw off the hated Tartar Yoke.

Moscow's new status demanded appropriate architectural renovations: churches, palaces, and fortifications, had to be built. The first new edifice, which was to serve as the main cathedral for the large centralized Russian state, was the Dormition Cathedral, erected in 1475-79 by Aristotele Fioravanti. To gain an understanding of the unstated continuity of tradition in Russian architecture, the Italian master was sent to Vladimir to study the 13th century white stone Cathedral of the Dormition there. The synthesis of pre-Mongolian ancient Russian architecture with elements of the Italian Renaissance style, using the classical orders and the Golden Mean of proportion, resulted in the creation of a powerful, majestic quincunx building, the main body of which is a massive cube. This church became the model for the construction of urban and monastery cathedrals all over Russia for more than two centuries.

The end of the 17th century was characterized by drastic changes in the political and cultural life of the Russian state. In place of old, patriarchal Rus came a

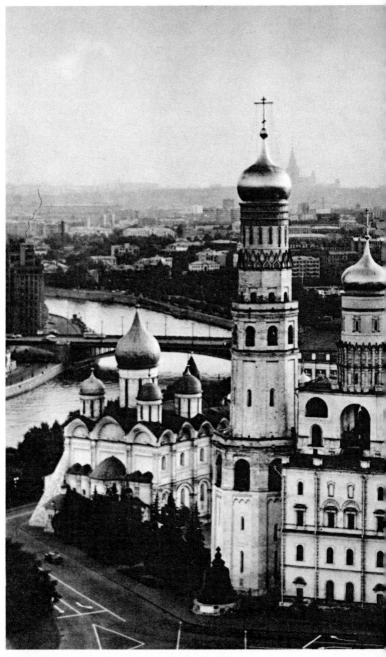

Kremlin Cathedrals against a view of present-day Moscow

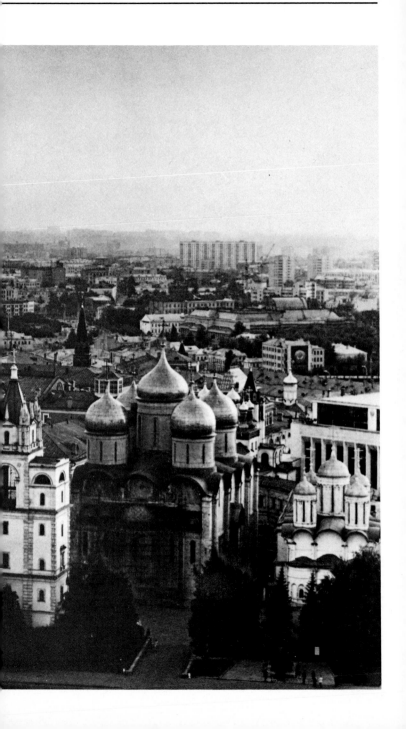

more modern Russia, shaken by the reforms of Peter the Great, who ascended to the throne in 1682. The new tsar and the supporters of his reforms took a lively interest in the development of manufacturing in the European countries, their achievements in engineering and economy, their methods of trading, their way of life in general, and the state of the arts there in particular. Thus, baroque found its way to Russian soil, bringing the epoch of old Russian architecture to a close. The new style, which reflected the spirit of the absolute monarchy in art and architecture, appeared in Russia at the beginning of the 18th century and was especially appropriate for the construction going on in the new capital of the country – St. Petersburg – with its grand palaces and majestic parks and ensembles. For baroque was a style of splendor and magnificence which revelled in the ornate and was exquisitely suited to the massive scale of the buildings going up there. In decor, the broken line reigned supreme. White stone carving – often quite splendid and ornate – was contrasted with the smooth surface of the walls, which were painted in darker colors. With the appearance of the baroque style in Russian urban planning, the principle of constructing entire architectural ensembles came to the fore. This idea was developed even further when classicism replaced the baroque style in Russia at the end of the 18th century.

Extremely interesting for Petrine Russia and later periods was a style known as Moscow or Naryshkin Baroque, employed extensively in church architecture. The style took its name from the Naryshkin family of boyars, relatives of Peter's mother, who were first to commission a building of this type. The basic features of this style over the years were the stepped pyramidal composition of the building – an octagonal tier surmounting a rectangular volume which replaced the traditional single cube of the main body – and the multitude of white stone carving which decorated the exterior.

From the splendid, even pompous lines and forms of baroque, the taste of the basic commissioner of buildings – the nobility – took a sharp turn to the simplicity and clear logic of Classicism in the second half of the 18th century. In both government buildings and private residences of the period, the classical orders were prevalent, while ornament consisted of sculptural reliefs on classical motives, mascarons, and termini. Classicism came into its own in church architecture as well, with the traditional cube-shaped main body being replaced by a rotunda girded by porticoes.

The order and regularity of the new style did not touch just individual buildings. In almost all major Russian cities, at the end of the 18th century, special commissions were set up to elaborate a master plan for the reconstruction and further urban development. In connection with this work, streets were straightened and squares laid out; the façades were evened up, and new ensembles were formulated. In the old cities, special arcades for markets and shops were built.

In the 1830s, along with the development of the idea of the greatness and military might of the empire that came into being after the victory over Napoleon in the war of 1812, classicism reached its apogee in the Late Empire Style, characterized by an austerity that emphasized the massiveness of the buildings, which

were literally smothered in a sumptuous ornamentation of military symbols.

The appearance of Russian cities in the second half of the 19th century was shaped by the arbitrary employment of the most widely differing architectural elements and methods developed up to that point. At the end of the 19th century, the revival of interest in ancient Russian architecture resulted in the construction of a number of buildings harking back to the old Russian style. At about that time, *art nouveau* came into vogue with its characteristic ornamental rhythm of fluid, flowing lines and skilful use of the latest achievements in building technology.

During the years of Soviet government, large-scale industrial, civil, and residential projects have been undertaken. These extensive building programs have affected the old Russian cities described in our tour guide to some extent. At the end of World War II, many cities of our country lay practically in ruins, and the critical housing problem had to be solved in the shortest possible time, so construction was begun on a larger scale than ever. While cities and architectural ensembles of interest have been restored, streets have been widened in those places where the existing structures were of little value and could be torn down. Construction continues in the old Russian cities, but it is done with ample taste and care to insure that those monuments of ancient architecture which are of historical value will remain for the generations to come. Special architectural preserves have been created in those urban areas which are especially rich in fine old buildings.

SMOLENSK
KALININ

Smolensk

Smolensk, the center of Smolensk Region of the Russian Federation, is situated 667 kilometers from the Byelorussian city of Brest, which is at the Polish border. It is 400 kilometers west of Moscow and has a population of 280 thousand. It is a major railway junction and river port for the upper reaches of the Dnieper. In this large industrial center, machine building and light industry dominate. It has its own medical, pedagogical, and physical education institutes, and many branches of Moscow institutes of higher learning operate here. Most of the city's museums are incorporated into a history, art, and architecture museum-preserve. Smolensk boasts a drama theater and a puppet theater.

Smolensk is farther west than any other ancient Russian city and was the gateway to Kievan Rus, serving as an outpost for the first Slavic state. Today, it is located on the Warsaw – Brest – Minsk – Moscow roadway, and most tourists who come to the Soviet Union by over-land routes, pass through this city.

Smolensk is first mentioned in chronicles under the year 863, but the city is certainly older, since the records for that year state that the armed forces of Varangian princes Askold and Dir decided not to pass through Smolensk during one of their campaigns against Constantinople, even though they passed by as they sailed south from Novgorod to Kiev along the Dnieper: they considered the city too mighty and populous.

The history of the appearance of Smolensk is connected with the large Slavic tribes of Krivichi who lived along the entire watershed 'from the Varangians to the Greeks' in the 6th-9th centuries. In 882, the city became part of the Kievan state. In the many burial mounds located outside the city, archeologists have found evidence of the early military campaigns and extensive trade relations maintained by the inhabitants of Smolensk. There are weapons of iron, Byzantine and Arabic coins, and objects of applied art of Persian manufacture. Smolensk lay along one of the major trade routes of the time, and the very name of the city is closely connected with these waterways. For here, in ancient times, traders and troops headed downstream to Kiev tarred ('smolili') their boats. The ancient settlement was most likely located a bit to the side of the present historical center: the excavations done on Cathedral Hill (Sobornaya Gora), as the place was later called, show that a citadel once stood there, although nothing earlier than the 11th century has been found on this particular spot. The citadel occupied two and a half hectares, while the prince's residence was protected by a moat, evidence of which can be seen even today (as the western section of Krasnyi Ruchei Street runs along it) and by a rampart with

a wooden wall.

In the 11th century the episcopate was located in the city, and it subsequently became the capital of the Smolensk principality which gained rapidly in power. The political and economic growth of the principality and the military prowess and vigor of its princes, who were fond of large, impressive buildings, led to a great deal of stone construction in the city. Three stone churches have survived from those times; since they are at different corners of the city, they should be included in logical, rather than chronological order for the tourist who begins his excursion from Cathedral Hill or the citadel. However, in the interests of historical perspective, they are presented at the beginning of this section, for indeed, they are the most ancient architectural monuments of Smolensk.

THE CHURCH OF SS. PETER AND PAUL (tserkov Petra i Pavla) (20 a Ulitsa Kashena) stands on the right bank of the Dnieper next to the railroad station. It was built of small plinths in 1146 in the shape of a typical Byzantine cruciform church which served as the model for Russian architects at the time. Almost square in plan, the four-piered Church of SS. Peter and Paul has three apses and one dome. Its laconic design, typical for buildings of this sort, is clearly in keeping with the structural elements of the exterior. Thus, the division of the façades into three segments by pilaster strips is reflected in the interior articulations of the pillars. The wall arches on which the drum of the dome rests are reflected on the outside in the semi-circular *zakomari.*

There are very few purely ornamental elements here: narrow bands of crenelated brickwork and blind arcading around the base of the *zakomari,* above the apses, and at the top of the drum. The drum's surface is decorated with flat vertical bar tracery at regular intervals which extends downward from the arcading, and a horizontal row of ceramic tile insets

completes the design. In the upper part of the broad pilaster strips of the western corners are crosses in relief. The arched windows are framed by austere one-stepped bays, and the portals, by triple ledges.

In the western part of the church is a special gallery for the prince's family and his retinue. There is a small chapel in the gallery with a tiny apse of its own.

In the 17th and 18th centuries, the church underwent significant alterations, however, during the restoration work conducted in 1962 by Pyotr Baranovsky, one of the finest Soviet restorers, the building was reconstructed to its original appearance. Later excavations revealed that soon after its construction, the Church of SS. Peter and Paul was enclosed by galleries on three sides.

The austere, majestic silhouette of the church is now part of an ensemble of later buildings: the **Chambers of Uniate Archbishop Lev Krevtsi** (1632) and the bell-tower of St. Barbara's Church (1753), crowned by a tall tiled tent roof. To the north and south of the bell-tower stand two richly decorated porches. The residence of the bishop of Smolensk, a rare example of Russian secular architecture, is especially valuable since in those days, living quarters were almost invariably built of wood and did not survive for long periods of time.

Looking at another excellent monument of pre-Mongolian architecture, the **CHURCH OF St. JOHN THE DIVINE** (tserkov Ioanna Bogoslova) (Ulitsa Bolshaya Krasnoflotskaya), built in 1166-70, it is difficult to imagine that this structure was once almost identical to the Church of SS. Peter and Paul, for many reconstructions have considerably altered its appearance. And moreover, the earth around it is almost two meters higher than originally. Nonetheless, it has been demonstrated conclusively that the Church of St. John the Divine once resembled its predecessor not only in external appearance but even in details of decoration. A recent par-

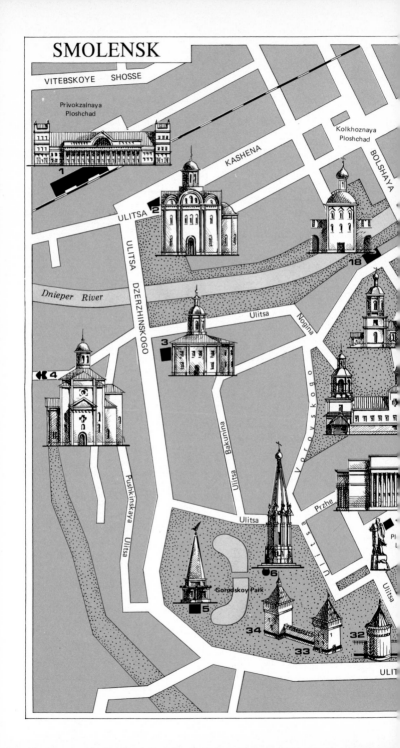

SMOLENSK

VITEBSKOYE SHOSSE

Privokzalnaya
Ploshchad

Kolkhoznaya
Ploshchad

KASHENA

BOLSHAYA

ULITSA

ULITSA DZERZHINSKOGO

Dnieper River

Ulitsa

Nogina

Ulitsa

Vorovskogo

Ulitsa Bakunina

Pushkinskaya

Ulitsa

Przhe

Ulitsa

Ulitsa

Gorodskoy Park

ULIT

1

2

3

4

5

6

18

34

33

32

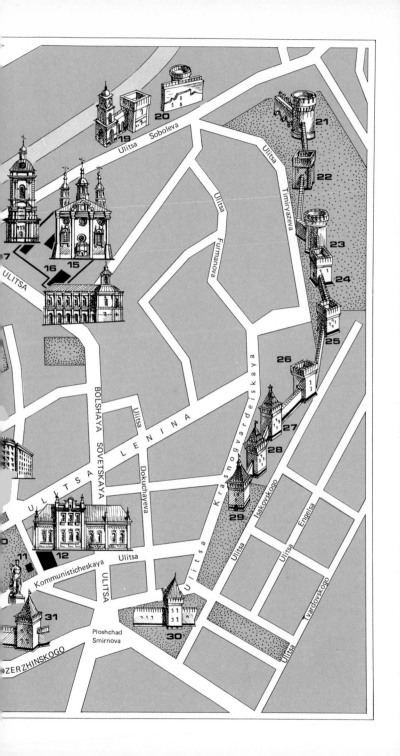

1. Railway station
2. Church of SS Peter and Paul, 12th century
3. Church of St. John the Divine, 12th century
4. Church of the Archangel Michael (Svirskaya), 12th century
5. Monument to the St. Sophia Regiment
6. Monument to the Heroes of the 1812 War
7. Monument to Lenin
8. Drama theatre
9. Tsentralnaya Hotel
10. Monument to Mikhail Glinka
11. Monument to Vladimir Kurilenko
12. Sergei Konenkov Sculpture Museum
13. Catherdal of the Ascension, 17–19th centuries (Exhibition Hall)
14. Church of the Resurrection, 18-th century (Planetarium)
15. Dormition Catherdal, 17–18th centuries
16. Buildings on the Cathedral Hill
17. Monument to Mikhail Kutuzov
18. Pyatnitskaya Tower
19. Volkova Tower
20. Kostyrevskaya (Red) Tower
21. Veselukha Tower
22. Pozdnikova Tower
23. Oryol Tower
24. Avraamievskaya Tower
25. Zaaltarnaya (Beluhka) Tower
26. Voronina Tower
27. Dolgochevskaya Tower
28. Zimbulka Tower
29. Nikolskaya Tower
30. Makhovaya Tower
31. Donets Tower
32. Gromovaya Tower
33. Bubleika Tower
34. Kopytenskaya Tower

tial restoration, during which the plastering was removed, exposed the original plinth and the original form of the windows. In the 12th century, the church was also surrounded by galleries, the foundations of which were found during excavations.

At the turn of the 12th century, the Smolensk school of architecture reached its zenith, for the Russian builders had begun to depart from the canons of Byzantine and Kievan architecture. The Russians were inclined to a more balanced sense of proportion and a striving heavenward in their churches that was absent in earlier structures. One of the brightest pages in the history of Russian architectural style was written by the builders of Smolensk, who even had their say in the recipe for making mortar, to which they added charcoal ashes.

The only example of late 12th century architecture there to have come down to us – and it is in excellent condition – is the **CHURCH OF THE ARCHANGEL MICHAEL** (tserkov arkhangela Mikhaila), later known as the **SVIRSKAYA CHURCH** (Ulitsa Malokrasnoflotskaya), the helmet-shaped dome of which rises proudly above the Dnieper. It was built as the palace church of Prince David Rostislavich in 1191-94 at some distance from the city, though now it is on the western edge of town.

The tall, symmetrical main body of the church is surrounded by three lower porches which, from the altar side, serve to balance the protruding, almost cylindrical central apse. (The two lateral apses are significantly smaller and lower and are rectangular in plan.) The elevated drum is noticeably narrower in comparison with the square space under the drum and the wall arches. All this taken together gives the Church of the Archangel Michael a remarkable proportionality, a sense of elegance and an air of beauty. The church is in good condition with its dynamic outline intact, although it has been somewhat dis-

torted by later alterations of the vaults and plaster-work on the walls.

Contemporaries were quick to note the particular refinement and richness of the interior decoration of this church. The early 15th century Ipatyevskaya Chronicles contain a detailed description of the building, praising its beauty and multitude of icons decorated in gold, silver, pearls, and precious stones.

The Church of the Archangel Michael is the third and last of the examples of pre-Mongolian architecture to have come down to our day in Smolensk, but excavations have proven that many more such structures existed; there was once an entire architectural ensemble built in stone within the citadel consisting of the Monomakh Cathedral, a palace chapel and tower, a series of parish and monastery churches, including something utterly unique for a Russian principality – a "Latin Chapel" with a rotunda, built for the foreign traders, the unusual shape of which is testified to by chronicles. This list of ancient buildings consists almost exclusively of churches, because in those days, only the most important structures, i.e., the larger churches or, extremely rarely, some princely mansions or fortifications were built of stone. Everything else was built of wood, and thus, after the passage of centuries, no traces of these other buildings remain.

The excavations around Smolensk have proven very fruitful and have enabled us to learn a great deal about the manner in which construction was carried out in ancient Rus and the techniques used. The most remarkable find so far – and one unlike anything that has been come across in any of the other ancient Russian cities – is two kilns for firing brick from the late 12th or early 13th centuries unearthed near the Church-on-the-Stream (tserkov na Protoke) and on Ulitsa Pushkina. Round, and over four meters in diameter, the kilns are made of brick on a clay foundation. The fire chamber is formed by the

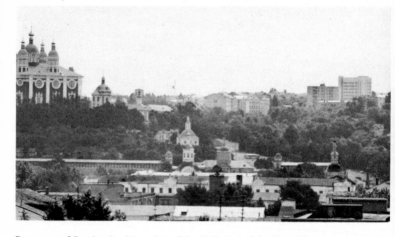

Panorama of Smolensk with a view of the Cathedral of the Dormition

arches of seven lateral walls that, taken together, form a straight arch. Research done in other ancient Russian cities confirms that the builders of Smolensk erected churches in Novgorod, Old Ryazan, and even in Kiev.

The Smolensk principality continued to flourish until the 1230s when the devastating forays of the Lithuanian armies began. In addition, in the year 1230, a terrible epidemic swept the city, claiming thirty thousand lives. Although the Tartar invasion did not touch Smolensk directly, it did have negative consequences. Nonetheless, the city did not lose its independence and even went to the aid of Novgorod in its fierce battles against the Teutonic knights.

In 1404, after a protracted struggle, the Smolensk lands were forcibly united to the Great Lithuanian principality. Along with Polish and Lithuanian troops, the regiments of Smolensk took part in the Battle of Grünwald (1410) which decided the fate of the Teutonic Order and halted its aggressions in the East. The regiments of Smolensk showed exceptional steadfastness and courage during critical moments of the battle.

For more than a century, Smolensk was cut off from the rest of the Russian lands, and it was only in 1514, after a long siege, that Great Prince of Moscow Vasily III succeeded in dislodging the enemy from the city and making it a part of Rus once again – a Rus now dominated by Moscow.

The defensive significance of Smolensk as a buffer zone on the Western borders of the Russian state was enormous for Moscow itself, since the seizure of this key city would clear the way for the enemy to the very gates of the capital. Therefore, when the Smolensk fortress suffered heavy fire damage in 1554, Tsar Ivan the Terrible (the son of Vasily III) ordered new fortifications built forthwith. So the city was enclosed by an oaken wall and surrounded by deep moats. By the end of the 16th century, this wooden fortress no longer met even the minimal requirements for fortifications, so in 1596, by order of Tsar Fyodor Ioannovich (son of Ivan

the Terrible), but actually, by the will of Boyar Boris Godunov, the real ruler of Russia during the reign of this God-fearing sovereign, work was begun on the largest **stone fortress** to be built in the entire history of Russia. The circumstances of the construction of this grandiose building project, in which the whole country participated, are sufficiently interesting to be described in more detail, for indeed, this fortification played an exceptionally important role in preserving the integrity of the Russian state during the period of Polish-Lithuanian invasions.

The time-frame during which the fortress had to be constructed was dictated by the approaching end of the twelve-year truce with Poland, due to occur in 1603, after which the Russian lands would once again be threatened by enemy invasion. Thus the building was conducted at an unprecedentedly rapid pace. A precise, strict schedule established even the day and hour of the arrival in Smolensk of Prince Vasily of Zvenigorod with his deacons and of architect Fyodor Kon, a native of those parts. These two men were placed in charge of the project by the sovereign himself.

Precisely according to schedule, in the cold of twilight on December 25, 1595, a string of sledges crossed the Bolshoi Bridge which had been erected over the Dnieper. To the ringing of church bells, they passed through the settlement on their way to the Cathedral of the Dormition to receive the blessing of Archbishop Feodosy for the building of the fortress and to procure the necessary materials and supplies.

They did not lose a minute, but immediately set about finding sources of clay suitable for firing bricks, places to calcine lime, and quarries with stone that could be used for the wall masonry and as rubble for filling the walls. They surveyed the forest for logs suitable for piles and for firewood, and ascertained how many people would be required to do the work, what supplies would be needed, and how best to obtain them. The plan for the fortress and estimates

for construction were drawn up. At the end of the winter, Fyodor Kon took all his calculations and estimates to Moscow then, without waiting for royal approval, he sent out for manual laborers from all parts of Russia. Thus, streams of stone masons and brick layers, kiln makers and stone cutters, carpenters and potters began to pour into Smolensk from all over the country. In the spring of 1596, for the official laying of the foundation of the fortress, Boris Godunov himself arrived, offered prayers of thanksgiving, and rode around the perimeter of the future fortress with his retinue. Fyodor Kon was not only the finest builder in all of Russia: he was an excellent organizer and co-ordinator, so the fortress was built quite rapidly, efficiently, and well. The bricks were fired at several factories built especially for that purpose, and construction was carried out along the whole perimeter simultaneously. Work began at the crack of dawn and continued until dark, and in the final stages, it was kept going round-the-clock, by torch-light and bonfires at night. Up to three hundred thousand people would be working on the fortress at any one time. To speed up the construction of the fortress, Boris Godunov forbade, under pain of death, all stone building not being done by government order in the other Russian cities as well. (A hundred years later, this extreme measure was employed by Peter the Great during the building of St. Petersburg, the new capital).

The great bulk of work on the fortress had been completed by 1600, and it was finished in 1602. Cannon were installed at once, heavy artillery in the towers and lighter ordnance along the walls. In approving the fortress, Boris Godunov wrote ecstatically: "We have created a structure so inexpressibly beautiful that there will not be another like it in the whole world... The Smolensk wall shall now become the pearl necklace of all Orthodox Russia: the envy of its enemies and the pride of the Moscow state."

And in fact this fortress remained the equal of none. Its mighty walls,

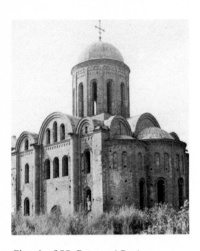

Church of SS. Peter and Paul

which stretched for about six and a half kilometers, had 38 defense towers connected by straight segments of wall, each approximately 150 meters in length, which would allow the soldiers within to fire in any direction. Nine of the towers were entry points. The foundation of the fortress was sunk deep into the subsoil in some places, while in others, it was strengthened by a complex system of piles. The walls ranged in height from ten to twelve meters and had a stone socle. The upper parts were faced in brick and filled with rubble and boulders cemented together with mortar. The tops of these walls were so broad that a troika in harness could drive along them with room to spare. On the level stretches before the walls, moats were dug. From the standpoint of military engineering, the fortress was superb, and it was also a first-rate piece of architecture.

In 1609, the Smolensk fortress got the chance to prove its worth as a defense installation when the Polish and Lithuanian armies laid siege to the city. Day after day, month after month, the enemy attempted in vain to capture the city. The siege of Smolensk lasted almost two years, and it was finally taken only as a result of treachery from within.

The heroic defense of Smolensk, which held off enormous enemy forces, and the show of bravery put forth by its defenders and their calls for unity raised the fighting spirit of the country and gave it time to pull together a people's volunteer corps commanded by Kuzma Minin and Dmitry Pozharsky, who subsequently defeated the invaders. However, Smolensk remained in the hands of the Old Polish State until 1654 when the Russian army took the city after a two-month siege.

The fortress is quite impressive even today, although not all of it has been preserved. Only segments remain, and the wall is dilapidated and has crumbled in places. But even in such a state, the fortress is unquestionably the most interesting historical and architectural monument of the city. Thus, it is advisable to begin a tour of the city with this ancient structure.

The **eastern wall** of the fortress is

by far the most striking, for it runs unbroken for more than two kilometers above a deep ravine which leads down to the Dnieper. Nine towers have been preserved on this section of the wall, and they rise above their surroundings like mighty giants. The many-faceted **Gorodetskaya Tower,** also known as The Eagle (Oryol), is a most impressive piece of masonry. During restoration, its formidable machicolations were covered with a high wooden tent roof, as in days of old. From the lovely round **Veselukha Tower** which rises above the Dnieper, a breathtaking view can be had of the river and the hills, meadows, and fields stretching to the horizon beyond. Even today, this section of the wall divides the cheery houses buried in verdure within the fortress walls from the gloomy, uninhabited land beyond, quite jagged and cut through by deep ravines leading all the way down to the river.

Significant fragments of the walls have been preserved in the north and south-west along the riverside and several of the gate towers remain intact, in particular, the **Eleninskaya (Nikolskaya)** and the **Avraamievskaya** towers. To provide for better defense, the gateways were cut not straight, but at an angle. At present, to make transport more efficient and convenient, these gates are closed, and traffic moves through a large break in the wall near the Eleninskaya Tower. This mighty tower was considered but a minor one, so we must stretch our imaginations to picture the awesome grandeur and power of the many-tiered central structure, the Frolovskaya Gate Tower, which unfortunately has not come down to us. It stood by the Bolshoi Bridge which spanned the Dnieper and was the main entrance to the city from the direction of Moscow. At the beginning of the 18th century, the tower was pulled down, since it was in such a state of disrepair that it had become a hazard to passers-by. The Hodegetria Gateway Church (Odigitrievskaya tser-

kov) dated from the beginning of the 19th century, commonly known as the **Dnieper Gate** (Dneprovskie vorota), with symmetrical bell-towers on either end, stands on the former site of the main tower, dividing the remaining fragments of the wall.

The might of the fortress, the length of its walls, and the striking outline of the towers demand one's full attention at first and prevent one from taking note of its decorative elements which, upon closer examination, prove quite rich and varied. Even rows of precisely fitted rusticated stone blocks rise right from the grass. Glancing further up, one's eyes pause to rest on a platband with a triangular pediment that modestly frames the slightly recessed arched loop-hole. At the height of a man's head, the stone masonry changes to brickwork with broad bands of light-colored mortar. Those connected with the construction work said of the bricks with which the fortress was built: "They were so hard that bricks more durable or of a better quality could not be made, no matter how hard we tried." After three rows of brickwork, the flat surface of the wall is broken by a band of white stone which runs in both directions until it is lost from view in the curve of the wall. This decorative band extends the whole length of the fortress wall and seems to tighten the whole structure into a mighty fist poised to strike. The very top of the wall ends in a high palisade of merlons with vertical slits for embrasures.

The decoration of the walls pales before that of the ornate towers with their several tiers of platbanded embrasures and tall merlons in the form of swallows' tails. The gates have fine portals with bold contours which outshine by far the portals in the towers of the Moscow Kremlin.

Unfortunately, we know very little about the great architect Fyodor Kon, and what we do know is connected with his two most outstanding works: the fortifications of the White City (Byely

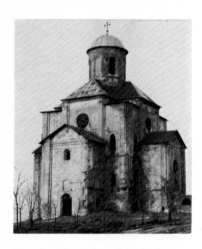

Church of the Archangel Michael
(Svirskaya Church)

Gorod) in Moscow and the Smolensk fortress. Thus his fame as a builder of fortifications was assured. But he was also well known as a builder of private houses and churches. Without knowing anything of his secular or ecclesiastical projects, it is possible to assert that this type of work was what attracted him the most, since it certainly inspired him and called forth great well-springs of talent. For so joyous and humanistic was his natural gift that in serving his homeland during a trying period in its history – when called upon to erect a fortress – while building towers for cannon, he made them pleasing to the eye, truly a delight to behold.

During the better than forty years the Polish gentry ruled in Smolensk following its capture in 1611, many significant buildings were put up, including a town hall, trade rows, several Roman Catholic churches, and a Jesuit Collegium. But all that has come down to the present from those days are the earthen ramparts (presently located on the territory of the park).

After Moscow liberated the city in 1654, experienced craftsmen were sent periodically to repair and restore the fortress walls. Secular architecture thrived, but all private structures were built of wood. However, several churches put up at the end of the 17th and beginning of the 18th centuries remain and contribute a great deal to the present-day appearance of the city. The most interesting of them is, of course, the new **CATHEDRAL OF THE DORMITION** (Uspensky sobor) which dominates the city skyline. It was erected on **CATHEDRAL HILL** within the confines of the oldest part of the city where Kievan Grand Prince Vladimir Monomakh had put up stone buildings within the original citadel long before. The construction of this church, so grandiose in scale, was conceived as a monument to the heroic defenders of Smolensk during the Polish-Lithuanian intervention and was ordered by Tsar Alexei Mikhailovich (the father of Peter the Great) in 1677. For various reasons, the construction work dragged on for an entire century which, needless to say, had a definite effect on the appearance of the building, which

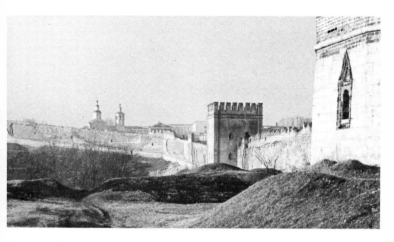

Fortress walls

underwent alterations in keeping with the changing artistic tastes of the times.

Crowning the hill, the Cathedral of the Dormition, still a working church today, was one of the largest Orthodox churches in all of Russia. From the ground to the base of the cross, it is 69.7 m high, 42.6 m wide, and 52 m long. Even now, the church makes a distinct impression from almost any point in the city. The building is a giant cube in form topped by a multi-stepped cornice. Broad, flat pilasters divide the façade into three sections, reflecting the interior division of piers supporting the vaults. It is surmounted by five domes placed closer to high apses. The helmet-shaped domes above the lanterns with their lancet windows (the windows of the central, wooden drum are false) in turn support refined, graceful onion-shaped domes resting on their own smaller drums. The first tier of the cathedral has enormous arched windows with ornate platbands, and the upper tier has round windows with moulded frames.

The enormity of the cathedral is felt immediately upon entering. Four mighty piers divide the inner space into a central nave and two aisles. In the western section is a staircase leading to the choir stalls which surround the church on three sides. The main feature of this impressive structure is the iconostasis which rises like a wall of tracery from the floor to the very vaults. Along with the lectern and the Bishop's throne, this grandiose masterpiece was carved over a period of ten years (1730-40) by Ukrainian Sila Trusitsky and his apprentices and assistants. This iconostasis is considered one of the most outstanding examples of 18th century wood carving.

The columns of the central iconostasis, the cornices of each of the tiers, the panels framing the icons – every detail is covered with masterful carving in which grape vines intertwine with clusters of berries, flowers, and oak and maple leaves. The angels and heads of cherubs which grace the structure are also carved of wood. The whole iconostasis has been gilded,

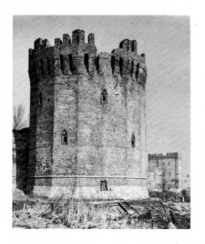 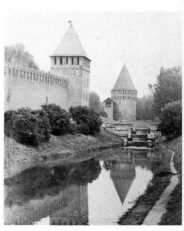

Ancient fortress towers (before and after restoration)

and in the bright rays of the sun or the dimmer light of the chandeliers, icon-lamps, and candles, the reflection is so brilliant, it seems about to burst into flames. The lectern and the Bishop's throne are also quite ornately carved.

In all probability, the icons were executed by artists of the same workshop, but unfortunately, only the icon *The High Priest* (above the Holy Doors) has come down to us unaltered. The rest, like the murals on the walls and vaults, have been repeatedly painted over and restored. The carved side-iconostasis in the side-chapels (the work of Sila Trusitsky's assistants Andrei Mastitsky and Fyodor Olitsky) were executed over a period of several years, from 1743 to 1746. An extremely valuable example of ancient Russian applied art, the *Shroud of Christ,* made in 1561 by embroideresses from the city of Suzdal, is preserved in the cathedral (to the left of the entrance).

In recent years, the iconostasis of the cathedral has been fully restored, and the exterior walls have been repainted in the original green and white, so today, the church looks just as impressive and majestic from a distance as it did two centuries ago.

Next to the Cathedral of the Dormition stands a two-tiered **bell-tower** built between 1763 and 1772. The lower tier incorporated a bell-tower erected a century earlier, as is demonstrated by the icon-cases, small recesses, and tile inserts, which were common decorative elements of that time. Still, the main thrust of the bell-tower is vertical, as it consists of two rectangular volumes surmounted by a dome on a miniature drum. It is principally a baroque structure with 24 Tuscan columns on the lower tier, and 16 Corinthian on the upper. Most probably, the same Pyotr Obukhov who completed work on the cathedral built the bell-tower as well. The extension to house a clock on the east side of the tower appeared in 1795. The bell-tower was restored along with the cathedral in 1958-61.

Since an entire ARCHITECTURAL ENSEMBLE appeared on Sobornaya Hill with time, it is worthwhile departing from the chronological

order of our route to have a look at the various buildings of interest on the hill.

Generally, tourists reach the hill from Bolshaya Sovietskaya Street via the **Cathedral Steps** (Sobornaya lestnitsa), which are of architectural interest in and of themselves. The Steps were originally built by Pyotr Obukhov in 1767 in the ornate baroque style. Then, in 1784, they were rebuilt in the more austere classical style by Mikhail Slepnyov, architect for the province, who looked after the city of Smolensk quite assiduously. The lower flights, faced with masonry, are of white stone, and the upper flights are of granite. The brick parapet has moulded pillars crowned with mushroom-shaped capitals. The top flight of stairs divides into two branches which skirt the chapel that stands on the breast wall. This landing affords an excellent panorama of the part of the city which lies along the Dnieper, and from here, an arched gate with a triangular pediment — the main entrance — leads to the territory of the Cathedral of the Dormition.

An open gallery links the top landing of the Cathedral Steps with the **Gateway Church of the Epiphany** (Bogoyavlensky sobor). In 1858, the gallery was enclosed by intricate open-worked wrought iron railings. The church's positioning is somewhat unusual, for while the eastern side rests on the hill, the western section is supported by a broad arch. The cobblestone road which passes under this arch also leads from the lower part of the city to Sobornaya Hill. This structure was erected by Mikhail Slepnyov in 1781-87 in place of a wooden church. In 1812, the church was seriously damaged by Napoleon's troops and later underwent repairs. The cathedral suffered greatly during the fascist occupation of World War II and was restored in 1946.

Another gallery links the Cathedral of the Epiphany to the **former residence of the archbishop,** located on the western slope of Sobornaya Hill.

This fine example of secular architecture dates back to 1774, and Pyotr Obukhov is believed to be the architect. The façades of this elongated, two-storey building are broken by pilasters. The first floor windows are square, while the rectangular windows on the second floor have triangular pediments. This building has come down to us with alterations.

On the eastern slope of the hill, the small **Church of St. John the Baptist** (tserkov Ioanna Predtechi) was built in 1703. Adjoining it to the north is the two-storey **Metropolitan's Chambers.** In the middle of the 18th century, a refectory was added to the church, and after the new residence of the archbishop was built on the western slope of the hill, the sacristy and library were housed there. After World War II, the building was repaired and given over to the local lore museum. Some of the original furnishings have been preserved, including the only 18th-century tiled stove in Smolensk. Presently, the exhibits of the **Nature Section of the Smolensk Museum-Preserve** are on display here. In the building across from the metropolitan's chambers, the permanent exhibition, **The Russian Home,** based on collections made at the end of the 19th and beginning of the 20th centuries, can be seen.

Adjacent to the metropolitan's chambers is the elongated two-storey **consistory** built in 1790 in the style of Russian classicism. Presently, the regional archives are kept here.

On high ground near the group of buildings on Sobornaya Hill stands the former **TRINITY MONASTERY** (Troitsky monastyr), the premises of which are presently divided by Bolshaya Sovetskaya Ulitsa. The main church of this monastery was built in the second half of the 17th century. The square, pillarless building is well proportioned and has a single, rather low apse, and a modest narthex added on to the western side. The faceted drum supports a small dome. The only decoration is a semi-circular cor-

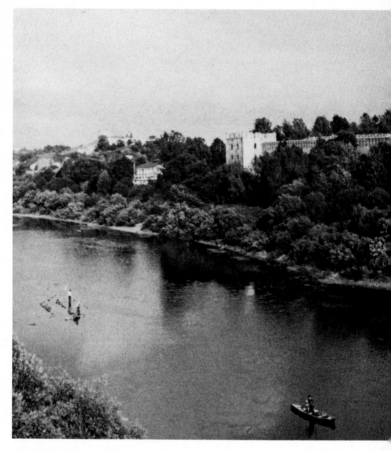

The Dnieper River as it flows past Cathedral Hill

nice extending around the middle of the façades on the main body of the church and around the western façade of the narthex. Cheery platbands brighten the church porch, as does the splendid baroque pediment. These latter are characteristic features of Moscow architecture of the first half of the 18th century and attest to renovations done on the church during that time. The cathedral was pillaged and badly damaged by Napoleon's troops in 1812, but it was restored soon after. Unfortunately, the ornate porches of the church have not survived.

To the south of Trinity Cathedral stands the **Church of the Conception of St. Anne** (tserkov Zachatiya Anny) (1767) which has come down to us in

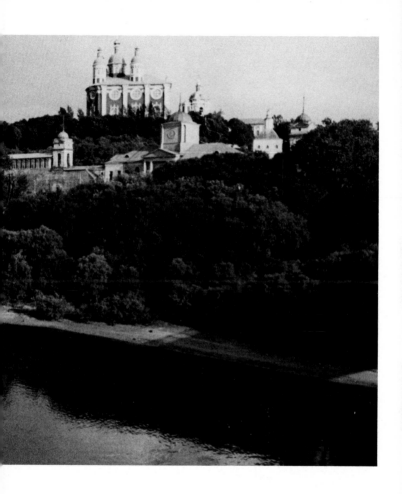

rather poor condition. The most interesting feature of the church is the five-faceted apse. To the west is a long, low building which once housed the infirmary.

The monastery **bell-tower** (1733) on the other side of Bolshaya Sovetskaya Ulitsa has two tiers and is crowned by a dome on a two-tiered octagonal drum.

Not far from the Trinity Cathedral is the CATHEDRAL OF THE ASCENSION (Voznesensky sobor) of the former Monastery of the Ascension (9a Ulitsa Konenkova) with its side-chapel, refectory, and bell-tower. It was erected between 1694 and 1698 and completed in 1700 after a bad hurricane which did extensive damage to the building. There is

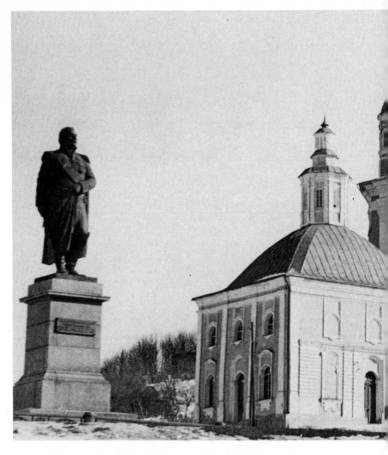

Historic buildings of Cathedral Hill

almost no decoration on the walls, which have three rows of windows, the first row being rectangular, the second, square, and the third, hexagonal. Atop the church is a simple octagonal drum with a helmet-shaped dome. The side-chapel and the narthex repeat exactly the decorations and style of the first two tiers of the church. The pyramidal bell-tower is just as ascetic and impressive. The almost total lack of ornament on the façades is possibly the result of later alterations. The Cathedral of the Ascension was restored at the end of the 1960s, and the **exhibit hall of the Smolensk museum-preserve** is now situated there.

In 1764, to the north of the Cathedral of the Ascension, the small **Church of St. Catherine** (Ekaterinskaya tserkov) was built. It is attributed

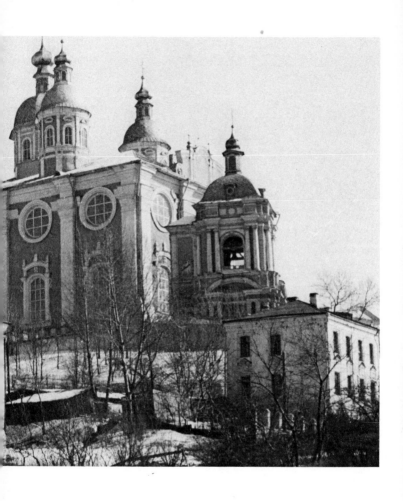

to the great Russian architect Matvei Kazakov. Its low cubic volume is surmounted by an onion-shaped dome on a figured base. In 1830, above the main gate of the monastery, the **Akhtyrskaya Church** with its round drum topped by a dome was built in the classical style. The first floor of the eastern façade of the church is a false rusticated arch with deep vertical bays running along the sides.

A distinguishing trait of construction in the city at the end of the 17th and beginning of the 18th centuries was that the forms and methods of Naryshkin or Moscow Baroque, which totally dominated in Moscow at the time, did not gain wide acceptance in Smolensk, a place known for its architectural conservatism. This feature is common in other provincial towns of Russia.

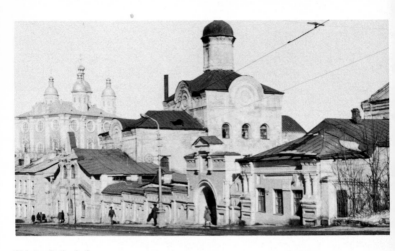

Trinity Cathedral

A tour of the 18th century architectural monuments of the city can begin with the LOWER CHURCH OF ST. NICHOLAS (Nizhne-Nikolskaya tserkov) (1748) by the Staryi (old) Bridge on the right-hand bank of the Dnieper (Ulitsa Staroleningradskaya). This church is reminiscent of the cathedral of the Trinity Monastery, especially with its decorative semi-circular cornices in the center of the façades. However, it is much more ornate: the façades are divided by pilasters, and the slightly recessed arched windows have platbands with elaborate patterns of raised tracery and projecting corners, while the figured bays above them complement the complex design. The entrance and the narthex porch leading to the second floor were added in the 1860s. At the same time, the stone drum supporting the dome was replaced by a wooden one. In 1766, a three-tiered bell-tower was built to the west of the church above the arched passage that served as the main gateway to the premises.

One of the most interesting architectural monuments of the second half of the 18th century is the CATHEDRAL OF THE TRANSFIGURATION (Preobrazhensky Sobor) of the former Avraamy's Monastery situated in the eastern section of the city near the fortress walls (18-20 Ulitsa Krasnogvardeiskaya) which was erected in 1755 in place of a wooden church. The main body of the cathedral is rectangular and sweeps upward to a five-faceted apse. Close by the narthex stands a bell-tower. A two-tiered gallery, originally open, was added on in the mid-19th century. Both the cathedral and the bell-tower are topped by small domes resting on two-tiered drums.

The extremely elaborate and interesting baroque decor is quite unusual for the buildings of Smolensk. The platbands that surround the windows of the façades are lavishly ornamented with triangular pediments, scrolls, *kokoshniki,* semi-columns, and other rich decoration. The unique cartouche above the central window of the first tier is reminiscent of a heraldic shield.

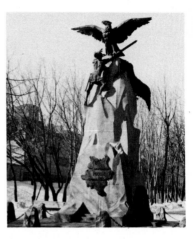

Monument to the Heroes of the War of 1812 against Napoleon (Monument with Eagles)

Consistent elements of Smolensk architecture of the mid-18th century were the rectangular or cubic main body of the church itself, and the two-tiered octagonal drums supporting domes. These features were so well liked by the townsfolk that they continued to appear in buildings of much later construction.

Built atop a hill in the eastern part of the city in 1782, ST. GEORGE'S CHURCH (Georgievskaya tserkov) (18a Ulitsa Furmanova) can be seen from a distance. Curiously enough, the decor and composition of the church follow the principles of Moscow Baroque, which had come into vogue in the capital many years before. Thus, an octagon surmounts the rectangular base of the church, and the octagon is topped by a two-tiered drum supporting a dome. Another characteristic feature of this style — richly ornamented platbands — is also present.

The last of the 18th century architectural monuments of the city is the CHURCH OF THE INTERCES-SION (tserkov Pokrova) (5 Ulitsa Timiryazeva) which stands on a high hill right next to the fortress wall. The construction of this church in 1794 marked the advent of classicism in provincial architecture. The church's **bell-tower** is especially fine with its low cubic volume situated atop a tall first tier which serves as a pedestal for the slender octagon that houses the bells with its helmet-shaped dome. Nearby stands the **Hodegetria Gateway Church** (Odigitrievskaya tserkov) discussed above which replaced the Frolovskaya Tower.

In 1779, a master plan for Smolensk was approved, according to which the city's streets were to be widened and straightened, and the central part was to be divided into square blocks, without taking into account the actual relief of the area, which was quite complex. The realization of this plan would invariably have had a negative effect on the extant historically and architecturally valuable buildings.

However, this project was interrupted by the War of 1812. Once again the city, which had suffered so much

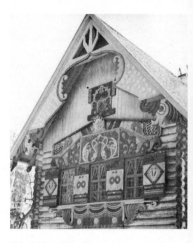

Talashkino. The *Teremok*

in the past, was subjected to enemy invasion.

On those August nights, the air was filled with the aroma of ripening apples, for the orchards of Smolensk were producing a bumper crop. On the 4th of August, day broke quietly, and the air was clear. But suddenly, at eight o'clock, the booming of cannon was heard, and soon after, the French army approached and began to storm the city. This is how a friend of Alexander Pushkin, poet Fyodor Glinka, who was present, described what took place: "Everything outside the fortress walls was in flames, and the air was thick with smoke of various hues. Through the crimson dawn came the rumble of exploding bombs, the thunder of cannon, the crack of rifle volleys, the beating of drums, the screams and moans of old men, women, and children. This was the terrible sight that met our eyes, deafened our ears and made our hearts freeze in terror. The Russian troops sallied forth to meet the attack." The heated battle continued for two days, but the brunt of the massive assault was borne by the brave Russian regiments and the strong fortress walls, and the forward march of the French troops was halted. The enemy was able to take the city only when, in compliance with the general strategy for defense of the country as a whole, Russian Commander Barklay-de-Tolly withdrew his troops to join up with the rest of the Russian army.

"The sole witnesses to our entry into the devastated city of Smolensk were the smoking ruins of buildings and the corpses — French and Russian alike — which we buried in a common grave... Never before in all our military activity had we seen such a sight, and we were deeply moved... Over half of the buildings were destroyed by fire, and in spoils, we took only a few worthless cannon..." Napoleon wrote home to his Empress in Paris after entering the city through the Nikolskye Gate.

Just as Smolensk had saved the country two centuries before from enslavement by the Polish-Lithuanian state, by delaying Napoleon's troops for several days, it allowed the two Russian armies of Barklay-de-Tolly and Bagration to join up. And as two centuries before, the invaders began to perish at the hands of Smolensk partisans. While still in the city,

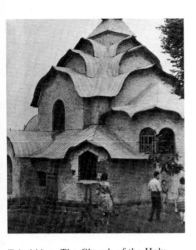

Talashkino. The Church of the Holy Spirit

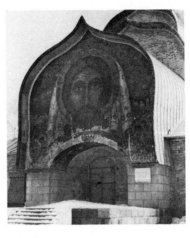

Nikolai Roerich. Mosaic of the *Holy Mandilion*

Napoleon began to negotiate for a peace treaty, making the suggestion to Emperor Alexander I via captured Russian General Tuchkov.

The heroic victory of the Russian people in the war against Napoleon is reflected in many of Smolensk's monuments. The inscription on the MONUMENT TO THE HEROES OF THE PATRIOTIC WAR OF 1812 reads, *Grateful is Russia to the Heroes of 1812*. This monument was erected in 1913 (sculptors: Stepan Nadolsky and Colonel N. Shutsman, Army Corp of Engineers). In this fine sculpture, often called the Monument with Eagles, Russia is represented as a high, inaccessible cliff with an eagle's nest at the top. A Gallic soldier in medieval armor is attempting to reach the peak, but one of the eagles defending the nest has grabbed the enemy's arm in its mighty claw, while the other bird covers the nest with its wing. The fierce birds symbolize the armies of Barklay-de-Tolly and Bagration which united to defend Russia. The monument is located in the square of Heroes' Memory Garden in

the downtown section of the city. By the entrance to the garden stands a **bust of** the great military commander **Mikhail Kutuzov** (1912) erected with money collected by the residents of Smolensk province. There are other monuments in Smolensk in honor of the victory in the War of 1812. The most significant of them, a **bronze statue of Field Marshal Kutuzov-Smolensky** on a tall granite pedestal, was erected in 1954 at the foot of the Cathedral Hill (sculptor Georgi Motovilov). The pyramidal **obelisk** crowned by a faceted cupola with a cross, **To the Heroic Defenders of Smolensk, 4-5 August 1812** (architect Antoni Adamini), was unveiled in 1841 in the city park. The **Monument to the St. Sophia Regiment,** dedicated to the members of this brave fighting outfit who took part in the battle near Smolensk in 1812, was erected by the members of the regiment on the centennial of their predecessors' valiant feat of arms. The tall tetrahedral obelisk resting on a hexagonal pedestal with a stepped surround surmounted by an eagle with wings outspread was

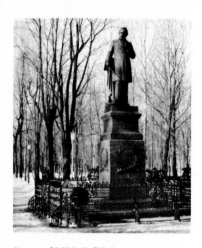

Statue of Mikhail Glinka

made by Boris Tsapenko, a native of Smolensk and private in the 7th company of the Regiment.

After the war, work on the reconstruction of the city was resumed in Smolensk according to a new master plan approved in 1817. Fortunately, all that was to be done in the old section of the city was some relatively insignificant road work. In terms of architectural styles, classicism was in vogue at the time, and it had a definite effect on construction going on in Smolensk. Unfortunately, very few of the buildings of this period have survived. Several of the classical-style churches have already been described, and of the secular structures, the most interesting is the building of the former NOBLEMEN'S CLUB (presently, the Medical Institute, 3 Ulitsa Glinki) which looks out over the old city park, now known as Mikhail Glinka Park. The building was erected in 1825 according to a design by Avraam Melnikov. The building has two identical façades running along parallel streets. In the center of each façade is a portico with six Ionic columns supporting a triangular pediment. Entrance arches are located in the rusticated socle of each portico. The lower two-storey wings of the building are ornamented by flat pilasters and modest cornices.

Smolensk has three notable buildings from the end of the 19th and beginning of the 20th centuries. One of them is the former **Roman Catholic Church** built in 1894 in the Polish Gothic style in the southern part of the city on what is today Uritsky street (Ulitsa Uritskogo). The two others were built in the *art nouveau* style. The first is the **home of the merchant Budnikov** which dates back to 1895 and is located at the intersection of Kommunisticheskaya and Mayakovskaya streets (Ulitsy Kommunisticheskaya i Mayakovskogo). The rich majolica decor of the façades is quite interesting. The second *art nouveau* building is the ART GALLERY (7 Ulitsa Krupskoi). It was erected between 1903 and 1905 specially to house the collection of well-known connoisseur of Russian art and antiquities, Princess Maria Tenisheva. Of red brick,

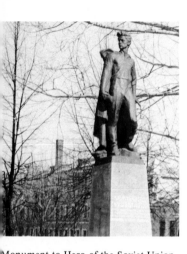

Monument to Hero of the Soviet Union,
partisan and Komsomol member
Vladimir Kurilenko

with ornamental bands of white brick, green majolica tiles, and an elegant cartouche above the main entrance, the building was constructed to the design of artists Sergei Malyutin and Viktor Vasnetsov and the princess herself. By all means, this gallery is worth a visit, for some of the exhibits are truly excellent. There are some first-rate 16th century icons of the Moscow and Novgorod schools, as well as canvasses by many outstanding Russian artists, including Fyodor Bruni, Ivan Aivazovsky, Ivan Shishkin, Vladimir Makovsky, Ivan Kramskoi, Nikolai Ghe, Ilya Repin, Isaak Levitan, Konstantin Korovin, and Mikhail Vrubel; the collections of early 20th century and Soviet art are also quite good. The European paintings include works by artists not to be found in other Soviet museums (*Portrait of an Old Man,* by H. Cassel; *Flowers,* by Juan de Arellano; and *Judith with the Head of Holofernes,* by Giovanni Antonio Pellegrini).

The small village of Talashkino (18 km from Smolensk) is also connected with the activities of Maria Tenisheva. A BRANCH OF THE SMOLENSK MUSEUM-PRESERVE is presently located on the site of her estate and includes the studios and workshops she had built here at the end of the 19th and beginning of the 20th centuries. There were joiners' shops and potters' studios, linen and embroidery shops; and in all of them, ancient Russian folk crafts were cultivated. Here, in close contact with the masters of folk art employed there, many important figures in the Russian arts sought and found inspiration.

The richly decorated wooden **Teremok** (a fairy-tale house) built in 1901 to a design by Sergei Malyutin is also located in a picturesque corner of the museum-preserve. The wares of Tenisheva's workshops are on display here: embroidery, wooden articles, cloth, and ceramics, as are many objects connected with the life and activities of that remarkable artist, singer, and social figure Maria Tenisheva.

Nearby in the **village of Flyonovo,** the interesting **Church of the Holy Spirit** (tserkov Svyatogo Dukha), which

serves as a mausoleum, was built in 1902. Over the portal is a large, bright-colored mosaic of the *Holy Mandilion* executed by Nikolai Roerich.

Over the years of Soviet government, established in Smolensk in 1917, a large number of industrial enterprises and civil buildings, apartment houses, schools, kindergartens, and hospitals were built. The development of the city was interrupted by World War II.

The nazi occupation brought untold misfortune and destruction to the city. Of 8,000 buildings in the city, 7,300 were destroyed completely, including 93 per cent of the housing. Neither were the historical and cultural monuments spared the ravages of war. Many priceless buildings were razed, and the Nazis carted works of art and valuables from the city — icons, paintings, fine china, crystal, furniture, bronze, and objects of historical worth were looted. Only part of what was taken was recovered after the war, while the rest has been lost, probably irretrievably. Smolensk was one of the fifteen Soviet cities considered totally destroyed, and as such, by governmental decree, it was rendered immediate material and economic aid for reconstruction.

This time as well, Smolensk, the gateway to the heart of the country, fought to the death. From 10 July until 10 September 1941, the battle of Smolensk continued, paralyzing enemy crack troops who were on their way to Moscow and foiling Hitler's plan to take the capital by *blitzkrieg* warfare. The partisans of the area were a continuous threat and thorn in the side to the nazis occupying the city.

The memory of those who died in the war is revered in Smolensk. In the HEROES' MEMORY GARDEN, their names are inscribed on slabs of black marble at the foot of the fortress wall, and their deeds have become part of the glorious history of the city. At the beginning of Frunze Street (Ulitsa Frunze) in the center of town is the **Bayonet Monument** symbolizing the intractability of the defenders of Smolensk in the summer of 1941. In

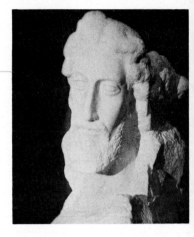

The Son of Man. Sculpture by Sergei Konyonkov

the southwestern suburb of the city at the place where the nazis carried out mass executions of Soviet citizens, the lovely Readovsky Park stretches over many hectares. Here, the **Burial Mound of Immortality with obelisk** serves as a constant reminder of those who gave their lives for their country during the last war. Every year on May 9, Victory Day, the people of Smolensk come here to honor the memory of their fellow citizens at the monuments, steles, and graves of the park.

But life continued, and the wounds of war were healed. The architectural monuments of the city have long been restored. Today, Smolensk looks younger and more vigorous than ever as it continues to grow by leaps and bounds. Its rich history lives on in the monuments described herein. It is a history to be proud of, as Smolensk is proud of the many outstanding figures who have contributed to it. Among them are Mikhail Glinka, the founder of Russian classical music; traveller and researcher Nikolai Przhevalsky; naturalist Vasily

Dokuchaev; Admiral Pavel Nakhimov; Marshal Mikhail Tukhachevsky; aircraft designer Semyon Lavochkin; first cosmonaut Yuri Gagarin; poets Mikhail Isakovsky, Alexander Tvardovsky, and Nikolai Rylenkov; and sculptor Sergei Konyonkov.

These famous sons of the city will never be forgotten, for streets have been named after them, museums dedicated to their lives and activities, and monuments erected in their memory. For example, a MONUMENT TO MIKHAIL GLINKA was put up in 1885 in the city park. A visit to THE SERGEI KONYONKOV SCULPTURE MUSEUM (7 Ulitsa Mayakovskogo) is a must for anyone who goes to Smolensk. The fame of the peasant's son Konyonkov (1874-1971) from the village of Karakovichi not far from Smolensk spread far beyond the borders of the Soviet Union even during the sculptor's lifetime.

The well-known *Self-Portrait* hewn from a large block of wood opens the exhibition. Its likeness to the sculptor is not difficult to discern. The figure seems tied to the base by roots as mighty as those that connected Konyonkov to his native Smolensk.

All the major themes of Konyonkov's work are included in the exhibition: the events of the revolution, portraits of figures in the arts, images capturing the beauty of nature, epic literature and social thought, lyricism and folklore. Among his major works are *V. I. Lenin, Vladimir Mayakovsky, Lev Tolstoy, Girl, Naiad, Pan Playing His Pipe, Marfinka,* and *Modest Mussorgsky.* The best works by this remarkable man can be termed classical in that they represent a striving toward the genuine ideals of humanity, intelligence, and harmony.

Many of his sculptures were inspired by masterpieces of classical Greek sculpture. He had the chance to work by the walls of the ancient Parthenon and to obtain fine marble from the ancient quarries at Mt. Pentelicon, from which Phidias and Polyclitus often got their stone. Although he traveled to many lands, like the legendary Antaeüs, he was always drawn back to his native land, for it was here that he derived his inspiration and strength.

To remember a person's face better, sometimes it is necessary to look away and then gaze at it once more. And so it is with cities. After examining all the sites of interest and admiring the beautiful monuments, at the moment of parting, it is well worth looking out at the city as a whole once more from some higher vantage point. In Smolensk, such a look-out point can be had from the New Bridge (Novy most) across the Dnieper. The water flows slowly below, and the buildings of the old and new sections of the city seem to float in a sea of greenery like so many boats. Sobornaya Hill rises above this sea of green, and fields, meadows, and hills stretch out to the horizon and disappear in a blue haze. It is especially important to have such an overview of the city, for Smolensk is the key to all of Russia and to its ancient monuments. This city provides the essential clue to an understanding of the vast spirit of the land, to the majestic calm of its wide-open spaces and its subdued natural beauty, to the unhurried charm of its ancient cities.

Historical and Architectural Monuments[1]

Church of SS. Peter and Paul, 1146 — 20-a Ulitsa Kashena
Church of St. Barbara and bell-tower, 1753 — 20-a Ulitsa Kashena
Church of St. John the Divine, 1166-70 — Ulitsa Bolshaya Krasnoflotskaya

[1]Here and in other such lists are included monuments under state protection.

Church of the Archangel Michael or Svirskaya Church, 1194, bell-tower, 1785 —
Ulitsa Malokrasnoflotskaya

Earthen fortifications known as the Lithuanian Ramparts, 15th-16th centuries —
territory of the park on Ulitsa Dzerzhinskogo

Fortress walls and towers; the Kopytenskiye Gate, the Bubleika, Gromovaya,
Donets, Makhovaya, Nikolskaya, Gorodetskaya (Oryol), Veselukha, Yele-
ninskaya, Avraamievskaya, Belukha, Pozdnikova, Krasnaya, and Volkova
towers, 1596-1602 — the downtown area of the city

The Dnieper Gate (Hodegetria Gateway Church) 1813 — 1 Ulitsa Soboleva

Earthen ramparts known as the Korolevsky Bastion, 1611-13 — territory of the
Park on Ulitsa Dzerzhinskogo

Earthen embankment known as the Sheinov Bastion, 17th century — Ploshchad
Smirnova (Smirnov Square)

Buildings on Cathedral Hill (Sobornaya Gora)

Dormition Cathedral, 1677-79, 1732-40, 1772
Bell-tower, 1763-1772
Metropolitan's chambers with his private Church of St. John the Baptist and the
refectory, 1703
Church of the Annunciation, 1774
Residence of the archbishop, 1774
Cathedral Steps and the Gate of the Dormition Cathedral, 1767,
renovated in 1784
Gateway Church of the Epiphany, 1781-87
Cathedral guest rooms, end of the 18th century
Consistory, 1790

The Trinity Monastery — Ulitsa Bolshaya Sovietskaya

Trinity Cathedral, 1672-75, 1727
Bell-tower, 1733
Church of the Conception of St. Anne, 1767
House of the archmandrite, 1671-75

Ascension Monastery — 9, 9-a Ulitsa Konyonkova

Cathedral of the Ascension and bell-tower, 1694-98
Church of St. Catherine, 1764
Akhtyrskaya Gateway Church, 1830

Avraamy's Monastery — 18-20 Ulitsa Krasnogvardeiskaya

Cathedral of the Transfiguration, 1755
Instructors' Wing, 2nd half of the 18th century
Library Wing, 2nd half of the 18th century

Church of the Archangel Michael or Svirskaya Church, 1194, bell-tower, 1785 — Ulitsa Malokrasnoflotskaya

* * *

Lower Church of St. Nicholas, 1748, bell-tower, 1766, chapel, end of the 19th century — 7 Ulitsa Staroleningradskaya
Church of the Resurrection, 1765 — Ulitsa Voikova
Church of the Transfiguration of the Savior, 1766 — Ulitsa Revvoensoveta
Church of the Exhaltation of the Cross, 1767 — 33 Ulitsa Novo-Moskovskaya
Church of the Savior (Okopnaya Church), 1775 — 4 Ulitsa Okopnaya
Church of St. George, 1782 — 18-a Ulitsa Furmanova
Church of the Intercession, 1794 — 5 Ulitsa Timiryazeva
Upper Church of St. George, 1810 — 2 Ulitsa Verkhne-Tolmachevskaya (in the courtyard).
Former Noblemen's Club, 1825 — 3 Ulitsa Glinki
Polish Gothic-style Roman Catholic Church, 1894 — 8 Ulitsa Uritskogo
Budnikov House, 1895 — 19 Ulitsa Kommunisticheskaya

Monuments

Monument to Mikhail Glinka, 1885 — sad imeni Glinki (Glinka Park)
Monument to Vladimir Lenin, 1967 — Ploshchad Lenina (Lenin Square)
Monument to the Heroes of the War of 1812, 1913 — sad imeni Kutuzova (Kutuzov Garden)
Monument to Kutuzov, 1954 — Ulitsa Bolshaya Sovetskaya
Monument to Hero of the Soviet Union, Partisan and Komsomol Member Vladimir Kurilenko, 1966 — square on the corner of Glinka and Mayakovsky streets (Ploshchad na uglu Ulits Glinki i Mayakovskogo)
Monument to the St. Sophia Regiment in Honor of the Centennial of the Heroic Defense of Smolensk in 1812, 1912
The Bayonet Monument to the Soldiers of the 16th Army, 1970 — Ulitsa Frunze
Burial Mound of Immortality, 1970 — Readovsky Park
Bust of Yuri Gagarin, 1974 — Prospekt Gagarina (Gagarin Avenue)
Monument to Sergei Konyonkov, 1974 — intersection of Konyonkov and Przhevalsky streets (perekrestok Ulits Konyonkova i Przhevalskogo)
Monument in Honour of the Liberation of the Smolensk Region from the Nazis — Ulitsa Oktyabrskoi Revolutsii

Information for Tourists

Hotels
Rossiya — 23/2 Ulitsa Dzerzhinskogo
Tsentralnaya — 2/1 Ploshchad Lenina
Smolensk — 11/30 Ulitsa Glinki
Phoenix Motel — 15 km from the city on the Moskva-Minsk Highway

Restaurants
Tsentralnyi — 2/1 Ploshchad Lenina
Smolensk — 30 Ulitsa Nikolayeva
Dnieper (in the Smolensk Hotel) — 11/30 Ulitsa Glinki
Zarya — 2/12 Ulitsa Konyonkova
Vityaz — 2b Ulitsa Kutuzova

Rossiya (in the Rossiya Hotel) — 23/2 Ulitsa Dzerzhinskogo
Stereobar (bar) — 18/1 Ulitsa Bolshaya Sovetskaya

Museums and Exhibitions
Smolensk Museum-Preserve of History, Architecture and Art
 Departments: History — 8 Ulitsa Lenina
Lenin in Smolensk Region — 15 Ulitsa Lenina
Smolensk Region in World War II — Heroes' Memory garden (skver Pamyati
 geroyev)
Nature — 7 Sobornyi dvor
The Russian Home (Exhibition) — 7 Sobornyi dvor
Sergei Konyonkov Sculpture Museum — 7 Ulitsa Mayakovskogo
Art Gallery (former Tenisheva Museum) — 7 Ulitsa Krupskoi
Exhibition Hall — 9a Ulitsa Konyonkova
Planetarium — 9 Ulitsa Voikova
The *Teremok*, the Talashkino branch of the Smolensk Museum-Preserve
All departments of the Museum-Preserve are open from 10 a.m. to 6 p.m.

Theaters and the Philharmonic Society
Smolensk Drama Theater — 4 Ploshchad Lenina
Puppet Theater — 1 Ulitsa Soboleva
Philharmonic Society — 1 Ulitsa Soboleva

Cinemas
Oktyabr — Ploshchad Smirnova
Sovremennik — 15 Ulitsa Oktyabrskoi revoliutsii

Stores
Beryozka (foreign currency) — Hotel Tsentralnaya, Motel Phoenix
Souvenirs — 11 Ulitsa Lenina
Tsentralnyi (Central) Department Store (univermag) — Ulitsa Oktyabrskoi
 revoliutsii
Rubin (jewellery) — 33 Ulitsa Bolshaya Sovietskaya
Melodiya (records) — 13 Ulitsa Lenina

Service Stations and Garages
19a Prospekt Gagarina
Near the Phoenix Motel

* * *

Smolensk Branch of Intourist — 21 Ulitsa Lenina (in the Tsentralnaya Hotel)

Kalinin

Kalinin, formerly Tver, is the center of the Kalinin Region of the RSFSR. It is 149 km to the northwest of Moscow on the Moscow-Leningrad Highway and has a population of over 400,000. This railroad junction and Volga River port is a major industrial center with highly developed sectors in machine-building, textile, chemical, printing, and several branches of light industry.
There are four institutes of higher learning in Kalinin, including a university, and drama, children's, and puppet theaters. Kalinin boasts a museum of local lore, a picture gallery, a museum of everyday life in old Tver, and one dedicated to the life and works of prominent Russian satirist Saltykov-Shchedrin.

The next stop on our tour of ancient Russian cities is Kalinin, which, like Smolensk, is located on one of the major motor routes by which visitors from abroad travel to the capital: the Moscow-Leningrad Highway. Like many other ancient cities, Kalinin owes its existence to a river, for it was founded on the left bank of the largest waterway in Europe — the Volga — at the point where the Tvertsa River flows into it. It is not clear whether the river gave the city its name or vice versa, and the etymology of the word "Tver" is likewise unknown, but one version is that it comes from the Finnish word 'tiort', meaning rapid, while another says that it derives from the Russian word 'tverd', which means protective wall or fortress.

In any case, Tver was founded in the early 12th century by citizens of the ancient Russian city of Novgorod, situated in the northwest of the country, on the site of an ancient Slavic settlement. The spot for the new city was chosen with an eye to the major trade routes of the time which ran from the Varangians to the Greeks. The first written reference testifying to the existence of Tver is from the year 1164 when it was mentioned in Novgorod documents. In 1182, Vsevolod the Big Nest, so called because of his large family, Prince of Vladimir and Suzdal, seized the land above the Volga from Novgorod and built the Tver Kremlin or fortress on the right bank of the Volga at the mouth of the Tmaka River, cutting off the latter's supply of grain from the south. In chronicle entries for the year 1209, Tver was mentioned in connection with this war.

In 1238, Tver shared the tragic lot of many other Russian cities: it was sacked and burned by the troops of Batu Khan. However, it recovered rather quickly, and in 1246, it became the capital city of an independent principality.

It is significant that the first stone building to be constructed in all of Rus since the invasion of the Golden Horde was erected in Tver in 1285. This building, the Cathedral of the Transfiguration, with its richly decorated interior, unfortunately has not survived. (It was in such a state of disrepair at the end of the 17th century

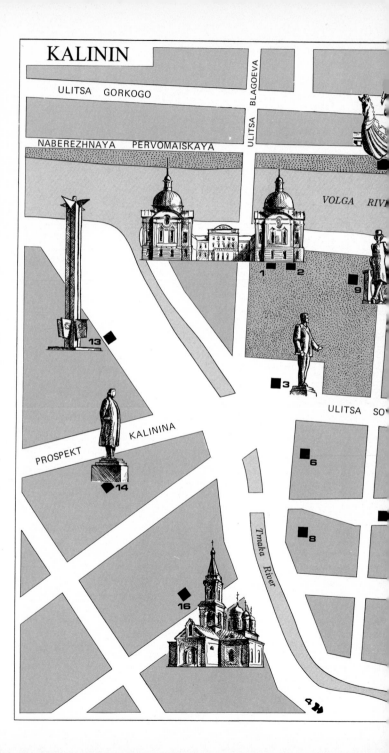

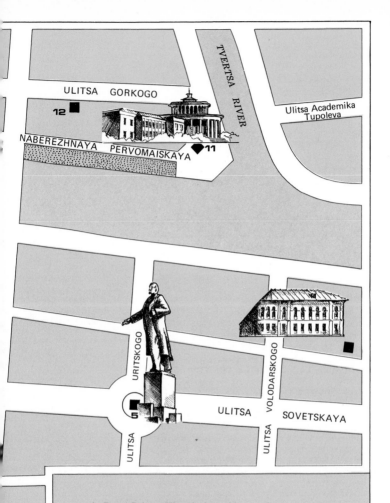

ULITSA GORKOGO

TVERTSA RIVER

Ulitsa Academika Tupoleva

NABEREZHNAYA PERVOMAISKAYA

12 ■

◆**11**

5 ■

URITSKOGO

ULITSA

ULITSA VOLODARSKOGO

ULITSA SOVETSKAYA

1. Royal Palace—Historical, Architectural and Literary Museum
2. Art Gallery
3. Monument to Mikhail Kalinin
4. Common Grave of the Revolutionaries
5. Monument to Lenin
6. Tsentralnaya Hotel
7. Monument to Mikhail Saltykov-Shchedrin
8. Circus
9. Monument to Alexander Pushkin in the city park
10. Monument to Afanasy Nikitin
11. River Terminal
12. Cathedral of the Dormition in the Otroch Monastery, 17th century
13. Victory Obelisk
14. Monument to Ivan Krylov
15. Old Tver Museum
16. White Church of the Holy Trinity, 16th century

that it had to be pulled down.) In 1317, a new fortress, considerably exceeding the old one in size, was built above the Volga (now the territory of Revolution Square, *Khimik* Stadium, and part of the public gardens). New earthen ramparts were dug, and the wooden walls and towers were covered with clay and whitewashed to resemble white stone. The lavish chambers of the prince and the fine homes of his retinue and the clergy within the fortress walls were a lovely sight indeed.

In 1327, a rebellion broke out in Tver against the cruelty and cupidity of Cholkhan, the Golden Horde's tribute collector in that region. This was one of the largest rebellions against the Tartar Yoke anywhere in Russia throughout the history of that entire period. It was put down mercilessly, and Tver and other settlements were burned to the ground. Only toward the end of the century did the city recover. In the 15th century, Tver reached the height of its political and economic influence. Its great beauty and might were noted by many, including ambassadors and travellers from other lands. The fame of Tver's craftsmen spread far and wide, especially that of its stone masons, founders, jewellers, and engravers. The population of the principality grew rapidly as Russians from other places ravaged by the Golden Horde streamed into the area. A rich, powerful principality, Tver tried to pursue independent policies, and for two centuries opposed the attempts of Moscow to unite the Russian lands into a centralized state under its leadership. Only in 1485 did Grand Prince Ivan III succeed in subduing the unruly principality and placing it firmly under the control of Moscow.

During its heyday in the 15th century, Tver was a large city of artisans and merchants who led intense, energetic lives. While the political, religious, and architectural center of Tver was the kremlin which looked out over the Volga, the Tmaka, and a deep dry moat

on three sides, the center of everyday life for the townsfolk was the large, noisy market square where the shops of the local merchants stood. On market days, this square filled with carts piled high with a multitude of goods from near and far, for the principality maintained commercial ties not just with other Russian cities but, with the countries of Western Europe and the Near East as well. There was a special inn for traders who came to town. The customs house, where duty was paid on merchandise, was close by. Not far away was a tavern.

The market square was filled with an incessant hubbub in which the shouts of town criers reading the princely orders and decrees mingled with the haggling of buyers and sellers that sometimes ended in brawls. There was the creaking of carts and the lamentations of beggars, the shrill hawking of the peddlers, and the growling of a tame bear led about on his chain by wandering minstrels and clowns to amuse the public. The illiterate came to this square to have scribes make up petitions or documents for them, and there was always some priest without a parish willing to offer up prayers for a small fee. The idlers inevitably to be found here milled about the marketplace, adding to the general racket.

The fairly broad, straight streets leading from this square received their names either from the churches located on them or from the occupation of those who lived there. There were corduroy roads where the inhabitants were more prosperous, but the unpaved streets where the poor lived were almost impassable when bad weather set in. Fire was the sword of Damocles hanging over those parts of town where all the buildings were wooden. Ancient chronicles report four conflagrations in the 15th century — in 1413, 1443, 1449, and 1465 — when better than half the city burned down. Individual houses, and sometimes entire streets, were reduced to ashes regularly.

In 15th-century Russia, and especially in Tver, the energetic, bold merchants who engaged in trade with far-off lands began to stand out

Monument to Afanasy Nikitin

among the other traders and crafts-men of the cities. These men went on long journeys over roads fraught with danger — for there were many robbers and brigands about — in search of goods and markets in distant lands and even foreign countries. From these ancient times, an anonymous drawing of a Russian merchant has come down to us. He is a fellow of about forty with a powerful build and an expressive face bespeaking intel-ligence, great energy, and inquisitive-ness. He is wearing a long caftan trimmed in fur, a peaked cap, and fop-pish boots of Moroccan leather. The scroll in his hands indicates that he can read and write.

One such merchant, Afanasy Niki-tin, brought world-wide fame to his native city. In 1466, he set out down the Volga in a boat, headed for distant lands. But near Astrakhan (a city at the mouth of the Volga where it flows into the Caspian Sea) he was fallen upon by robbers and lost almost ev-erything he had, escaping with his life by some miracle. Despite this cruel twist of fate, he did not lose heart, but rather crossed the Caspian Sea to Per-sia, after which he set out by water for India, which he reached a quarter of a century before Portugese navigator Vasco da Gama who was searching for a sea route from Europe to Southern Asia. After three years of adventure-filled wandering in India, Nikitin returned home with a lengthy diary, which he published as a travelogue under the title, *Journey Beyond Three Seas*. The colorful, vivid language and keen powers of observation of the author, as well as the fascinating information about the life and cus-toms of 15th century Indians made *Journey Beyond Three Seas* one of the major literary works of that time.

On the left bank of the Volga, at the point from which Nikitin began his remarkable journey, stands a **monument** to this incredible man. The figure of the explorer stands on a pedestal that resembles the pointed prow of a boat (1955, sculptor Sergei Orlov; architect Grigory Zakharov).

The appearance of this literary mas-terpiece was not just a chance occur-rence, for the city of Tver had long-

52

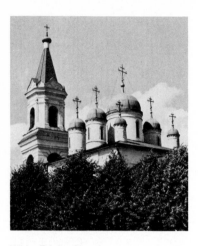

White Trinity Church

standing written traditions, resulting in a rich collection of unusual works. Chronicle-writing began in Tver in the 13th century, and at the beginning of the 14th century, The *Tale of How Prince Mikhail Yaroslavich Was Killed in the Golden Horde* appeared. In the mid-15th century, several works came into being, the most notable of which was *In Praise of Boris Alexandrovich, Prince of Tver,* by Foma the Monk. Soon the patriotic *Ballad of Shchelkan Dudentievich,* inspired by the events of the rebellion against the Golden Horde which took place in 1327, was on every lip. In 1406, work on a literary version of the *Kiev-Pechersky Paterikon,* a major Russian historical document of the middle ages, was begun.

The political and economic flourishing of the principality in the 15th century facilitated the development of art in Tver, and the princedom's striving for independence did not fail to make its mark on this process. Tver already had its own icon-painters in the 13th century who were influenced alternately by the Novgorod, Rostov-Suzdal, and Moscow schools, but an independent trend in icon-painting appeared here only in the 14th and 15th centuries.

The Tver icon-painters preferred a cool palette, and the dominant tone of their works was blue. The finest examples of Tver icon-painting, including *The Dormition* (first quarter of the 15th century) and other works, are to be found in the Tretyakov Gallery in Moscow.

The earliest architectural monuments of Tver have not come down to us, and in fact, the oldest building that remains was erected in 1564. This is the WHITE TRINITY CHURCH (tserkov Byeloi Troitsy) beyond the Tmaka River (the corner of Ulitsa Engelsa and Pereulok Trudolyubiya). This rather small church, which originally had a single tile-covered dome, is cubical in form and quite characteristic for Russian stone architecture of the 16th century. It was built by Gavrila Toushinsky, and the side-chapel was the work of Pyotr Lamin. In 1584, six more domes were added to the original one. In 1692, the doors and windows were widened, the *zakomary* were done away with, and a tent roof

appeared. A winter church was built on the western side, and a bell-tower was put up in the 19th century. The church has undergone internal alterations as well. The enormous 18th century iconostasis, with murals of later origin, and the moulded capitals of the piers have changed considerably the original austere appearance of the interior. Even today, the White Trinity Church is surrounded by small wooden houses and orchards; it is a working church.

After submitting to the Moscow principality, Tver withdrew from the political arena, and very little is known of the goings-on there in the 16th century. The Polish-Lithuanian-Swedish intervention brought Tver grief and disaster, as it did Smolensk. Almost the entire city was destroyed, and the inhabitants were decimated. A home guard organized by Prince Mikhail Skopin-Shuisky drove the enemy from Tver, but it took the city half a century to recover from the consequences of the occupation. At the end of the 17th century, trade and construction again picked up in Tver. Of the residential structures of that period, the MERCHANT ARE-TIEV'S HOUSE (3/21 Ulitsa Nakhimova) is quite interesting. It is located in the section of the city beyond the Volga not far from the new bridge. The old vaults and the moulding on the ceiling have been preserved. Presently, this building (1764-68) houses the **Museum of Life in Old Tver.** When you enter this old two-storey building and find yourself beyond the massive door, surrounded by the quiet of the thick stone walls, you can sense the durability of this house at once. It was built unhurriedly to last not years, but centuries. This stately building served many generations of the famous Are-tiev merchant family. When you grasp the solid wooden handrail of the handsome spiral staircase leading to the second floor and walk through the small rooms that make up the halls of the museum, gaze at the tiled stoves which are almost as old as the building itself, and marvel at the lovely

mouldings of the vaulted ceilings and the broad windowsills, your first impression is intensified by a feeling of comfort and warmth. The sense of proportion on a scale with actual human needs has a charm all its own, for this sense was later to give way to the luxury and grandeur of large private estates which appeared in keeping with the changing tastes of the times.

While the museum is not a large one, the exhibition is quite extensive and has a large number of varied and fascinating objects. The chief function of the museum is to shed light on the everyday life of various segments of the population of Tver province and to display objects of applied art created by peasants or craftsmen of the city in the 17th and 18th centuries, including hand-woven articles, embroidery, lace, gold-thread embroidery, and chasing on silver. There are some fine examples of towels with embroidered borders, shirts, dresses, and women's head-dresses.

The museum has a fine silver collection, including both objects for liturgical and secular use, such as cups, spoons, Gospel covers, goblets, jewellery, panagias, chalices, and other fine pieces.

On the first floor, the interior of a Tver peasant's hut of the latter half of the 19th or beginning of the 20th century has been recreated. Worthy of particular note are the carved beer mugs, the ceramic dishes, the toys, farming implements, and tack and harness for a horse. A monument to an entire era in Russian peasant life and culture is the hand loom, once an invariable feature of every household, and an item still in use in some villages of Kalinin Region. From holiday towels and clothing to doormats — almost all the cloth articles used by a peasant family were hand-woven by the woman of the house, who passed down the art of weaving to her daughters. And so it was until fairly recently.

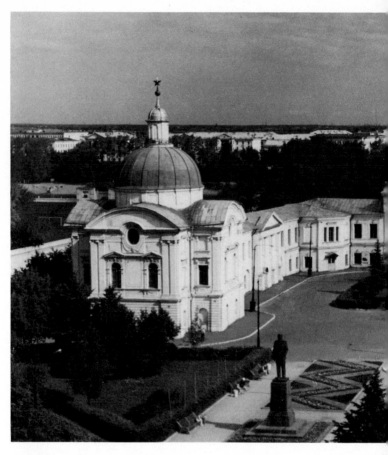

Revolution Square (Ploshchad Revoliutsii). The Royal Palace

Tver has a fine example of Narysh-kin (Moscow) baroque which appeared several decades after this style came into fashion in the capital, as was often the case with provincial towns. This is the **DORMITION CATHEDRAL** (Uspensky sobor) **OF THE OTROCH MONASTERY** (1722, Pervomaiskaya Naberezhnaya, next to the Rechnoi Vokzal, or river-boat station). A nice view of this cathedral, which towers above the mouth of the Tvertsa, can be had from the Stepan Razin Embankment. On the opposite side of the river's mouth stands the tall St. Catherine's Church (Ekateri-ninskaya tserkov, 1781, 24 Ulitsa Kro-potkina).

At the beginning of the 18th century, in connection with the construction of St. Petersburg and the Vyshnii Volochek canal systems, which pro-

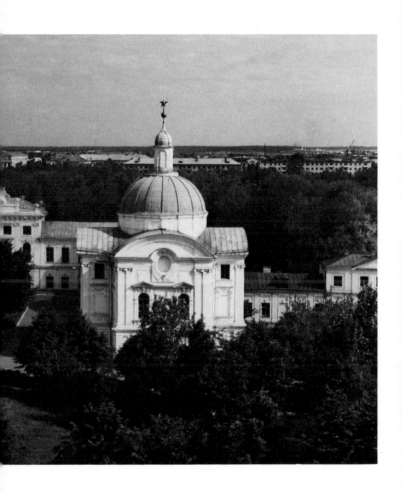

vided a water route from the Volga to the Neva, the significance of Tver increased tremendously, for now it was located on the route between the old capital of Moscow and the new one at St. Petersburg. Naturally, the volume of trade grew by leaps and bounds, and branches of industry and the handicrafts also grew, particularly those connected with shipbuilding. In the mid-18th century, of 212 Russian cities, Tver ranked fourteenth in population. In 1785, it gained the status of provincial center.

Since most of the houses in Tver were still being built of wood, as before, the city was continually at the mercy of the fires that swept through it periodically. Thus, the fire of 1763 destroyed the central part of the city and the wooden fortress walls. After this disaster, a government decree on

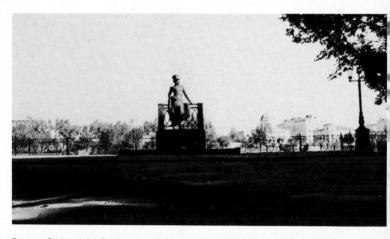

Statue of Alexander Pushkin on the Volga Embankment

the planning and reconstruction of the old cities, including Tver, was announced. For the formulation of the new city plan, a group of Moscow architects headed by Pyotr Nikitin arrived. This group included the young Matvei Kazakov, who later became a well-known Russian architect. By 1777, the plans had been completed, and Tver became the first provincial Russian city to have its narrow, winding streets, which were virtually impassable in spring and fall, replaced by broad, straight avenues lined by buildings with even rows of façades. Pyotr Nikitin, a student of that superlative Russian baroque architect, Dmitry Ukhtomsky, did an excellent job of working out a new master plan for Tver. And in fact, the system he developed was so successful that it was later adopted and modified for use in dozens of other cities throughout the country.

The basic plan for downtown Tver consisted of three main roads leading out from Post Office (now Soviet) Square. The central avenue was Voznesenskaya (later Millionnaya, and presently Sovietskaya) Street – the main road to Moscow – which led to the bell-tower of the Cathedral of the Transfiguration in the fortress. The left-hand branch ran to the corner tower of the fortress, and the right-hand branch led to the Volga River crossing. The Volga itself was skilfully included into the system of city streets, for a series of roads which ran at right angles to the three main branches led down to the embankment. In accord with this new plan for the construction of the city, work was continued until the mid-19th century, and even today, scarcely any changes have had to be made.

The commission of architects from Moscow did not just lay out a new city plan but also designed the major architectural ensembles and made plans for specific buildings as well. One of the finest such ensembles is the octagonal **Fontannaya Square (now Lenin Square)** on Voznesenskaya (now Sovietskaya) Street. The buildings here are of a style typical for architect Nikitin, representing something of a transition from baroque to classicism.

One of the chief architectural monuments of Tver from the mid-18th century is the ROYAL PALACE, designed as a stopping place for members of the Russian emperor's family on the long journey from St. Petersburg to Moscow (3 Ploshchad Revolyutsii). It was built in 1763-75 on the site of the bishop's residence which had been destroyed by fire. The structure is typical for Russian architecture of that time: the lateral wings project far forward of the main wing, and the façades are richly decorated. The U-shaped central wing and two side pavilions, which look out onto the city's central street, were designed by Nikitin and Kazakov. But the austerity and laconic lines of the wings connecting this segment of the palace to the main wing bespeak later construction — the beginning of the 19th century — and are obviously the work of a distinguished master. And indeed this is the case, for between 1804 and 1812, the palace was remodelled for the governor-general of the province by the young Carlo Rossi, who would later make a name for himself in St. Petersburg. Rossi transformed the single-storey open passages connecting the palace and the pavilions into two-storey wings. He also made many alterations in the interior of the palace and in its decor, but unfortunately, this part of his work was destroyed during the fascist occupation.

From the classical period, the CHURCH OF THE ASCENSION (1813, 38/20 Ulitsa Sovietskaya) designed by talented and versatile Tver architect Nikolai Lvov, and the former NOBLEMEN'S CLUB (1840, 14 Ulitsa Sovietskaya, now the Officers' Club) are worthy of note.

In the old part of the city, the most interesting ensembles are the early classical residential buildings, particularly the row houses along the Stepan Razin Embankment, which are quite characteristic of provincial cities in the second half of the 18th century. Though the rows are uniform, their façades are far from monotonous, as the two-storey structures combine elements of classical composition with details of baroque decor.

In the second half of the 19th century, with the building of a railroad between Moscow and St. Petersburg and the opening of a steamship line from Tver to Rybinsk (renamed Andropov in 1984), Tver became a major textile center.

On 28 October 1917 (old style) Soviet government was declared in Tver, and in 1931, the city was renamed Kalinin in honour of Mikhail Kalinin, President of the Soviet republic for many years, who was from Tver province.

The two-month fascist occupation in 1941 brought great misfortune to the city: all its enterprises were put out of commission, and two-thirds of the housing was destroyed.

Today Kalinin is a highly developed industrial, scientific, and cultural center producing textiles, excavators, railway cars, printed matter, ready-made garments, synthetic fibers and leather. Four scientific research institutes which study problems of synthetic fibers, railway-car construction, textile manufacture, and hydromechanics and land-reclamation are located in the city. Kalinin has three theaters, a philharmonic society, a circus, and nine cinemas.

The city boasts several interesting museums as well. In the Royal Palace is one of the oldest museums in the country: the **Museum of History, Architecture, and Literature,** opened in 1886. The Museum of Life in Old Tver in the home of the Arefiev merchant (18th century) is a branch of this museum.

The Royal Palace also houses a **Picture Gallery,** the exhibits of which include a fine collection of Russian 14th-17th century icons, the best of which are *Our Savior* (mid-15th century) and *St. Nicholas* (beginning of the 16th century). Russian masters of the 18th century, whose works are marked by a transition to secular themes, are well represented. The gal-

lery also features works by outstanding portraitists Alexei Antropov, Fyodor Rokotov, Vladimir Borovikovsky, and Vasily Tropinin, canvases executed by Russian masters Alexei Venetsianov, Ivan Kramskoi, Alexei Savrasov, Ivan Aivazovsky, Ivan Shishkin, Arkhip Kuinji, and Isaak Levitan, as well as by those coryphaei of 19th century realistic painting, Ilya Repin and Vasily Surikov.

The interesting but complex period in the development of Russian art at the beginning of the 20th century is represented by the works of Konstantin Korovin, Arkady Rylov, Mikhail Nesterov, Alexander Benois, Nikolai Roerich, Valentin Serov, Mikhail Vrubel, Boris Kustodiev, and Mark Antokolsky. Their canvases reflect the variety and depth of the search for new creative methods in the art of that time.

Eleven of the gallery's halls are devoted to contemporary Soviet art, and another six are given over to West European painting, sculpture, and graphics by artists from Italy, France, Flanders, Holland, Denmark, Belgium, Czechoslovakia, and Hungary. Among the gems of the West European department are *The Driving Out of Hagär,* by Dutch artist Solomon de Bray and *Still Life,* by Frenchman Etienne La Hire (16th century). The gallery also has a large department of decorative and applied arts.

Many well-known Russian writers were connected with Tver in one way or another. Of especial interest are the **places connected with famous poet Alexander Pushkin,** now a nature preserve and official historic site included in the special tourist route, *The Pushkin Ring Road,* which runs from Kalinin to Torzhok, then on to Bernovo and Staritsa. These were the places the poet always visited on his way from St. Petersburg to Moscow and back.

In Pushkin's day, Tver was the first large city on the highway from Moscow to St. Petersburg. But for the poet, Tver was a great deal more than just a way-station along the route. Many of Pushkin's dear friends lived here, including Alexander Kunitsyn, a teacher from the Lyceum[1] he attended; man-of-letters and rector of St. Petersburg University, Academician Pyotr Pletnyov, to whom Pushkin dedicated the first part of his novel in verse, *Eugene Onegin;* author of the historical novel *House of Ice,* Ivan Lazhechnikov; and poet Fyodor Glinka. After visiting his friends, Pushkin continued down Kosaya Novgorodskaya Street (presently Theater Way), where a **monument to the great poet** (sculptor, Ekaterina Belashova) was erected in 1972. Then he went to the floating bridge that spanned the river, crossed it, and continued on to the point where the monument to Afanasy Nikitin now stands. Passing the two identical columned buildings, which their creator Matvei Kazakov intended to serve as an architectural gateway to the city, as it were, he rode along the bank of the Volga (presently Pervomaiskaya Embankment) to the striped posts of the St. Petersburg outpost, where the gas station now stands. Ahead of him stretched the road to St. Petersburg, which was quite a long one in those days.

The sculptures of Pushkin in Tver are quite fine ones. Across from the city park, along the embankment of the Volga on a gentle slope framed by a wrought iron railing with cast-iron street lamps in the style of the last century is the figure of the poet in a free and natural pose, leaning against the parapet. This **sculpture** by Oleg Komov (1974) is one of the major monuments to the poet in the city. The relaxed stance and calm face of the poet, and the close-fitting frock-coat without a single wrinkle seem

[1]Lyceum — an exclusive private school for the children of high-ranking nobility. Pushkin studied at the Lyceum in the suburbs of Leningrad — now the town of Pushkin — from 1811-17. The Lyceum building is now a museum.

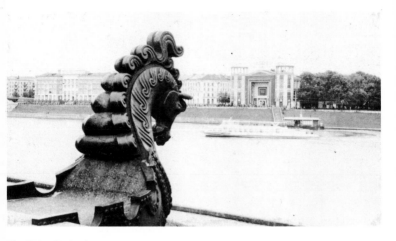

The Volga Embankment

intentionally to limit the number of perspectives from which the work can be viewed, reducing it to just the silhouette of the great man.

Another great Russian literary figure had close connections with Tver: from 1860 to 1962, writer and satirist Mikhail Saltykov-Shchedrin was vice-governor of Tver province. In 1976, in honour of the 150th anniversary of the writer's birth, a memorial museum was opened on Rybatskaya Street where he lived while in Tver. And a **monument** to him by sculptor Oleg Komov was erected on Pravda Street near the Tsentralnaya Hotel.

Well-known fabulist Ivan Krylov (1769-1844) spent his childhood and youth in Tver. In a square on the shore of the River Tmaka, not far from the place where he lived, towers a **bronze figure** of this man whose works, like those of Aesop, Hans Christian Andersen, and the Brothers Grimm have delighted generations of Russian and Soviet children (sculptors Sergei Shaposhnikov and Dmitry Gorlov; architect Nikolai Donskikh, 1959).

The memory of Tver's heroes of the October Revolution of 1917 is sacred to the people of Kalinin. On Revolution Square next to the Royal Palace is the **common grave** of the heroes of the revolution. Every year on December 16, the day the city was liberated from fascist occupation in 1941, the people of Kalinin come to lay wreaths on the common grave at Lenin Square, for here lie some of those who died defending their homeland during the Second World War. On that day, a memorial torch burns at the 45-meter **Obelisk of Victory** memorial complex near the confluence of the Tmaka and the Volga.

In 1970, in honor of the 25th anniversary of the victory over the Nazis, the monument **Anti-Tank Obstacles** was erected on the eastern approaches to the city. The monument **Tank** was set on its western approaches, and another monument, **Howitzer,** was unveiled along the road to the airport.

There are generally look-out points in any city which give visitors the best overall view. There are two

such places in Kalinin, and naturally, both are connected with the Volga. You can spend hours admiring the continuous, unbroken lines of the 18th and 19th century buildings on the Stepan Razin Embankment standing on the Pervomaiskaya Embankment, by the river-boat station or the Dormition Cathedral of the Otroch Monastery. The city can also be viewed from the high right bank. The lovely building of the river-boat station catches the eye, and to the right and left of it opens up a striking panorama of the city crowned by the various domes of several old churches. And the prow of the boat of that great traveller of Tver, Afanasy Nikitin, points right at the observer as if to remind him that the greater portion of his journey to the ancient cities of Russia still lies ahead.

Historical and Architectural Monuments

White Trinity Church, 1564 — the corner of Ulitsa Engelsa and Pereulok Trudoliubiya

Dormition Cathedral of the Otroch Monastery, 1722 — 18 Pervomaiskaya Naberezhnaya

Royal Palace, 1763-75 and beginning of the 19th century — 3 Ploshchad Revoliutsii

Greenhouse of the Royal Palace, 18th century — 3 Ulitsa Sovietskaya

Church of SS. Boris and Gleb at Zatmachye, 17th century — 5 Krasnoflotskaya Naberezhnaya

Church of the Resurrection, 1731 — 19 Ulitsa Rozy Luxemburg

Trinity Church Beyond the Volga, mid-18th century — Ulitsa Gorkogo

Church of the Three Confessors, mid-18th century — 38 Pervomaiskaya Naberezhnaya

Mid-18th century House — 19 Ulitsa Volnogo Novgoroda

House of Arefiev the Merchant, 1764-1768 — 3/21 Ulitsa Nakhimova

Late 18th-century House — 2/1 Klubny Pereulok

Late 18th-early 19th century House — 24 Ulitsa Kropotkina

Ensemble of buildings at Lenin Square, end of the 18th century

Church of St. Catherine, 1781 — 24 Ulitsa Kropotkina

Mansion, 18th century — 8-12 Ulitsa Sovietskaya

Mansion, 18th-19th centuries — 19/4 Ulitsa Nakhimova

Interesting residential buildings on various streets: Mid-18th-1st half of the 19th century: 15, 15/25, 20, 22, 24, 28-30, 32, 34-36, 39-42, 48, 65 Ulitsa Sovietskaya; 39/18, 53/16, 64, 67, 70, 72, 73 Ulitsa Pravdy; 11, 12, 14, 17/39, 22/32 Ulitsa Krylova

Interesting residential buildings on the embankments: Mid-18th-2nd half of the 19th century: 7-30 Naberezhnaya Stepana Razina; 28/2, 40, 42 Zatveretskaya Naberezhnaya

Church of the Ascension, 1813 — 38/20 Ulitsa Sovietskaya

Mansion, beginning of the 19th century — 11-12 Krasnoflotskaya Naberezhnaya

Mansion, 1st half of the 19th century — 41/30 Ulitsa Radishcheva

Former Noblemen's Club, 1840 — 14 Ulitsa Sovietskaya

Gymnasium for Boys, an ensemble of buildings from the 1840s — 2, 4, 6 Ulitsa Sovietskaya

Monuments

Monuments to Alexander Pushkin, 1972, 1974 — Teatralny proezd and the City Garden
Monument to Afanasy Nikitin, 1955 — Zavolzhskaya Naberezhnaya
Monument to Mikhail Saltykov-Shchedrin, 1976 — Ulitsa Pravdy
Monument to Ivan Krylov, 1959 — square on the bank of the Tmaka River
Obelisk of victory, 1970 — at the confluence of the Tmaka and Volga rivers
Monuments, 1970 — Anti-Tank Obstacles — the eastern approaches to the city; Tank — the western approaches to the city; Howitzer — along the road to the airport

Information for Tourists

Hotels
Tsentralnaya — 33/8 Ulitsa Pravdy
Seliger — 52 Ulitsa Sovietskaya
Tver Motel — 130 Leningrad Highway
Tver Campgrounds — 130 Leningrad Highway

Restaurants
Tsentralnyi — at the hotel
Seliger — at the hotel
Tver — at the motel
Rossiya — 10/11 Naberezhnaya Stepana Razina

Museums and Exhibitions
Picture Gallery — 3 Ploshchad Revoliutsii
Museum of Life in Old Tver (House of the Arefiev merchant family — 3/21 Ulitsa Nakhimova
Saltykov-Shchedrin Museum — 11/37 Ulitsa Rybatskaya
　　All museums are open from 11 a.m. to 6 p.m.
Industrial Exhibition — 38 Ulitsa Sovietskaya. Open from 10 a.m. to 5.30 p.m.

Theaters and Concert Halls
Drama Theater — 43/18 Svobodny Pereulok
Children's Theater — 44 Ulitsa Sovietskaya
Puppet Theater — 9 Prospekt Pobedy
Circus — 2a Tverskaya Ploshchad
Philharmonic Society — 1 Teatralnaya Ploshchad

Stores
Beriozka (foreign currency) — 18 Tverskoi Prospekt
Souvenirs — 31 Ulitsa Sovietskaya
Znanie Book Store — 16/1 Prospekt Chaikovskogo

Service Stations:
151st km of the Moscow-Leningrad Highway
176th km of the Moscow-Leningrad Ring Road.

* * *

Kalinin Branch of Intourist — 130 Leningrad Highway, Tver Motel.

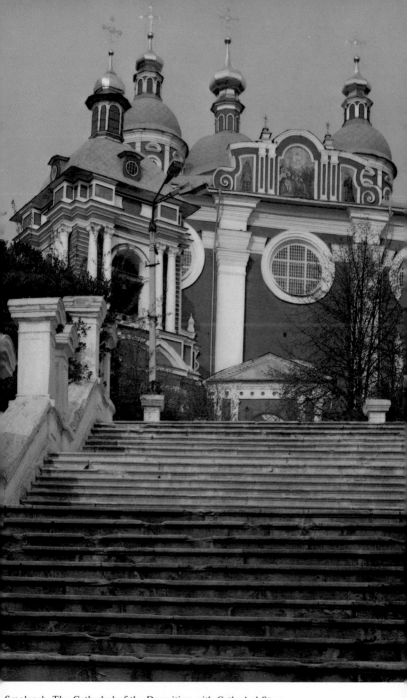

Smolensk. The Cathedral of the Dormition with Cathedral Steps

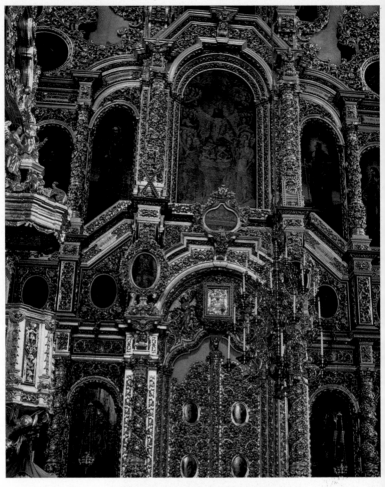

Iconostasis of
the Cathedral of the
Dormition

Fortress walls
and towers

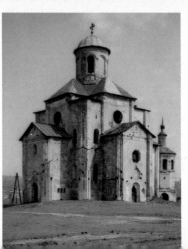

Church of the
Archangel Michael
(Svirskaya Church)

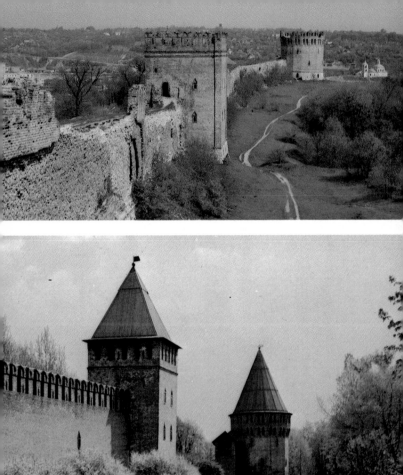
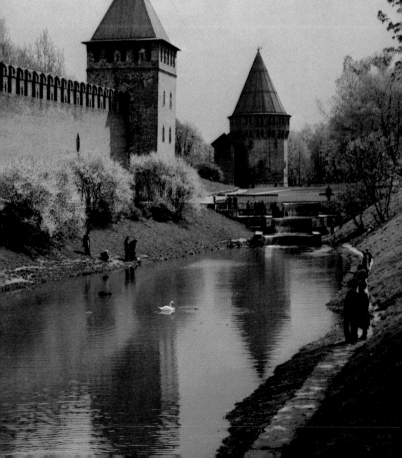

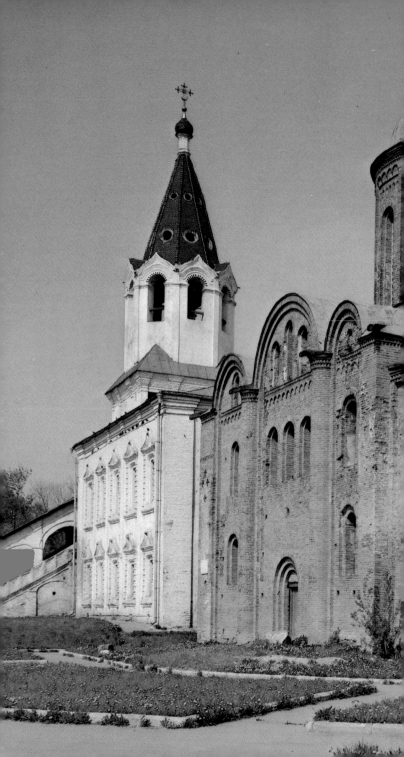

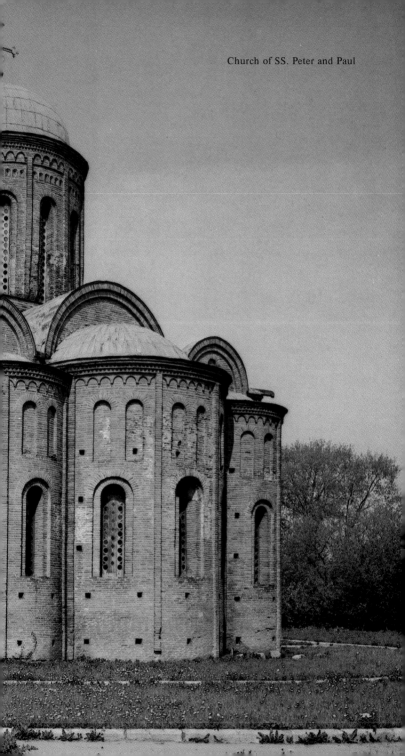

Church of SS. Peter and Paul

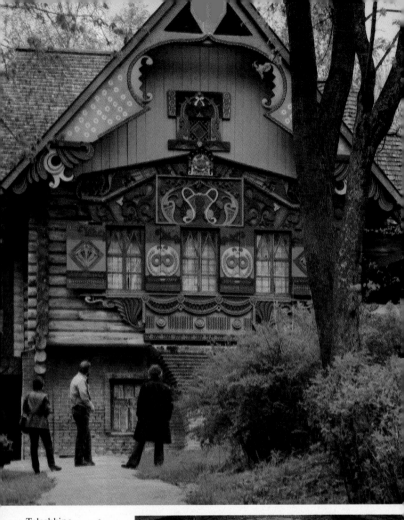

Talashkino.
The Teremok.

The Mosaic of
the Holy Mandilion

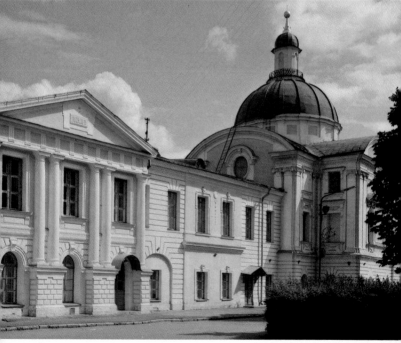

Monument to Afanasy Nikitin

Royal Palace

ZAGORSK
PERESLAVL-ZALESSKY
ROSTOV
YAROSLAVL

Zagorsk

Zagorsk is a town in Moscow Region and a railway junction located 71 km to the north of Moscow along the Yaroslavl Highway. It has a population of over 100,000. Industries include electrical engineering, optical instruments, building materials, paint, and varnish production, light industry, and toymaking. On the territory of the Trinity-St. Sergius Laura is a historical and art museum-preserve with architectural monuments of the 15th-18th centuries and a toy museum. In 1930, the city was named Zagorsk in honour of Russian revolutionary figure Vladimir Zagorsky.

A small town an hour to the north of Moscow, Zagorsk is rightly famous for the unique, excellently preserved historic, architectural, and artistic ensemble located here: THE TRINITY – ST. SERGIUS LAURA or Monastery (Troitse-Sergiyeva Lavra), the founding of which marked the beginnings of the city. This laura repeatedly played a major role in the dramatic events that took place during several critical periods in Russian history.

The monastery won fame long ago. In 1575, Danish envoy Jacob Ulfeldt noted: "This monastery is enormous, with towers and earthen ramparts and a great stone wall surrounding the whole of it. Of all the monasteries in Russia, it is the most famous." Well-known traveller, Syrian Archdeacon Paul of Aleppo, who visited the monastery in the 17th century, was so impressed that he confirmed: "There is no monastery like it, not just in the lands ruled by Moscovy, but in all the world."

In actuality, the monastery took a patriotic stance, invariably coming out in defense of the interests of the state as a whole, not simply defending the idea of a free and independent Rus in theory, but taking an active part in the struggle to bring this about. Thus, the monastery occupied a very special place in the spiritual, political, and cultural life of the country.

Over the centuries, the monastery enjoyed the favor of the princely families and then of the tsars and their relations; therefore, within its walls worked the finest architects and artists of medieval Russia, including the brilliant Andrei Rublev. Lavish gifts made the monastery sacristy a unique treasure-trove of Russian applied art and jewellery. At present, these priceless objects can be seen in the display cases of the historical and art museum of the preserve.

But before entering the ancient vaults of the monastery, a bit of history so you can appreciate the significance of this monument of art and architecture and orient yourself more easily in terms of the centuries, epochs, and styles which have made their mark here.

The monastery was founded in the 1340s by Sergius of Radonezh, an outstanding figure of the time of

whose life we know a great deal from the biography or *Life* of him compiled in the 15th century by the major Russian chronicle writer of that time, Epiphanius the Wise, and reworked a few decades later by Pachomius the Serb who came to Rus from Mt. Athos in Greece.

Sergius (Bartholomew until he took his vows as a monk) was born in 1322 into the family of a Rostov boyar. His parents had moved from Rostov the Great to the small town of Radonezh near Moscow, and it was from this town that he and his brother set off for the depths of the forest in about 1345, having decided to become monks. They built their cells and a small wooden church dedicated to the Trinity on Makovets Hill at the confluence of the Konchura River and a forest stream.

Word of the holiness of the ascetic brothers spread for miles around, and soon, other pious men began to gather about them. Each newcomer built his own cell close to that of the brothers and set about the heavy labor of clearing the forest little by little to make a vegetable garden. Soon, a small monastery had grown up around the church and was fenced off by an oak paling. In 1355, the brothers adopted a new set of rules for the monastery: from that time forth, they would all take their meals together; everyone, including Sergius, would help with the communal work, and all their property would be common. These innovations required that the whole monastery be rebuilt, since new buildings were needed, among them a refectory, a kitchen, a bakery, and various other husbandry buildings. Two new churches were erected as well. One of them, a gateway church, was built above the eastern entrance to the new enclosure surrounding the monastery. Along this eastern side, the monk's cells were built in rows facing the central structures. Thus, the monastery was triangular in plan. In 1357, the Metropolitan of Moscow conferred upon Sergius the title of hegumen of the monastery.

The spiritual quests of those days, which often resulted in the taking of monastic vows, were an attempt on the part of the Russian people to oppose morally the horrible, devastating nightmare of the infidel yoke, which deprived them of all hope of actual political freedom. This intolerable spiritual and economic oppression brought to bear upon them by the invaders resulted in occasional desperate rebellions which were put down quite cruelly. But despite this, the idea of freeing the country from foreign domination and bringing about its restoration gradually gained hold of the national consciousness. But this idea was still a long way from realization, because Rus did not yet have the strength to throw off the Tartar yoke. So naturally, in seeking a means of doing away with this oppression, people turned to the alternative offered to them by Christianity. At that time, Byzantium was threatened with Turkish conquest; the resulting alarm and inner strife brought widespread popularity to the religious teaching of Gregory Palamas, an adherent of a type of asceticism known as hesychasm. Palamas preached the renunciation of worldly cares and contemplation as the path to spiritual salvation and the salvation of the state. This ascetic movement, which failed to save Byzantium from the Turks, found many adherents in Rus, Sergius of Radonezh among them. However, such a dynamic person as Sergius could not give himself over to meditation entirely, for he was unable to ignore the plight of his country.

Even before the founding of the monastery, the intensive process of consolidating the lands of Rus under the leadership of Moscow had begun, and this city was now destined to become the stronghold of the movement for liberation and restoration of the Russian state. Sergius of Radonezh played a major role in this process of consolidation. With his keen understanding of statecraft, he used his indisputable authority to smooth out the discord among the principalities and encouraged his followers to found new monasteries which could serve as foreposts in the coming struggle against the Golden Horde. With his active moral and material support, an army was formed under

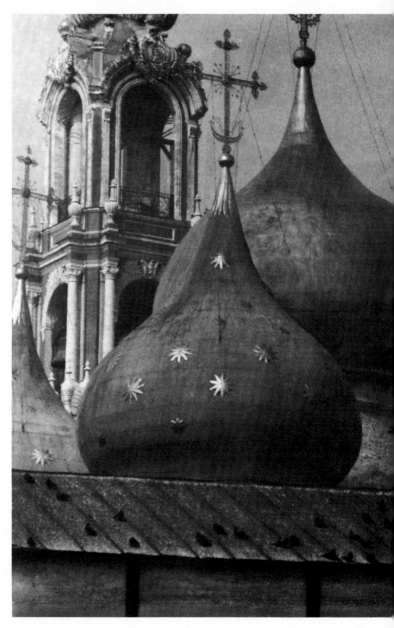

The Domes of Trinity–St. Sergius Laura

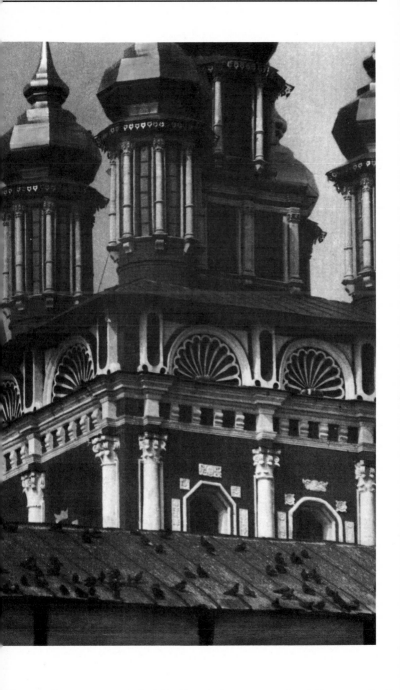

HISTORIC BUILDINGS
AND ARCHITECTURAL
MONUMENTS
OF THE LAURA:

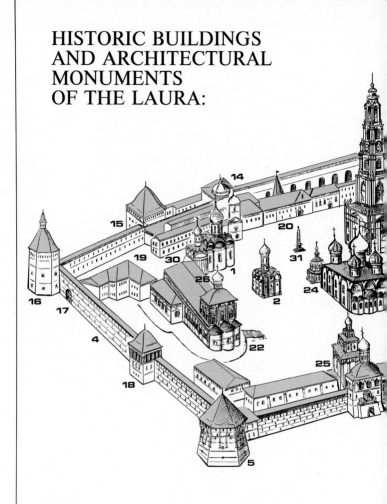

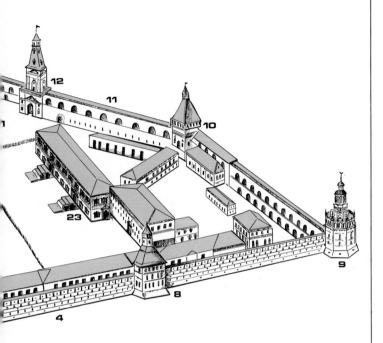

1. Trinity Cathedral and the Nikon Side-Chapel
2. Church of the Descent of the Holy Spirit
3. Cathedral of the Dormition
4. Fortified Walls
5. Pyatnitskaya Tower
6. Krasnaya (Beautiful) Vorotnaya (Gate) Tower
7. Uspensky (Dormition) Gate
8. Sushilnaya (Drying) Tower
9. Utichya (Duck) Tower
10. Zvonkovaya (Bell) Tower
11. Solyanaya (Salt) Tower
12. Kalichya (Pilgrim) Vorotnaya (Gate) Tower
13. Plotnichya (Carpenter's) Tower
14. Kelarskaya (Cellarer's) Tower
15. Pivnaya (Beer) Tower
16. Vodyanaya (Water) Tower
17. Vodyanie (Water) Gate
18. Lukovaya (Onion) Tower
19. The Metropolitan's Private Chambers
20. Kaznacheisky (Treasurer's) Wing of the Monks' Cells
21. Infirmary and the Church of SS. Zosima and Savvaty
22. Refectory and St. Sergius' Church
23. Royal Palace
24. Chapel-at-the-Well
25. Gateway Church of St. John the Baptist
26. St. Micah's Church
27. Church of the Smolensk Virgin
28. Bell-Tower
29. The Godunovs' Mausoleum
31. Obelisk

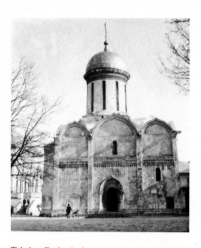

Trinity Cathedral

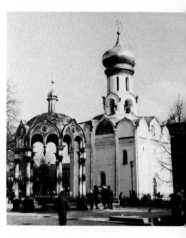

Church of the Descent of the Holy Spirit

the leadership of Moscow Prince Dmitry Donskoi who won a significant victory over Khan Mamai at Kulikovo Field in 1380. After the passing away of its founder, the Trinity-St. Sergius Monastery continued to preserve the patriotic tradition begun by him.

In 1408, under Sergius' successor Nikon, the monastery was burned to the ground during one of the Golden Horde's devastating raids on Moscow. However, by that time, thanks to the lavish donations of the boyars and princes — of both money and land — and due to the contributions of the common people, the monastery was already quite wealthy, so it was soon rebuilt. In 1422-23, the white stone **Trinity Cathedral** (Troitsky Sobor) was built on the site of Sergius of Radonezh's grave, and later, this remarkable man was canonized by the Russian Orthodox Church.

We will begin our tour of the monastery with this church, the oldest building in Zagorsk. The cathedral, which is near the west wall, may be reached either via the central square of the monastery or by turning left and walking past the refectory. In the latter case, you will approach the church from the altar side. From this perspective, it seems to grow out of the smaller St. Nikon's Side-Chapel, similar to it in form. Its builders chose a style typical of Moscow architecture in those days: a small, single-domed, four-piered church of a kind that had its roots in pre-Mongolian white stone architecture. However, an innovation was employed here which was so well liked that it was used repeatedly for the next century: above the keel-shaped *zakomari* crowning the façades rose a tier of *kokoshniki*, which considerably enlivened the silhouette of the building.

The tall apses at the altar, of equal height, extend all the way up to the *zakomari;* light, slightly protruding pilaster strips divide the façades into three segments; keel-shaped portals are recessed deep into the walls, and three-tiered bands of carved stone decorate the walls, apses, and drum of the dome.

The interior of Trinity Cathedral is

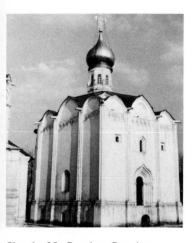

Church of St. Paraskeva Pyatnitsa

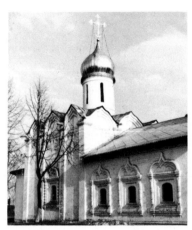

Church of the Presentation of the Virgin Mary

rather unusual: lancet vaults and arches reminiscent of Balkan architecture of the time give reason to suspect that Serbian craftsmen took part in the construction work. The narrow splayed windows do not let in much light, as if to prevent the worshipper from being distracted by what is going on outside, thus allowing him to devote his entire attention to his prayers.

The name of a famous artist of Ancient Rus, Andrei Rublev, is closely connected with this cathedral, since it was for this church that he painted his superlative icon, *Old Testament Trinity,* known the world over as the most perfect example of ancient Russian art which has come down to us. Andrei Rublev and his friend Daniil Chyorny received the commission to do murals for the church from Nikon several years before the construction work was completed. Unfortunately, Rublev's frescoes have not come down to us: they were scraped off in the 17th century when the walls were being repainted. And very little remains of

the 17th century frescoes, for that matter: the fragments which have been preserved stand out as light patches against a darker background of contemporary imitations of ancient painting.

The iconostasis was made between 1425 and 1427. Since the church was dedicated to the Holy Trinity, that icon — the main one in the iconostasis — was situated immediately to the right of the Holy Doors that led to the altar. As historical sources inform us, this icon was painted to the glory of St. Sergius. Although the original icon is now in the Tretyakov Gallery in Moscow, while an excellent copy replaces it in the iconostasis, this marvelous work of art deserves more detailed note, since anyone who goes to Zagorsk will surely stop in at the Gallery for a look at what is generally recognized to be one of the finest works of art ever created. But first, a word about Andrei Rublev.

Sadly, we know very little of this artist of genius. He was born about 1360 and received a secular education. When

already a grown man, he took monastic vows — possibly at the Trinity Monastery, but more than likely at the Andronicus Monastery in Moscow, where he was buried in 1427 (some sources say 1430). His creative powers developed in the fertile soil of a Rus dominated by Moscow, while his worldview was strongly influenced by the resurgence of national culture which occurred in the second half of the 14th and beginning of the 15th century. A focal point of this process was to reveal a profound interest in moral and spiritual problems, embodying as they do a new, heightened understanding of the spiritual beauty and moral strength of the person.

Sergius of Radonezh and Andrei Rublev were two of the great philanthropes of their age, and so it is fitting that the icon of the *Trinity* is dedicated to Sergius, who struggled so often for concord and peace. One can feel the sense of harmony emanating from the three comely young men who have appeared before the aged Abraham to foretell the birth of a son to him. There is an all-pervading atmosphere of peace, love, beauty, and the profoundest of human experiences. The glimpse of divine truth revealed by their expressions and gestures unites them in an extraordinary moment of unconcealed emotion and nobility of spiritual reflection and striving. Thus, through this religious subject, the artist has portrayed his contemporaries' search for moral ideals.

The *Trinity* was executed masterfully: it can be viewed equally well close up or from a distance, in both instances revealing superlative brushwork. The range of colors employed is equally remarkable: the central figure is set apart by the startling contrast of maroon and azure. Never before or after Rublev, throughout the whole history of icon-painting, has such an elevated, pure use of blue or gold been attained. All the elements of form produce a splendid artistic expression of the basic idea of the *Trinity:* the harmony between human life and the world around it.

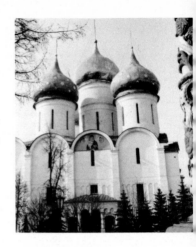

Dormition Cathedral

Over the centuries, the *Trinity* was restored many times and covered with linseed oil, which darkens after several decades. When it had darkened, it would be repainted once more and placed in an icon-setting of gold and precious stones. Finally, in 1919, it was removed from the setting by restorers and cleaned, so that now, its enchanting shades may once again entrance the viewer.

The *Trinity* icon was located in the lowest, or local range of the iconostasis, which contains 15th to 17th century icons. Above it is the tall Deesis range, the icons of which are two meters high. Next is the range of the Twelve Feasts which consists of rather small icons devoted to the twelve major feasts of the Christian Church. The following range is the Prophets' range, with half-length depictions of the Old Testament Prophets. With the exception of the central icon of the Virgin, the icons in these latter three ranges date back to the time of Rublev. The fifth, topmost range, the Old Testament Patriarchs' range, was added to the iconostasis in the 16th century.

Which of the icons from the epoch

of Rublev are actually the work of the great master is a rather difficult question to answer, since unfortunately, icon-painters almost never signed their works. Moreover, several painters could work on a single icon, and to make matters more complicated, the master might well retouch the works of his students with a few sure strokes. Therefore, the authorship of most works of ancient Russian art may be established only with varying degrees of certainty. In the opinion of experts, Rublev himself painted at least two icons in the Deesis range — *The Archangel Gabriel* and *Apostle Paul* — and two icons in the Twelve Feasts row — *The Baptism of the Lord* and *The Transfiguration.* Like his *Trinity,* they are distinguished by the characteristic poses of the figures which are quite memorable, by their plasticity and gentleness of line, as well as by the rare degree of skill displayed in their execution.

Rublev did his work at the Trinity-St. Sergius Monastery at the height of his talent and fame. His works of that period, even during his lifetime, were considered unsurpassed examples for other icon-painters to imitate. You will have the good fortune of seeing other, earlier works by this remarkable painter in the ancient Russian city of Vladimir.

It is even more difficult to say which of the icons in the Trinity Cathedral are the work of Daniil Chyorny, another outstanding artist who took part in the painting of the interior. There is almost no evidence upon which to base even an educated guess; however, it is suggested that the other main icon of the cathedral, *Christ in Majesty,* in the center of the Deesis is the work of Daniil Chyorny, or some other accomplished master with a strong sense of individualism.

The next oldest building to come down to us is the **Church of the Descent of the Holy Spirit** (tserkov svyatogo Dukha or Dukhovskaya tserkov) erected in 1476 and originally dedicated, like the main cathedral of the monastery, to the Trinity. Its

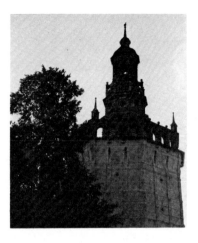

Utichya (Duck) Tower

builders were experienced masters from Pskov, a city with ancient traditions and a distinctive architectural style. These workmen were invited along with many others to take part in the construction of the new Kremlin in Moscow — quite a grandiose project indeed.

The Church of the Descent of the Holy Spirit has been restored to its original appearance, with the exception of the onion-shaped dome, which was initially helmet-shaped. This is the oldest extant church where the bell-tower and church proper are found under a single roof. The striking, original details worked into the design of the ordinary cruciform domed church with the usual four piers and three apses by the clever masters of Pskov had a significant effect on church architecture for years to come.

Though equal in height to the Trinity Cathedral — the builders had probably been forbidden to erect a church taller than the monastery's cathedral — the Church of the Descent of the Holy Spirit is better proportioned and more graceful. It may

be that this was done intentionally to create a contrast between the somewhat squat structure nearby and the lighter one which seems to sweep upward. Incidentally, the uppermost platform in the drum supporting the cupola was used as a watch tower until the beginning of the 17th century.

At the same time, one cannot fail to note the tactfulness exhibited by the builders of the new church with respect to the old cathedral. A number of decorative elements (the keel-shaped *kokoshniki*, recessed portals, and the tile and terra-cotta frieze) repeat analogous ornamentation on the Trinity Cathedral. In this way, tribute is paid to the masters of old, and two dissimilar structures are given a sense of architectural unity. The technique of repeating architecturally analogous designs and decor on neighboring buildings was a new discovery in Russian architecture and created the possibility of connecting individual buildings to form entire ensembles.

This technique was seized upon quite successfully by the builders of St. Nikon's Side-Chapel, erected in 1548 on the south side of the cathedral over the hegumen's grave. Thus, the small chapel, which has no piers, is nicely linked to both churches. This charming, graceful structure has the same keel-shaped *kokoshniki,* and its single large apse repeats and elaborates upon the decor of the Church of the Descent of the Holy Spirit's apses. At almost the same time as St. Nikon's Side-Chapel, the churches of the **Presentation of the Virgin** (Vvedeniya Bogoroditsy) and of **St. Paraskeva Pyatnitsa** were erected beyond the south wall of the monastery in 1547. These two churches were badly damaged in the 17th century during the siege of the monastery by the Polish and Lithuanian armies. The churches have been restored, and on the apses of the Church of the Presentation, the garlands with bar tracery of hewn brick descending from them

catch the eye immediately, fo they are familiar to us from th Church of the Descent of the Holy Spirit.

In ancient Rus, monasteries were never simply a refuge for those who wished to retire from the cares of this world, for they stood on ground which was constantly subject to attack by various invaders and nomadic tribes. All monasteries were for tresses as well — the first defenders of the Russian land. Therefore, after erecting a church, the monks always set about building defensive walls ramparts, and the like. The Trinity Monastery was no exception. In the 1540s and 1550s, the monks replaced the old oaken pale with a mighty brick fortress repleat with moats and stakes

The construction of the new walls had far-reaching consequences no only in terms of the monastery's defensive capabilities – for it played a decisive role in the struggle of the Russian people against the Polish and Lithuanian interventionists, success fully withstanding a sixteen-month siege — but also in terms of the further development of construction of the monastery itself. As often happened in such cases, the new fortress signifi cantly enlarged the territory of the monastery, moving its center to the northeast of the Trinity Cathedral and totally altering the scale of the old buildings with respect to the new walls surrounding them. After the monk's cells and the husbandry build ings were moved closer to the new walls, the main cathedral seemed dwarfed by its surroundings and somewhere on the periphery of the territory, while the center of the monastery was quite empty. So the decision was made to build a new church here in honor of Ivan the Ter rible's conquest of Kazan and Astra khan.

The construction work was begun in 1559, and Ivan the Terrible himself along with all his family donated lav ish sums to the project. However, the church was finally completed and

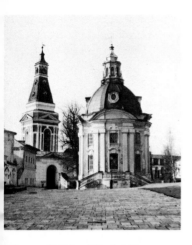

Infirmary, Kalichya (Pilgrim) Tower,
Church of the Smolensk Virgin

consecrated only in 1585 during the reign of Ivan's son, Tsar Fyodor Ioannovich. This long delay was due to the fact that Ivan the Terrible, who was providing the funds for the building, began to suspect that the monks disapproved of his domestic policies, and therefore grew cooler towards the monastery.

As was the custom at the time, the Dormition Cathedral in the Moscow Kremlin, built between 1475 and 1479, was taken as the model for the new church. And thus, the new compositional focal point of the Trinity Monastery became the enormous **Dormition Cathedral** with its voluminous forms, high walls divided by pilasters and decorated with a broad band of blind arcading, and mighty semicircular *zakomari*. In the 17th century, the cathedral was crowned by five large domes positioned close to each other. It is in this form that the church has come down to us, with the exception of the reconstruction of the west porch of the main entrance in the 18th century and the addition of a crypt (All Saints' Church) under the

cathedral for the burial of eminent patrons at the end of the 19th century.

While the ancient frescoes of Trinity Cathedral and the Church of the Descent of the Holy Spirit have not survived, time has dealt more kindly with those of the Dormition Cathedral: they have come down to us through the centuries with no serious losses. The interior walls of the cathedral were painted between May 20th and August 30th 1684 by two artels of icon-painters, one from the monastery itself and the other from Yaroslavl, headed by well-known Pereslavl artist Dmitry Grigoriev (Plekhanov). In all, thirty-five artists were engaged in the painting of the enormous vaults and walls of the gigantic cathedral.

The reserved nature and cool tones of the palette, ranging from dark blue to violet, as well as the solemn character of the compositions are quite in keeping with the austere architectural form of the church. On the vast surfaces are painted many canonical subjects, like the scene from the acathistus, *The Dormition of the Virgin,* scenes from the ecumenical councils, and *The Last Judgement.* The tiered composition of the frescoes repeats and complements the multi-tiered iconostasis, the rich carving and floral design of which clearly betray features of the lavish baroque style which would come into vogue in the 18th century.

The Polish-Lithuanian invasion of the beginning of the 17th century brought grief and destruction to the Russian land; the Trinity Monastery did not escape unharmed this time either. Relevant documents and a detailed account of the siege written by cellarer Avraamy Palitsyn give us a fair idea of the heroic defense of the monastery, in which the peasants and artisans from towns and villages all around took shelter.

By the time the Polish and Lithuanian armies under the command of their finest leaders, Sapieha and Jan Lisowski, lay siege to the

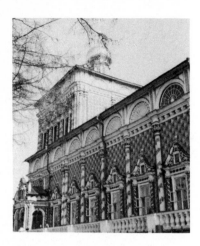

Refectory and St. Sergius' Church

Trinity Monastery on September 23, 1608, the well-fortified cities of Pereslavl-Zalessky, Rostov, Yaroslavl, Uglich, Suzdal, and Nizhni Novgorod were already under control of the invaders, and Moscow was also besieged. So there was no help to be expected from any quarter. However, neither the mighty army of many thousands beyond the walls nor the threat that all within would be killed if the monastery did not surrender peacefully frightened the defenders of the fortress.

The first assault was not successful, so the leaders of the intervention set about a methodical artillery bombardment and lay siege to the monastery. The defenders burned all the villages for miles around so there would be no place for the enemy to take cover. According to the established rules for siege warfare, they divided the walls into segments for better defense, designated special detachments for sallies, and set aside some forces as reserves. Food and water were strictly rationed. The storming of the fortress sometimes lasted for days at a time, but the monastery's artillery along the walls and in the towers did not allow the enemy to get close enough to put up ladders or to set battering rams in place. The soldiers who made it to the walls were met by a rain of stones and bricks, and streams of boiling tar were poured down on their heads from above. The enemy suffered grave losses; in fact, more enemy troops died at the foot of the monastery walls than in all the conquered provinces together. But the siege was continued, for the desire of the invaders to capture the legendary treasures of the Trinity Monastery was great.

But conditions were even worse for the besieged. The cold weather and shortage of firewood, food and fresh water, not to mention the disease which raged in the crowded conditions, took 2,125 lives in the course of a single winter, according to Avraamy Palitsyn. As a result only two hundred people capable of bearing arms remained alive come spring. However, despite all these hardships, the monastery held out courageously until the arrival of commander Skopin-Shuisky, who routed and resoundingly defeated the enemy on January 12th, 1610. The heroic defense of the Trinity Monastery served as an example for the entire country, which then gathered its forces to rebuff the enemy.

During the long months of the siege, the walls, towers, and other structures were badly damaged, but repair and restoration work was begun only after 1630, more than likely, since the economic resources and strength of the country had been utterly drained, and it was unable to recover from the damage done by the occupation for a long time. The walls and towers were not just restored but were made higher and more sturdy once repair work was begun.

The length of the newly restored fortress walls was 1,370 meters, and they were 10 to 14 meters high and about 6 meters wide. They had three tiers with loop-holes, the lowest of

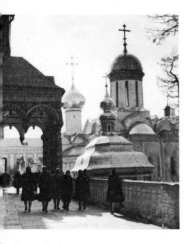

Refectory Gallery

and from an architectural point of view.

An important place in the architectural ensemble of the Trinity Monastery is occupied by the complex of buildings erected in the northeast corner of the grounds between 1635 and 1638. This complex consists of the **Infirmary and the Church of SS. Zosima and Savvaty,** consecrated to the two Russian monks who founded the well-known Solovetsky Monastery on one of the islands in the White Sea in the 16th century. The arrangement of the buildings is quite original: an elegant tent-roofed church rises above the first floor of the infirmary, while the second floor is displaced to the sides of the church, emphasizing its tall, graceful outline. The exterior of the church is richly decorated with garlands and bar tracery running along the apses, reminiscent of the ornamentation of St. Nikon's Side-Chapel of the Trinity Cathedral, while the colored tile inserts and bands of blind arcading on the tall tent roof are analogous to the ornament of the main cathedral of the Solovetsky Monastery.

This fascinating church gladdens the eye with its joie de vivre like almost no other in all the lands of Rus and represents one of the most productive periods in the history of Russian architecture. It is impossible to determine the source of the tent roofs which began to appear on churches at about that time, but more than likely, they derived from the type of roof possibly employed for ancient wooden towers, which of course have not survived. (If this is so, then these proposed tower roofs may have something in common with the archaic form of the wooden churches which are found to this day in the Russian North.)

But whatever its origins, the tent roof then played an enormous role in Russian church architecture until its use was officially forbidden by the powerful Patriarch Nikon at the end of the 17th century. The head of the

which was a row of casemates with loop-holes almost at ground level. The second tier opened into the monastery yard in a series of mighty arcades. The upper tier was a high protected gallery with narrow embrasures and machicolations which, due to the fact that it projected, the defenders could engage the enemy either close up or at a distance. The multi-tiered towers were also excellent from a military point of view.

Generally, 17th century structures were magnificently decorated. This is true of the monastery fortress as well, for it combines whimsically a stern might and unconcealed elegance. The **Utichya** (Duck) **Tower** — from which, according to legend, Peter the Great used to shoot ducks — or the **Zhitnaya** (Barn) **Tower,** as it is also known, is a fine example of this combination of functionality and elaborate ornamentation. Octagonal, with four tiers and 77 loop-holes, it is unusually richly decorated for a structure which was primarily military in function. All eleven towers of the monastery are interesting both as fortifications

Church considered the tent roof a departure from church canon resulting from secular influences. And indeed, these tent-roofed churches were quite often erected in honor of some political or military event. Nikon's ban made single- or five-domed construction mandatory for churches, but happily, the tent-roofed style had already had a considerable impact on Russian church architecture, so many of these remarkable structures have come down to us.

In architecture and icon-painting, in the tent-roofed churches of the 17th century, and in secular construction as well, the art of exterior decoration reached its peak. The buildings of this period are enlivened by an endless array of decorative elements and patterns which make churches look like fairy-tale castles and chambers like carved chests set with precious stones. This love of decoration was borrowed from folk art and used to beautify the walls of all manner of secular structures and churches alike. By the same token, many forms of applied art, especially jewellery-making, casting, chasing, filigree, enamelwork, and glazed tile-making reached the height of their development in the 17th century.

The end of the 17th century was marked by a rise in the significance and influence of the Trinity Monastery, since it found itself at the center of the internal political struggle that preceded the reign of Peter the Great. The monastery was a firm supporter of the young tsar, for which it was generously rewarded when Peter finally took firm hold of the Russian throne. As a result of Peter's lavish donations, the monastery was able to erect an entire ensemble of outstanding buildings, including the Refectory by St. Sergius' Church, the two-storey Royal Palace, the residence of the Father Superior, the Gateway Church of St. John the Baptist, the Chapel-at-the-Well of the Dormition Cathedral and an analogous structure near the Church of St. Paraskeva Pyatnitsa.

The two main buildings, the

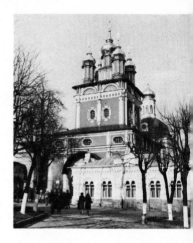

Gateway Church of St. John the Baptist

Refectory and the Royal Palace were erected opposite each other to the south and north, respectively, of the large central square of the monastery. Their similar style and decoration gave the square a sense of architectural unity.

The Refectory with its St. Sergius' Church (1686-92) is one of the most interesting examples of Russian architecture of the end of the 17th century. Its central hall for formal ceremonies and receptions is about 500 square meters in size — at that time quite large for a hall with no pillars. The enormous 85-meter building rests on a high basement which houses the kitchen, bakery, storerooms, and other husbandry facilities. It draws the eye at once, outshining all the other buildings of the monastery in richness and variety of decor. Its walls are like a cheery carpet with their multi-colored checker-board design that creates the illusion of faceted relief-work. Its rare elegance is heightened by the tall columns of carved, painted intertwining grapevines and by the intricate carved white stone platbands around the

windows, and the sculpted scallop shells inscribed into the *kokoshniki* of the attic. Another striking decorative element of the Refectory is the high open gallery surrounding it with its two formal staircases, parapet, and figured balusters.

The interior of the building was formulated with equal care and ingenuity. The walls and vaults of the gigantic refectory hall and the vestibule are covered with baroque ornament in high relief. The carved iconostasis of St. Sergius' Church, brought from one of the Moscow churches, is a genuine masterpiece executed by Russian artisans in the late 17th century.

The **Royal Palace** was built immediately after the Refectory, and although the formal open staircase leading to the second storey and several other elements of construction and design have not survived, the building is nonetheless quite beautiful and impressive. Its unusually richly decorated façades with their multi-colored checker-board pattern, figured tile platbands, and panels are quite similar to those of the Refectory. The construction of the Royal Palace marked the appearance of an entirely new type of building in Russia. The stone chambers of the tsars of the 15th and 16th centuries and the wooden mansions that preceded them were always a conglomeration of separate structures joined by passageways, staircases, and galleries, thus presenting a complicated, picturesque architectural complex of a multitude of asymmetrical volumes. But in this case, the builders united all these disparate elements under one roof in a building 85 meters long and 20 wide. The kitchen and other auxiliary rooms were located on the first floor, while the second consisted of a suite of formal halls and living quarters. This building thus became the prototype for the enormous royal palaces of the 18th and 19th centuries.

The third major construction project of that period was the new **Gate-way Church of St. John the Baptist** (tserkov Ioanna Predtechi) whose dome rose high above the monastery walls. Erected between 1692 and 1699, the work was commissioned by the extremely wealthy Stroganov family of industrialists, who were great patrons of the arts and literature. A whole style in 17th century Russian culture is connected with the Stroganov family: it is reflected partly in architecture, but mostly in icon-painting and gold-thread embroidery. And thus, with the Church of St. John the Baptist, the Stroganovs made their contribution to overall appearance of the Trinity Laura.

The unusual Stroganov style is visible in the abundance of white stone carving and in the liberal use of the classical orders, which had lost all functional significance long before. Thus, a row of Corinthian semi-columns which do not support anything appear quite unexpectedly in the second tier of the church's façade. They might seem to be supporting the figured cornices, but since they do not reach all the way to the ground, it is actually the cornices which hold the columns in place!

In the southwest corner of the monastery grounds is the **Metropolitan's Chambers.** Judging from the bands of colored tiles preserved on three of the structure's façades, it was built at about the same period — the end of the 17th century. However, the alterations made in the second half of the 18th century drastically changed the appearance of the building which included elements of much older structures. The pediment of the chambers bears a representation of the metropolitan's regalia.

One more picturesque monument from the end of the 17th century is the **chapel-at-the-well** next to the Dormition Cathedral. Near the altar of this chapel is a well. The refined proportions of the tiered volumes and their faceted forms, the richness of carved decoration and color make the chapel resemble some marvelous creation

from a fairy tale, especially when it is compared with the austere massiveness of the Dormition Cathedral. The positioning and stylistic unity of the chapel with respect to the Refectory and Royal Palace make it a compositional link within the monastery ensemble.

The form of this chapel-at-the-well influenced the design of the **chapel at the Pyatnitsky Well — the Well of St. Sergius** — an analogous structure built at the turn of the 17th century outside the monastery walls near the Church of the Presentation of the Virgin. Standing near the entrance to the monastery on the right side of the highway, the festive appearance of this delightful structure gives visitors a foretaste of the many pleasant surprises which await them inside the monastery proper.

At the end of the 17th century, the monastery and the settlement that had grown up around it both flourished as never before or after. The town, located on the busy highway from Moscow to Vologda and Arkhangelsk in the north, was quite large and had more residents at that time than Rostov the Great, Pereslavl-Zalessky, and many other ancient Russian cities.

The first major 18th century building at the monastery is **St. Micah's Church** erected in 1734 at the northwest corner of the Refectory. The small church's most interesting feature is a broad gambrel roof similar to that of the Dutch colonial style in America. During remodelling carried out at the monastery during the mid-18th century, all the major buildings were to be given such roofs. And thus, many ancient structures were "blessed" with them in keeping with the fashion of the times, with the result that their individual features and charm were lost, being entirely concealed by the official new formal style. This made a great deal of work for restorers in the present century whose job it was to strip them of these coats of mail and remove later brick and plaster work to return these remarkable buildings to their original appearance.

Another building of that time, the **Church of the Smolensk Virgin** (1745-53) was constructed in an altogether different style by well-known Moscow architect Dmitry Ukhtomsky. This example of St. Petersburg baroque is situated in the northeast section of the grounds across from the Infirmary and the Church of SS. Zosima and Savvaty. More than anything it resembles the pavilions or small hermitages which were being built in the large gardens of suburban estates at the time.

The major 18th century structure at the monastery, and one which unites the whole architectural ensemble is the majestic BELL-TOWER, the tallest, most elegant, and most beautiful in all of Russia. The history of its construction (1740-70) is a long and complex one.

The original design for the bell-tower was worked out by court architect Schumacher and sent from St. Petersburg in 1740, two years after the original petition of the head of the monastery for such a design. With it came the order that the work was to be supervised by architect Ivan Michurin who had previously drawn up a plan of the monastery grounds.

Michurin realized that there was a major flaw in Schumacher's design: the bell-tower was to be erected in the geometrical center of the main square of the monastery, aligned with the west entrance of the Dormition Cathedral. But in that location, it would block the path to the ancient Trinity Cathedral and overwhelm the comparatively modest structure with its massiveness and height. Moreover, the space around the bell-tower would be so crowded that a good view of it could not be had from any point on the grounds. Therefore, in spite of the opposition, he suggested that the tower be constructed to the north after the space between the main buildings of the monastery and the proposed construction site had been cleared. Thus, a year later, work was begun on the bell-tower at the site sug-

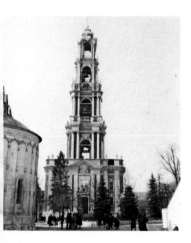

Bell-Tower

gested by Michurin, and that is where it stands to this day.

The Moscow architect exhibited similar boldness and independence during the actual work as well, since he so altered the proportions and details of construction and decor that practically nothing of the original project remained. The work went rather slowly, and in the space of the seven years during which the work was supervised by Michurin himself, only two of the proposed three tiers were completed.

In the process of building the bell-tower, the second main flaw in Schumacher's design became glaringly evident; the tower was not nearly tall enough, which meant it could not possibly fulfil one of its major functions — that of uniting the disparate buildings that made up the complex plan of the monastery ensemble, which after all included the gigantic Dormition Cathedral. When new domes were added to this cathedral in 1753, it almost equalled in height the three-tiered bell-tower.

Therefore, Ukhtomsky, who replaced Michurin, decided to add another two light, airy tiers surmounted by a dome in the shape of a chalice with four crowns.

As a result, when the work was finally completed in 1770 (already without Ukhtomsky who had had a serious conflict with the clergy over his intention to ornament the bell-tower with allegorical sculptures representing the human virtues) this superb structure, executed in accord with the canons of the classical orders, had reached an unprecedented height of 87 meters, including the cross at the top, exceeding the height of the bell-tower of Ivan the Great in the Moscow Kremlin by six meters.

Today, no matter what angle Trinity Monastery is viewed from, its marvelous bell-tower is the first thing that catches the eye. It is equally visible from all points within the Laura walls with its four identical façades, yet it is so light and airy a structure and so fine of line and proportion that it does not dwarf its smaller neighbours despite its great height. This unusual delicacy has been achieved by making the successive tiers which rise above the two-storey lower tier equal in height with the surrounding structures, combined with the fact that although the pylons successively decrease in size, the width of the central arch remains the same. The white stone columns framing the central arch and the turquoise color of the tower intensify the impression that it sweeps upward.

Thus, the bell-tower gracefully carries out its function of giving the finishing touch to the outlines of the monastery and serves as a shining example of the amazing sense of tact of the Russian artisans of that time, demonstrating their subtle understanding of the canons of building within an architectural ensemble consisting of widely disparate structures harking back to various epochs and styles. Unquestionably, the bell-tower beautifies the monastery grounds and complements the more ancient buildings around it, making them more lovely in their own right.

In 1792, an **obelisk** was unveiled in the central square of the monastery. Its pedestal bore four oval slabs with descriptions of the historical events

connected with the Trinity-St. Sergius Laura.

In 1764, the monasteries all over Russia were deprived of their lands, as a result of which the Trinity-St. Sergius Laura lost its enormous holdings and the income from them as well. In 1782, the large village of St. Sergius which had grown up around the monastery was given the official status of a settlement (posad). When first, a good highway was built, and subsequently, a railroad was laid connecting it to Moscow, the settlement grew quickly. Hotels, shops, and rooming houses sprang up due to the growing stream of visitors to the Laura. In 1814, the Moscow Seminary was transferred to the monastery and housed in the Royal Palace. In 1919, the settlement of St. Sergius became a city.

The years of Soviet government have brought many changes to the monastery. In the first years after the revolution, all articles of artistic value there were nationalized, and a **Museum of Art and History** was founded within its walls. In 1940, the territory of the Laura was declared a historical preserve. Systematic restoration of the buildings and ancient works of art began. Today, the Trinity-St. Sergius Laura ensemble represents the brilliance and talent of those Russian architects of the past who created buildings quite unlike those anywhere else in the world. Meanwhile, the fabulously rich collections of its cathedrals and museums acquaint visitors with ancient icon-painting, 18th century portraiture, and applied art. We will now discuss the museum collections at some length.

The famous works Andrei Rublev painted at the Trinity Monastery do not eclipse the many other fine icons brought here from elsewhere or painted at the monastery, which was one of the major centers of icon-painting. Among the most ancient and interesting icons in the museum are two believed to have belonged to Sergius of Radonezh himself: *St. Nicholas the Miracle Worker, Archbishop of Myra and Lycia* and *The Virgin Hodegetria,* both 14th century work.

The museum has a fine collection of 14th century art by masters from the Trinity Monastery, Moscow, Pskov, and other lands as well. Among the 14th and 15th century works which seem to anticipate the masterpieces by Rublev are three outstanding Russian icons: *The Virgin Hodegetria, The Virgin of Vladimir,* and *The Trinity,* painted not long before Rublev.

Reflected in the works on display from the 15th century — the zenith of the Moscow icon-painting school — is the strong influence Rublev had on the artists of that time, their fascination with his emotionality and the sincerity of his images, as well as the harmony of his color schemes. The high level of artistic skill of the period is evident from such icons as *The Virgin of Vladimir, The Virgin Eleusa, The Petrovskaya Virgin, The Jerusalem Virgin,* and *St. Leontius of Rostov.*

The second half of the 15th century, the period when a united Russian state and a common Russian culture were formed, was a very favorable time for the development of icon-painting. One of the greatest Russian icon-painters, Dionysius, worked during this period, and his paintings reflected the hopes and aspirations of the Russian people with their bright, joyful character. Dionysius was a brilliant colorist, and his frescoes and icons can easily be distinguished by their soft pastel tones. In the local (bottom) row of the iconostasis of the Trinity Cathedral is a half-length portrait of St. Sergius of Radonezh with a border of scenes from his life. This icon was presented to the monastery by Ivan the Terrible and is the work of the school of Dionysius.

The Zagorsk collection is especially rich in precisely dated and signed icons — an extremely rare phenomenon in ancient Russian art. Among the signed works of the 15th

century are *The Virgin of Vladimir* by David Sirakh (1571) and a folding tryptich *The Apparition of the Virgin to St. Sergius,* the central panel of which is signed by the cellarer of the monastery Evstafy Golovkin in 1588. This icon was considered the protector of the Russian army, and in 1652, Tsar Alexei Mikhailovich (Peter the Great's father) took it with him on his military campaign. In 1591, the self-same Golovkin painted the well-known icon, *The Life of St. Sergius.*

One of the finest Russian artists to have worked within the walls of the Trinity Monastery is a major figure in 17th century Russian art, the last of the great icon-painters, Simon Ushakov, whose work can be seen in the cathedrals of the Moscow Kremlin and in the major museums of the country.

The leading court icon-painter, Ushakov was an innovator who used the realistic techniques, three-dimensional representations, and perspective, anticipating the laws of secular painting of the next century. He called for all artists to take up the banner of the new art and even wrote a tract in defense of it which explicated his understanding of the task of the artist and set forth his philosophic and artistic credo. He considered the image depicted on an icon to be "the life of a memory, the memory of those who have gone before us, a testimony of the past extolling the virtuous, an expression of might, the resurrection of the dead, eternal praise and glory, a means of arousing the living to imitation of the pious, and a reminiscence of bygone deeds".

There are several icons by Ushakov at Zagorsk: *St. John the Divine, The Dormition of the Virgin, The Holy Mandilion,* two icons of Sergius of Radonezh, *The Pantocrator Enthroned,* and finally, The *Last Supper* painted for the Holy Doors of the Dormition Cathedral in 1685, a year before the artist's death.

In concluding our discussion of the collection of ancient Russian painting at the Zagorsk museum-preserve, we might sight an interesting icon bearing a portrait of *Maxim the Greek* (secular name, Michael Trivolis) painted in the 18th century, but harking back in manner of execution to a much earlier era, to an image of the chronicler; Maxim was buried at the Trinity Monastery in 1556.

Among the 18th century pieces on display, the canvases by major Russian portraitists Ivan Nikitin and Alexei Antropov are of considerable interest. Nikitin painted the well-known formal portrait of Tsarina Praskovia Fyodorovna, and this work, like his others, exhibits a unique insight into the hidden depths of his models' characters. Antropov painted portraits of Empresses Elizabeth and Catherine the Great, and of Emperor Peter III. The halls of 18th century art contain many other significant works of Russian and foreign art.

While there are excellent exhibits of ancient Russian art in other Soviet cities, such as Moscow and Leningrad, the Zagorsk museum excells in one form of ancient Russian art, the collection of which outshines all the other museums. We are referring, of course, to the marvelous collection of tapestries.

The tapestry collection came about largely as a result of gifts to the monastery made by tsars and princes, including Vasily III and Ivan the Terrible, and by the boyars and other prominent figures.

Tapestry-making was widespread in Russia in the 15th-17th centuries, and many princely houses, as well as those of the boyars and merchants, had their own workshops. Often, the workshop was supervised by the mistress of the house or her daughters, all of whom were generally highly skilled needlewomen.

Embroidery was known in Rus from time immemorial, but tapestry emerged as an art form with the advent of Christianity. Like icon-painting, it was used as a means of depicting religious and state leaders canonized by the church as well as for the illumination of scenes from the Bible and the Gospels. These embroidery works were used in the decoration of churches and in the

Abramtsevo Estate-Museum

manufacture of portable iconostases. Shrouds of Christ, banners, and veils to be placed under icons made by Russian needlewomen were remarkably beautiful and elegant.

First, an icon-painter would trace the outline of the pattern for the embroidery on the cloth — usually silk — and then, the needlewoman would fill in the pattern with various colors of thread, including gold and silver thread. Her textured designs would create an imitation of some expensive fabric, such as Italian or Persian brocade. In the 16th and 17th centuries, this embroidery work would be decorated with pearls from Russia's northern rivers and with precious stones.

The result was a work of outstanding artistic merit and great value, for a large Shroud of Christ could easily take several years for the finest embroidresses in the workshop to complete, and large quantities of expensive materials would go into the making. The loss of especially valuable pieces of embroidery in fires was even noted in the ancient chronicles.

One of the oldest and most remarkable examples of tapestry at Zagorsk is the embroidered pall with a full-length portrait of St. Sergius of Radonezh done in the 1420s. Looking at the very vivid, true-to-life image of the celebrated founder of the monastery with its clearly individual features on an intelligent, perspicacious, strong-willed face, it becomes clear why this type of art was called "painting with a needle". This piece of embroidery is in fact a remarkable piece of artwork which reveals the most subtle nuances of form and character. It is possible that the drawing for this pall was made by Rublev himself.

A large number of styles, methods, and techniques were used in the execution of a tapestry, and each finished work was unique. For example, the oldest of the Russian Shrouds of Christ which have come down to us — the so-called *Blue Shroud* of Christ — made at the very beginning of the 15th century, not long before the pall of St. Sergius, also done in silver thread, differs considerably from it, for the embroidery of the former is quite flat.

The excellent condition, vivid

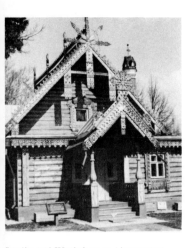

Studio and Workshop at Abramtsevo

Church at Abramtsevo

colors, and precise design distinguish the shroud, *The Miracle at Chonae,* made at the end of the 15th century. This work depicts one of the deeds of the Architstrategus Michael: the moment he strikes a cliff with his staff so that a fissure appears in it into which the water from a mountain stream begins to flow. The curve of his raised wing and the folds of his garments portray the dynamic pose of the archangel emphasized by the static figure of the stooped Elder Arkhip standing before the temple.

Just as the most wonderful of all icons — Rublev's *Trinity* — was painted for the Trinity Monastery, so the most remarkable of all Shrouds of Christ — that of the Staritsky Princes — was made for this monastery in 1561 in the workshop of Princess Evfrosinia, the aunt of Ivan the Terrible.

Evfrosinia Staritskaya was an ambitious, domineering woman. In an attempt to put her son Vladimir on the throne, she hatched several plots against Ivan the Terrible, as a result of which, she and her son were finally executed. Although she did not achieve the success she desired in the political arena, the princess managed to surpass the royal family in one sphere at least: her embroidery workshop was larger and finer than that of the tsar.

The scene *Holy Women at the Tomb* is depicted on a large piece of fabric (2.76 m × 1.74 m). The grief of those gathered is portrayed with particular forcefulness, especially that of Mary Magdalene, whose eyes are swollen from crying. This shroud, in which more than forty different stitches have been used, displays an exceptionally unified composition, sense of rhythm, and color scheme.

Over the centuries, the sacristy of the Trinity Cathedral was presented with many marvelous works of art by the richest and most influential families in the country, and thus, it became one of the first art museums in Russia. It possesses pieces by Byzantine and West European master craftsmen, but of course, the bulk of the holdings is the work of Russian artists between the 13th and 18th centuries. The fabulous collection of sacred utensils at the Zagorsk

museum can well serve as a vivid illustration of five centuries of development in the art of jewellery-making. Many different techniques employing precious metals and stones, wood, ivory, and other materials were used. The exhibits of this department include superb carved miniatures and examples of filigree, casting and chasing, engraving, niello, and silver icon-frames, as well as cloisonné enamel.

Among the most ancient exhibits of the museum are two excellent 11th-century Byzantine-school cameos. The first is of jade and depicts St. George in armor, and the second, of Ceylon sapphire, bears the image of the Archangel Michael. The gold settings of the cameos are 19th-century work.

The Zagorsk collection is particularly rich in examples of the minor plastic arts, which were very popular in Ancient Rus, since they did not fall under the church's ban on sculpture in general, which was considered a manifestation of paganism.

One of the most valuable and skilfully-wrought works of miniature sculpture in the museum is the gilded panagia of Hegumen Nikon, executed in the first quarter of the 15th century. A reliquary dating back to about that time made of silver leaf with three rows of figures of saints cast in silver is also worthy of note. Another fine piece is a 15th-century icon with a cameo depicting St. Hepatius on the face side and the Prophet Daniel on the reverse side. A rare example of work from the turn of the 13th century is the pectoral icon with a cast silver image of St. George on the front and an engraving of St. Nicetas the Warrior slaying a demon on the back. There are also a number of 14th-century Novgorod pectoral icons.

The work of carver and jeweller Ambrosius, with whose activity at the monastery the flourishing of the minor plastic arts in the second half of the 15th century is connected, is of particular interest. Although documents inform us that Ambrosius

spent his entire life at the Trinity Monastery, we possess only one object signed by him — a folding walnut icon-case in a gilded setting made in 1456.

An excellent example of the high level of skill, expressiveness, and perfection of form, as well as harmonious proportionality characteristic of sacred utensils of the 14th and 15th centuries is the unusually beautiful 1449 chalice of red marble set in gold given to the monastery by Grand Prince of Moscow Vasily the Blind. The chalice is decorated in high relief filigree of gold with chased inscriptions from which the name of the maker — Ivan Fomin — is known.

One of the finest achievements of Russian decorative art of the 16th century is the gilded icon-setting for Rublev's *Trinity* donated to the monastery by Ivan the Terrible. In mastery of execution and skilful employment of the various techniques of chasing, niello, and *cloissoné*-work, as well as lavish use of precious stones — emeralds, sapphires, and rubies — this treasure of ancient Russian art has no equal.

The articles presented to the monastery by Boris Godunov and his family are likewise distinguished by fine workmanship and great material value. Godunov was both knowledgeable about and a great lover of jewellery. The jewellery workshop he organized on his ancestral lands in the village of Krasnoye on the Volga River south of Kostroma is known in particular for its niello to this day.

The department of Soviet applied arts is also quite interesting. Works by professional artists and folk craftsmen and artisans alike are on display, including embroidery and wood-carving, braiding and weaving, chasing and laquered wares, knitting and decorative painting, pottery and glassware.

The settlement of St. Sergius was known for its artists and craftsmen in the past, and this tradition is preserved in present-day Zagorsk. The

city is an important center of toy-making and even has the only research institute of toys, attached to which is a museum featuring Russian toys of wood, papier-maché, and other materials. The brightly-painted nested Russian matryoshka dolls made in Zagorsk are always in great demand. Matryoshka dolls and other toys made by Zagorsk folk craftsmen can be purchased at the souvenir stand across from the Trinity-St. Sergius Laura.

Zagorsk is the first stop in the popular tour of the Golden Ring which takes visitors to the historic cities of the Northeast of Central Russia. There are so many interesting sights in Zagorsk, it is impossible to describe them all, and there is no need to, for each person who comes to this remarkable museum-preserve makes his own discoveries.

Abramtsevo

Several kilometers from Zagorsk is a road sign marking the turn-off to Abramtsevo. In Russia, there are many old estates and homes tucked away in quiet corners far from the urban bustle which played no less a role in the history, culture, and arts of the country than many cities. One such peaceful nook is the ABRAM-TSEVO ESTATE MUSEUM-PRE-SERVE.

Since 1843, this picturesque estate near Moscow has been connected with the name of well-known Russian writer and cultural figure Sergei Aksakov. He often entertained such writers as Ivan Turgenev, Fyodor Tiutchev, and Nikolai Gogol as well as actor Mikhail Shchepkin at his country estate, and it is thought that Turgenev's novel *A Nest of the Gentry* owes much to the writer's visits there. Gogol gave the first reading of several chapters of the second part of his novel *Dead Souls* at Abramtsevo. The room in the attic where this great Russian writer stayed when he came to visit Aksakov has been restored.

The estate gained even more renown in 1870 when it became the property of industrialist and patron of the arts Savva Mamontov, a person who, in the words of artist Viktor Vasnetsov, "had a special talent for inspiring others" and who considerably expanded Abramtsevo's cultural traditions. Many well-known figures in the arts lived and worked at the estate during those years, including painters Ilya Repin, Valentin Serov, Vasily Surikov, Isaak Levitan, Konstantin Korovin, Ilya Ostroukhov, Mikhail Nesterov, the Polenov brothers, Mikhail Vrubel, Viktor Vasnetsov, sculptor Pavel Antokolsky, singer Fyodor Chaliapin, stage director Konstantin Stanislavsky, and actress Maria Yermolova.

In time period, spirit, and nature of search for artistic methods, the circle of artists at Abramtsevo was quite close to the group centered around Princess Tenisheva at Talashkino near Smolensk of which we have already spoken. This is not surprising since they were both inspired philosophically and artistically by the same people. The Abramtsevo circle was just as keen on the idea of collecting works of Russian folk art and objects from peasant life. They thought these objects should be preserved and supported a revival of the forms, motifs, and designs of folk art in painting and carving. Here at Abramtsevo, the first museum of folk art in Russia was founded, and woodworking — and subsequently ceramics — studios were set up. Here, for the first time, stylized furniture and various kinds of utensils decorated with carving were produced; due to the efforts of Mikhail Vrubel, the ceramics studio was responsible for the birth of a new era in majolica and glazed-tile production.

In addition to the rather unassuming wooden **house** with an attic and balcony, probably built at the turn of the 18th century, on the territory of the estate are a whole series of remarkable experimental buildings

designed by various artists.

In 1873 the **Banya-Teremok** (Bath-house Tower), with a roof and wings reminiscent of an old wooden house, was built according to the design of architect Ivan Petrov, better known by the pseudonym of Ropet. The uncommon abundance of carved cornices, platbands, hand-railings, and pediments give the charming structure the appearance of a fairytale cottage.

The **church** (1881-82) built according to the design of Viktor Vasnetsov with the participation of Vasily Polenov employs motifs of ancient Russian architecture. Its form is reminiscent of the architecture of Novgorod and Pskov. Another of Vasnetsov's projects is the **"hut-on-chicken-feet"** in the garden which is quite like the wooden houses of the north and which here resembles the fairytale hut of Baba Yaga the witch that stood on chicken feet and could move about from one place to another.

The museum of Abramtsevo will acquaint tourists with the lives of the famous people who visited the estate at one time or another and with Russian art of the second half of the 19th and beginning of the 20th centuries. Among the gems of the estate collection are Serov's *Girl with Peaches* and a majolica bench made by Vrubel, as well as many other interesting works.

Historical and Architectural Monuments

Trinity–St. Sergius Monastery

Trinity Cathedral, 1423, with the Nikon Side-Chapel, 1548, 1623
Church of the Holy Spirit, 1476
Dormition Cathedral, 1559-85
Fortress Walls, 16th-17th centuries
Pyatnitskaya Tower, 1640
Krasnaya (Beautiful) Vorotnaya (Gateway) Tower, 16th-17th centuries
Uspenskie (Dormition) Gate, mid-17th century
Sushilnaya (Drying) Tower, 16th-17th centuries
Utichya (Duck) Tower, 17th century
Zvonkovaya (Bell) Tower, 16th-17th centuries
Solyanaya (Salt) Tower (lower tier), 16th century
Kalichya (Pilgrim) Vorotnaya (Gateway) Tower, 1758-78
Plotnichya (Carpenters') Tower, 17th century
Kelarskaya (Cellarer's) Tower, 1642-1849
Pivnaya (Beer) Tower, 17th century
Vodyanaya (Water) Tower, 17th century
Vodyanie (Water) Gate, 16th-17th centuries
Lukovaya (Onion) Tower, 16th-18th centuries
The Metropolitan's Private Chambers, 16th century-1778
Kaznacheisky (Treasurer's) Wing of Monks' Cells, 16th-19th centuries
Infirmary and the Church of SS. Zosima and Savvaty, 1635-38
Refectory and St. Sergius' Church, 1685-92
Royal Palace, end of the 17th century
Chapel-at-the-Well, end of the 17th century
Gateway Church of St. John the Baptist, 1693-96
St. Micah's Church, 1734
Church of the Smolensk Virgin, 1745-48
Bell-Tower, 1740-70
Sacristy, 1782
Obelisk, 1792

Monuments Outside the Monastery

Church of the Presentation of the Virgin at the Temple, 1547
Church of St. Paraskeva Pyatnitsa, 1547
Pyatnitsky Well (the Well of St. Sergius), end of the 17th-beginning of the 18th
century
Krasnogorskaya Chapel-at-the-Well, end of the 17th century
Church of St. Elijah the Prophet, 1752
Church of the Dormition, 1769

Abramtsevo Estate

Main House, end of the 18th-beginning of the 19th century
Studio and Workshop, 1872
Banya-Teremok (Bathhouse Tower), 1873
Church, 1881-82
Hut-on-Chicken-Feet, end of the 19th century
Bench by Mikhail Vrubel, end of the 19th century

Information for Tourists

Restaurants
Russkaya Skazka (Russian Fairy Tale) — on the Moscow-Zagorsk Highway out-
side the city
Zolotoe Koltso (Golden Ring) — 113 Prospekt Krasnoi Armii
Sever (North) — 142 Prospekt Krasnoi Armii

Museums
Zagorsk Museum-Preserve of History and Art — on the territory of the Trinity-St.
Sergius Monastery
Departments:
Ancient Russian Applied Art of the 15th-17th Centuries
Ancient Russian Painting of the 14th-17th Centuries
Russian Art of the 18th-Early 20th Centuries
Russian Folk Art of the 18th-Early 20th Centuries
Contemporary Decorative and Applied Art
History
Architectural Monuments and Their Restoration
Monuments of the Monastery Necropolis
Monastery Walls and Towers
Kalichya (Pilgrim) Tower Museum
The museum is open from 10 a.m. to 5 p.m.
Toy Museum — 123 Prospekt Krasnoi Armii. Open from 10 a.m. to 6 p.m.
Abramtsevo Estate. Open from 11 a.m. to 5:30 p.m.

Cinema
Mir — 134 Prospekt Krasnoi Armii

Stores
Univermag (Department Store) — 141 Prospekt Krasnoi Armii
Book Store — 180 Prospekt Krasnoi Armii

Pereslavl-Zalessky

Pereslavl-Zalessky, a district center of Yaroslavl Region, is 124 kilometers from Moscow along the Yaroslavl Highway on the shore of Lake Pleshcheyevo. A railroad junction with developed chemical and light industries, it boasts an art and history museum and the architectural ensembles of several former monasteries.

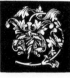 It is about 70 kilometers from Zagorsk to Pereslavl-Zalessky along a good highway. This strip of road is doubtless the loveliest of all those described in our guidebook. The region is hilly, and the straight road crests and descends over gently sloping landscape for kilometers at a time. The road is bounded first by mixed forest and then by conifers on both sides.

As a rule, 7 kilometers outside of Pereslavl-Zalessky, the driver makes a stop, for to the left of the road, surrounded by pine trees, stands a beautiful **17TH-CENTURY SHRINE.** Its tent roof rests on four piers and is decorated with glazed tiles. One of the legends of the city is connected with this shrine, for supposedly, it was built on the very site where Tsaritsa Anastasia, the wife of Ivan the Terrible, gave birth to her son Fyodor, the future Tsar of Russia. And thus, it got its name, the Fyodorovskaya Shrine, also known as the Shrine of the Holy Cross. Once, pilgrims and travellers on their way to Pereslavl left coins here for the coffers of the Fyodo-rovsky Monastery, founded in honour of this same event.

The road rises and falls for a few more kilometers until finally, from the top of Poklonnaya Hill, a lovely panorama of Pereslavl-Zalessky (Pereyaslavl until the 15th century) and Lake Pleshcheyevo opens up.

It is not often that the name of a city reveals both something of its history and geographical location. The name of one of the southernmost cities of Kievan Rus was given to this distant forest region — as was the case with many other southern cities, settlements, and rivers — by the Slavs who migrated from the steppes about the Dnieper to this northern locale in the 9th century. The second part of the city's name, Zalessky (beyond the forests), was added to distinguish it from the older city of Pereyaslavl and to indicate that indeed, with respect to Kievan Rus, it lay beyond many a dense forest, along with all the lands of Northeastern Russia. And it was precisely this natural protection from the danger of periodic raids by nomadic tribes provided by the forests that drew the migrants to the area, along with the abundance of fowl and other wildlife, the rich soil,

and the many untapped natural resources.

For a long time, this harsh and distant land was not valued in the least by the Kiev princes: it was made part of the patrimony of the younger sons or added piecemeal to the southern ancestral holdings of the major landowners. The land beyond the forests only came to be appreciated in the 12th century during the reign of Vladimir Monomakh, and especially during that of his son, Yuri Dolgoruky, Prince of Rostov and Suzdal.

Unable to consolidate his holdings in Kiev, Yuri, called Dolgoruky (Long Arm) for his constant attempts to extend his power to the distant northern lands, set about building and arming fortresses and founding cities in his principality. During this period, in 1147, he founded the small city on the Moskva River — originally a tiny settlement of craftsmen and traders — which was destined to become the capital of Rus. Five years later, in 1152, the mighty fortress of Pereyaslavl appeared on the shore of Lake Pleshcheyevo and took control of the most important strategic and commercial routes from Kiev to Rostov the Great, and from the upper reaches of the Volga to the fertile lands of Suzdal on the Novgorod side, and on the other, to the Klyazma and Oka rivers which led to the part of the Volga that served as a water route to Bulgaria, via which all Russian trade with the countries of the East was conducted. The Bulgar state was the first formed by the peoples of the middle reaches of the Volga and the Prikamya (10th-mid-15th centuries).

However, the city itself is much older. On the northern shore of Lake Pleshcheyevo still stand the swells of the ancient earthen ramparts that once surrounded the tiny village of Gorodishche, reminding us of the city of Kleshchina which existed here in the 10th and 11th centuries, but declined when the regional center was transferred to the new town of Pereyaslavl, which stood on the eastern shore of the lake.

Due to its strategic location, Pereyaslavl was given special attention among the cities and citadels which were built or whose fortifications were improved in the principality of Yuri Dolgoruky. The earthen ramparts surrounding the town (now the Rampart Ring Road) extended for almost two and a half kilometers and were 10 to 18 meters high and 6 to 8 meters wide at the crest. Twelve watch towers and a double row of paling stood on the embankments. The deep moat that formed where the earth had been dug for the ramparts joined the Trubezh and Murash rivers, as a result of which, the city was actually a man-made island. The bottom of the moat was lined with stakes as a final defensive measure. The area of the fortress was 28 hectares, equal to that of the Moscow Kremlin erected some three and a half centuries later.

This outstanding example of ancient Russian fortification works has come down to us in good condition, giving the Rampart Ring Road its name. A pleasant stroll along the high rampart, now covered with grass, provides the visitor with a breath-taking panorama of the city and the lake. The historical center of the city is Krasnaya Square. Here we will begin our discussion of its architectural monuments. During the first five centuries of its existence, Pereyaslavl suffered twelve invasions, all of which resulted in great damage to the city. Five times, it was sacked and looted by the Golden Horde, and it was attacked as many times as a result of the princes' internecine wars. Finally it was stormed twice by the Polish and Lithuanian armies.

On Krasnaya Square stands a building which is as old as the city itself: the **CATHEDRAL OF THE TRANSFIGURATION OF THE SAVIOR** (Spaso-Preobrazhensky sobor), erected in 1152-57. The cathedral is located in the northwestern part of the fortress right next to

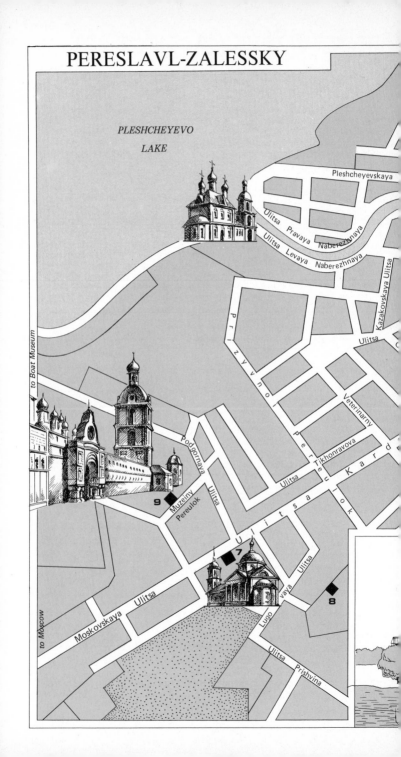

PERESLAVL-ZALESSKY

PLESHCHEYEVO

LAKE

Pleshcheyevskaya

Ulitsa Pravaya Naberezhnaya

Ulitsa Levaya Naberezhnaya

Kazakovskaya Ulitsa

Ulitsa

Prizyvnoi Pereulok

Veterinarny

Tikhonravova

to Boat Museum

Podgornaya Ulitsa

Ulitsa

Ulitsa Karda

Ulitsa

9

Muzeiny Pereulok

7

Ulitsa

8

Lugovaya Ulitsa

to Moscow

Moskovskaya Ulitsa

Ulitsa Prishvina

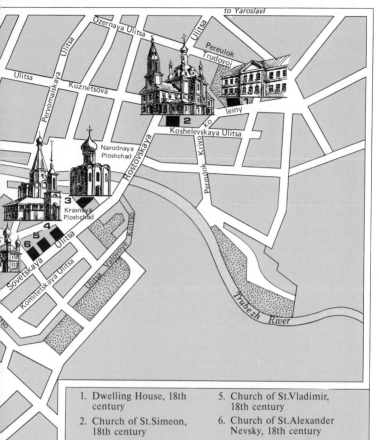

1. Dwelling House, 18th century
2. Church of St.Simeon, 18th century
3. Cathedral of the Transfiguration of the Savior, 12th century
4. Church of St.Peter the Metropolitan, 16th century
5. Church of St.Vladimir, 18th century
6. Church of St.Alexander Nevsky, 18th century
7. Church of the Purification, 18th century
8. Monastery of St.Daniel
9. Goritsky Monastery – Historical and Art Museum

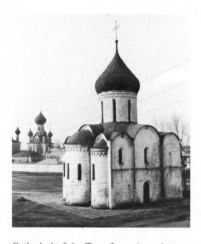

Cathedral of the Transfiguration of the Saviour

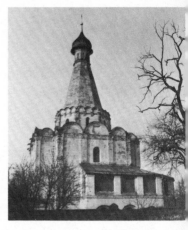

Church of St. Peter the Metropolitan

the rampart wall, with its main façade facing onto the square and the ancient road. Fortunately, the church has come down to us with its original appearance almost intact: only the earlier helmet-shaped dome was replaced by an onion-shaped one with a beautiful cross in the 17th or 18th century.

The massive cube that forms the body of the cathedral seems hewn of an enormous, monolithic boulder, its somewhat squat appearance being explained by the fact that the earth around it has risen a meter over the centuries. And thus, it seems that with its great weight, the building has sunk into the earth and taken root there. The reader is already familiar with the cruciform church with the common form of a single dome, four piers, and three apses which made its way from Byzantium to Kiev, and then spread throughout Rus. The Cathedral of the Transfiguration is just such a church.

Along with the Church of SS. Boris and Gleb in Kideksha (near Suzdal) of which we will speak later,

the Cathedral of the Transfiguration is the most ancient of the pre-Mongolian white stone churches to have survived to the present in Northeastern Russia. Therefore, it is extremely interesting to examine the first stage of development of architecture in this region, for the ideas which appeared here had a significant influence on Russian architectural thought for many centuries thereafter.

The church is quite simple: its façades are enlivened only by flat pilaster strips dividing them into three segments, reflecting the division of the interior into three longitudinal and transverse naves. Only the upper part of the cathedral, completed under the son of Yuri Dolgoruky, Prince Andrei Bogolubsky, has any decoration at all, and then, it is quite austere: there is a band of blind arcading on the apses, and a figured, inlayed frieze with a row of ornamental brickwork on drum of the dome.

Judging from archeological finds, the church was not the only building on the square, as it is now, but was more than likely part of a complex of

structures connected by passageways and galleries leading to both the fortress walls and the prince's wooden mansions.

The interior of this mighty building, which served more than once as a stronghold when the fortress was under attack, is not ponderous, for the walls and pillars thin imperceptibly at the top, creating an impression of lightness. In the 12th century, the walls were all painted in frescoes, and the floor was covered with polychrome majolica tiles, while the piers were painted with a texture that imitated colored stone. Unfortunately, none of the interior decoration of this seemingly spacious church has survived: the remaining fragments of the ancient frescoes perished in the last century. All that remains is a single fragment, *The Apostle,* presently on display at the Historical Museum in Moscow.

The next-oldest structure in the city of Pereyaslavl was built some four centuries after the brilliant Cathedral of the Transfiguration. This is the **CHURCH OF ST. PETER THE METROPOLITAN** (tserkov Petra Mitropolita) erected in 1585 on the site of a wooden church. An interesting event is connected with this church, but first a historical note.

After the death of Prince Andrei in 1174, the region around Pereyaslavl became an independent principality for a time and was ruled by Andrei's brother, Vsevolod Big Nest, so called for his large family and, more than likely, for the enormity of the territory he ruled. Under Vsevolod and his son Yaroslav, the city flourished as never before or since and became one of the major cultural centers of Northeastern Rus. It was here that one of the best-known works of ancient Russian literature, *The Supplication of Daniil the Exile,* was written.

In 1238, the Tartar hordes struck Pereyaslavl, and the foreign invaders burned and laid waste to the city. The difficult years of foreign domination under the Tartar yoke began during

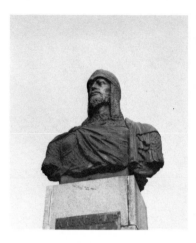

Monument to Alexander Nevsky

the reign of Prince Alexander Nevsky, known for his victories over the Swedes at the Neva River in 1240 and over the German Knights of the Teutonic Order in the famed Battle on the Ice at Lake Chudskoye in 1242. Troops from Pereyaslavl took part in both of these engagements.

Among the outstanding figures of Ancient Rus, one that does not fade from memory is Alexander Nevsky, for even today he is honored as a talented military commander and great patriot. As if in compensation for his short life — the prince died at the age of forty-three at the height of his power — fate early bestowed upon him maturity and responsibility. He ascended to the throne at eleven, and at fourteen, he led his first military campaign. By the time he was twenty, the Swedes feared him, and the Golden Horde had to reckon with him. He was born in Pereyaslavl, and it was from here that he set out on his last mission to the Horde to save the land of his birth from the revenge of the invaders for the uprising of 1262 against their tribute collectors. Having fulfilled his obligation, he died on the way back home on 14 November 1263. "The Sun

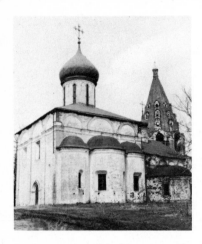

Trinity Cathedral of the Monastery of St. Daniil

of the Russian lands has set," said the chronicles of this loss. Seven hundred years later, the name of this great commander resounded once more: during World War II, one of the highest military honors established was the Order of Alexander Nevsky, presented to over forty thousand Soviet officers.

In his native city of Pereslavl, his memory is honored to this day, and a **monument** to this great man in armor stands in Krasnaya Square before the ancient cathedral.

Nevsky's son Dmitri, who died in 1302, willed his appanage to his uncle, Daniil, Prince of Moscow, which considerably strengthened the position of Moscow in its rivalry with the Tver principality. In 1304, the army of Tver suffered defeat near Pereyaslavl at the hands of the combined forces of that city and Moscow. In 1311, this enmity between the principalities unexpectedly broke out in a previously unheard-of scandal among the clergy: at a council of bishops in Pereyaslavl, Metropolitan Peter was brought to trial on suspicion of accepting bribes. However, the real state of affairs was

as follows: the presbyter of one of the southern Russian monasteries, Peter the Icon-Painter, had the office of Metropolitan of Kiev and All Rus conferred upon him by Aphanasius, Patriarch of Constantinople. He then proceeded to transfer his see from Kiev to Vladimir, but actually lived in Moscow, which was entirely not to the liking of Tver. So Prince Andrei of Tver began to slander him, accusing him of selling high offices within the church and demanding that he be brought to trial. At the proceedings, which were held at the Cathedral of the Transfiguration of the Savior, Peter proved his innocence and was acquitted, which drew Moscow and Pereyaslavl even closer together against Tver.

In memory of the council and of the first Metropolitan of Moscow, Peter, the Church of St. Peter the Metropolitan (5 Sadovaya Ulitsa) was erected not far from the Cathedral of the Transfiguration. This church's tall white tent roof catches the eye at once. And indeed, the building is quite a lovely one, because in the 16th century, not many tent-roofed churches had been built, so each of the early examples of this type of architecture had its own particular features not found anywhere else. The basic volume of this rather large structure is of a type more common to cruciform churches, but in place of a dome, a tall, austere, absolutely smooth tent roof rises above an octagonal volume and is crowned by an onion-shaped dome of aspen shingles. In days of old, the basement served as a dungeon for important civil prisoners, and later the state's monies, weapons, and ammunition were stored here.

The building has undergone alterations over the years: originally, it was surrounded not by a closed gallery, as now – this was an 18th century addition – but by an open promenade which rested on the arcade. In the 19th century, the tent-roofed bell-tower was replaced by the present one,

Near the walls of the Goritsky Monastery

which is classical in style.

The monasteries of Pereslavl-Zalessky have older 16th century buildings with which the reader will soon become acquainted. However, while the concentration of the architectural monuments in a comparatively small space in Zagorsk justified viewing them in chronological order, given the larger area of the present city, where groups of interesting buildings are spread out kilometers from each other, it makes more sense to continue our discussion of the old historical downtown and the monuments located near Krasnaya Square and then move on to other spots of interest.

Near the Church of St. Peter the Metropolitan, right by the Moscow-Yaroslavl Highway, which runs through the center of town, on the territory of the former Novodevichy Convent stand two identical brick churches half-hidden by the crowns of mighty linden trees. These are the **CHURCH OF ST. VLADIMIR** and the **CHURCH OF ST. ALEXANDER NEVSKY** (12 Ulitsa Sovetskaya) built

in 1745 and 1746, respectively, at a time when the baroque style dominated in the architecture of both Russian capitals. But these two churches pay tribute to the baroque then in vogue only in certain features of decor, while the basic cubic volumes with the massive, high central domes surrounded by four smaller domes whose their delicate drums are covered with metal plates hark back to earlier architectural traditions common to Yaroslavl at the end of the 17th century – a matter which will be discussed in the appropriate chapter. Of all the parish churches of Pereslavl, the most striking is the **Church of the Purification** (18 Ulitsa Moskovskaya) built in 1778 on a high hill in the southern part of the city on the side of the highway leading to Moscow. This church can be seen from almost any point in the city–from the lake, and the nearby monasteries. And a lovely panorama of the city and lake can be had from the church grounds as well. The Church of the Purification shows a strong classical influence.

From the hill where this church

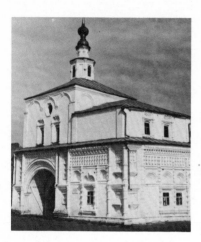

Goritsky Monastery. Holy Gates and
Gate Church

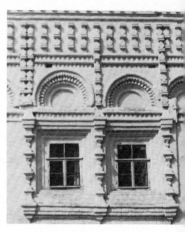

Elaborate white stone carving

stands, three roads open up before the
traveller, as in the Russian fairy tales,
and each of them leads to a monas-
tery, one of which – the **MONASTERY
OF ST. DANIIL** (Danilovsky Monas-
tery) – is quite close by. So we will
begin our tour of the well-known
cloisters of Pereslavl with it.

Although the Monastery of St.
Daniil (7-9 Ulitsa Lugovaya) was
founded comparatively late — in
1508 — by the monk Daniil from the
neighboring Goritsky Monastery, on
its territory stands the next-oldest
building in the city, after the Cathed-
ral of the Transfiguration: the lovely
Trinity Cathedral, built in 1532.
Daniil was a major clerical figure of
the times and father confessor to
Great Prince of Moscow, Vasily III,
who, during a visit to Pereyaslavl,
asked the hegumen to pray for the
birth of an heir to the throne. So the
Trinity Cathedral was built as a votive
church when a son, Ioann, later Tsar
Ivan the Terrible, was born to Vasily.
It is entirely possible that the architect
of the cathedral was well-known mas-
ter-builder of Rostov, Grigory Bori-
sov, who is credited with the design of

many architectural monuments of the
16th century, including the ensemble
of the Monastery of SS. Boris and
Gleb near Rostov, which will be dis-
cussed later.

Trinity Cathedral is similar to the
ancient Cathedral of the Transfigura-
tion, although it was built almost four
centuries later. However, it is lighter
and more elegant — considerably
more refined — than its predecessor. If
we try mentally to remove later addi-
tions and alterations, such as the
small chapel built over the grave of
Daniil in 1660 which hides the
northern façade of the cathedral, the
large square windows cut into the
walls in the 18th century, the tent roof
covering the *kokoshniki*, once visible
at the base of the drum, and the
onion-shaped dome which replaced
the earlier helmet-shaped one, before
us will stand one of the most marvel-
ous examples of 16th century archi-
tecture, a structure of rare beauty and
elegance of proportions.

The cathedral's 17th century **fres-
coes** are exceedingly valuable as well.
The walls, vaults, and dome were
painted in 1662-68 by an artel of artists

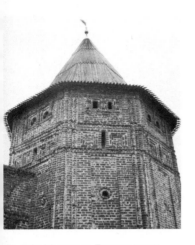

Goritsky Monastery. Fortress tower

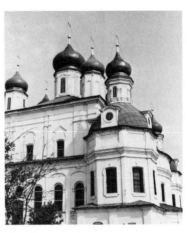

Dormition Cathedral of the Goritsky Monastery

from Kostroma, a city on the Volga. The artel was headed by the outstanding masters Guri Nikitin and Sila Savin who were invited to work at the Moscow Kremlin and in other churches of the capital. The subjects of the frescoes in the Trinity Cathedral are scenes from the Old and New Testaments, particularly from the book of Revelations. Representations of the most venerated saints of Russian Orthodoxy completed the gamut of traditional canonical subjects common to much of the monumental painting of that time.

Many architecturally interesting buildings were erected in the Monastery of St. Daniil in the second half of the 17th century with funds provided by Prince Ivan Baryatinsky. Naturally, they reflected the refined tastes and desires of this connoisseur of architecture, who was surprisingly knowledgeable in the subject. In his last years, Prince Ivan took monastic vows and the name of Father Efrem, and spent his final days in the monastery he had done so much to shape.

Thus, in 1687, the small **All Saints' Infirmary Church** (the infirmary itself has not been preserved), was built in the traditions still prevalent at mid-century. The low, rectangular building with sharply protruding apses has a single dome, the drum of which rests on a rectangular pedestal decorated with keel-shaped *kokoshniki*. A frieze of similar *kokoshniki* runs the length of the façades. The blind arcading of the drum ties the structure to the Trinity Cathedral.

Two years later, in 1689, a tent-roofed **bell-tower** was added to the Side-Chapel of St. Daniil of the main cathedral. To emphasize the size of the ancient building, the bell-tower was deliberately constructed in a rather squat fashion. The eight arches supporting the tent roof rest on a low but mighty cubic base decorated with a double row of vertical geometric indentions at the corners and delicate horizontal bar tracery and windows with festive platbands in the center of the façades.

In 1695, the most elegant building of that period, the **Refectory Church of the Exhaltation of the Virgin,** was completed. Although the structure has since suffered many alterations, including the demolishing of two richly

decorated porches, it is still remarkably lovely.

The reader is already familiar with this rather unusual phenomenon in Russian 17th century architecture from the refectory at Zagorsk which outshone not only the other churches, but the tsar's palace as well. Something similar happened at many other Russian monasteries.

Part of the reason for this was that the life-style and moral ideals of the monks had changed considerably by that time. The period of asceticism and the simple life full of spiritual quests and profound self-examination characteristic of the days of St. Sergius of Radonezh were long gone. The high ideals of being of service to the people had been transformed into the practice of charity, one form of which was feeding the poor at the monastery's refectory on church feasts. With the improvement of artillery, the role of the monasteries as fortresses and defenders of the Russian land declined. Lavish donations and enormous profits from the monasteries' holdings and enterprises allowed the monks to channel large sums for building. And neither did they deny themselves at table. All these factors increased the importance of the refectory, which, it would seem, should have played but a minor role in the life of the monastery. And thus, more attention was paid to its architectural design as well.

The final contribution of Prince Baryatinsky to the construction of the monastery was the **wall** and **gate** built in 1700, with which our tour of this unique architectural complex began.

Now we will proceed south along Moskovskaya Ulitsa to the very edge of the city. Here on a hill above Lake Pleshcheyevo is situated the **DORMITION MONASTERY**, or, as it has long been called due to the geography of its location, the **GORITSKY MONASTERY** (which means on-the-Hill) (Muzeiny Pereulok). As perhaps no other, this monastery experienced the vicissitudes of fate from decline and near-destruction to rebirth and reconstruction practically from the ruins.

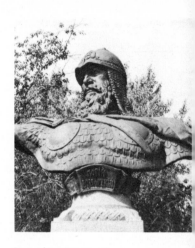

Bust of Yuri Dolgoruky

No detailed information on the ancient history of the monastery has come down to us. Apparently, it was founded in the 14th century during the reign of Ivan Kalita. In 1382, it was razed along with the city by the Tartar Khan Tokhtamysh and then restored and rebuilt under the patronage of Great Princess Evdokia, wife of Moscow Prince Dmitry Donskoi. The monastery stood on a busy highway and was frequently visited by great princes and tsars alike, as a result of which its sacristy was filled with the costly gifts of the wealthy. The Goritsky Monastery also possessed five thousand serfs, a multitude of villages and settlements, extensive farmland and forest holdings, mills, and salt-works. The profits from all this allowed the monks to build stone structures in place of the old wooden ones during the 16th and 17th centuries. The building program included a cathedral, a refectory chamber with the adjoining All Saints' Church, and a fortress wall with towers and beautiful, richly decorated gates.

In 1744, the fate of the monastery took an unexpected turn when the

enormous Moscow diocese was divided, and an independent diocese was created at Pereslavl. Many cities and settlements as well as six parish churches and monasteries were made subordinate to it. By the will of Empress Elizabeth, the Goritsky Monastery became the residence of the new Archbishop, her confessor Arseny Mogilyansky. The new position of the monastery as the seat of an archbishop naturally required a building program in keeping with its status.

With the aim in mind of creating a suitably lavish and luxurious residence for the new heirarch in keeping with the spirit of the times, his successors set about tearing down the wooden structures, including the cathedral and the belfry. As documents relate, "Bishop Serapion only tore down existing structures without building anything new at all."

The grandiose building project finally got underway in the 1750s under Bishop Ambrosy. The design called for the erection of an enormous cathedral with a gigantic formal palace-like building, to be known as Gethsemane, adjoining it from the west. It was to be connected to the cathedral, All Saints' Church, and the refectory, the latter of which was also to be reconstructed. The work dragged on for decades and was nearing completion: the cathedral was finished, and the walls of Gethsemane had been raised to the cornices. Then, in 1788, Catherine the Great, who succeeded Elizabeth, abolished the new diocese and the Goritsky Monastery as well, so all the work had been in vain, for the construction was abandoned, and the church officials left the monastery. The contents of the sacristy were sent to Moscow, and some of the bells were sent to St. Petersburg. The once-prosperous monastery was now deserted. For some time, the buildings were used by civil authorities, and then they stood empty for almost a century until in 1881, a seminary was opened here. A dormitory was built of brick and white stone taken from the

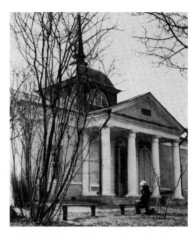

The Botik Estate-Museum

walls of Gethsemane, which were pulled down for that purpose.

In 1919, one of the first museums opened after the Revolution was set up on the territory of the monastery. The monastery ensemble, which included a number of unique buildings, was restored.

The most logical place to start our tour is with the **Eastern Gateway** which serves as the entrance to the museum and the adjacent **Gate-Keeper's House** with the southern **Holy Gate.** All these outstanding monuments were built at the same time by members of a single artel. They are unique in that they represent the only instance in 17th century monastery construction when the corner of the wall — crucial for defensive purposes — was adorned with buildings designed to delight the eye rather than with fortified towers.

To achieve the wide variety of patterns and designs covering the façades of both the gates and the gate-keeper's house, the builders used only about ten shapes of bricks which they laid in various combinations with different sides showing. The

effect of high relief thus created makes for a superb play of light and shadow: the design changes before one's eyes as the sun moves across the sky. In addition, the ornamentation of the Main Gates includes extremely rare examples of ancient Russian sculpture: galloping horses carved in white stone. The **St. Nicholas' Gateway Church** above the Holy Gate was probably of slightly later construction.

The rest of the 17th century wall and towers of the monastery also look quite imposing, especially the mighty southwest **tower** and adjacent walls which have been restored. The tower is crowned by an impressive tent roof which rises high above the surrounding structures. The tower itself is quite ornate in addition, being decorated with a row of semi-columns, bands of ornate brickwork, niches, and platbands around the upper tiers of loop-holes. The northern towers date back to the second half of the 18th century and are quite different in appearance: the large windows and obviously baroque decor of the upper segments make them quite unlike fortifications.

The large, seven-domed **Cathedral of the Dormition** (Uspensky Sobor, 1757) is a rare provincial example of Russian baroque, though the exterior is rather more plain than is usual for this style. But that is perhaps compensated for by the rich ornamentation of the interior: the walls and vaults are covered with stucco moulding, sculpture, and murals, while the carved, gilded wooden iconostasis is one of the most outstanding examples of Russian baroque. It was executed in 1759 by a group of carvers supervised by Moscow master craftsman Yakov Zhukov. The central section of the iconostasis – the Holy Doors – is decorated with a relief scene of the Last Supper and the carved symbols of the Four Evangelists — a lion, an eagle, an angel, and a bull.

On the west side of the cathedral, traces of the never-completed Gethsemane can be seen: the foundations of the building are clearly visible in the grass and lead to the more ancient All Saints' Church, which dates back to the second half of the 17th century. Its windows are surrounded by ornate carved white stone platbands. There are semi-columns at the corners of the building and a frieze of *kokoshniki* under the cornice.

The adjoining late 17th century Refectory underwent considerable alterations in the 18th and 19th centuries and has not yet been restored to its original appearance. A clearer impression of the building's construction can be gained from within the large central hall, more than three hundred square meters in area, with its various types of vaults. The hall is exceptionally well lit and airy. The high vaults of the second floor rest on an octagonal pier.

The massive rectangular **bell-tower** standing flush with the eastern wall of the monastery was built in the 1760s and 1770s.

There is an example of a type of Russian wooden architecture on display at the Goritsky Monastery which was quite widespread in the last century. This is the small wooden **chapel** brought from the village of Foninskoye which stands next to the refectory. This chapel is of the type commonly found on roadsides and in the villages round about. Its simple frame is made of hewn logs, and it has a single dome, several small pediments, a porch, and large windows. Inside the chapel are displayed icons, sculptures, banners, candlesticks, other objects commonly used during worship, and sacred utensils.

The refectory houses one of the richest and most interesting provincial museums in the country. Its collection numbers more than 30,000 items including ancient icons and sculptures, examples of applied art, embroidery, rare historical documents and books, as well as canvases by outstanding Russian artists.

The two oldest and most valuable works of art from Pereslavl are the sil-

Lake Pleshcheyevo

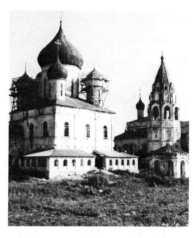

Monastery of St. Nikita the Martyr

er chalice presented to the Cathedral of the Transfiguration of the Savior by Yuri Dolgoruky and the 14th century icon of the *Transfiguration,* from the same cathedral which belongs to the brush of one of the most outstanding icon-painters of Russia, Theophanes the Greek. These two objects are located in Moscow in the Kremlin Armory Chamber and the Tretyakov Art Gallery, respectively. Photographs of both are included in the exposition.

The museum has a fine collection of icons, the best of which are a 15th century icon of *SS. Peter and Paul* in which the canonical representation of the apostles is enlivened by faces with purely Russian features; 16th century icons, *St. Elijah the Prophet and the Fiery Chariot, The Archangel Michael, The Archangel Gabriel, The Dormition of the Virgin, St. Nicholas the Miracle-Worker with Scenes from His Life,* one of the rare icons of *The Good Robber* from the mid-17th century; and *The Virgin of Vladimir* with Border Scenes dating back to the late 17th or early 18th century.

The collection of wood carving,

numbering more than a hundred pieces, is also quite fine, for this was an area in which local craftsmen excelled and for which they were known far beyond their native city. In 1867, the carved Holy Doors from the no longer extant Church of the Presentation of the Virgin in a nearby Rybnaya Settlement were displayed at the World's Fair in Paris, and were awarded a gold medal.

For the Russians, wood has always been the chief building material and medium for the manufacture of household implements as well as for objects of folk art and articles intended for religious use.

Ancient Russian wooden architecture and objects of art carved from wood will be discussed in the chapter devoted to Suzdal, while here we shall devote a few words to carved wooden folk sculptures, of which the Pereslavl museum has an interesting collection.

What are the peculiar features of Russian wooden sculpture as opposed to that of other peoples? We must start with the fact that wood carving was the favorite art form of the people of Rus

who, before the adoption of Christianity in 988, filled the countryside with anthropomorphic carved wooden images that served the pagan populace as objects of worship. Therefore, the proponents of the new religion suppressed this art form, for they saw the carvings as remnants of heathenism. A later reason for the ban on statuary was the struggle of the Russian Orthodox Church against the Roman Catholic ideas that were creeping into it. And this was not the end of the misfortunes suffered by wood carving in the land of Rus, for in two pronouncements by the Holy Synod — in 1722 and 1832 — wood carving was expressly forbidden, and the removal of all existing wood carvings from churches and chapels was ordered.

However, the Russian people were so devoted to wooden sculpture that despite the official disfavor in which it was held, it continued to exist and develop, and in some remote areas, pagan sculptures were preserved right up to the beginning of this century! In addition to religious sculpture, in the towns and villages, purely decorative sculpture, which was often painted, also existed, and was used, for example, as ornamentation on the gateways to estates. Evidence of this practice is often found in descriptions of 16th and 17th century Russian life written by foreigners. The Pereslavl museum boasts an excellent example of such amusing decorative sculpture: the whimsical figure of a Peasant Man from the end of the 17th or first half of the 18th centuries.

No matter what use they were intended for, Russian wooden sculptures were always profoundly human and emotional, noted for their winning spontaneity and touching simplicity, achieved by the attainment of a high level of artistic expressiveness and integrity equal to that of the finest examples of early Russian painting.

The most outstanding sculpture in the collection is *The Savior Grieving at Midnight* (17th-beginning of the 18th century) from the Cathedral of the Dormition at the Goritsky Monastery; it is a profound and unusually

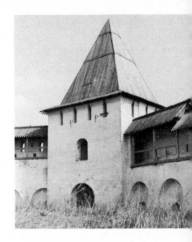

Walls and towers of Monastery of St. Nikita

vivid depiction in wood of the sufferings of Christ in prison.

St. Nicholas of Mozhaisk from the village of Skoblevo is a fine example of late 17th century carving on one of the favorite themes of the Russian craftsmen. The slight generalization of forms is characteristic for such figures, which are hewn from pieces of wood with an axe, rather than being carved with a knife or other tools.

The sincerity and exceptional skill with which the sculptural group, the *Last Supper* (early 19th century), a detail of the Holy Doors from a church in the village of Dmitrovskoye, is rendered is quite remarkable.

And a word about one facet of the woodcutter's craft unique to the area in the Refectory stands an enormous dug-out canoe hollowed out from a single mighty tree-trunk. Once it plied the waters of Lake Pleshcheyevo, and its peculiar design allowed it to crest the roughest waves of any storm. In the same section are fragments of the decoration from the vessels of the Pleshcheyevo Flotilla built at the lake by Peter the Great at the end of the

17th century. This subject will be dealt with in more detail in the section on the *Botik* Museum. The tradition of decorating vessels with wood carving goes back to pagan times in Rus and was preserved over the course of many centuries. In the description of the Russian Fleet built at Voronezh by Ivan the Terrible in the 16th century left by Englishman Jerome Garcey, we learn that the carvings decorating the ships included the painted figures of lions, dragons, eagles, elephants, and unicorns, lavishly ornamented with gold and silver. The Pereslavl museum boasts a pair of lions which are particularly expressive although they merely decorated boats from Peter's so-called "toy flotilla", rather than a real one.

The museum exposition features many valuable tapestries–an art form familiar to the reader from the Zagorsk collection. Two 16th century banners made by the first wife of Ivan the Terrible, Anastasia Romanova herself, are quite exceptional. There are also fine chalices, goblets, Gospel covers, splendid vestments, and many examples of ancient Russian decorative art and jewellery, including chased silver, engraving, gilding, and niello. The visitor will also get some idea of Russian crystal, china, and furniture of the 18th and 19th centuries and of the present-day life of the townsfolk. In the Dmitry Kardovsky Picture Gallery, named after an academician and artist who lived in the city, hang works by outstanding artists Ivan Shishkin, Vladimir and Konstantin Makovsky, Vasily Polenov, Filipp Malyavin, Alexander Benois, Evgeny Lanceray, Konstantin Korovin, Konstantin Yuon, and others.

Upon leaving the Goritsky Monastery, tourists will see the **bust of Prince Yuri Dolgoruky,** founder of the city, near the Eastern Gate. The monastery is visible from quite a distance, so advantageously was it situated by the original builders. And moreover, the perspective of the

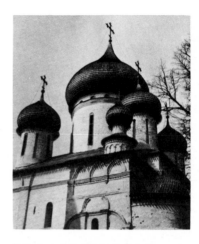

Cathedral of St. Nikita the Martyr

monastery changes with the distance from which one views it. The Goritsky Monastery is in fact even more beautiful from afar: like a picture painted in bold relief, it can be seen better from a distance.

The next stop on our tour, the **BOTIK MUSEUM,** is located three kilometers west of the city on the south shore of the lake near the walls of the Goritsky Monastery.

The characteristic tireless energy and thirst for reform of Peter the Great was nowhere so apparent as in army and naval affairs. From his youth, he was obsessed by the idea of turning Russia into a mighty naval power. He asked leave of his mother, the reigning Tsarina Natalya Kirillovna, to visit the monastery at Pereslavl, for he had heard that nearby was the largest lake in the vicinity of the capital. The lake greatly impressed the young Peter, who till then had sailed only on the relatively small Moskva River. So in August of the same year (1688) he returned to Pereslavl with Dutch ship-builder Karsten Brandt and set about building a flotilla. Less than a year later, two three-

masted ships and two yachts were already afloat. But then Peter was torn away from his undertaking and returned to matters of ship-building only in 1691. And again, we can only be amazed by Peter's indefatigable nature, for by summer of the next year, more than a hundred vessels of the most varied types, including the thirty-gun ships *Mars* and *Anna,* took part in grandiose maneuvers and a festive parade. This review of the first Russian fleet was attended by the whole of the nobility from the capital, a delegation of high-ranking clergy headed by the patriarch himself, and foreign ambassadors.

Thirty years later, Peter the Great, who had already defeated the Swedish Baltic Armada by then, again found himself in Pereslavl, and saw that his "toy flotilla" was simply cast aside and had fallen into disrepair. Enraged at such neglect of national relics, he forthwith issued a threatening order to the military commanders of Pereslavl that the remainder of the ships, yachts, and galleys should be carefully preserved.

Knowing well the stern character of the tsar, the military commanders immediately set about fulfilling the first order in the history of Russia concerned with the preservation of historic monuments. So the half-rotten remains of 87 ships were gathered under a roof where they burned, along with most of the city, during the catastrophic fire of 1783. Miraculously, one small craft — the *Fortuna* — escaped the flames. Peter himself had helped built it. So in 1803, a special building was erected for this boat: it was one of the first Russian museums. In 1852, the *Botik* Museum was made more impressive by a triumphal arch and an obelisk of red Finnish marble bearing the gilded emblem of the Russian Navy and the text of an order of Peter the Great. Today, you can see this firstling of the Russian fleet and fragments of other ships from the same time, carved decorations, navigational instruments, and other remnants of the "toy flotilla".

Standing on a steep precipice from which a view of the lake opens up, you can imagine to yourself hundreds o sails billowing in the wind and the brightly colored flags of the ships, the shells bursting and the blinding flashes of the salvoes to starboard and port, although the calm and quiet o the lake make it all seem like no more than a dream or legend.

The charm of this **LAKE** is that i seems created for the express purpose of transforming reality into legend. I is one of the loveliest spots in the city The measured beating of its wave upon the shore marks the boundary between history and legend to be sure.

In the 18th century, the city's coat of-arms first bore the image of a Lake Pleshcheyevo herring. The exclusiv right to catch this fish had been granted to the local fishermen by the Moscov princes at the beginning of the 16th century, and in return, they supplied the tsar's table with lavish portions of the tasty morsels. This is a true story fo which there is more than ample documentation.

The fact that in the tsar's court there existed the tradition that the fishermen of Pereslavl supply the herring for the feast following the coronation of the tsar was a mark of the firmness of the union with Moscow, as 16th century traveller Sigismund Herberstein informs us.

But the following tale is probably closer to legend: in 1382, during the invasion of Khan Tokhtamysh, the wife of Dmitry Donskoi, the very Evdokia who helped the Goritsky Monastery get back on its feet after it was sacked almost fell into the hands of the enemy but was miraculously saved. Several monks took her to the middle of the lake on a raft, and the thick fog hid them from their pursuers. But this is jus something the local folks claim, so you don't necessarily have to believe it.

Another legend connected with Lake Pleshcheyevo seems quite unbelievable, but the ponderous proof of i lies on the northeastern shore in th

Church of St. Simeon

Chernigov Chapel

form of a four-ton hunk of rock: the well-known Dove-Gray Boulder. In pre-historic times, this enormous boulder was washed down by glaciers. In the 8th and 9th centuries, it was worshipped by the Meria tribe and later, by the Slavs who migrated to the area. On certain days, they bedecked the boulder with flowers and held round dances about it. The pagan rites connected with the boulder were particularly deep-rooted, and the church struggled against them right up to the 18th century, but could never get rid of them altogether. So the priests had an enormous pit dug and rolled the boulder into it, but then the spring floods washed the soil around it away, and it rose to the surface once more, which strengthened the local people's belief in its magical powers. Finally, the clergy decided to use it as the foundation for a church, and thus employ it in the service of Russian Orthodoxy. But while it was being rolled across the frozen lake, the ice broke under it, and it sunk to the bottom. Gradually, everyone forgot about the boulder until some sixty years later it appeared in the shallow water and rolled closer and closer to the shore

with each passing year. Finally, it rolled onto dry land at the end of the 1840s, assisted, as it were, by the wind and the ice floes which froze around it in winter. And there stands the boulder to this day.

Pereslavl is rich in legends, but its history is even richer. Now we shall proceed to the northern edge of the city and the last major architectural ensemble–that of the **MONASTERY OF ST. NIKITA.** Along the way, be sure not to miss the **CHURCH OF ST. SIMEON THE STYLITE** or St. Simeon's Church (Simeonovskaya tserkov) as it is also known (Ulitsa Rostovskaya). Commissioned by the merchant Rastorguev and built in 1771 on the right hand side of the road leading from Pereslavl to Rostov, it is a curious combination of baroque and ancient Russian architectural forms. Here, standing next to an elegant five-domed church with rich baroque decor is a tent-roofed **bell-tower,** which made its appearance a century later, testifying to the staunch devotion of provincial cities to ancient and traditional forms and motifs. Right

before you reach the monastery, to the left you will see the city cemetery in the center of which, hidden by the trees, stands the smallest of Pereslavl's architectural monuments: the charming **CHERNIGOV CHAPEL** on the north side of Poklonnaya Hill from the direction of Rostov. It was built in 1702 on the exact spot where, by legend, Chernigov Prince Mikhail Vsevolodovich was cured of an ailment. According to a 16th century chronicle, *The Stepennaya Book,* in 1186, the prince came to the local Holy Man Nikita, and the saint healed him by handing him his staff.

We know for a fact that the prince of Chernigov was in Pereslavl that year. And there was also a certain Nikita — not a saint at all, but a tax collector who had earned ill-repute as a libertine, drunkard, and taker of bribes. To escape the wrath of the people and the punishment that was his due — for the prince had heard of his cupidity and disgraceful deeds — Nikita bound himself in chains, entered the monastery, and set about to pray for forgiveness. Later, Nikita was canonized, and in the 16th century chronicles, accounts of the "miracles" he had performed began to appear. Thus, legend has intertwined with historical fact to serve as the reason for the constrution of this lovely Moscow baroque chapel, the most unadulterated example of the style in these parts.

As we walk through the gates of the Monastery of St. Nikita, we are again taken back to the 16th century, to the days of Ivan the Terrible. This fortified monastery was built by order of the tsar himself to guard the strategic northern route from Moscow to the White Sea at the time when Ivan the Terrible was considering transferring the Russian capital to the northern city of Vologda.

Although stone construction had begun there under Ivan the Terrible's father, Vasily III, practically the entire monastery was rebuilt from the ground up. Mighty stone walls with six towers were raised, and a large cathedral, a refectory, and wings of cells were erected. It would seem only the extraordinary importance of this fortress can explain one puzzling fact: a large church completed only thirty years earlier was torn down and the new cathedral put up on that very spot.

The comparatively low **fortress walls** do not make a very striking impression, especially in comparison with the enormous cathedral beyond them. However, as you get closer, you will see that this is actually an excellent example of fortification works, quite capable of defending the monastery, from which a fine view for a distance of several kilometers can be had in all directions. During recent restoration work, the fortified towers were topped with tall wooden tent roofs, as in days of old.

The enormous four-piered, cruciform structure with two side-chapels and five apses, the **Cathedral of St. Nikita the Martyr** (Sobor Nikity Muchenika) puzzles scholars not just for the fact that its predecessor was razed to make way for it, but also in that the drum of its central dome — incidentally, the largest in diameter of all the 16th century Russian churches — rests on pointed arches, which simply do not appear in Russian architecture. It has been suggested that this feature, quite common in Caucasian architecture, might have been added by craftsmen who came to Rus in the retinue of Ivan the Terrible's second wife, Maria Temryukovna, a Circassian princess.

The ornamentation of the edifice, built within just three years, is rather austere. The façades are divided into three sections by plain pilaster strips which appear thicker than they actually are due to the deep niches of the slitted windows. Originally, the roof followed the shape of the *zakomari.* There are side-chapels on the southern and northern walls — the chapels of Nikita of Pereslavl and of All Saints' respectively. The first of

them dates back to the times of Vasily III, but has undergone alterations. The porch was most likely added to the cathedral in the 17th century. In the 18th century, the drums of the cathedral's domes were added, and during recent restorations, they were covered with wooden shingles, as were the apses. Due to the widely-spaced piers, the interior of the cathedral is spacious and well-lit.

Of the enormous **refectory** from the time of Ivan the Terrible, only the lower segment remains, while the upper half was rebuilt in the second half of the 17th century. The new tent-roofed **bell-tower** was built at the same time. The restoration of the complex of buildings at the Monastery of St. Nikita continues, and many fascinating and unexpected discoveries are made as the later layers are removed from the buildings, revealing their original features, in this mighty citadel erected by the first Russian tsar.

Historical and Architectural Monuments

Earthen Ramparts of the City, 1152 — Ulitsa Valovoye Koltso
Cathedral of the Transfiguration of the Savior, 1157 — Krasnaya Ploshchad
Church of St. Peter the Metropolitan, 1585 — 5 Ulitsa Sadovaya
Smolensk-Kornilyevo Church, 1696 — 27 Ulitsa Gagarina
Church of St. Vladimir, 1745 — 12 Ulitsa Sovetskaya
Church of St. Alexander Nevsky, 1746 — Ulitsa Sovetskaya
Church of St. Simeon, 1771 — Ulitsa Rostovskaya
Church of the Purification, 1778 — 18 Ulitsa Moskovskaya

Monastery of St. Daniil — 7-9 Ulitsa Lugovaya

Trinity Cathedral, 1530-32
Chapel of St. Daniil, 16th and 17th centuries
All Saints' Infirmary Church, 1687
Tent-Roofed Bell-Tower, 1689
Refectory and Church of the Exhaltation of the Virgin, 1695
Father Superior's Wing, 1696
Dormitory, 1696
Holy Gates, 1700

Goritsky Monastery — Muzeiny Pereulok

Holy Gates with the St. Nicholas' Gateway Church, 17th century
Gate-Keeper's House, 17th century
Eastern Entrance, 17th century
Belfry, 17th century
Bathhouse, 17th century
Dormition Cathedral, 1757
Refectory with All Saints' Church, 17, 18, and 19th centuries
Walls and Towers, 17th-18th centuries
Grave of Artist Dmitry Kardovsky (1866-1943)

Monastery of St. Nikita — Nikitsky Suburb, the northwest edge of the city

Cathedral of St. Nikita the Martyr, 1561-64
Refectory Chamber with the Church of the Annunciation, 1564-17th century
Walls and Towers, 16th century
Wing of Cells by the Eastern Wall, 17th and 18th centuries
Pillar Chapel, 1775
Gateway Bell-Tower, 1818
Chernigov Chapel near the Monastery of St. Nikita, 1702

Information for Tourists

Museums
History and Art Museum on the territory of the Goritsky Monastery, Muzeiny Pereulok, open 10 a.m. to 5 p.m.
Botik Museum — three kilometers west of the city, open 10 a.m. to 5 p.m.
Exposition of the History of the Cathedral of the Transfiguration of the Savior, in the cathedral, Krasnaya Ploshchad.

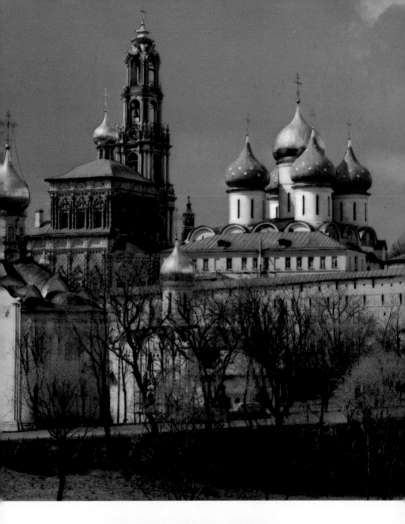

Zagorsk. A view
of the Trinity-
St. Sergius
Laura

Domed roofs of
the Dormition
Cathedral

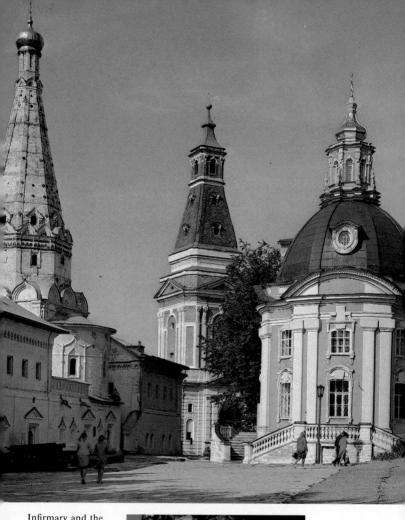

Infirmary and the
Church of SS. Zosima
and Savvaty
Kalichya (Pilgrim)
Tower and the Church
of Virgin of Smolensk

One of the
columns of the
Refectory Gallery

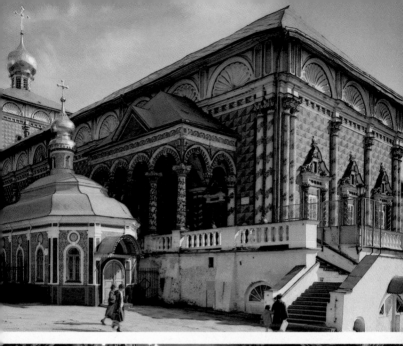

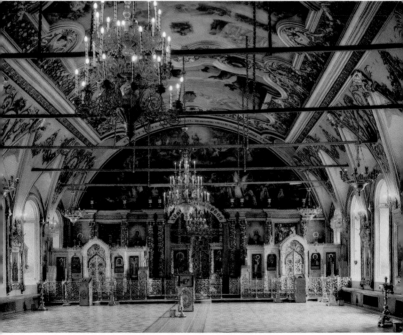

Refectory and St. Micah's Church

Interior of the Refectory

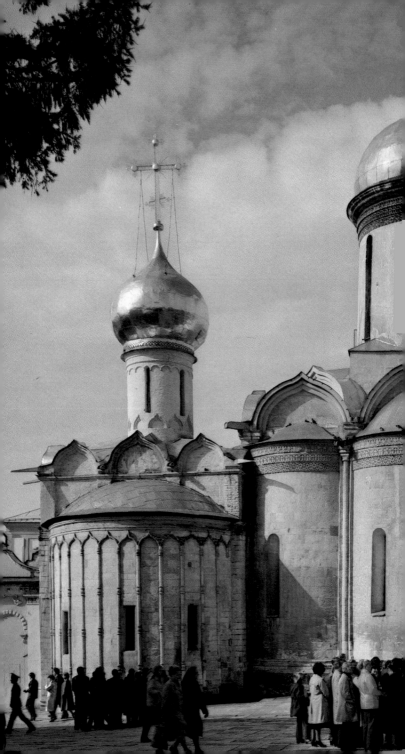

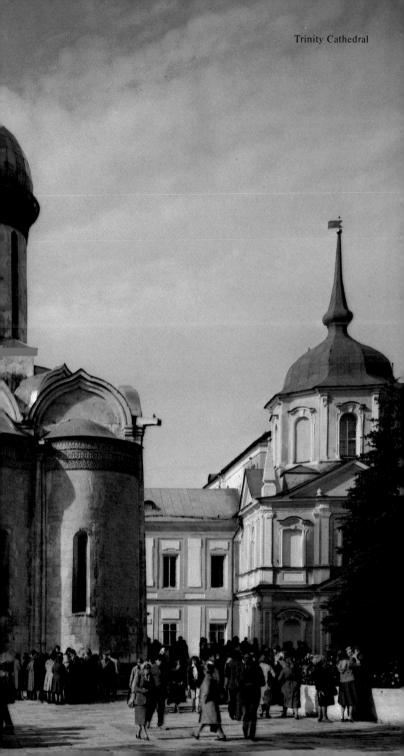

Trinity Cathedral

Gilded Panagia

Folding walnut icon-case
(carved by Ambrosius)

Icon of St. Nikon
by Simon Ushakov

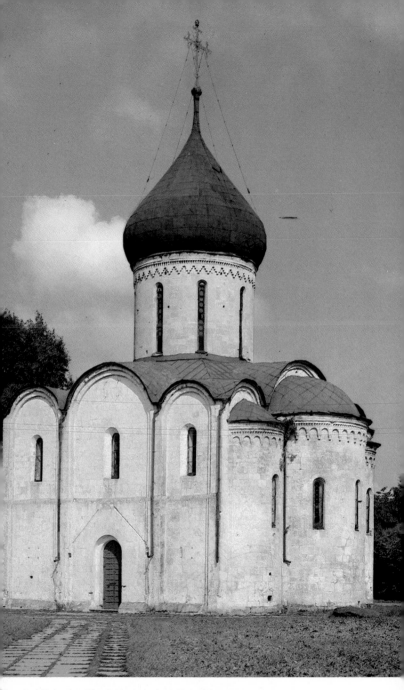

Pereslavl-Zalessky. The Cathedral of the Transfiguration

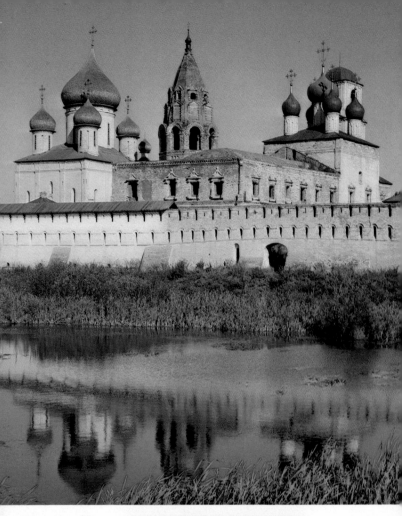

Monastery of St. Nikita

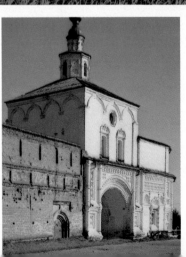

Holy Gate and the Gateway Church of the Goritsky Monastery

Rostov

Rostov is a district center in Yaroslavl Region, situated 190 km from Moscow on the Yaroslavl Highway on the shore of Lake Nero. It is a railroad junction with developed linen, garment, food, folk craft, and painted enamel-ware industries. There is a history, art and architecture museum.

 In days of old, not many cities earned the title of the Great (Veliki) and Rostov was one of the few. It played a major role in the formation and history of the country as well as in the development of Russian art. Rostov the Great is one of the most ancient Russian cities, first mentioned in the 12th century chronicle, *The Tale of Bygone Years,* among the entries for the year 862, now taken as the official year of its founding. But of course, the city is much older, since the chronicle refers to Rostov as a city of some note. Contemporary archeologists have unearthed the remains of an 8th-century settlement of the Meria, an Ugro-Finnish tribe, within the confines of Rostov. The presence of the Meria "near the Rostov lake" is also mentioned by the chronicler. Many of the rivers, villages, and Lake Nero itself bear Meria (Ugro-Finnish) names.

During the days of Kievan Rus, naturally, Rostov was a vassal of the southern capital. In the late 10th and early 11th centuries, the sons of Vladimir who christianized Rus, ruled in Rostov: first Yaroslav the Wise and then Boris. The new religion met with strong resistance in these parts. The first bishops sent to Rostov, Fyodor and Hilarion, were expelled from the city, and their successor, Bishop Leontius, was killed in 1071 during an uprising of the pagan priests.

Rostov came to prominence in the mid-12th century during the reign of Yuri Dolgoruky, a figure familiar to the reader by now. It was under him that Rostov received the title of "the Great", and its territories were expanded considerably. However, fearing the powerful Rostov boyars — members of an aristocratic landholding elite in pre-Petrine Russia — who were accustomed to managing their own affairs rather than submitting to the authority of a prince, Dolgoruky took up residence not in Rostov, but in a small fortress near Suzdal. Therefore, the area under his control was known as the Rostov-Suzdal principality.

While Yuri Dolgoruky, who did a great deal to strengthen Northeastern Rus, thought primarily of gaining control of Kiev, where he in fact became prince not long before his death, his

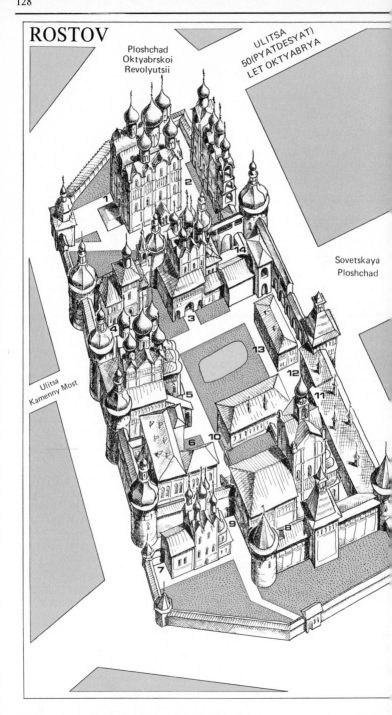

ROSTOV

Ploshchad
Oktyabrskoi
Revolyutsii

ULITSA
50(PYATDESYAT)
LET OKTYABRYA

Sovetskaya
Ploshchad

Ulitsa
Kamenny Most

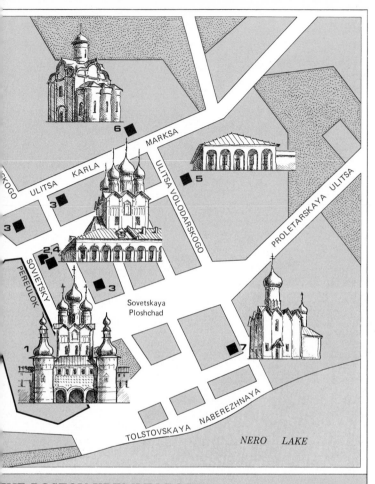

THE ROSTOV KREMLIN ROSTOV

1. Dormition Cathedral
2. Belfry
3. Gatechurch of the Resurrection
4. Church of the Virgin Hodegetria
5. Gatechurch of St. John the Divine
6. Krasnaya (Red) Chamber
7. Church of St. Gregory the Theologian
8. Prince's Chambers, living quarters
9. Belaya and Otdatochnaya Chambers
10. Samuil's or Metropolitan's House
11. Chambers of Church Dignitaries
12. Chambers of Iona and Church Dignitaries
13. House-on-the-"Pogreba"
14. Chasobitnaya Tower

1. The Rostov Kremlin
2. Arcade, 19th century
3. Trading Rows, 19th century
4. Church of the Savior at the Market Place, 17th century
5. Customs House
6. Church of St. Isidore the Blessed, 16th century
7. Church of the Nativity of the Virgin, 17th century

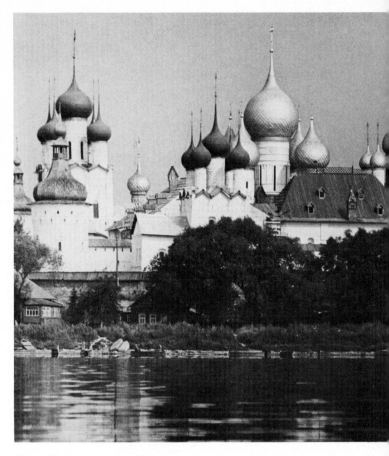

View of the Rostov Kremlin from Lake Nero

eldest son and successor Andrei Bogoliubsky consolidated his control over these lands to protect the Russian capital from the raids of the nomadic steppe tribes by transferring it to the quiet Zalessky region. True, once again for fear of the strong opposition of the boyars, he chose for the new capital not Rostov or Suzdal, but the younger city of Vladimir, founded by his grandfather Vladimir Monomakh.

At the beginning of the 13th century, when the Rostov principality had attained independence, Rostov was a heavily-populated, crowded city with a large assembly square next to the Dormition Cathedral, a princely court, aristocratic palaces and mansions, a large body-guard for the

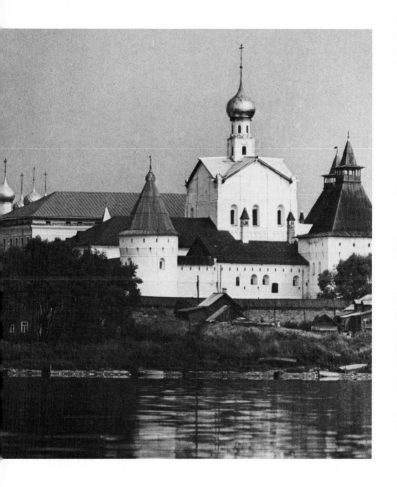

rince, and a significant number of traders and artisans. Here, in the Monastery of St. Gregory, there was a seminary with a fine library; the monastery's artisans and icon-painters were highly skilled as well. Unfortunately, after the death of Vsevolod Big Nest in 1212, his sons could not divide the power among themselves, and in 1219, the short-lived Rostov principality broke up into several smaller appendages — a process which was becoming common in Rus–the Rostov, Yaroslavl, and Uglich principalities which, along with most of the country, were razed in 1238 by the Tartar hordes.

During the difficult times of the Mongol Yoke, Rostov again became the principal city of Northeastern Rus

and repeatedly initiated uprisings against the invaders. With the rise of Moscow and the intensification of its role as the "unifier of the Russian lands", Rostov came under the control of Muscovy. Rostov was finally incorporated into the Moscow state in 1474 when Rostov Prince Ivan Dolgy sold the remainder of his hereditary domain to Moscow Great Prince Ivan III. After that, Rostov faded from the political scene and was mentioned more and more rarely in the chronicles.

Since Rostov was the see of a bishop, it retained its prominence within the church. In the first half of the 16th century, the Bishop of Rostov was elevated to the rank of Archbishop, and at the end of that century, to Metropolitan, which made the hierarch of Rostov subordinate only to the Patriarch of the Russian Orthodox Church. The Rostov see was quite wealthy, for at that time, the church owned hundreds of villages, enormous holdings of farmland and forest, and many enterprises. Collections during church services, donations, and lavish contributions also helped fill the church's coffers. Therefore, the Rostov clergy could finance an extensive stone building program. In the last third of the 17th century, a superb architectural ensemble of the metropolitan's court was erected in the Kremlin; this remarkable group of buildings sets Rostov apart from other Russian cities and has brought it fame in our day. The creation of the complex — one of the most beautiful ensembles in all of Russian architecture — is closely tied to the name of Iona, the ambitious Metropolitan of Rostov.

Iona became Metropolitan of Rostov in 1651. This was during the power struggle that occurred between Tsar Alexei Mikhailovich and Patriarch Nikon. In 1658, when Nikon realized that the tsar had grown cold toward him, he abandoned the patriarchal see of his own volition and retired to the New Jerusalem Monastery which he had founded not far from Moscow, expecting the tsar to beg him to return. But instead, the tsar appointed Iona, Metropolitan of Rostov, as Locum Tenens of the Patriarchate. It is entirely possible that Iona might have become the Russian patriarch if only things had worked out a bit differently... But it so happened that while he was officiating at the divine liturgy at Moscow's Dormition Cathedral, Nikon walked in unexpectedly, having returned to the capital without the permission of the sovereign. Obviously, Iona was flustered by this, for from force of habit, he walked up to the patriarch (who had fallen into disfavor) to receive his blessing, and was promptly packed off to Rostov. So Iona chanelled his enormous reserves of energy and ambition into a titanic building project which he continued for thirty years until the day he died, for this was the only means of self-expression that remained to the man who had almost become head of the church.

A century later, the confiscation of all church lands by the state considerably curtailed the financial possibilities of the metropolitan see, and its transfer to Yaroslavl, the center of the province, led to the decline of the Rostov Kremlin, which fell into a state of disuse, much like the Goritsky Monastery in Pereslavl-Zalessky. Its buildings were taken over by various administrative departments or turned into warehouses, and at the beginning of the 19th century, the city fathers got the idea of tearing down the decrepit buildings, and even set about to do just that, but fortunately, the demolition work was soon discontinued, and the deserted Kremlin continued to decline. Only in the 1870s was any restoration work done there, and finally, toward the end of the last century, a museum was opened on the premises.

In 1953, a dreadful storm greatly damaged the Rostov Kremlin, tearing the roofs off buildings and destroying the cupolas. After long and tedious restorations supervised by architect Vladimir Banige, the entire complex

was returned to its original appearance of the 16th and 17th centuries. Now the **ROSTOV-YAROSLAVL MUSEUM-PRESERVE OF ART AND ARCHITECTURE** has been opened here, and the **Rostov the Great International Youth Tourism Center** is also housed within the Kremlin's ancient walls.

On the approaches to the city from the direction of Pereslavl-Zalessky, to the right of the highway opens up a marvelous view of Lake Nero. And on its glassy surface is reflected the white, gold-domed **KREMLIN** like a vivid illustration from some Russian epic of old. This breath-taking view will amaze even those who are inured to the sight of architectural gems.

The Kremlin is just as lovely from close up with its mighty white walls that are almost a kilometer in length, with its round towers and countless domes, its tent roofs and tall vents with whimsical copper weather-vanes. The Kremlin is rectangular in plan, and it stretches from north to south. There are three main parts: the northern part which includes the Dormition Cathedral, the square surrounding it, and the belfry beyond the low wall; the largest, central part, consisting of the walled-off metropolitan's — or Kremlin— courtyard with its multitude of churches, residential and auxiliary buildings; and, finally, the southern part, which contains the metropolitan's orchard. Twenty million large eight-kilogram bricks were used to build the Rostov Kremlin.

The central building of the ensemble is the enormous **Dormition Cathedral**, built in the 16th century. The structure is rectangular in plan, with sides 20 and 30 meters long. The height of the church, including the cross, is 60 meters. The façades are divided vertically by flat pilaster strips: four on the south and north sides, and three on the western wall. Each segment of the wall ends in a keel-shaped *zakomari,* and therefore the roof seems wavy. A broad band of blind arcading divides the building

horizontally. The narrow, elongated windows are concealed by recessed bays. Five mighty domes tower above the church. They rest on high, light drums, also decorated with bands of blind arcading.

It has been documented that the present Dormition Cathedral is similar in appearance to the ancient cathedrals of Rostov which were built one after another on this same spot, all the way back to the first wooden cathedral erected at the end of the 10th century, shortly after Christianity was introduced in the region. The copper lion-mask handles attached to the inside of the massive main doors on the west side have come down to us from the twelfth century. The tomb of canonized Bishop Leontius, martyred by the pagans in 1071, has also come down to us from about the same time. It was discovered in 1884.

The interior of the cathedral is very spacious, with six hexagonal piers supporting the vaults. The carved, six-tiered iconostasis dates back to the first half of the 18th century. The frescoes were executed in the 1660s and 1670s by masters from the Kostroma artel headed by Guri Nikitin and Sila Savin, familiar to the reader from their work at the Monastery of St. Daniil at Pereslavl-Zalessky. Unfortunately, these frescoes were badly damaged during a fire and are presently under restoration. Of the cathedral's former riches we can guess from the following information from the diary of Polish Commander Jan Sapega who seized and pillaged Rostov in 1608: among the valuables he took from the cathedral was a life-sized image of St. Leontius cast of eighty kilograms of pure gold.

The four-bayed **belfry** of the cathedral was built between 1682 and 1687 during the time of Metropolitan Iona. In form, it resembles the bell-tower of Ivan the Great in the Moscow Kremlin which could be seen from the windows of the patriarch's chambers which Iona occupied for two years. The building of the belfry

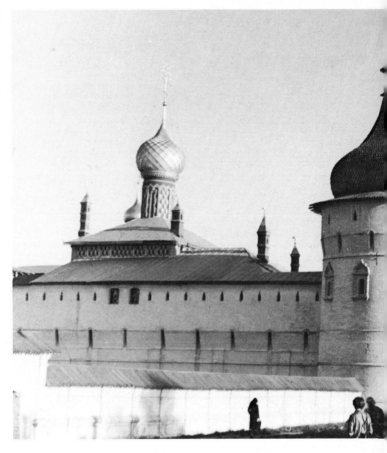

Walls and towers of the Rostov Kremlin

is an excellent resonator, for it has cavities from top to bottom, all the way down to the very foundations. The thirteen bells hanging here are a superb example of 17th century Russian casting. The largest of them was cast in 1688 by Rostov master Flor Terentyev and named *Sysoy* in honor of Iona's father. It weighs over thirty tons and has a velvety tone with marvelous overtones. Its peals can be heard twenty kilometers from the city

The art of bell ringing was known in Russia as far back as the 10th century For hundreds of years, it was part o Russian life: the joyous pealing of bells notified the people of victorious battles greeted the troops returning from the battlefield, mourned the fallen, marked holidays, and pointed out the road t

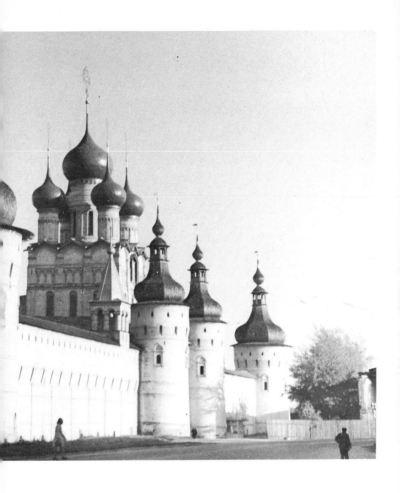

travellers who had lost their way.

During fires or other disasters, the pealing of a special bell sounded the alarm. Knowing the power of such bells to arouse the people to action, conquerors generally carried them away from defeated cities or otherwise "sent them into exile". Thus, Ivan III took the alarm bell from recalcitrant Novgorod, and Boris Godunov sent the alarm bell from Uglich to Siberia for ringing the news of the murder of Tsarevich Dmitry. Desiring to arouse the Russian masses to struggle against the autocracy, 19th century Russian writer and revolutionary Alexander Herzen called his emigré journal *The Bell*.

The ringing of bells was not just a part of the history and life of the Russian people; it was a great art passed down

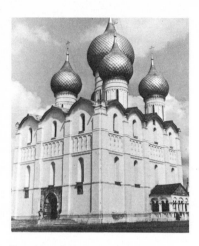

Dormition Cathedral

from generation to generation. Many famous Russian composers, such as Glinka, Moussorgsky, Rimsky-Korsakov, and Rakhmaninov, used bells in their compositions. And the great Hector Berlioz came all the way to Rostov just to listen to its magnificent bells. At one time, Novgorod was famed for its bells, then that honor passed to Moscow, but from the 17th century on, Rostov the Great has unquestionably held first place in the skill of its bell-ringers and in the gamma of clear and varied musical pictures painted by its wondrous bells.

The following type of chiming was probably the most ancient and widespread in all of Rus: the bells would be rung in turn from largest to smallest, and this would be repeated several times. Then, after the last, barely audible peal of the smallest bell, they would all be rung simultaneously in a single mighty chord. After this, the chiming would be repeated. The most austere and solemn of the Rostov chimes is the *Iona* Chime, which is quite laconic. The *Akim* Chime appeared in Rostov in 1731, and its sound creates the impression of a solemn procession. A type of chiming popular during the reign of Pet-

er the Great is the *Egory* Chime, noted for its smooth, measured rhythm. If the three largest bells are rung simultaneously, a magical harmony fills the air and against this background, the chiming of the smaller bells can be heard particularly distinctly. At the end of the 19th century, the *Ionofan* Chime originated in Rostov: the smaller bells peal merrily while the bells of middle range carry the melody. With the exception of the ordinary, *everyday* chimes, no fewer than five bell-ringers were needed to perform the complex pieces that made the bells of Rostov famous. Only in Russia did the clappers move, striking the edge of the stationary bell to produce the sound, rather than vice versa, allowing bells of enormous sizes to be cast. Such large bells were capable of producing amazingly powerful, beautiful sounds.

In 1963, a unique recording of chimes performed by the old bell-ringers was made in Rostov. The record of Rostov the Great's remarkable bells is very popular and is a fine memento of the city.

A peculiarity of the composition of the metropolitan's courtyard, sep-

arated from the cathedral square by a low wall, is that all its principal churches and chambers are incorporated into the fortress wall or adjoin it, and look out onto the central courtyard with its pond. The tall **walls** of the Rostov Kremlin, which reach 12 meters in height and are two meters thick, and have loop-holes, battlements, and mighty towers appear to be actual fortifications. But this is not a fortress at all: it is rather the lavish enclosure of a rich castle or estate, since elements essential to all fortification works are missing. For example, the towers have no loopholes low enough for firing on the battlefield. Almost all the walls have windows, and the loop-holes that do exist are more decorative than functional. Iona probably allowed himself such departures from the rules of traditional 17th century monastery construction for his personal residence, sacrificing functional and defensive features in favor of purely decorative elements, because he pinned his hopes on the city's earthen ramparts. It was possible to reach any part of the Kremlin via the closed passages and towers, without having to go outside at all. A segment of these passageways is open to tourists at present.

The Rostov Kremlin has five churches, all two storeys high. Moreover, the church itself occupies the second storey, while the first floor, a high basement, was used for some husbandry purpose. For example, the basements of the churches of the Resurrection of Christ and of St. John the Divine served as the entranceways to the Kremlin. As a rule, the churches have no piers and are square in plan. The interiors are divided into two segments by a stone wall, fulfilling the function of an iconostasis. In three of them (the Transfiguration of the Savior-above-the-Cellars, St. John the Divine, and the Resurrection of Christ) the iconostases have paintings on Biblical themes connected with the names of the churches.

The design and decor of the churches of the Resurrection (1670) and of St. John the Divine (1683) are quite similar. They rest on high basements with arched gateways; the elegant cubic bases of the churches are enclosed on three sides by covered galleries; the rather elongated drums are crowned by five domes topped by crosses. Both of these picturesque buildings are flanked by round towers and have small belfries in the wall next to them. Each church has two richly decorated façades: the windows boast elaborate platbands, and the geometrical recesses in the patterned brickwork have colored tile insets. Varied bands of blind arcading frame the entrances and exits. All the different effects created by the decoration are accomplished by the skilful use of brickwork alone.

The **Church of the Resurrection of Christ** was built above the Holy Gate connecting the metropolitan's courtyard to the cathedral square, while the Church of St. John the Divine was raised above what was formerly the main entrance to the Kremlin.

The walls, columns, and vaults of the Church of the Resurrection were painted, most probably, in 1675, by Yaroslavl master Sevostyan Grigoryev and his son Lavrenty. The subjects of the paintings follow the expected order. Thus, the Deesis, Twelve Feasts, Prophets', and Old Testament Patriarchs' rows are to be found on the stone altar partition. The other frescoes, which deal with the Earthly Life, Passion, Death, and Resurrection of Christ, cover the walls and vaults of the church. The palette of the frescoes is quite beautiful, and the light pastels of the figure of the Risen Christ with arms raised and garments flowing are especially lovely.

Austere, light blue tones dominate in the frescoes of the **Church of St. John the Divine,** dedicated to one of the apostles closest to Christ, and the best beloved. The paintings in the lower tier depict an episode from the life of a local saint, Avraamy of Ros-

Belfry

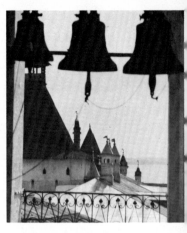

The famous bells of Rostov

tov (a historical personage) in which, according to legend, he met St. John the Divine not far from Rostov. These frescoes, dated to the year 1683 by surviving inscriptions, are attributed to Dmitry Grigoryev.

The **Church of the Transfiguration of the Savior-above-the Cellars** (Spasna-Senyakh, 1675) is generally considered the gem of the Rostov Kremlin. This was the private church of the Metropolitan, and was so-named because it was part of a whole complex of buildings connected by large open galleries.

Though this church seems austere and laconic from the outside, its interior is quite lavishly decorated. Everything here was made with the idea of exhaulting the clergy in attendance: the solium (the elevated floor in front of the iconostasis where only clergy may go — Tr.) is as large as the main nave where the worshippers stand and must be reached by eight steps, while the chancel is raised even higher. The solium has a stone arcade with five spans, each of which bears a pendant in the aperture. The arcade

rests on thick gilded columns, and the Holy Doors, which are made of brass, resemble portals in perspective. The atmosphere of pomp and circumstance is intensified by the frescoes, which are devoted to Evangelical accounts of Christ's Earthly Life and appearances after His Resurrection. The fresco of the Last Judgement occupies the entire west wall. The frescoes were most probably painted immediately after the completion of the church.

The **Church of the Virgin Hodegetria** differs significantly from the sanctuaries just described, for it was erected twenty years later under Iona's successor, Metropolitan Iosaf. Serving as a refectory church, resting on a basement, and being cubic in form, this building is considerably less proportionate and elegant than the earlier structures. The platbands around the windows and other decorative elements are characteristic of the mid-17th century, while the paired columns and painted façades which came into fashion at the end of the century attest to the influence of the

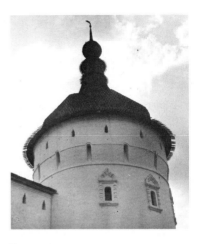

Fortress tower

style in which the refectory church at Zagorsk's Trinity-St. Sergius Laura was executed. The interior decor of the church is done in stucco moulding in the spirit of Moscow baroque.

The chambers of the Rostov Kremlin are also exceedingly interesting from an architectural point of view. The **Belaya** (White) **Chamber,** which served as a dining hall, is located in the same complex as the Church of the Transfiguration of the Savior-above-the-Cellars. The open passageways mentioned in the name of the church (which lead to a broad staircase) connect various buildings intended for different purposes. A wide portal with a door leads to this chamber; beyond the door is a narrow intermediate structure, the so-called **Otdatochnaya (Reception) Hall,** where the host greeted and bid farewell to his guests. The chamber has a small pantry. In the larger White Chamber — one of the biggest such structures in all of Rus — the single mighty pylon supporting the broad vaults immediately catches the eye. The walls of the chamber, which was intended for the sumptuous repasts of the metropolitan's important guests, were originally covered with frescoes (a distinguishing feature of the buildings erected during the time of Iona) but they were later covered with the stucco moulding which has not come down to our times. Presently, a museum exposition is housed in the White Chamber.

One of the most ancient buildings in the Kremlin is the **Prince's Chambers** (Knyazhyi terema) located across from the White Chamber. This is a small, vaulted, rather dark building with narrow doors and even narrower mica windows. The hiding-places and prison cells give a graphic impression of the life of the 16th century princes. The stoves, faced with glazed tiles during the time of Peter the Great, are also of interest.

The Chamber of Metropolitan Iona connects the Prince's Chambers with another ancient structure: the **Archbishop's Chamber** located between the Water (Vodyanaya) and Orchard (Sadovaya) towers of the Kremlin. This building got its name

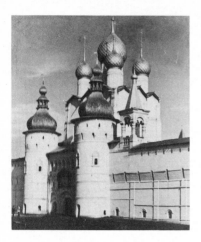

Church of the Resurrection

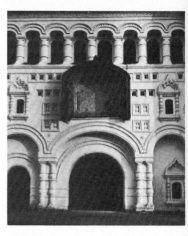

Gallery

from the fact that the heads of the Rostov See lived there — first the archbishops, then the metropolitans, until a special residence was built for the latter. Then these chambers were used for husbandry purposes. The windows cut into the façades close to each other are decorated with platbands, under which runs a row of geometrical indentions, recesses, and loop-holes in the brickwork. The principal decorative element of the building is the gilded vents on the roof which run from the large stoves inside.

The large, three-storey museum building standing in the center of the Kremlin courtyard is **Samuil's** or the **Metropolitan's House,** formerly known as the Cross-Vaulted Chamber. The lower floor was built in the 16th century, and the second storey was added during Iona's time. The metropolitan's rooms were located on the second storey, while the Cross-Vaulted Chamber, the Court Chamber, and other administrative departments were housed in various parts of the building. The structure came to

be known as Samuil's House in the 18th century at the time of Metropolitan Samuil, who added the third storey. In the 19th century, after one of the periodic re-modellings, the building was turned into a seminary. Presently, a museum exposition is housed here.

In the southwestern section of the courtyard stands a separate building — the **Red (Krasnaya) Chamber** (1680) — a spacious two-storey structure where the tsar and his large retinue were housed during their visits. The Red Chamber proper, as the whole building was once referred to, is quite large, with an area of almost 250 square meters, and although it has large windows, the interior is rather dark. The vaults, which rested on a single mighty pylon, were covered with frescoes which have not been preserved, since this building suffered more than the others of the Kremlin over the centuries and was restored practically from ruins. At present, the dining hall of the International Youth Tourism Center is housed here. As in days of old, long bare wooden tables

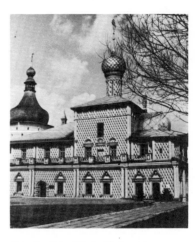

Church of the Virgin Hodegetria

fill the hall. The many other spacious quarters for the royal family have been turned into accommodations for the youth hotel. The elegant, striking Red Chamber is further adorned by a porch and a gallery resembling a fairy-tale house.

Before we speak of the museum, we must return to the history of the creation of this unique Kremlin ensemble, since our tour is practically over, although the more curious tourists may of course make use of a map of the Kremlin to visit the other structures not described in this book.

For centuries, no one knew who had designed this architectural gem, for it was obvious that the Kremlin had been built according to a single co-ordinated plan designed by a true master, whose name was not recorded in the construction documents or chronicles. It was suggested that this omission might have been intentional: perhaps the ambitious Iona wanted his greatest creation connected with his name alone in the years to come.

And thus, the name of the Krem-lin's designer was discovered not long ago in a recently unearthed list of dignitaries who contributed to the construction of the Church of St. John the Divine. Immediately after the family of the metropolitan himself appears the family of stonemason (i.e., architect) Pyotr Ivanovich Dosayev. The most logical explanation for this unusual fact is that the name which stands next to that of the metropolitan must have belonged to a man who had rendered Iona and the Metropolitan See of Rostov some special service, such as the building of the Kremlin.

The **ROSTOV MUSEUM** opened its doors more than a century ago, in 1883, originally as a museum for the Metropolitan See's valuables. One of the most ancient treasures of the collection is a 12th century Byzantine panagia with the Virgin Orans on stone which belonged to Rostov Prince Mikhail Tyomkin. Another interesting example of stone carving is the cruciform limestone grave marker dating back to 1458, with its multi-figured composition. It was

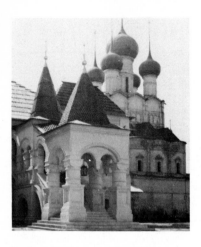

Porch of the Krasnaya (Beautiful) Chamber

Copper weather-vanes, aspen shingles

placed by clerk Stefan Borodaty on the grave of his son Ilya.

The museum boasts a rare 15th century carved wooden sculpture: *St. George Slaying the Dragon,* the spontaneity of which is close to that of the carved wooden toys common folk made for their children. The splendid 16th century carved wooden Holy Doors from the Rostov Church of St. Isidore the Blessed, were executed in 1572 by order of Ivan the Terrible. The relief carving covers the leaves of the doors entirely and extends to the small icon-cases which have scenes from the Gospels, and round medalions with figures of the apostles.

The Holy Doors from the wooden Church of St. John the Divine of the River Ishna (not far from Rostov) made in 1562 are no less valuable artistically. This gem is covered with delicate floral ornament with gilded relief-work on a red background. The paintings on the doors are quite skilfully executed.

Rostov was a recognized center of icon-painting, and around it grew up the Rostov-Suzdal school of icon-painting, upon which the Moscow school of the 14th and 15th centuries was based. The best pre-Mongolian icons done in the period when the Rostov principality flourished are noted for their solemnity and spirituality, and for the refined images of the saints depicted. Though the icons are quite large, detail and careful ornamentation, with particular attention to decorative elements have not been ignored, while the palette is subdued. These early Rostov icons are in the Tretyakov Art Gallery in Moscow and the museums of the Moscow Kremlin as well as in the Russian Museum in Leningrad.

The finest icons of the Rostov Museum are the *Archangel Michael,* 14th-15th centuries; the *Virgin of Vladimir,* late 15th-early 16th centuries; the *Rostov Saints and St. Sergius of Radonezh,* of about the same time; and *Virgin in a Blue Robe* and *St. Gregory the Theologian,* both 16th century works. The multi-figured composition, *The First Ecumenical Council,* is interesting for its representations of ancient urban architecture.

The Rostov Museum has many fine examples of Russian tapestries: the pall of Avraamy of Rostov, made in the 16th century, most probably by the embroidresses of Anastasia Romanova, wife of Ivan the Terrible; the pall of St. Leontius of Rostov, the gift of Moscow Great Prince Vasily III (1514); a marvelously-wrought 16th century Shroud of Christ presented to the Monastery of St. Avraamy of Rostov by Boris Godunov; and a Shroud of Christ presented to the Dormition Cathedral by Metropolitan Varlaam and the Stroganov family of industrialists and patrons of the arts.

The decorative and applied arts are well represented: the museum has fine collections of chasing, niello, and silver filigree, including altar crosses, icon-settings, Gospel covers, and chalices. There is also a fairly good collection of Russian samovars and carved and painted articles made of wood by folk craftsmen; the household articles in this section include distaffs, ladles, sledges, and small chests, all of which are skilfully executed and decorated artistically.

But the best-known craft in Rostov is its famous painted enamel-ware, known in Russian as *finift*, from the Greek word "fingitis", or "colorful, shiny stone". Fine enemel-ware has been produced in Russia since the 12th century, and now as then, the process by which it is made is rather complex. First, the glassy-looking enamel is prepared from various chemicals, such as lead oxide, borax, soda, and alkali. Then this mass is spread on convex metal plates and fired thrice at a temperature of about 1000°C. The resulting shiny, milky-white pieces of enamel are then painted with fusible colors and fired several more times. The result is a bright-colored miniature that seems to glow from within — truly a joy to behold — which cannot be damaged by water and does not fade with the centuries.

No one knows precisely when the production of enamel-ware began in Rostov, but by 1788, it was a thriving craft. The local masters made icons, decorations for sacred utensils, for Gospel covers, and for icon-settings.

At present, the local *factory* preserves the fine traditions of local craftsmen of years gone by. The ancient method of making enamel-ware and the old designs are still employed. Beautiful jewellery and handsome souvenirs with motifs from ancient Russian legends, landscapes from the area, and various designs can be had. Among the more interesting examples of enamel-ware in the museum are the insets for a cross from 1791 made by artist Pyotr Ivanov, and the medallions from a late 18th century Gospel cover.

The museum also has a fair collection of canvases by major Russian artists from various periods, including Vladimir Borovikovsky, Ivan Aivazovsky, Ivan Shishkin, Alexei Savrasov, Vasily Polenov, Mikhail Nesterov, Konstantin Yuon, and Igor Grabar.

Near the Kremlin are several other monuments of ancient Russian architecture worth mentioning. Right across from the gate leading to the cathedral square in a courtyard stands the **CHURCH OF THE SAVIOR-ON-THE-MARKET-PLACE** (Spas-na-Torgu) built from 1685 to the 1690s. This tall quincunx church rests on a basement resembling the structures near the Kremlin in almost every detail: the façades topped by small triple pediments, the gallery with a band of blind arcading, the pendants on the platbands, and the iconostasis covered with frescoes. The church got its name from the rows of shops and stalls that stood there from time immemorial. The present arcade was built in the 1830s.

One of the most ancient and most valuable architectural monuments of Rostov is the **CHURCH OF ST. ISIDORE THE BLESSED** (originally the Church of the Ascension) which dates back to the 16th century. It was located in the settlement beyond the fortress walls (presently Ulitsa Karla Marksa). On the west wall is a stone slab which tells us that the church was erected in 1566 by order of Ivan the

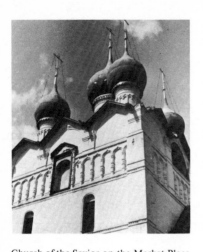

Church of the Savior-on-the-Market-Place

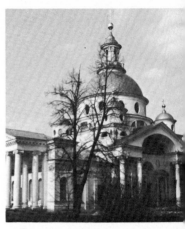

Church of St. Dmitry of the Monastery of Our Savior and St. Jacob

Terrible. Well-known Moscow architect Andrei Maloi is cited as the author of the project. This is one of the rare instances when the architect of the building is noted.

The church is almost square in plan with no piers and a single dome. The cross vault of the type found here made its way into Moscow architecture in the first half of the 16th century. The façades are divided into three segments by pilaster strips. The central segment is higher and wider than the lateral ones and is topped by an ogee arch, while the arches to the sides are semi-circular. The form of the façades heightens the impression that the elegant silhouette of the building is striving heavenward.

In 1770, a side-chapel dedicated to St. Isidore the Blessed was added to the western façade. At the same time, in the 1760-1770s, the frescoes on the interior of the church were painted, most likely by the Ikonnikov brothers from Yaroslavl. The style of painting is similar to that of the Savior-on-the-Market-Place and is singularly interesting since, while abiding by traditional canon in terms of subject – Scenes from the Life of Christ – the murals are very dynamic and filled with motion, a feature characteristic of baroque. In the lower tier of frescoes devoted to the life of St. Isidore, there are unique depictions of ancient Rostov architecture. The marvelous Holy Doors from this church are preserved in the local museum.

There is one more monument in the old part of the city which is worth a visit, the **CHURCH OF THE NATIVITY OF THE VIRGIN** (tserkov Rozhdestva Bogoroditsy, Sovetskaya Ploshchad) built in 1678. It is located on the territory of the former Nativity Monastery. More than likely, the architect was one of those who took part in the construction of the Kremlin. The single-domed church rests on a basement, and the façades are topped by three *kokoshniki,* making the building quite typical for late 17th century Rostov architecture.

As you approach the Kremlin from the direction of Moscow, the view of the main gate and the Church of Gregory the Theologian is blocked

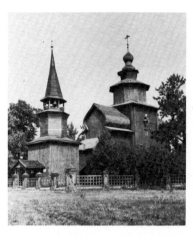

Wooden Church of St. John the Divine
on the Ishna River

rom the right by a large two-storey
uilding not mentioned in any travel
uide to date. Until recently, there
ere plans to tear this building down
o give approaching visitors a better
iew of the Kremlin. However, when
ne plaster was knocked off and the
ricks examined, it turned out this
as no eyesore, but a large building
rected three or four centuries ago.
hen, traces of the original windows
nd doorways were found: there were
normous arched doorways, bays,
nd traces of platbands. And thus one
f the rarest architectural finds of re-
ent years was made: part of the
etropolitan's **STABLES** had been
iscovered. It was built at the same
me as the Kremlin and was an essen-
al part of its operations. This is the
nly example of such a structure to
ave survived of the ones known to
ave existed in the 16th and 17th cen-
uries.

Once, there was a large stable here —
whole complex of administrative and
usbandry buildings, including all the
ervices connected with roads and
ansportation that were an inevitable
art of any large household or estate in

those days.

The largest stables in Russia were those of the tsar, which provided him and his large retinue with transportation for their visits to suburban estates or monasteries, or for hunting trips. The tsar had separate stables for saddle, sledge, and carriage horses, a shed for carriages with a large tack room, quarters for the grooms, coachmen, and watchmen, haylofts, and larders with all the necessary supplies at hand for extended journies. The post of Master of the Horses was quite a high and influential one in the court: the tsar himself appointed the stable-master from among the boyars. Analogous stables existed at the Moscow Patriarchate, at large monasteries, and on major private estates.

If you view the Rostov Kremlin from the side of Lake Nero — and it is from there that the best panorama can be had — you will notice two monasteries — those of St. Avraamy of Rostov and of Our Savior and St. Jacob — standing to either side like stone watchmen.

The **MONASTERY OF ST. AVRAAMY OF ROSTOV** (Ulitsa Zhe-

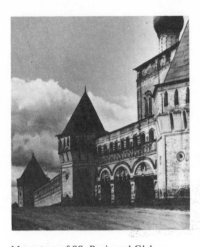

Monastery of SS. Boris and Gleb

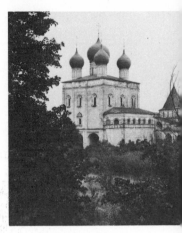

Gateway Church of St. Sergius

lyabovskogo), one of the most ancient in Rus, was founded in the 12th, or possibly the 11th century. However, until the time of Ivan the Terrible, all the buildings were wooden, so none of the early structures has survived. Nonetheless, the **Cathedral of the Epiphany** (Bogoyavlensky sobor) erected in 1552-54 by order of Ivan the Terrible in honor of the defeat of the Kazan Khanate is probably the most ancient structure in the city.

What connection could there possibly be between a Rostov monastery and Kazan? Again, we must turn to legend for the answer. From ancient times, a crozier which Avraamy reputedly received from the Apostle John himself had been kept at the monastery. Reputedly, this was the very crozier with which he smashed a pagan idol. According to legend, the monastery was built on the site where the temple to this pagan idol once stood as a means of struggling against idol worship. When setting out on the campaign against Kazan, the tsar stopped off at Rostov and took the crozier, counting on its aid in the battle against the infidels. In the

fall of 1552, after a long siege, Kazan finally fell. In honor of this major event in the history of the Russian state, several churches were built, including the world-famous Cathedral of the Intercession (or of St. Basil the Blessed) on Red Square in Moscow. In gratitude for the miraculous assistance of the crozier the Monastery of St. Avraamy received a large stone cathedral.

It is believed that the Cathedral of the Epiphany is the work of Andrei Maloi, who built the Church of St. Isidore the Blessed. Although it is of the type traditional at that time for the main cathedral of a monastery, or an urban cathedral, i.e., quincunx, four-piered, and three-apsed, it differs considerably from its fellows, for it rests on a basement, has narthexes on three corners, a small narthex on the western façade, and a gallery on the south side. Thus, this cathedral is quite original and picturesque in appearance. Essentially, it is a whole complex of buildings resting on a single basement.

Not far from the cathedral stands the **Church of the Presentation of the**

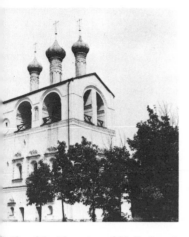

Belfry of the Monastery of SS. Boris and Gleb

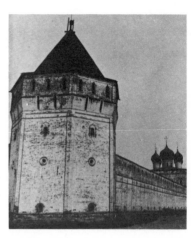

Fortress tower

Virgin (Vvedenskaya tserkov) erected, it is thought, in 1650 during the tenure of Metropolitan Iona who was not yet the metropolitan, but simply the negumen of this monastery. Iona's father is buried under the altar of this church (Iona himself is buried in the Dormition Cathedral).

Of the ancient buildings once so numerous in this monastery, the only other one to have survived is the **St. Nicholas' Gateway Church,** flanked by towers on either side. Unfortunately, it has undergone many alterations. In the 19th century, a bell-tower was added, and a classical portico was built on the western façade. All the other buildings in the monastery were erected in the 19th century.

The **MONASTERY OF OUR SAVIOR AND ST. JACOB** (Spaso-Yakovlevsky) occupies a much more prominent place in the panorama of the city than does the Avraamy, for its location is much more favorable. It stands on the approaches to Rostov from the Moscow side, and can be seen for many kilometers. It was founded at the end of the 14th century, probably by Bishop Iakov.

The first stone building, which served as the monastery cathedral, the **Church of the Immaculate Conception** (near the lake), was erected only in 1686, under Metropolitan Iona. The interior of the tall, four-piered, three-apsed church with five domes was painted in frescoes in 1689-90, and these frescoes are among the gems of late 17th century monumental painting in Rostov. The baroque iconostasis, carved in 1762-65, is also a masterpiece.

In 1725, flush against the Church of the Immaculate Conception, another structure, the **St. Jacob's Church** (Yakovlevskaya tserkov) was built, creating an unusual compositional effect. Later, this church was rebuilt, and it has come down to us in the form given it after major repairs in 1836. These repairs served the purpose of connecting architecturally the older church with the new St. Dmitry's Church erected in 1794-1802 in the classical style. Thus, the façades of the St. Jacob's Church repeat the southern façade of St. Dmitry's.

The **Church of St. Dmitry** was built by Moscow architect Elizvoi Nazarov, and Dushkin and Mironov, serf architects of Count Sheremetev. Despite the slight disproportionality of its various sections, it is considered an outstanding example of Russian classicism, the likes of which is not to be found, even in the capital.

Shortly after the Kremlin Church of St. John the Divine was erected in 1689, a **wooden church** of the same name appeared three kilometers from Rostov on the Ishna River (not far from the Moscow-Yaroslavl Highway). This is one of the rare examples of 17th century wooden architecture to have survived in the central regions of Russia. Moreover, it still stands on the spot where it was erected and has not been transferred to one of the open-air museums of wooden architecture, as is the case with many such monuments.

Legend has it that this marvelous structure floated down the Ishna River already assembled and positioned itself on the spot where it now stands. For the sake of accuracy, we must say that in those years, the frames and various structural elements of buildings were often assembled in the forest and floated down the river in almost completed form to the places they were to be erected. In such a manner, entire fortresses could appear in the course of several days, to the bewilderment of contemporary enemies and modern historians alike when confronted with accounts of such improbably short periods for construction in ancient documents and chronicles.

The church on the meadow has come down to us in good condition, though with several alterations: it was covered with boards painted dark red, the southern gallery was torn down, and a bell-tower was added. The proportions of the church are quite suitable to the shapes employed, and thus, the tiered, single-domed sanctuary strives upward in elegant fashion: a slightly elongated shingled dome rests on a small hexagon, which is in turn supported by an octagon upon a rectangular base. To the west and east respectively, the narthex and altar project out from the rectangular base.

If you climb the stairway leading to the gallery, you can enter the church through the ogee-arched portals to admire the four-tiered iconostasis with its ancient images of saints. The gilded Holy Doors are an exact copy of the originals, which are preserved, as noted earlier, in the Rostov Museum. Examine the interior of the church attentively, for the logs were fitted together so closely that even after three hundred years, you cannot stick a knife-blade between them.

* * *

Today, ancient Rostov the Great is a thriving city, constantly growing, with new residential districts springing up everywhere. Needless to say, the new high-rises are erected well beyond the bounds of the museum-preserve where the ancient architectural monuments are located. The number of tourists who visit this lovely city is constantly growing, too, and no one remains indifferent to its charms. Over thirty thousand Soviet and foreign tourists are hosted each year by the Rostov the Great International Youth Tourism Center which operates on the territory of the Kremlin.

Borisoglebsky — The SS. Boris and Gleb Settlement

At the spot where the Yaroslavl Highway splits off from the road leading from Rostov to Uglich, there is a picturesque, hilly region. On both sides of the road are coniferous forests interspersed with broad meadows. On the eighteenth kilometer of this extremely pleasant drive is locat-

ed the ancient Settlement of SS. Boris and Gleb. After a turn in the road, through the trees on the left there suddenly appear the enormous fortified towers of the **MONASTERY OF SS. BORIS AND GLEB.** There are fifteen mighty towers in all, and on the territory of the monastery, ten buildings dating from the 16th and 17th centuries have survived. The monastery, dedicated to the first two Russian saints and martyrs, the brothers Boris and Gleb, was founded in the 14th century by two associates of Sergius of Radonezh, the monks Fyodor and Pavel. They are buried here in the crypt of the Cathedral of SS. Boris and Gleb. The architecture of the monastery is exceedingly interesting, since building in stone began here almost a century before that of the Rostov Kremlin, and many of the forms and methods later used in Rostov were anticipated here. Subsequently, the architecture of this monastery was strongly influenced by the building going on in Rostov, so we can trace visually the development of one of the most splendid architectural schools of ancient Rus.

The first stone building erected on the territory of the monastery, and the most ancient building here, is the Cathedral of SS. Boris and Gleb, erected between 1522 and 1524, probably by well-known Rostov architect Grigory Borisov. Extremely modest in decor, the four-piered, single-domed church has come down to us with alterations which did nothing to improve its appearance. A tent roof, fashionable in the 17th century, replaced the old roof with its graceful zakomari. At the very end of the 18th century, a figured cupola was added, windows were cut into the walls, and various annexes, none of which was very expressive, were built onto the cathedral. All this puts the church in an unfavourable light, especially with respect to the brilliant structures of subsequent times.

Next to the cathedral stands the Church of the Annunciation and adjoining Refectory. Built in 1524-26 by the same architect, it also underwent later alterations and has come down to us essentially in its 17th century form. An unusually elegant and even festive two-storey porch has been built onto the west side of the church. It is decorated with the arches and pendants characteristic of Rostov architecture, and the traditional elaborate platbands and geometric patterns in the brickwork with colorful tile insets are also present.

The 16th century Residence of the Father Superior immediately to the north of the Church of the Annunciation has been altered considerably as well. The best feature of the decor of this building is the wide band of ornamental brickwork with small bays that runs the length of the walls.

The two **gateway churches** flanked by towers are particularly worthy of note: they were built almost a century and a half apart. In composition, they clearly tie the monastery complex to the Rostov Kremlin and reveal the sources of its architectural forms. The earlier, quincunx **Church of St. Sergius** was probably built in 1545 and is similar to the main cathedral of the monastery in form. At the same time, the platbands around the windows and the especially ornate gallery (on the side of the exterior façade) resting on an arched gateway with pendants in the spans make for a whimsical combination of 16th century austerity and the richness of decoration common in the 17th century. Two mighty hexagonal towers with machicolations are integrated into the portal-and-gateway-church complex, a combination which was repeated when the opposite entrance was built. The Vodyaniye (Water) Entrance and Gateway Church of the Purification were erected in 1680 during the tenure of Metropolitan Iona.

The festive yet majestic **Church of the Purification** is rightfully considered one of the finest examples of Rostov architecture in which the combination of a gateway church with two

towers is realized with exceptional refinement. The tall, quincunx church is similar to those of the Rostov Kremlin, however, its façades are divided into just two segments by pilaster strips, and moreover, the pilaster strips do not extend all the way to the cornices, but only to the broad band of blind arcading. Obviously, it is the decor that plays the main role here. Despite the variety of means and methods employed, it is clear that the types of decor were chosen deliberately and systematically. Thus, the pendants suspended in the arches of the portals are repeated in the beautiful gallery of the second tier; the windows of the church are concealed by niches and surrounded by high ogee-arched platbands which are reminiscent of the two tiers of windows in the towers. The drums supporting the domes are richly decorated with figured ornamental brickwork. The gallery and gates are entirely covered by patterned stonework. The walls of the St. Sergius' Church are painted in frescoes, and the building presently houses a **museum.** From the museum visitors can exit onto the open gallery and walk atop the entire length of the monastery walls, which extend fo about a kilometer and a half.

In 1680, the monastery ensemble was complemented and completed by a marvelous triple-spanned **belfry** similar to the one in Rostov, but light er in form. It is positioned quite favor ably in the monastery courtyard and dominates the view, especially from the side of the Church of St. Sergius Its richly decorated porch is reminis cent of the porch of the Refector Church of the Annunciation.

The power and might emanating from the high 16th century monastery **walls** and enormous fortified **tower** pervade the entire place, and indeed they served as a sure defense for the city of Rostov from the direction of Uglich during an important period in history. The sense of power and beauty, austerity and elegance inter twined here proved quite productive for the further development of Rus sian architecture.

Historical and Architectural Monuments

The Rostov Kremlin

Monastery of St. Avraamy of Rostov — Ulitsa Zhelyabovskogo

Cathedral of the Epiphany, 1552-54
St. Nicholas' Church and Bell-Tower, 17th-19th centuries
Wing of Cells, 1730
Dormitory, 1731
Father Superior's House, 1725-1800
Walls, towers, 1778-1800
Church of the Presentation of the Virgin, 1650

The Monastery of Our Savior and St. Jacob — Ulitsa Dobrolyubova

Church of the Immaculate Conception, 1686
Bell-Tower, 1776-86
Father Superior's House, 1786-95
Wing of Cells, 1776-95
Walls, towers, 1776-1806
Church of St. Dmitry, 1794-1802
St. Jacob's Church, 1836
Watch-Tower, 19th century

* * *

Church of St. Isidore the Blessed, 1566 — Ulitsa Karla Marksa
Church of the Savior-on-the-Sands (Spas na Peskakh), 1608 — Ulitsa Kirova
Church of the Nativity in the Nativity Monastery, 1678 — Sovetskaya Ploshchad
City Ramparts, 1681
Church of the Savior-on-the-Market-Place (Spas na Torgu), 1685-90 — Sovetsky Pereulok
Stables, 17th century — Ulitsa Kamenny Most
Church of the Tolg Virgin (of St. John the Kind), 1761 — Ulitsa Dekabristov
Arcade (Gostiny dvor), 1830s — Ulitsa Pyatidesyatiletiya Oktyabrya
Customs House (Mytny dvor), 1830s — Ulitsa Karla Marksa
Church of St. John the Divine on the Ishna River (wooden), 1689 — Bogoslovo village, 3 km from Rostov on the Ishna River
Church of SS. Peter and Paul and Bell-Tower, 1799 — Porechye-Ribnoye village

Monastery of SS. Boris and Gleb — Borisoglebsky settlement

Cathedral of SS. Boris and Gleb, 1522-24
Church of the Annunciation, 1524-26
Archbishop's Kitchens (Communion Bread Building), 1520s
Gateway Church of St. Sergius, 1545

Walls, towers, 1545
Father Superior's House, 16th century
Gateway Church of Purification, 1680
Belfry, 1680
Dormitory, 1805

Information for Tourists

Hotels
Rostov — 64 Ulitsa Sverdlova

Restaurants
Rostov (in the Rostov Hotel) — 64 Ulitsa Sverdlova

Museums
Yaroslavl-Rostov Museum-Preserve of History, Architecture, and Art, on the territory of the Kremlin. Open: 10 a.m. to 5 p.m. The more interesting churches are open to visitors from 1 May to 1 October.

Stores
Arcade — 4 Ulitsa Pyatidesyatiletiya Oktyabrya
Books (Knigi) — 2 Ulitsa Kooperatsii

Yaroslavl

Yaroslavl, the center of Yaroslavl Region, is located 280 kilometers from Moscow. Its population is about 600,000. Yaroslavl is a Volga port city and a railroad junction.
It has many highly developed branches of industry, including machine-building (motor-building, fuel industry, electrical engineering, polymer machine-building, etc.); chemical (manufacture of rubber goods and synthetic rubber); oil-refining; light, food, and construction materials industries. The city has four institutes of higher learning, including a university, a drama theater, and a puppet theater. The museum and architectural monuments located here are administered by the Museum-Preserve of History, Architecture and Art. There is also a picture gallery.

Not long ago, archeologists made a sensational discovery: on the edge of modern Yaroslavl, a sturdy wooden paling dating back to the end of the 9th or beginning of the 10th century was located. Within the paling were the remains of dwellings, household utensils, implements of labor, and jewellery, all of which testified to the fact that by the early middle ages, a large trading settlement had grown up here. The present city got its name from Yaroslav the Wise who ruled the area from 988 to 1010. Yaroslavl's favorable location at the confluence of the Kotorosl and the Volga rivers, the latter of which was a major trade route, promoted the growth of the city for many centuries. In the 12th century, Yaroslavl was part of the Rostov-Suzdal Principality, but in 1218, it became the center of an independent one. In the two short decades that remained before the Tartar invasion, Yaroslavl grew by leaps and bounds, flourishing as never before. Building in stone began, and the arts and handicrafts reached new heights. In 1238, like most of the cities of Rus, Yaroslavl was sacked and pillaged by the Tartar hordes. Despite harsh reprisals, during the more than two centuries of the Tartar yoke, Yaroslavl rose up against the invaders time and again. The active role it played in the historic Battle at Kulikovo Field in 1380 under the leadership of Moscow Prince Dmitry Donskoi is well known.

A new period in the history of Yaroslavl began in 1463 when it became part of the Moscow state: never once after that did it betray this union. In the 16th and especially the 17th centuries, the significance of Yaroslavl increased sharply: it was a major trade center on the Volga route leading to the countries of the Middle and Near East, while maritime trade with Europe passed through the city on its way to the only Russian sea port of that time – Archangelsk on the White Sea. In terms of volume of trade, in the mid-17th century, Yaroslavl was second only to Moscow and Kazan, and in population, to the capital alone. And in terms of architecture, the city managed to surpass even Moscow in some respects.

Yaroslavl's architecture made a great contribution to Russian national

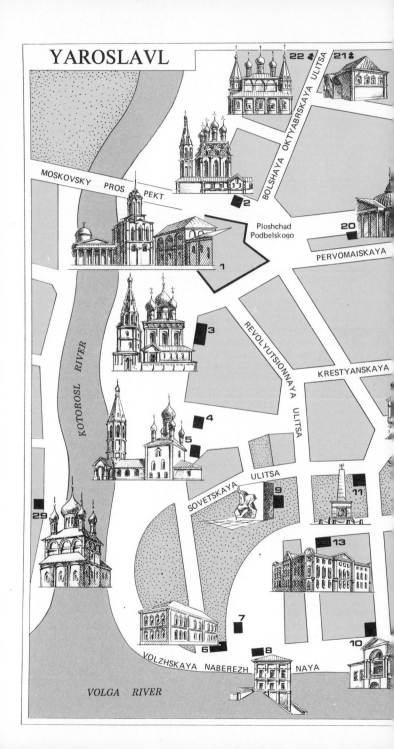

YAROSLAVL

MOSKOVSKY PROS PEKT

Ploshchad
Podbelskogo

BOLSHAYA OKTYABRSKAYA ULITSA

PERVOMAISKAYA

REVOLYUTSIONNAYA ULITSA

KRESTYANSKAYA

SOVETSKAYA ULITSA

KOTOROSL RIVER

VOLZHSKAYA NABEREZHNAYA

VOLGA RIVER

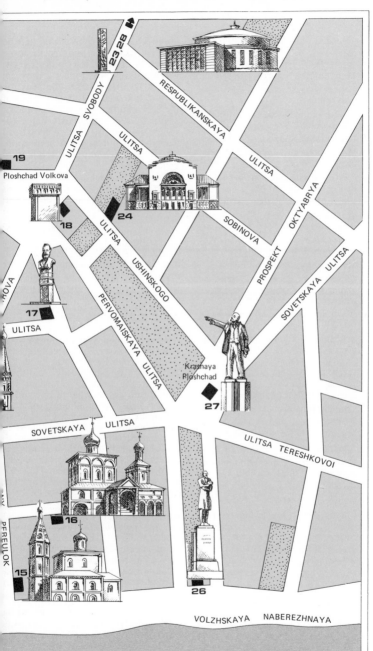

architecture as a whole, and can be divided into three periods: the time before the unification with Moscow. when building was influenced by the Rostov traditions; then, the Moscow period, followed, in the second half of the 16th century, by a third period of original development in which local styles held sway. During this third period, an independent and quite interesting school of architecture appeared here.

Thus Yaroslavl began to flourish under Ivan the Terrible in the 16th century, and its prominence continued into the 17th century, a very dramatic period in Russian history. For fifteen years, the Time of Troubles[1] continued: there was much blood-letting, and the country was devastated by the Polish-Lithuanian-Swedish intervention, ravaged by plaque, and torn apart by violent peasant uprisings. The Russian Orthodox church was beset by problems as well: a schism from which the Old Believers, many of whom burned themselves en masse rather than accept Nikon's reforms resulted. But the turn of the century also saw an unprecedented rise in patriotism on a mass scale after the Tartar yoke was thrown off. And thus, an energetic building campaign was undertaken nation-wide to restore the country from the smouldering ruins left behind by successive invaders. And an overall national style emerged in Moscow and the various Russian principalities which made as much of a contribution to world architecture as the classical orders had in their time. This new style was epitomized by the tall, pointed tent roof.

The Russian medieval period ends with the advent of the 17th century and the emergence of the towering figure of Peter the Great with his massive program of reforms. Ancient Russian art and architecture gave way to styles which were imported, though the influence of older Russian ideas upon them

[1] The term used by Western historians for the end of the 16th and beginning of the 17th centuries in Russia, which marked the short reign of Boris Godunov, who attempted to strengthen the centralized government and domination of Moscow.

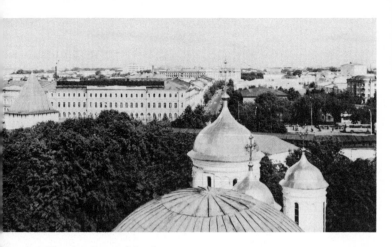

Yaroslavl. The central part of the city

is undeniable. It was precisely at the end of these glorious years of history that Yaroslavl made its mark on the course of events, for the city was the base of the popular uprisings against the Polish and Lithuanian invaders. Yaroslavl played an enormous role in the unification of the Russian forces, which had a definite effect on the spiritual tenor of the times.

The stratum of society that made possible the rapid development of architecture was a merchant class that had become very rich. The tastes of the merchantry were closer to those of the common people, and some marvelous churches were commissioned as a result; these structures often combined the best in traditional ancient Russian construction methods with the intricate decor fashionable at the time and exceeded the contemporary churches of the capital in size. The frescoes and decorative tile-work of these buildings were exceptionally fine. Yaroslavl fared quite well during the remodeling and alterations of the street plan which affected most Russian cities in the 18th century, as we have noted. As a result of the reconstruction, the ancient edifices were given a more spacious quarter and became the focal points of the main squares and neighborhoods.

The natural surroundings of Yaroslavl provided a good basis for architects to work from as well. The confluence of the Volga and Kotorosl rivers forms an arrow, and the hills and depressions which cut through the central part of the city where most of the architectural monuments are located give the place a surprisingly picturesque, individual appearance. This, in combination with the precisely laid-out streets and squares, make Yaroslavl one of the most beautiful cities in Russia.

At the beginning of this book, the reader was promised that no two cities herein were alike, even though many buildings and even entire ensembles were executed by the same master craftsmen and architects. And thus we have Rostov and Yaroslavl, quite close together and both famed for their architecture. Although the chief monuments date back to the very same time period, in the former case, the talent of the builders was guided by the frustration of an ambitious cleric, and in the second, it was

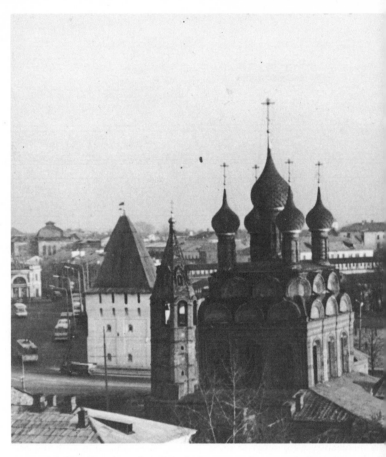

Monastery of the Transfiguration of the Savior

governed by the boldness and expansive nature of the rising merchant class. Thus quite divergent goals and tastes determined the widely differing appearances of these two fine cities in the northeast of central Russia.

However, our tour of the city's monuments will begin not with the fruits of the "golden age" of Yaroslavl architecture but rather with the not-so-well known but no less interesting

MONASTERY OF THE TRANSFIGURATION OF THE SAVIOR (Spaso-Preobrazhensky monastyr) (25 Ploshchad Podbelskogo) which was founded in the 12th century and took the place of the city citadel. This is where you will find the most ancient buildings in the city.

The first stone structures appeared at the Monastery of the Savior at the beginning of the 13th

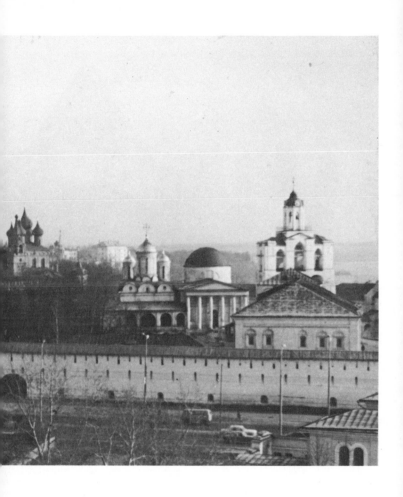

century before the Tartar invasion. The monastery was recognized as a major center of learning, for it was here that the first school in northern Russia was opened. This school had an excellent library in which many unique ancient Russian manuscripts and chronicles were preserved. Some of these have come down to us and are kept in the local museum. In the 1790s, the only known copy of the

ancient Russian epic poem, *The Lay of Igor's Host,* which brought world fame to the early literature of Rus, was unearthed here.

In the 15th-17th centuries, the monastery was one of the largest and richest in all of Rus, and in the 16th century after the stone walls and towers were erected, it was one of the strongest fortresses in the regions beyond the Volga. A large garrison

Belfry of the Monastery of the Transfiguration of the Savior

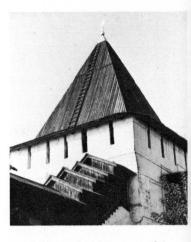

Uglich Tower of the Monastery of the Transfiguration of the Savior

with artillery was quartered in it to guard the tsar's treasury. In 1609, the monastery successfully withstood the siege of the Polish and Lithuanian interventionists. In 1787, the garrison was abolished, and the monastery became the residence of the bishop of Yaroslavl. Today, extensive restoration work is being carried out on the territory of the monastery, and it has been made part of the Yaroslavl History, Architecture, and Art Museum-Preserve.

The central place in the monastery ensemble is occupied by the *Cathedral of the Transfiguration of the Savior* (Spaso-Preobrazhensky sobor) which dates back to 1516, when it was rebuilt after the fire of 1501. In the 17th century, a covered porch was added. The three-domed church with a roof of semi-circular and ogee-arched *zakomari* stands atop a high basement and is surrounded by an open two-storey gallery. The strict geometrical forms, precision of line, and paucity of decor are typical of the "Ancient Russian classical style" and link this building to the cathedral of the Monastery of the Intercession in Suzdal.

The frescoes of the cathedral were executed in 1563 and 1564 by Moscow (Larion Leontyev and Tretyak and Fyodor Nikitin) and local (Afanasy and Dementy Sidorov) masters; these were some of the best frescoes painted in the 16th century. The work on the eastern wall, especially the magnificent figures of the Archdeacons and St. John the Baptist above them, is particularly fine. The image of Christ Pantokrator in the cupola of the central dome, and *The Last Judgement* on the west wall are particularly expressive. The artists skilfully used the peculiarities of illumination of the walls, vaults, and drums to better put across the ideas of the subjects. The frescoes are exceptionally interesting in that they serve as landscapes with representations of the most varied architectural forms of Ancient Rus: belfries, single-domed churches, and many-domed cathedrals. Even details of decor can be clearly discerned.

Flush against the south wall of the cathedral stands the late-classical style **Church of the Yaroslavl Miracle-Workers** (tserkov Yaroslavskikh chudotvortsev) erected in 1827-31.

A complex of 16th and 17th cen-

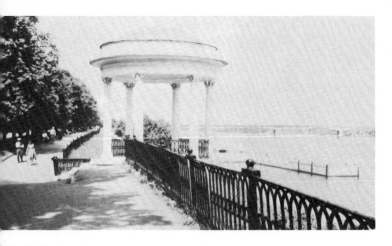

Volga Embankment

tury buildings consisting of a refectory chamber and Refectory Church of the Nativity of Christ (tserkov Rozhdestva) and the Father Superior's Chambers looks out into the central square of the monastery. The most ancient part, the **refectory,** was built in the first half of the 16th century. The exterior of the two-storey edifice is quite simple and austere. The façades are decorated only with windows in arched niches and flat pilaster strips. The second floor of the interior is much more impressive: as in many similar 16th century chambers the vaults of the ceiling are supported by a single mighty pillar in the center and the walls. This created a great deal of free space for the numerous monks who resided at the monastery to take their meals together.

The **Father Superior's Chambers** stand next to the Refectory. Although the decor of this building is modest and sparse as well, consisting only of ornate platbands and cornices, it clearly demonstrates the differing architectural tastes of the 16th and 17th centuries: the bar tracery and comparatively elaborate ornamentation of the one stand out in stark contrast to the reserve and austerity of the other, older building.

The pillar-shaped **belfry** of the monastery is another example of 16th century architecture. In its lower tier was the Church of the Virgin of the Caves (tserkov Pecherskoi Bogomateri), the iconostasis of which is similar to those of the Rostov churches already familiar to the reader, for it has been painted directly onto the stone wall. The visitor can become acquainted with these ancient frescoes as well as with the two exhibits which have been set up in the church: **Russian and Dutch 16th-19th Century Bells** and **16th-17th Century Epigraphic Monuments of the Monastery of the Transfiguration of the Savior.** At one time, the belfry was connected to the cathedral by a two-tiered gallery, and two tall tent roofs of stone crowned the building. In the 17th century, these roofs were covered with glazed green tiles. Then, at the beginning of the 19th century, the pseudo-Gothic roof with the small rotunda which can be seen today replaced the older roofing. There are now viewing platforms on the upper tiers from which a lovely panorama of Yaroslavl opens up.

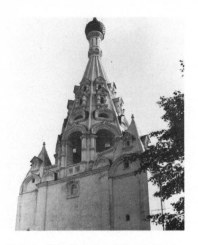

Church of the Nativity of Christ. The Gateway Church and the Bell-Tower

The four buildings in which the **monks' cells** were located lie along a single axis. Erected at the end of the 17th century, they are quite typical of secular architecture of that time. Their façades are enlivened by ornate platbands around the windows, pilaster strips, and horizontal bands.

In describing the monastery's monuments, it is logical to begin with the **Holy Gate,** especially since it is one of the most ancient and most interesting structures here. Although the gate once served as the main entrance to the monastery, now it is at the farthest corner of its territory. In essence, the Holy Gate is all that remains of the 16th century fortifications. It was built in 1516 at the same time as the cathedral but underwent modifications in the 17th century when some decorations typical of the time were added to the side that faced inward: pilaster strips, geometric indentations in the brickwork, and a decorative band. On the east side of the gate, a tall watch-tower with a pointed roof and a large clock was erected. It was here that the alarm bell hung. Thus we now have a whole complex of buildings including a fortress tower with two entrance ways, a gateway church with a gallery and a watch-tower. In ancient times, additional fortifications with loop-holes adjoined the outer walls of the tower, for from this side, the monastery could hold the main ford across the Kotorosl under fire. At the same time, great care was taken over the visual impression the south façade of the monastery made from across the river, and in this, the Holy Gate played the key role. The traditional love of the residents of Yaroslavl for frescoes and murals made itself felt even in this fortified structure: in 1564, the vault of the main entrance and sections of the walls were painted, but unfortunately the frescoes here have come down to us in rather poor condition.

At the end of the 18th and beginning of the 19th centuries, the entire length of the south wall was rebuilt to improve the view of the monastery's ancient buildings from the side of the river. At the corners, in place of the old fortified towers, two smaller round **towers,** the **Mikhailovskaya** and **Bogoyavlenskaya,** which served a purely decorative function, were erected.

However, the two northern stone watch-towers, the **Bogoroditskaya and Uglichskaya towers,** built in the first half of the 17th century, are reminiscent of the mighty defensive structures once prominent at this formerly heavily-fortified monastery. The stepped wall which rises up to the Uglichskaya Tower gives it an especially impressive appearance.

At the present time, in the Seminary Wing of the monastery, **two branches of the Yaroslavl Museum-Preserve,** the **History and Nature museums,** have been opened.

Near the Monastery of the Savior on the side of the Moscow Highway, stands the large, beautiful stone **CHURCH OF THE EPIPHANY** (tserkov Bogoyavleniya, 25a Ploshchad Podbelskogo) which gives onto a picturesque view of the old part of the city. It is wise to pause to have a look

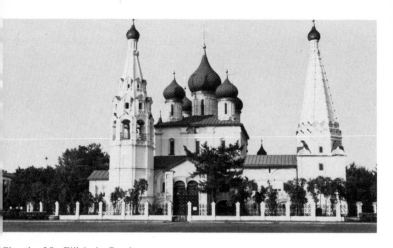

Church of St. Elijah the Prophet

at this church on the way into town so as to avoid making a detour later. This church is one of the relatively late examples of the Yaroslavl school of architecture, and it will be described in more detail toward the end of our excursion to give the reader a better idea of the process of development the school underwent. So for now, we will begin with the center of the ancient city where the first stone churches were erected in the area: the churches of St. Nicholas, the Nativity of Christ, and St. Elijah the Prophet. Erected in the 17th century, these structures have many features in common: a free, asymmetrical grouping of components, basements, tower-like side-chapels on the northern façades, porches with arches, and rather austere decor.

Since this route leads visitors to the banks of the Volga, along which many architectural monuments are concentrated, we must say a word about this, the chief "tourist attraction" of the city. For the Volga River was the principal factor in determining much of Yaroslavl's history and continues to play an important role in the present economic life of the town.

Moreover, the river is the major natural feature and resource of the area and greatly enhances the beauty of the man-made monuments which spread out along its banks. Those of you who met this, the greatest of all Russian rivers, in Kalinin at the very source of its route across the whole country will surely be eager to see it again. And you will not be disappointed, for the Volga runs much deeper and wider here; it is more majestic, and from its high banks, many vessels, large and small, can be seen. The automobiles on the far shore look like mere ants.

The lovely Volga Embankment (Volzhskaya neberezhnaya) is buried in greenery: trees, grass, shrubs on well-kept lawns, and fine gardens shade the gleaming white façades of the restored buildings which are maintained in excellent condition. From the steep shore rises the **17th century Volga Fortress Tower,** a remnant of the ancient city fortifications, and a small classical-style rotunda of the late 19th century pavilion – a fairly recent addition. In a word, the Volga Embankment is a fine place for a stroll.

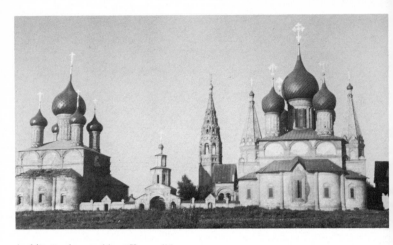

Architectural ensemble at Korovniki

The oldest parish church in all of Yaroslavl is the **CHURCH OF ST. NICHOLAS**—*NADEYINA* (tserkov Nikoly Nadeyina, 2a Narodny Pereulok) which was erected in 1620-22 with funds provided by Nadey Sveshnikov. The Annunciation Chapel built onto this church was intended for the private use of the merchant, so that like a prince, he could attend the divine liturgy in the narrow circle of his friends and relatives.

Unfortunately, the alterations the church underwent at the turn of the 17th century considerably distorted its earlier appearance. Of the original five green-tiled domes, only one remains. A bell-tower was also added, much to the detriment of the simple lines of the façades, which bespeak the fondness of its builders for the austere traditions of the 16th century, though they failed to hold to the typical clarity of construction of that earlier time: the semi-circular *zakomari*, which would ordinarily reflect the interior outline of the vaults, are a purely decorative element here.

The interior frescoes were painted in 1640-41 in an equally traditional manner, but certain features were further developed in the subsequent period by the Yaroslavl school of art and architecture: an interest to the point of absorption is displayed on the part of the artists in the life of one of the most popular and beloved of all Russian saints – Nicholas the Miracle-Worker – and scenes from his life presented here are executed with an exactness of detail making them akin to genre painting. The priceless baroque **iconostasis** was carved in 1751, according to a design supposedly by a native of Yaroslavl, Fyodor Volkov, the founder of Russian national theater, who attended this church in his youth. The **interior of the Annunciation Chapel,** intended for the use of the man who commissioned the church, is particularly interesting, especially in light of its unique tableau-like iconostasis framed in ornamented lead.

A hundred paces from the Church of St. Nicholas, also on the riverbank, stands another early Yaroslavl sanctuary – the **CHURCH OF THE NATIVITY OF CHRIST** (tserkov Rozhdestva Khirstova, 1 Ulitsa Kedrova) built in 1635-44 by order of the Nazaryev merchant family. Many features of this

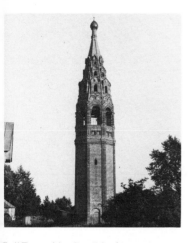

Bell-Tower (the Candle) of Yaroslavl

Church of St. John Chrysostom

church are unique in Russian religious architecture, first of all the magnificent tent-roofed **gateway church** and **bell-tower.** This enormous many-tiered structure amazes with its elegance and refined, rhythmic sweep upwards, and the mastery exhibited in the decoration of the building is no less impressive. The soft outline of the arcade of the gallery located above the gate is repeated by the arches of the entrance way. A stone pendant is suspended from the aperture of these arches that are supported by the intersecting annulets of the column. The next tier consists of the mighty rectangular volume of the church. A pair of pointed columns have been built on to the west corner of the church: they act as piers and their annulets intersect at the center. On the east corner are rectangular towers with pyramidal roofs which resemble tiny tent-roofed chapels. Finally, an enormous faceted tent roofs rising high above the octagonal bell-tower, the elegance of which is emphasized by three rows of sharply projecting windows and sixteen vertical stone bands which converge at the base of the small figured drum of the dome.

For the first time, glazed tiles were used in the decoration of the Church of the Nativity. Soon after, these tiles became one of the major ornamental elements for church buildings in the city and the hallmark of the local school of architecture.

Glazed-tile making was an ancient art in Russia and had its roots in 10th-11th century Kiev, then 12th century Ryazan and Vladimir. Evidence of the widespread use of these shiny flat tiles in architecture is revealed by the presence of a special clay projection which was used to attach the tiles to the wall. During the rule of the Golden Horde in Rus, this art form almost disappeared, but it re-emerged in the 15th century. This re-emergence was gradual and quite modest – not as an independent art form, but as a substitute for white stone carving in which the designs traditionally employed by stone-cutters were simply repeated. In the 16th century, polychrome tiles began to appear on the walls of the Moscow cathedrals and then on those of other cities. But the golden age of glazed tiles was the 17th century when the homes and stoves of Moscow, Yaroslavl, Zagorsk, and many other cities were decorated with the colorful ceramic plates. Begin-

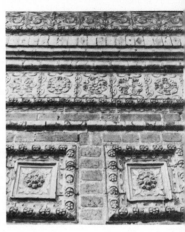

Church of the Tikhvin Virgin with glazed tile decoration

ning with the epoch of Peter the Great who ordered that Russian tiles be modified to resemble Dutch ones, the secrets of this ancient art were gradually forgotten. It was not until the present that the artists and ceramicists of Yaroslavl learned to produce tiles which are practically indistinguishable from the ancient originals. Thanks to their skill, the lovely ornament of the Yaroslavl churches can now be adequately restored.

The tile frieze of the Church of the Nativity is also worthy of note since the enterprising and decisive merchants who commissioned the sanctuary did not hesitate to have their names inscribed in iridescent glaze, thus leaving a record of their deeds for posterity and for history.

The **CHURCH OF ST. ELIJAH THE PROPHET,** built in 1647-50, stands on Elijah (presently Soviet) Square, which has long been the center of the city in terms of its overall plan and architecture: all the major thoroughfares lead off this square in various directions. This church was erected for one of the richest and most influential Russian merchant families of that epoch – the Skripins –

who were close to the courts of tsar and patriarch alike. The large, cubic, quincunx sanctuary rests on a high basement; this imposing structure the façades of which have almost no ornament at all, is reminiscent of the urban cathedrals of the 16th century. However, the love of elaborate decoration so prominent at the time found its expression in the galleries, side-chapels, and bell-tower, which, in combination with the central structure, create an exceptionally lovely ensemble.

The elaborate open **galleries** and **porches** with their carved white stone insets featuring mythological beasts and birds, and the double archlets with carved pendants suspended from them (a technique which later appeared in almost all the Yaroslavl churches) are all quite striking. The tiny northeastern side-chapel erected in honor of SS. Gury, Samon, and Aviv, protectors of the family, is quite lovely with its roof in the form of many tiers of *kokoshniki,* something quite common in Moscow architecture, but rare in Yaroslavl.

The church looks especially lovely from the side of the square. Its com-

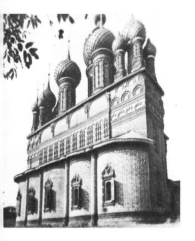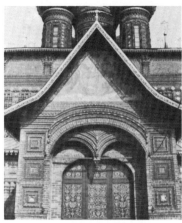

Church of St. John the Baptist at Tolchkov. General view. Entrance

plex asymmetrical composition consists of the massive quincunx church, the elegant, intricately ornamented porch, and a beautiful tower to either side. One of these is actually the roof of the southwestern Chapel of the Deposition of the Robe. This stone tent roof, erected on the eve of the official ban on their use by Patriarch Nikon, is a true gem of this original Russian architectural form.

The Church of St. Elijah the Prophet has come down to us in excellent condition with insignificant alterations such as the pitched roof which replaced the earlier *zakomari*. The chief treasures of the church – its **frescoes and murals** – have been preserved in excellent condition. The frescoes were executed in 1680 and 1681 by an artel of icon-painters headed by Guriy Nikitin and Sila Savin of Kostroma who are quite familiar to the reader by now. Four Yaroslavl artists directed by Dmitry Semyonov also took part in the work. In three centuries, they have not been repainted a single time, and during recent restorations, they had only to be thoroughly cleaned.

The remarkably vivid, clear colors and exceedingly rich palette are com-

bined with lively artistic expression, piquant images, and uncommonly lavish ornament. Especially fine are the cycles dedicated to the life of the Prophet Elijah and his disciple, the Prophet Elisha. Here, the artistic narrative is presented not in the form of borders around a central image as in the Church of St. Nicholas, but in a continuous flow in which intermingled with scenes from the Bible and the deeds of the prophets are the first depictions of scenes that approach the secular, for example, haggling in a market place, the harvest, or apple-picking. These latter scenes are exceedingly detailed. Majestic figures of princes in ceremonial vestments grace the western piers. Their faces are so individualized it seems they were painted from life.

The Church of St. Elijah the Prophet seems to be the result of the creative quest of the Yaroslavl architects of the first half of the 17th century in which the joyful decor and expansive asymmetrical plan popular at the time combine gracefully with the simplicity and austerity of form of the 16th century. The church's frescoes – vibrant, colorful, and optimist-

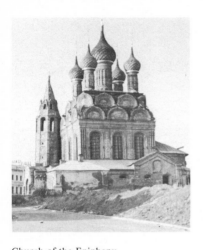

Church of the Epiphany

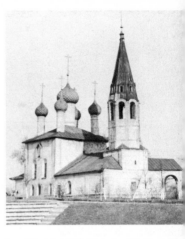

Log Church of St. Nicholas (Rublenyi)

ic – are possibly the greatest achievement of monumental art in Yaroslavl. This building made way for the next phase in the development of the succeeding type of church distinguished by the absence of the basement, a free-standing bell-tower, a compact composition centered around a cathedral-type central mass with side-chapels, fine masonry with richly decorated walls, and the extensive use of glazed tiles.

It is so fascinating to make a close study of the architectural theories employed in the construction of the finest churches of that time that the author is compelled to break with the territorial principle according to which this excursion has been organized, though it is preferable in large cities where the architectural monuments are located some distance apart. By the way, this concerns only the route being followed in the present tour guide, which is roughly chronological for the sake of clarity and logical presentation of materials. Have a look at the map included in the book and visit all the points of interest in the central part of the city, then go to the outskirts of town, referring back to the text of the guide book as needed.

This new type of church which made use of the best architectural developments of the past decade reigned supreme until almost the end of the 17th century. One of the finest examples of this type of building and of the Yaroslavl school is the **ENSEMBLE IN THE KOROVNITS-KAYA SLOBODA**[1] (Cowpasture Settlement, 2 Portovaya Naberezhnaya) Standing on the right bank of the Kotorosl at its confluence with the Volga and situated such that it is best viewed from the river, the church is quite lovely from all angles.

The focal point of the complex the **Church of St. John Chrysostom** (tserkov Ioanna Zlatousta) at Korovniki was built between 1649 and 1654 with funds provided by two residents of the settlement, Ivan and Fyodor Nezhdanovsky. Since the high basement which appeared in earlier structures is absent from this one, the building now appears squat, despite

[1] Sloboda is the old term for the outlying regions of a city which is now retained simply from tradition. The main occupation of the residents of Korovnitskaya Sloboda was cattle breeding, hence its name for "korova" means "cow" in Russian.

the fact that the enormous onion-shaped domes on tall drums topped by large crosses are quite high. In fact, they are almost as tall as the main body of the building itself. Visually, however, this seeming disproportionality is not so noticeable because of the low gallery and the two symmetrical tent-roofed side-chapels on a single axis to the north and south of the building which give it a pyramidal shape.

Though the stone decor was rather modest at first, in the 1680s, at the height of the decorative arts in Yaroslavl, the ornamentation was made considerably more elaborate. In addition, lavishly ornamented porches with pendants suspended in the apertures of a double row of arches and glazed tiles on pediments made the building even more elaborate. The simple pilaster strips of the western façade were replaced by triple semi-columns with carved white stone capitals and glazed tile inserts. Windows were cut into the façades and surrounded by ornately carved platbands, and the window of the central apse was framed with an incredibly intricate glazed tile platband five meters in height.

The **Church of the Virgin of Vladimir,** built some fifteen years later, served as a winter (heated) church for the Church of St. John Chrysostom, and essentially repeats the structure and architectural form of the larger sanctuary. To conserve heat, an additional lower vault was constructed, rendering the upper segment of the church purely decorative in function.

The next addition to the growing ensemble at Korovniki was a tall, tent-roofed **bell-tower** erected in 1680, at an equal distance from the two churches and on a single axis with them. Thus, the bell-tower became the compositional focal point of the ensemble. The tower's uncommon elegance earned it the name the Candle of Yaroslavl. The Moscow (Naryshkin) baroque **Holy Gate,** built at the turn of the 17th century, completed the ensemble.

The big terrible fire of 1658 in which the fortress of the Log City, all the bridges, three monasteries, twenty-nine churches, and about 1,500 homes and workshops were destroyed prompted the construction of stone urban churches throughout the area.

The finest features of the well-known Church of St. John Chrysostom were realized in the formulation of the **CHURCH OF ST. NICHOLAS-ON-THE-WATERS** (tserkov Nikoly Mokrogo) erected at the opposite end of Yaroslavl (1 Ulitsa Chaikovskogo) between 1665 and 1672. This sanctuary is noted for the marvelous glazed tile platbands surrounding the altar windows and for the ornament of the narthex. The glazed tile work decorating the **CHURCH OF THE TIKHVIN VIRGIN** (1686, 1 Ulitsa Chaikovskogo) which stands next to St. Nicholas' is even more striking, in particular, the small cone-shaped tower above the narthex, which is completely covered with glazed tiles. In 1673, frescoes which harked back to the finest traditions of the past were painted in the Church of St. Nicholas-on-the-Waters. It is believed that the famed Gury Nikitin was among the artists who painted the frescoes there.

Another such church which dates back to the same time (1672) is the **CHURCH OF THE TRANSFIGURATION OF THE SAVIOR-IN-THE-CITY** (tserkov Spasa Preobrazheniya na Gorodu, 3 Pochtovaya Ulitsa) which stands on the bank of the Kotorosl. In the 17th and 18th centuries, the central market of the city was located here. In this church, too, the height of the drums and domes exceeds the height of the building itself, and the northern tent-roofed side-chapel is almost identical to the side-chapel of the Church of St. John Chrysostom. Of the 1693 frescoes, the two lower tiers are certainly the most interesting, for here, the history of the adoption of Christianity in Rus is depicted: panoramas of cities, battles, and ceremonial processions are shown.

Next, our path takes us beyond the Kotorosl to the ancient leather-dressing settlement (sloboda) of Tolchkovo, once the richest in the area. The first architectural monument we come to is the **CHURCH OF ST. THEODORE** (Fyodorovskaya tserkov), the silhouette of which is already familiar to the visitor with its five mighty shingled domes. This church was erected in 1687 with funds provided by the parishioners, so they were the ones responsible for choosing and approving the plan for the building. Like all the Yaroslavl churches, this one has some features not found elsewhere: wide, semi-circular decorative *zakomari* are supported by multi-tiered bands of starkly silhouetted brickwork – practically the only decoration on the smooth walls of the façades. The closed porch and side-chapel on the southern façade were added in the 18th century. The frescoes were painted in 1715 by an artel under the direction of the leading masters of the time, Fyodor Ignatyev and Fyodor Fyodorov. The frescoes devoted to the Life of the Virgin were executed in the romantic manner akin to fantasy common in the popular folkprints of the time. In the lower tier of the carved, gilded iconostasis, a work by Gury Nikitin, *The Almighty,* has been preserved. In this icon, monumentality is successfully combined with remarkable attention to detail.

Not far from the Church of St. Theodore is the central church of the Tolchkovo Sloboda, the **CHURCH OF ST. JOHN THE BAPTIST,** erected between 1671 and 1687. For good reason, this structure is considered the pinnacle of Yaroslavl architecture. Although, in general, it does not depart from the quincunx cathedral-type composition common at the time, the chapels on either side are unique in Russian architecture and unlike anything to be found elsewhere. In a single line with the eastern façade of the main building, they are practically as tall as the church itself and form a broad, wall-like structure with five apses. And since, in place of the traditional tent roofs the chapels are also topped by five domes, the silhouette of the building takes on a fantastic shape with its fifteen domes.

The decoration of the whole surface of the main church, the gallery, side-chapels, and porch is unusually rich and looks as if it is trimmed in fine lace, although it would seem impossible to achieve such an effect with mere brickwork. Painting and glazed tile insets further enrich the decor.

In square meters of **frescoes,** this church exceeds all the others in Russia, and in breadth of subject, it has no equal anywhere in the world. Practically the entire Bible, both Old and New Testaments, is portrayed on the walls of this church, and the murals on the lower tier of the south and north walls contain portraits of all the saints of the Russian Orthodox Church! The grandiose frescoes with their austere greenish palette were executed in 1694 and 1695 over a period of but five months by an artel of sixteen Yaroslavl icon-painters headed by outstanding artist of the end of the 17th century, Dmitry Grigoryev (known to the reader from his work in Pereslavl-Zalessky) and by Fyodor Ignatyev.

This entire architectural and artistic marvel – the enormous six-tiered carved wooden iconostasis, the superb 17th and 18th century icons, and the unique carved Holy Doors in the Chapel of SS. Gury and Varsonofy – are truly worthy of being called a masterpiece.

The tiered, pillar-like bell-tower of St. John the Baptist, crowned by a small dome, was erected at the turn of the 17th century.

We have yet to deal with two important tendencies in 17th century architecture without which our story of the golden age of church construction in Yaroslavl would not be complete. This was the appearance of the more spacious, better-lit pillarless church at the very end of the 17th century, which occurred as part of the

secularization, to a certain extent, of both church architecture and art. The best example of this new trend is the **CHURCH OF THE EPIPHANY** (25a Ploshchad Podbelskogo across from the Monastery of the Transfiguration) which was mentioned in the section on the monastery. Erected between 1684 and 1693 with monies donated by merchant Alexei Zubchaninov, this enormous five-domed sanctuary has but a single vault "disguised" from the outside by two rows of *kokoshniki.* Nine large windows make the interior, which is not cluttered by the usual pillars, extraordinarily light and airy, creating ideal conditions for the artists, which they did not fail to take advantage of; they also managed to conceal the transition from the walls to the vaults with frescoes, thus making the church appear even taller.

The use of glazed tiles was also perfected in the decor of the Church of the Epiphany. Glaze in shades of green which contrasted well with the red of the bricks was used on the tiles which cover a large part of the surface.

At about the same time – in 1695 – not far from the Monastery of the Transfiguration of the Savior, on the territory of the former Log City (8 Kotoroslnaya Naberezhnaya) – the former site of the prince's residence – the **LOG CHURCH OF ST. NICHO-LAS** (tserkov Nikoly Rublenogo) was built. This urban church has five elegant domes, a low narthex, and a slender bell-tower with a pointed tent roof joined in a single complex, the carefully calculated proportions of which reveal the hand of a skilled master. The whitewashed walls are absolutely plain, while the lyrical charm of the whole draws much from the simple natural beauty of northern Russia, and that is probably why this marvelously uncomplicated type of building became widespread in the construction of a multitude of village churches in Ancient Rus.

The appearance, within two years, of such utterly dissimilar churches as Epiphany and St. Nicholas so close together is one more proof of the fact that there was no set dogma or stagnation in the architectural thought of Russia at the time.

In addition to the fine churches, ancient fortifications and residences have also survived. As we have already noted, the role of the Kremlin (Log City) in Yaroslavl was essentially taken over by the mighty fortress of the Monastery of the Transfiguration, but the nearby settlement had its own fortification works – a series of earthen ramparts with wooden walls and towers which were utterly destroyed in the fire of 1658. In place of the old wooden paling, stone **towers** without walls, of which two have survived to the present day, were erected. The remaining two are the **Volga (Volzhskaya)** or **Arsenal Tower** on the bank of the Volga River (7 Volzhskaya Naberezhnaya) and the **Znamenskaya** (the Tower of the Sign) or **Vlasyevskaya Tower** (21 Ulitsa Pervomaiskaya). Despite later alterations, they have both – especially the latter – retained their impressive appearances.

There are two extremely interesting 17th century dwellings in the city. The first, known as the **IVANOV HOUSE** (4 Ulitsa Chaikovskogo, near the Church of St. Nicholas-on-the-Waters is a typical residence of a well-to-do city dweller of that time with ample storage facilities in the high ground floor, and bed- and living-chambers on the upper floor. The decor of the façades consists of platbands around the windows, a figured cornice, and a band of brickwork between the first and second floors.

An immeasurably richer dwelling – the **METROPOLITAN's CHAMBERS** – (1 Volzhskaya Naberezhnaya) was erected in the 1680s by architects of Rostov Metropolitan Iona who took part in the construction of the Rostov Kremlin. This large two-storey building looks quite elegant after restoration, although a significant part of the original ornament has been lost – the magnificent porches, in particular. The intricate platbands

Volkov Square and the Fyodor Volkov Drama Theater

around the windows, the delicate bands of cut stone between the two storeys, and the flat pilaster strips stand out distinctly against the smooth white wall.

Presently, the Metropolitan's Chambers house the **Division of Ancient Russian Art of the Yaroslavl Art Museum,** one of the richest in the country. The most outstanding work of ancient art from Yaroslavl, the *Virgin Orans* or *Sign of the Virgin* painted in about 1218, is now in the Tretyakov Gallery in Moscow. But the museum collection boasts such excellent pre-Mongolian icons as *The Savior* (mid-13th century) – according to legend, the icon before which local princes Vasily and Konstantin prayed – and the remarkable and deeply dramatic *Virgin of Tolg* (14th century).

Among the 15th century icons in the museum collection are the icons from the Deesis Row of the Church of St. Paraskeva Pyatnitsa at Vspolye (Yaroslavl Region), the *Jerusalem Virgin* from the city of Uglich, and other icons typical of the local school. The richest part of the collection are works of the local Yaroslavl school of icon-painting (the 15th to 17th centuries)

characterized by a rich color gamut, a large number of icons with interesting and varied border scenes, complex compositions, an abundance of details from daily life, and an inclination towards concreteness and accuracy. Among the 16th century gems are such icons as *Holy Women at the Tomb of Christ,* the *Annunciation,* and *St. John the Baptist – Angel of the Desert.* The finer 17th century works include *Life of St. Sergius of Radonezh* and many others.

The Yaroslavl museum also features works by two Russian Orthodox artists of the 17th century – Fyodor Zubov and Semyon Kholmogorets – who came from Veliky Ustyug and Kholmogory (the northern cultural centers of Rus) respectively.

The main part of the museum (23 Volzhskaya Naberezhnaya) is in the former **PROVINCIAL OFFICE BUILDING** erected in the 1820s. Two days after the victory of the October Revolution in Petrograd in 1917 Soviet power was proclaimed in Yaroslavl, and this structure became the People's Building. The art museum has an excellent collection of Russian painting in which all the

The *Karabikha* Estate-Museum

major periods are well represented.

The 18th century marked the advent and development of secular art in Russia, as represented by the portraits of such superb masters as Alexei Antropov, Ivan Argunov, Fyodor Rokotov, and Vladimir Borovikovsky. The rise of national consciousness and a high estimation of the spiritual values of the person were noted in the art of the first half of the 19th century, represented by the works of Orest Kiprensky, Vasily Tropinin, Karl Bryullov, and Ivan Aivazovsky. The flourishing of realism is reflected in the art of the second half of the 19th century; works by artists of this period such as Vasily Perov, Alexei Savrasov, Ivan Kramskoy, Ilya Repin, Konstantin and Vladimir Makovsky, Vasily Vereshchagin, and Ivan Shishkin can be seen in the museum. In treating the complex period of the late 19th and early 20th centuries, we must make special note of the collection of Konstantin Korovin presented here, for it is one of the most valuable and most interesting in the country: many canvases from the final, Paris period of his work are on display here. The other pre-revolu-

tionary pieces in the museum are marked by a high degree of skill and ardent searches for fresh means of expression called forth by the stark changes taking place in the spiritual climate of society. The oils by Nikolai Roerich, Igor Grabar, Boris Kustodiev, and Zinaida Serebriakova are typical of those turbulent days.

The Soviet division of the museum is also worth seeing, for among the artists represented here are Konstantin Yuon, Nikolai Krymov, Sergei Gerasimov, Robert Falk, and Ilya Mashkov.

In the second half of the 18th century, the architecture in the vast majority of Russian cities was altered drastically in connection with the reorganization of the form of local city government. Most of the larger cities received new plans for future construction and reconstruction of the older parts of town (you will recall this fact in connection with your visits to Kalinin, Smolensk, and Vladimir). Yaroslavl was also affected by these innovations, for in 1777, it became the center of an enormous viceregency, since by that time, it had acquired considerable prominence as an indus-

trial and commercial center of Russia.

At the end of the 18th century, the old center of the city underwent reconstruction. On the main streets and squares, next to and around the architectural monuments grew up solidly-built stone administrative and commercial buildings and town houses, all in keeping with the tastes and fashions of the times – and the prevalent style was Russian classicism. You may acquaint yourself with the 18th and 19th century structures of the city while taking a pleasant stroll down Pervomaiskaya, Ushinskaya, Sovetskaya, and Bolshaya Oktyabrskaya streets, the Volzhskaya Naberezhnaya (embankment) and other by-ways where many buildings constructed in the past two centuries are still standing. The most interesting of them are the Trade Rows (Torgovye ryady, end of the 18th century, Ulitsa Bolshaya Oktyabrskaya), the Arcade (Gostiny dvor, 1814-18, 7 Ulitsa Pervomaiskaya), the Matveyevsky Estate (end of the 18th and beginning of the 19th centuries, Sovetskaya Ploshchad), the house of the former Physicians' Society (19th century, 15 Volzhskaya Naberezhnaya), the building of the Theological Consistorium (1815, Ploshchad Podbelskogo), and the Seminary (1818, the corner of Respublikanskaya Ulitsa and Bolshaya Oktyabrskaya Ulitsa). Naturally, various offices are now housed in some of them, while others have been made over into apartments, so they can be viewed only from the outside.

From the Volga Embankment, a good view of the arches of the bridges over the river can be had. You can watch the steamboats making their way up and down the river and get a good view of the new regions of Yaroslavl on the opposite bank where the quiet settlement of Tveritsy stood not so long ago.

The Karabikha Estate

The name of great Russian poet and patriot Nikolai Nekrasov is closely connected with Yaroslavl. Nekrasov preached "great faith in honest labor" in the name of one's home land. And he himself had great faith in the Russian person and his ability to change society. Some of Nekrasov's finest works, including the poems *Red-Nosed Frost, Russian Women, Grandfather,* part of *Who Lives Well in Russia,* and his verses *"Orina, a Soldier's Mother", "Kalistrat",* and *"Renaissance"* were composed at the Karabikha Estate 15 kilometers from Yaroslavl on the Moscow Highway. He lived at Karabikha during the summer months from 1862 to 1875.

In 1949, a **museum** dedicated to Nekrasov with two big departments was opened at Karabikha. The literary department (in the main building) deals with the life and writings of Nekrasov, while the memorial department in the east wing where the poet's private rooms were located has a collection of hundreds of things which surrounded him during his life. Thousands of people visit the museum every year, but the largest number of guests come to Karabikha every year in July when the annual National Nekrasov Poetry Festival is held.

Historical and Architectural Monuments
The Monastery of the Transfiguration of the Savior (25 Ploshchad Podbelskogo)

Holy Gate, 1516
Cathedral of the Transfiguration of the Savior, 1516
Church of the Yaroslavl Miracle-Workers, 1831
Refectory, 16th century
Father Superior's House, 17th century

Jglich Tower, about 1646
Bogoroditskaya (Virgin) Tower, first half of the 17th century
Belfry, 16th century, 1808
Sacristy, 1817

* * *

Church of St. Nicholas – *Nadeyina* (tserkov Nikoly Nadeyina) and bell-tower, 1620-21 – 2a Narodny Pereulok
Church of the Nativity of Christ and bell-tower, 1644 – 1 Ulitsa Kedrova
Church of St. Elijah the Prophet and bell-tower, 1647-50 – 22 Sovetskaya Ploshchad
Church of St. John Chrysostom in Korovniki, 1649-54 – 2 Portovaya Naberezhnaya
Church of Metropolitan Peter, 1657 – Kotoroslnaya Naberezhnaya
Church of SS. Athanasius and Cyril, 1664 – 15 Ploshchad Chelyuskintsev
Church of the Ascension, 1667 – 62 Ulitsa Svobody
Volzhskaya (Volga) or Arsenal Tower, 1658-68 – 7 Volzhskaya Naberezhnaya
Vlasyevskaya (Znamenskaya) Tower, 1658-68 – 21 Ulitsa Pervomaiskaya
Church of the Vladimir Virgin in Korovniki, 1669 – 2 Portovaya Naberezhnaya
Bell-Tower, 1670s, Ensemble in Korovniki, – 2 Portovaya Naberezhnaya
Church of St. Demetrius of Thessalonica, 1671 – 41 Ulitsa Bolshaya Oktyabrskaya
Church of the Transfiguration of the Savior-in-the-City (na-Gorodu) 1672 – 3 Ulitsa Pochtovaya
Church of St. Nicholas on-the-Waters (tserkov Nikoly Mokrogo) and bell-tower, 1665-72 – 1 Ulitsa Chaikovskogo
Church of the Virgin of Tikhvin, 1686 – 1 Ulitsa Chaikovskogo
Church of the Archangel Mikhail, 1657-80 – 67 Ulitsa Pervomaiskaya
Church of St. John the Baptist in Tolchkov, 1671-87 – 68 Kotoroslnaya Naberezhnaya
Bell-Tower of St. John the Baptist in Tolchkov, end of the 17th and beginning of the 18th centuries – 68 Kotoroslnaya Naberezhnaya
Church of St. Theodore, 1687 – 74 Ulitsa Yaroslavskogo
Metropolitan's Chambers, 1680s – 1 Volzhskaya Naberezhnaya
Bell-Tower of the Church of St. Nikita the Martyr, 1693 – 30 Ulitsa Saltykova-Shchedrina
Church of the Epiphany, 1684-93 – 25a Ploshchad Podbelskogo
Log Church of St. Nicholas (tserkov Nikoly Rublenogo), 1695 – 8 Kotoroslnaya Naberezhnaya
Ivanov House, end of the 17th century – 4 Ulitsa Chaikovskogo
Korytov House, 17th century – 7 Ulitsa Zelentsovskaya
Olovyannikov House, 17th century – 27 Ulitsa Sobinova
Rabotnov House, 17th-18th centuries – between Ulitsa Streletskaya and 2nd Tolchkovsky Pereulok
Church of the Annunciation, 1688-1702 – 51 Volzhskaya Naberezhnaya
House of the former Physicians' Society, 18th-19th centuries – 15 Volzhskaya Naberezhnaya
Vakhrameyev House, 1780 – 12/4 Ploshchad Chelyuskintsev
Provincial Office Building, 1780 – 5 Sovetskaya Ploshchad
Courthouse, 1785-87 – 1 Sovetskaya Ploshchad
Kudasov House, 1799 – 4a Krasnyi Syezd
Matveyevsky House with two wings, 18th-19th centuries – 12-14 Sovetskaya Ploshchad
Sorokina House, 1810 – 13 Sovetskaya Ploshchad
Former restaurant Staryi Passazh (The Old Arcade), 1790-1830 – 2/7 Ulitsa Ushinskogo

Theological Consistorium, 1815 - Ploshchad Podbelskogo
Arcade (Gostinyi dvor) with rotunda, 1814-18 - 10 Ulitsa Pervomaiskaya
Seminary, 1818 - 108 Ulitsa Respublikanskaya
Semyonovsky Bridge, 1820 - 58 Volzhskaya Naberezhnaya
Provincial Governor's Pavilion, 1830 - Volzhskaya Naberezhnaya

Monuments

Vladimir Lenin (1939, sculptor V. Kozlov) in Krasnaya Ploshchad
Nikolai Nekrasov (1958, sculptor G. Motovilov) at the beginning of Pervomaisk
 Boulevard
Fyodor Volkov, founder of Russian professional theater (1973, sculptor A. Solo
 vyev) in Ploshchad Volkova
Leonid Trefolev, 19th century poet and democrat born near Yaroslavl (1960
 sculptor A. Chernitsky) in Ploshchad Trefoleva
Obelisk in honor of the Thirtieth Anniversary of the Victory in WW II (197£
 sculptor N. Pimenov) at the intersection of Ulits Svobody and Chaikovskog

Information for Tourists

Hotels
Yaroslavl - Ploshchad Volkova
Yubileinaya - 26 Kotoroslnaya Naberezhnaya
Volga - 10 Ulitsa Kirova
Restaurants
Medved (at the Yaroslavl Hotel) - entrance at 2 Ulitsa Svobody
Volga - 10 Ulitsa Kirova
Moskva - 1 Ulitsa Komsomolskaya
Solnechnyi - 60 Ulitsa Chkalova
Yubileinyi - 26 Kotoroslnaya Naberezhnaya
Museums
Museum-Preserve of History and Architecture (Monastery of the Transfigura
 tion of the Savior) -25 Ploshchad Podbelskogo
Branches of the Museum-Preserve:
 Church of St. Nicholas–*Nadeyina* (tserkov Nikoly Nadeyina) - 2a Narodny
 Pereulok
 Church of St. Elijah the Prophet – Sovetskaya Ploshchad
 Metropolitan's Chambers (ancient Russian art) - 1 Volzhskaya Naberezh
 naya
Art Museum - 23 Volzhskaya Naberezhnaya
Estate of Nikolai Nekrasov at Karabikha - 15 km from Yaroslavl along the Mos
 cow Highway
Cosmos (Space) Museum at the village of Bolshoye Nikolskoye, 27 km to th
 northwest of Yaroslavl, at the birthplace of Valentina Tereshkova, world-fa
 mous first woman cosmonaut
All museums are open from 10:00 a.m. to 5:00 p.m.
Theaters, Philharmonic Society
Fyodor Volkov Drama Theater - Ploshchad Volkova
Children's Theater - Ulitsa Svobody
Puppet Theater - 7 Ulitsa Komitetskaya
Philharmonic Society - 13 Ulitsa Komitetskaya
Stores
Rostovskaya Finift (Rostov Enamel) - 13 Ulitsa Kirova
Jewellery Store - 12 Ulitsa Kirova
Central Department Store - Ploshchad Truda
Podarki (Gift Shop) - 38 Prospekt Lenina

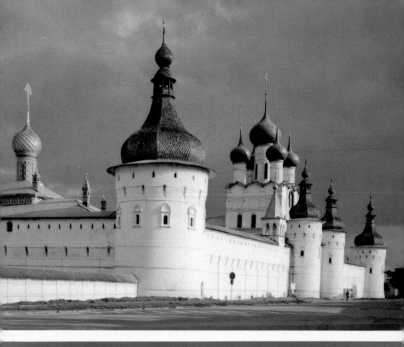

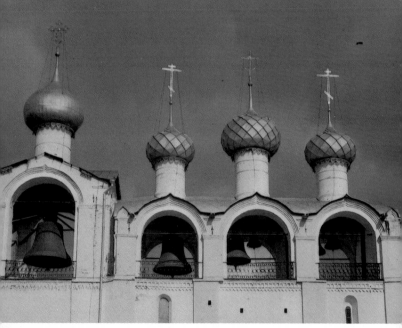

Rostov. The Kremlin

Belfry

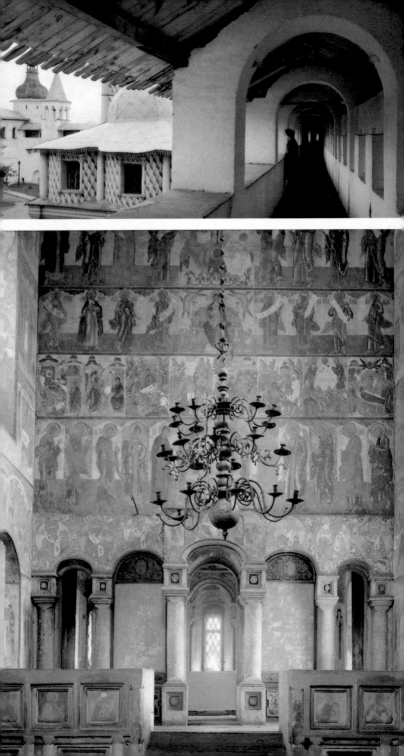

In the gallery

Church of the
Virgin Hodegetria

Interior of the
Church of the
Resurrection of
Christ

Carved wooden
sculpture *St.
George Slaying the
Dragon*

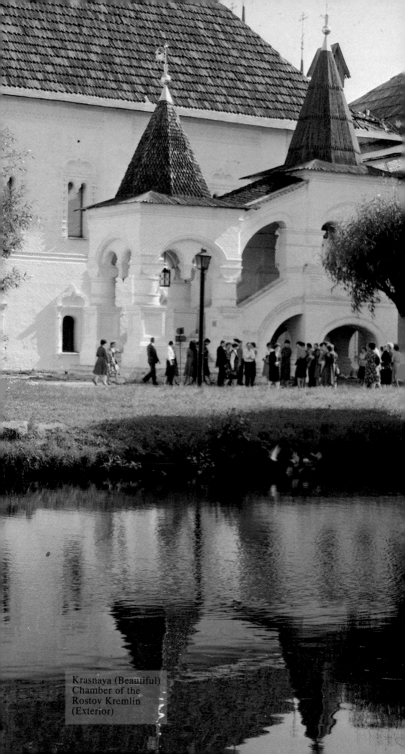

Krasnaya (Beautiful)
Chamber of the
Rostov Kremlin
(Exterior)

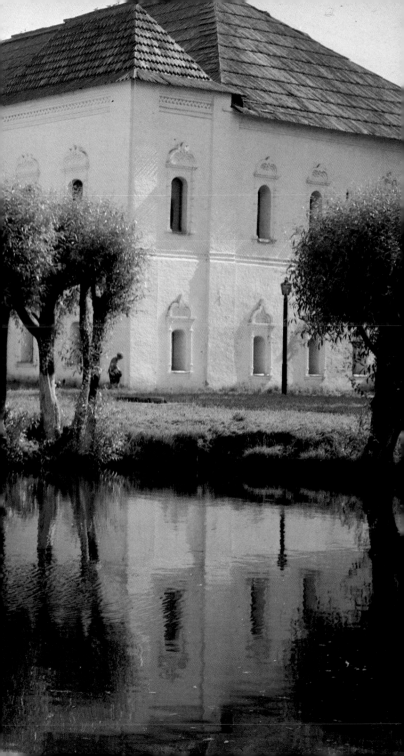

Lion-mask

Monastery of SS.
Boris and Gleb

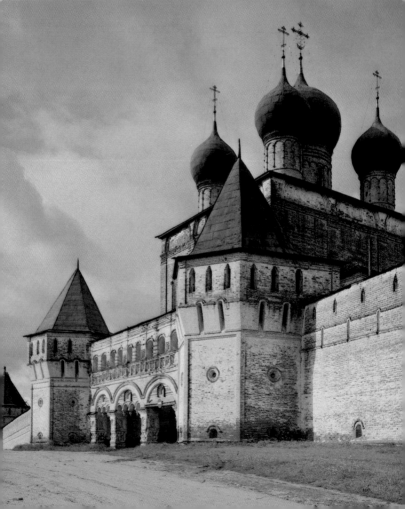

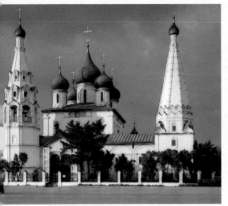

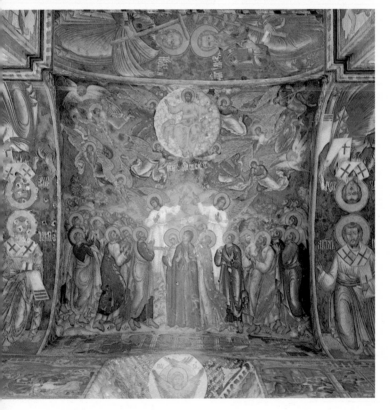

Yaroslavl. The Church of St. Elijah the
Prophet.

General view. Interior.

Detail of fresco.

Monastery of the Transfiguration of the
Savior. View from the Kotorosl River

Yaroslavl ceramic tile

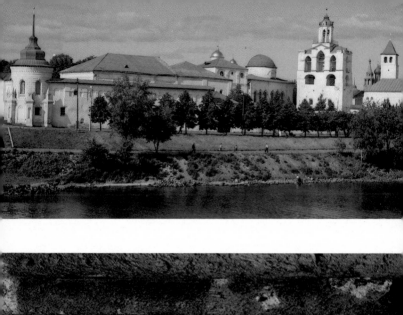

VLADIMIR
SUZDAL

Vladimir

Vladimir, a city of more than 300,000, is the center of Vladimir Region. Located 190 km to the northeast of Moscow along the Gorky Highway on the Klyazma River, it is a railroad junction and industrial center of note in central Russia. Its enterprises produce electric motors, tractors, high-precision machinery, watches, musical instruments, shoes, textiles, and many other goods. The city boasts a polytechnical institute, a teacher's college, a drama theater, a puppet theater, 140 libraries, and a History, Architecture, and Art Museum-Preserve.

The Russian state, which had its beginnings in Kiev, continued to strengthen its hold on the northern lands 'beyond the forests' with great zeal, especially during the reigns of powerful Kievan Prince Vladimir Monomakh and his son Yuri Dolgoruky. But history, who draped first ancient Rostov, then Suzdal with the raiment of the capital city gave this finery at long last to Vladimir, founded in 1108 by Vladimir Monomakh and named 'in honor of himself'.

Archeologists have discovered that Vladimir was founded on the site of a nameless settlement which had existed from the second half of the first millennium B.C. The ancient dwellers of this place were herders who knew something of agriculture. Slavs from the northwestern and western principalities of Kievan Rus migrated to the area at the end of the 10th and beginning of the 11th centuries.

Vladimir flourished under the grandson of Monomakh, Prince Andrei Bogoliubsky, who moved the seat of his government from Kiev to Vladimir in 1158 and began a decisive struggle for the unification of Northwestern Rus in opposition to Kievan Rus, which was torn by internecine strife. Andrei played an important role in the formation of the Great Russian nationality and the Russian nation.

During Andrei's reign, Vladimir's might grew, and a period of energetic building – both in stone and wood – was soon underway. From all corners of Rus, stone-masons, carpenters, joiners, potters, blacksmiths, founders, painters, and jewellers responded to Andrei's call. Even foreign craftsmen – Germans, Poles, Caucasians, and men from Byzantium – came to Vladimir. Fortifications, cathedrals, monasteries, and towers sprung up like mushrooms in the new Russian capital.

Prince Andrei was able to realize only part of his grandiose plans: his Vladimir outshined the glitter and glory of Kiev, but he did not succeed in uniting the Russian lands under the new capital, for in 1174, he was murdered as the result of a plot by the boyars. Neither did his brother and successor, Vsevolod Big Nest, manage to do this, although Vladimir

reached its pinnacle during his reign. Vsevolod was hampered in his plans by enemies from without: in 1238, after fierce resistance by its defenders, Vladimir was taken by the Tartar invaders, and the city was pillaged and burned.

However, even under the Tartar yoke, Vladimir remained the center of Northeastern Rus. It was here that the See of the Metropolitan of All Rus was located at the end of the 13th and the beginning of the 14th centuries, and it was in the Cathedral of the Dormition that the coronation of the Great Prince took place. But with the rise of Moscow, an inevitable lessening in the significance of Vladimir occurred, so by the beginning of the 16th century, it had become just an ordinary city with a glorious past. Although Vladimir became a provincial center in 1796, this had almost no effect on its economic development, and at the beginning of the 19th century, it was a sleepy little town far off the beaten track in which existence continued from day to day simply by force of inertia. Fortunately, despite adversities, fires, and human neglect, the area around Vladimir is rich in priceless reminders of its golden era, serving as a mighty bridge between the ancient state of Kievan Rus and the more modern centralized government at Moscow. In the city itself, three pre-Mongolian buildings have survived: the Golden Gate, the Cathedral of the Dormition, and the Cathedral of St. Demetrius.

In fortifying Vladimir, Prince Andrei departed somewhat from the customary scheme for ancient Russian cities of a fortified citadel (Kremlin) with a settlement beyond the walls, behind which the local people would take cover in the event of an attack. Andrei created a triple system of defenses, surrounding the entire city with the outer walls (an analogous situation can be found in Smolensk, where four and a half centuries later, the settlement was likewise enclosed by a wall.) All that remains of this complex system of defenses is the **GOLDEN GATE** (at the beginning of Ulitsa Tretyego Internatsionala) built between 1158 and 1164.

The main gate to the city got its name from the Golden Gate of Kiev, which, in turn, was named in honor of the Golden Gate of Constantinople. The doors, experts assert, were covered with sheets of gilded copper which were stripped off by the Tartar invaders when they sacked the city.

Towering high above the other structures of the city, even today, the gate is the main entrance to old Vladimir from the direction of Moscow. However, in the more than eight centuries of its existence, the gate has undergone a series of alterations. The most ancient part is a high, rectangular frame on which the original forged hinges that held the enormous oaken doors in place can still be seen. Over the centuries, the arch has sunk a full two meters into the earth. Above the doors was a battlement, and to this day, the rectangular grooves for the insertion of the planks for this platform can be seen. From here, the defenders shot down at the attackers and poured boiling tar or water on them.

The gate was erected using the rubble masonry method: the space between two closely-fitted slabs of white stone was filled with cobblestones and mortar. The vaults that eased the structure were of tufa. The gate itself was shut with a heavy iron squared beam.

At one time, the enormous arch was crowned by the gold-domed Church of the Deposition of the Robe, while the present brick church was built at the end of the 18th and beginning of the 19th century. At the same time, the sections of the earthen ramparts adjoining the gate were removed, and in their place, the round towers with buttresses concealed inside were built to keep the arch from collapsing.

Now, a **Military History Exposition** telling of the valor and bravery of the people of Vladimir from the 12th cen-

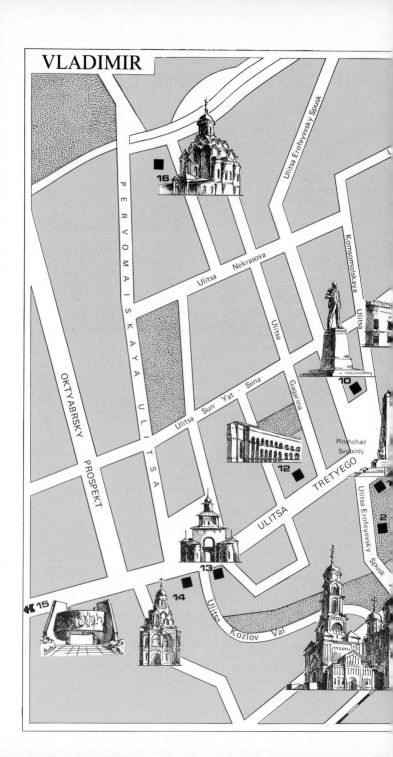

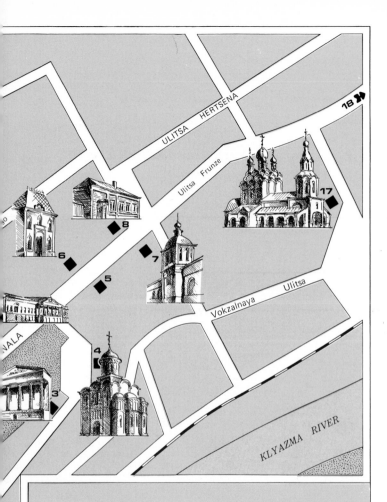

1. Cathedral of the Dormition, 12th century
2. Town Council, 1906-1907
3. Gubernia Office Building 1785-1790
4. Cathedral of St. Demetrius, 12th century
5,6. Vladimir and Suzdal Historical and Architectural Museum - Preserve
7. Monastery of the Nativity, 12th-18th centuries
8. Stoletov House-Museum
9. Noblemen's Club, 1826
10. Monument to Lenin, Svoboda Square
11. Monument in Honor of the 850th Anniversary of the Founding of Vladimir
12. Trading Arcade, 1787-1790
13. Golden Gate, 12th century
14. Exhibition of Crystal, Laquered Miniatures and Embroidery, Church of the Trinity
15. Monument with Eternal Flame in honor of the Vladimir people fallen in the Civil War and World War Two
16. Cathedral of the Dormition in the Knyaginin Convent, 15th-16th centuries
17. Church of Our Lady, 1649
18. Monument to Mikhail Frunze

Panorama of Vladimir

tury to the present is housed in the Golden Gate. The sixty steps of the inner staircase lead to the gateway church, in the center of which is a diorama with a sound-track recreating episodes from the battle against the Tartar Hordes. The exposition boasts weapons from the 13th century and later years: charges for catapults, various types of poleaxes, flintlock rifles, and swords.

There is a bust of Prince Dmitry Pozharsky who led the home guard that drove the Polish-Lithuanian invaders from the country at the beginning of the 17th century, as well as one of the few portraits of great Russian Generalissimo Alexander Suvorov done during his lifetime — both tributes of the people of Vladi

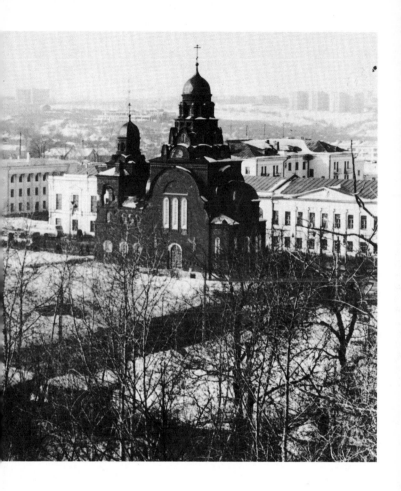

mir to their famous native sons. Another prominent military man from Vladimir was General Nikolai Stoletov, who led the Bulgarian home guard in the Russo-Turkish War of 1877-78. The Order of the Bulgarian People's Republic naming the summit of the Shipka Pass in honor of General Stoletov hangs in this section of the exhibition.

The Gallery of Heroes of the Soviet Union, located where the 12th century battlement once stood, tells of the feats of valor performed by people from Vladimir during the Second World War. For their bravery, more than 160 men and women from this town were awarded the high title of Hero of the Soviet Union during the last war.

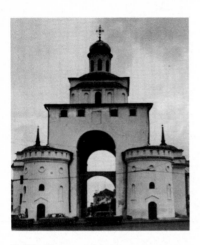

Golden Gate

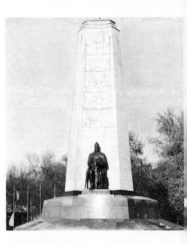

Monument in honour of the 850th
Anniversary of the founding of Vladimir

The **CATHEDRAL OF THE DOR-
MITION** (Uspensky sobor), the ancient
heart of Vladimir, was erected in the
brief space of two years, between 1158
and 1160, and dedicated by Prince And-
rei to the Dormition of the Virgin,
which, according to the Church Calen-
dar, coincided with the chief festival of
St. Sophia's Cathedral in Kiev. In this
manner, Andrei wished to emphasize
that this cathedral was the successor
to the older, Kievan one. There was
another symbolic significance to the
choice of this particular name for the
new cathedral: just as the twelve
apostles, who had scattered to the
four corners of the earth gathered
round the Virgin's death-bed, the
Russian principalities, divided by
internecine strife, should unite and
rally around Vladimir. Thus, the new
cathedral served the noble goal of
uniting the Russian lands, Prince
Andrei's most ardent desire. Andrei,
following the example of the builder
of the most ancient church of Kiev –
the Church of the Tithes, of which the
foundations have been located – con-
tributed a tenth of his riches and reve-
nues to the construction of the

cathedral.

The Cathedral of the Dormition
was the largest structure in the new
Russian capital of Prince Andrei and
the architectural focal point of the
city. From the crest of the hill on
which it was situated, the great church
towered over the city and its surroun-
dings. Built entirely of white stone
and crowned with a single gilded
dome, the richly – even lavishly –
decorated church with its fine interior
made an indelible impression on ev-
eryone who saw it. In fact, people
were so struck by the cathedral that
legends began to spring up about it.
Thus, seventeen years after its com-
pletion, one of the many 'miracles'
associated with the church occurred to
Andrei's brother Vsevolod, who was
setting out on one of his many cam-
paigns: as he passed through the city
gate and was ascending a hill, the sol-
diers were looking lovingly out at the
city to bid it farewell before the battle,
when suddenly, before their very
eyes, they saw the mighty Cathedral
of the Dormition suspended above
the white stone city. And in fact,
sometimes the rays of the rising sun

strike the cathedral in such a way as to make it appear that the church has left the earth and is soaring among the clouds.

In 1185, the Cathedral of the Dormition was badly damaged by the fire that swept through the city: thirty-two churches alone were burned to the ground. Cracks appeared in the blackened walls of the cathedral, and the bonds that held the stones together came loose: a very dangerous situation, since the building could collapse at any minute. Therefore, extensive repair work was carried out on the church between 1185 and 1189; alterations in the design were also made in keeping with the spirit of the times, for this was the zenith of Vladimir's prominence in Russian history. The craftsmen of Prince Vsevolod Big Nest built new walls around the old ones, added four domes, enlarged the chancel, and added a gallery. The light, exultant architecture of the old church was replaced by the solemnity and majesty of the new building, truly a more appropriate burial place for the great princes of the Russian state. Essentially, this is the form in which the cathedral has come down to us despite all the misfortunes and adversities that have beset it over the centuries. In 1810, a tall bell-tower was erected next to the cathedral, and in 1862, a winter or heated side-chapel – the Chapel of St. George – was built between the cathedral and the bell-tower. During the extensive restoration work carried out in recent years, the surfaces of the carved white stone walls were reinforced, and new fragments of the ancient frescoes were uncovered.

The restorations have improved the appearance of this ancient monument considerably. Rising from the steep bank of the Klyazma River, the massive white stone building is as breathtaking today, in contemporary Vladimir, as it was in the days of Prince Andrei. Its façades are rather austere, with their subdued, laconic carved pattern. But in contrast, the portals and apertures of the windows have rich, intricate profiles. Naturally, the feature present in every church in Vladimir, a band of blind arcading – is present here as well.

The interior of the cathedral holds many surprises for the visitor as well: the unusually high main nave is well lit by the twelve-windowed lantern of the central dome. The ancient nave is connected to the galleries dating back to the time of Vsevolod Big Nest by a system of arches and apertures cut into the original walls of the cathedral. In one of the niches of the galleries are located the sarcophagi of Andrei Bogoliubsky and Vsevolod Big Nest, who are buried under the vaults of the cathedral.

The enormous gilded iconostasis (1773-74) is 25 meters high at the center. It contains a hundred icons. The most ancient of the icons from this iconostasis, which are the work of the great Andrei Rublev himself, are now in the Tretyakov Gallery in Moscow and the Russian Museum in Leningrad.

The **frescoes** are among the most valuable attributes of the cathedral. The greatest artist of Ancient Rus, Andrei Rublev, worked here with Daniil Chyorny and their assistants in the summer of 1408. (The technology of the time required that fresco-painting be done only in the summer.) In the 19th century, the artists invited to do the restoration work simply scraped off the frescoes by Rublev and painted new ones in their place. The fragments of the old painting which miraculously survived were uncovered in 1918, and many thought no new discoveries were in the offing.

However, it was not in vain that scholars referred to the Cathedral of the Dormition in Vladimir as the chief book of ancient Russian art which had not yet been read to the end. Over the past few years, a group of specialists from the Vladimir restoration workshops under the direction of Alexander Nekrasov have made some amazing discoveries, uncover-

Cathedral of the Dormition

ing new fragments of Rublev's fres-
coes on the walls and vaults of the
cathedral. And even more amazing
are the previously unknown frescoes
found under the layers of soot, dating
back to the time of the reconstruction
of the cathedral under Vsevolod the
Big Nest, and fragments of the origi-
nal decorative painting done in 1161
by Andrei Bogoliubsky's artisans.

The reader is already familiar with
the painting of the brilliant Rublev in
connection with his work at the Trinity
Cathedral in Zagorsk. This master of
genius worked in Vladimir near the
beginning of his career but already his
search for the ideal man shows through
clearly. Again we have the striking
images which come from purity of spir-
it, a sense of harmony, cleanness of line,
and use of colors which allow us to
experience the spiritual richness of the

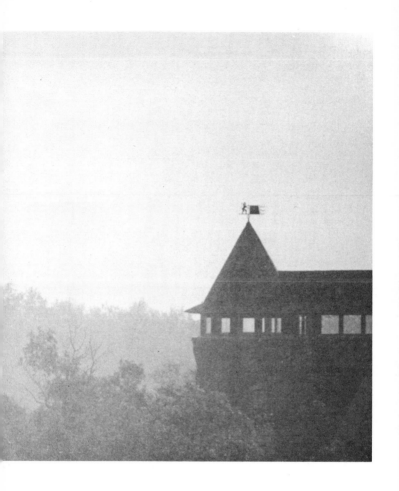

nest people of the distant past.

A large part of the fragments uncovered recently deal with the Last Judgement, an ever-present theme in the frescoes of almost every Orthodox church from the times of Byzantium. Generally, in such compositions, sinners writhe in torment and despair when called before the Judgement throne to answer for their evil deeds. Yet the torments, hatred, and despair which were so abundant in the cruel atmosphere of those troubled times are contrasted in the works of Rublev with love and kindness. Pessimism is countered with the belief that evil will be overcome in the end, giving place to love and eternal harmony. This is the message the angels depicted on the entrance arch seem to be trumpeting, and this is precisely the thought put across in the composition, *The Procession of the Righteous into Hea-*

ven, on the southern pier and the slope of the southwestern vault.

The other frescoes by Rublev which have been uncovered, *The Transfiguration, The Descent of the Holy Ghost, Epiphany,* and *The Rejection of Cain's Offerings,* revealed new and important facets of this great artist's talent. Until the discovery of these frescoes, it was believed that in his murals as opposed to his icons, Rublev worked more like a graphic artist, since in the murals discovered earlier, the colors had been faded by dampness, and the play of the various hues had been lost. But now it is obvious that this was merely the result of the use of imperfect emulsions which faded the frescoes as the restoration work was being carried out. By comparison, it is sufficient to glance at the remarkably rich gamut of hues in a recently discovered fresco in which the torso of a soldier is depicted. Here, the rendering of the image is purely artistic rather than decorative, and it is quite clear that Rublev was an outstanding colorist in his monumental works as well as in his icons.

The third treasure of Vladimir which has come down to us from the 12th century is the **CATHEDRAL OF ST. DEMETRIUS** (Dmitrievsky sobor, 60 Ulitsa Tretyego Internatsionala) erected between 1194-97 by order of Prince Vsevolod Big Nest not far from the Cathedral of the Dormition, likewise on the edge of the precipice. The church may be reached by passing the enormous edifice of the Provincial Administrative offices, built in the classical style at the end of the 18th century between the two cathedrals.

After the stern might of the enormous Cathedral of the Dormition, embodying the political power and independence of the Vladimir princes, it is difficult to imagine a building which could compete with it in the expression of these ideas. But nonetheless, upon seeing the Cathedral of St. Demetrius, and admiring its brilliant sense of proportion and architectural rhythm, as well as its amazing white stone carvings, you

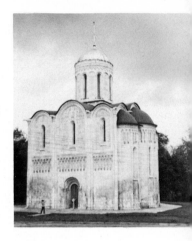

Cathedral of St. Demetrius

cannot help but realize that truly, this relatively small, four-piered, single domed church (much like the original Cathedral of the Dormition) was perfectly capable of expressing the might of the Vladimir princes.

It is impossible to tear your eyes away from this cathedral; you involuntarily seek to discover the nature of its particular charm and fascination, for the form is quite a simple one: four walls and a dome. The unusually forceful impression the church makes is due largely to the clever architectural techniques which have been employed. The lower part of the building, which seems to grow from the hill, is almost bare of decoration, the plain, even surface is broken only by the sharp lines of the doors. Although the upper tier, which is covered with carvings, is not very high, the curved *zakomari* and apses of the church make it seem to strive heavenward. And this upward thrust is further emphasized by the semicylindrical pilasters which divide the façades vertically into three parts, and by the ideal proportions of the lantern, the diameter of which is identical to the width of the central section

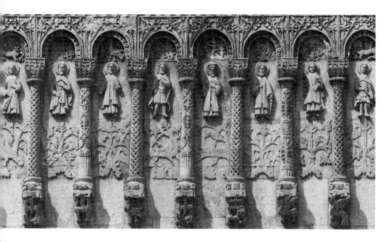

White stone carving on the walls of the Cathedral of St. Demetrius

of the façades, while its height is slightly less than that of the upper, ornate tier of the cathedral. The gilded, helmet-shaped dome has gently sloping outlines and subtly completes the composition of the building.

The most amazing feature of the Cathedral of St. Demetrius is its white stone **carving**. The band of blind arcading dividing the two tiers is highly decorative: the colonnettes seem to hang down onto the smooth walls of the first tier like luxurious carved fringe. And above the band of blind arcading covering the surface of all the façades is a host of mythological creatures: birds, beasts, and floral patterns totally at variance with the church canon which dictated the proper themes for such art. It seems all the favorite subjects of ancient Russian woodcarving are represented here. Obviously, the clergy didn't dare to interfere with Vsevolod's desires – for the images used in the decoration of the cathedral are clearly pagan – especially since the structure was erected as the royal church. Instead, they silently took their revenge for his lack of respect: generally, those who commission cathedrals are lavishly

praised in the chronicles, but in this case, not a single word was said of the construction of the marvelous new cathedral – a fact which caused future scholars infinite trouble in establishing the date when the building was erected. Finally, this date was determined with the help of indirect data.

The reason for the enormous collection of plants and animals depicted on the cathedral walls – more than 500 figures in all – does not seem so strange if we take into account the symbolism behind it, for the decoration of the façades shows that the might and authority of the prince metaphorically extend to the whole world. This idea is expressed most clearly on the northern façade, which faces the city, where Prince Vsevolod himself is depicted enthroned, surrounded by his sons. Another segment of carving which treats the same idea is the composition, the Ascension of Alexander the Great, representing the divine origin of royal power, on the southern façade. This subject was quite a widespread one in Medieval Europe, appearing on the walls of St. Mark's in Venice, and it was also well known in Rus. The intentional placement of these two carvings on opposite sides of the church can only

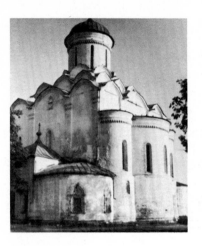

Cathedral of the Dormition of the
Princess's Convent

mean that Vsevolod, who like Alexander, had extended his power over an enormous territory, was calling for a strong, unified, hereditary power to which the boyars should submit, so Rus would become as mighty a state as the Greek Empire had been under Alexander.

The cathedral vaults are quite high and majestic. Here, the light streaming through the narrow windows illuminates the fragments of fine 12th century frescoes in which the Twelve Apostles, a Host of Angels, and the Procession of the Righteous Being Led into Heaven by the Apostle Paul are depicted. Scholars believe that these frescoes were painted by two masters, one a Greek, whose work can be distinguished by the stern, tense expressions on the faces of his figures, and the other a Russian whose manner of painting is softer and more poetic.

As in other Russian cities, stone building was interrupted for a long period in Vladimir by the Mongol Yoke, so the next-oldest structure in the town after these three pre-Mongolian masterpieces is the **CATHED-**

RAL OF THE DORMITION OF THE PRINCESS'S CONVENT (Uspensk Sobor Knyaginina monastyria) which dates back to the end of the 15th and beginning of the 16th centuries. The convent is not far from Victory Square (Ploshchad Pobedy across from the cathedrals of the Dormition and St. Demetrius. It was founded at the turn of the 12th century by the wife of Vsevolod Big Nest Princess Maria, and thus, the convent got its name. The convent's old cathedral in which both the princess and her sister Anna, who became Vsevolod's second wife, were buried, did not survive, so the existing church was erected on its foundations Although the façades of this church are bare of decoration, the fact that the single dome rises from two tiers of *kokoshniki* gives it a very elegant appearance.

The well-preserved **frescoes** of the cathedral, executed in the mid-17th century by an artel of Moscow icon painters under the direction of Mark Matveyev, are extremely interesting For example, in the scene, the *Last Judgement,* you can feel the transition from the peacefulness and lucidity of Rublev to a passion for realistic detail complex composition, and intricate treatment of subject which marked the art of the new period. Where earlier had reigned hope and love, again horror and grief made their appearance. This fresco suggests the inevitability of atonement for one's evil deeds via the representation of monstrous serpent coiled about group of sinners, squeezing them to death. A tiny figure, naked and quite alone, symbolizing the human soul, is pictured amidst the nightmarish yawning graves.

In 1649, when Vladimir was no longer the capital and had even fallen behind the other cities of Rus in its development, on the same side of the ravine above the Klyazma River where the ancient cathedrals stand the extremely graceful **CHURCH OF OUR LADY** (Bogoroditskaya tserkov

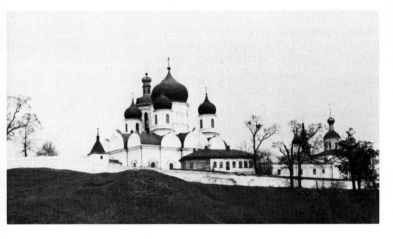

Bogoliubovo architectural ensemble

106 Ulitsa Tretyego Internatsionala) was erected. This tall, finely-proportioned church has closely-fit onion-shaped domes on elongated drums atop a triple row of *kokoshniki*. One of the more interesting attributes of this church was the enormous wax candlestick made in the form of a candle, and therefore known as the **"slender candle".** The object was hollow and the entire surface was painted with vivid, colorful folk ornament characteristic of the time, for secular motifs had finally made their appearance in religious art. The "slender candle" is presently on display at the Vladimir Museum.

Some 18th century secular structures are still standing in the city as well. The most interesting of them is the **ARCADE** (Gostiny dvor) built in the style of Russian classicism (1787-92, presently rows of shops) and the long former **NOBLEMEN'S CLUB** building with its curious combination of two orders of columns (presently the Officers' Club) as well as a **GYMNASIUM FOR BOYS** or high school (presently an institute at which school teachers may upgrade their qualifica-

tions, 1826, 1841, 33 Ulitsa Tretyego Internatsionala).

Contemporary Vladimir is a city of growing industry and tourism. New hotels and restaurants are being built, while old buildings are constantly being renovated and employed in the tourist industry. These various museums and exhibitions acquaint the visitor both with the ancient culture of old Vladimir and with modern life in this fascinating town.

In the old Water-Tower (Kozlov Val), the upper floor of which has been turned into a viewing platform, the extremely interesting **exhibition** *Old Vladimir,* has been opened to provide information on the life and customs of the city dwellers from the second half of the 19th to the early 20th century. Sign-boards, periodicals and official documents are exhibited to recreate the atmosphere of pre-revolutionary Vladimir.

The **History Exposition** is housed in the main building of the Vladimir-Suzdal History, Art, and Architecture Museum-Preserve (64 Ulitsa Tretyego Internatsionala).

The **Memorial House-Museum of**

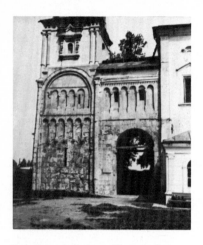

Bogoliubovo. Staircase Tower and passageway

the Stoletov brothers – General and Hero of Shipka Pass Nikolai (1833-1912) and well-known scholar and physicist Alexander (1839-96) – is located at 3 Ulitsa Stoletovykh.

In the halls of the **picture gallery** (Vladimir's 850th Anniversary Park) are works by Russian and Soviet artists Ivan Nikitin, Fyodor Rokotov, Vasily Tropinin, Alexei Savrasov, Ivan Shishkin, Ivan Aivazovsky, Viktor Vasnetsov, Nikolai Romadin, Anna Golubkina, and contemporary Vladimir artists.

In the enormous stone former Old Believers' Trinity Church (Troitskaya tserkov), built at the end of the 19th century near the Golden Gate, is housed an **exhibition of folk and applied art:** laquered miniatures painted on papier-maché boxes and caskets with black backgrounds from the city of Palekh; articles of glass and crystal, old and new, from the city of Gus-Khrustalnyi; and embroidery from the city of Mstera.

The **Industrial Goods Exhibition** (47 Oktyabrsky Prospekt) acquaints visitors with the products of Vladimir's various industrial enterprises, such as precision machines with digital controls, pianos, motorcycles, televisions, watches, refrigerators, and furniture with the Vladimir trademark which is known in more than a hundred countries.

Bogoliubovo

About 10 km from Vladimir along the Gorky Highway is the settlement of Bogoliubovo where Prince Andrei Bogoliubsky built his residence when he transfered the seat of government from Kiev to Vladimir.

We must pause to say a few words about the **SUNGIR GULLY** in passing. Not long ago, this name was familiar only to the residents of the nearby villages and the workers from the brick factory which dug its clay here. But today, thanks to a unique archeological discovery, Sungir is known to scholars and tourists everywhere. It all started in 1956 when an excavator scooped some mammoth bones from the quarry. The archeologists began their work, and thus, a human settlement dating back more than 25,000 years was discovered. The graves of a man and two teenagers, implements of labor, various utensils, and jewellery were located there. These finds allowed scholars to partially reconstruct the way of life of the inhabitants of Sungir. It seemed their manner of living was not nearly so primitive as had been imagined earlier: for example, the people's "wardrobe" consisted of breeches sewn of leather and fur together with the shoes, as is presently common practice with toddlers' pajamas, and shirts which were pulled over the head, cloaks held together at the neck by a pin of bone, and round fur caps. This garb strongly resembles the present-day clothing of the peoples of the Far North.

No less interesting is the Sungirians' arsenal: daggers, spears, and javelins of straightened mammoth tusk which was subsequently bent to the necessary shape, a task beyond

the powers of modern technology.

Extremely important for archeologists were the unique examples of primitive art: beads made of mammoth bone, figures of horses, bone figurines, pendants, and other pieces of jewellery. Several of the objects have decorations in multiples of five, which leads scholars to believe that the inhabitants may have had elementary counting skills. Objects used in extremely complex rituals characteristic of much later periods have also been found.

At the sight of these finds, a branch of the Vladimir-Suzdal Museum-Preserve will be built.

The **FORTRESS OF PRINCE ANDREI** was built simultaneously with Vladimir in 1158-65 and was quite an unusual structure for those times, according to the chronicles, being made entirely of stone, including the walls – a fact which is confirmed by archeological evidence as well.

At the center of the ensemble was the **Cathedral of the Nativity of the Virgin,** the remarkable beauty of which was touted in the chronicles. It also amazed the many foreign guests who were received by the prince at his residence. The façades were richly decorated with carving, frescoes, and gilding. The interior, which glittered with gold, silver, pearls, and precious stones, was even more lavish. Unfortunately, in the 17th century, in keeping with the fashions of the times, the windows of the ancient building were widened. As a result, cracks appeared, and it eventually collapsed. Only the northern wall remained, and it was incorporated into the structure of the church of the same name built on this site a bit later.

The prince's palace, the fortress walls and towers, and the gateway church did not survive even that long, for after the death of Andrei, the princely residence was transferred to Vladimir, and Bogoliubovo was repeatedly attacked and looted by the Tartar Hordes. Gradually, neglect and the passage of time wore away the fine ornament of these examples of ancient architecture.

So now, all that remains to us from the time of Andrei is a monument which can immediately be distinguished from the 18th and 19th century structures. This is the **Staircase Tower and passageway** leading from it to the Church of the Nativity of the Virgin. It can be distinguishes not only by its porous white stones façade, chipped with time and turned greyish-yellow with the centuries, but also by its band of blind arcading so typical of Vladimir architecture, and by the semi-columns which lead all the way to the semi-circles of the *zakomari*, as is the case with the Cathedral of St. Demetrius. The design and construction on the whole are quite refined, especially the marvelous triple-arched window on the west side of the tower. The tent-roofed bell-tower was added in the mid-18th century.

If you ascend the winding staircase to the second storey of the tower, from which, in ancient times, it was possible to follow the various passageways, bridges, galleries, and walls all the way around the perimeter of the fortress without setting foot on the ground, you will be able to see the later murals with scenes of Prince Andrei's murder on the walls of the remaining passageway.

What actually happened on that tragic June night in 1174? The first step in this bloody denouement had been taken long before by Andrei's father, Yuri Dolgoruky, who had condemned to death the rich, influential Rostov Boyar Kuchka, and then married his son to the daughter of the executed boyar. Although the son cannot answer for his father, a secret grudge against the princes remained hidden in the hearts of the Kuchka clan. During the turbulent years of his reign, Andrei managed to bring Kiev, Novgorod, and almost all the other cities of Rus under his control, practically becoming the ruling prince of all Rus. The younger vassals of the prince and the boyars, knowing he was quick to anger and even quicker to take

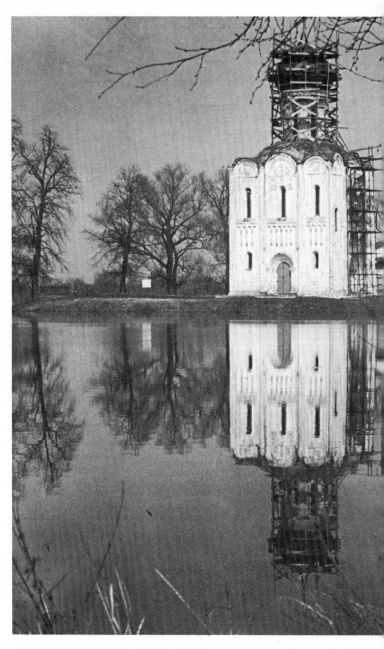

Church of the Intercession on the River Nerl

Band of blind arcading of the Church of the Intercession on the River Nerl

revenge, were reduced to servile obedience: for the least infraction, heads would roll. The sculpture of the prince reconstructed by Soviet anthropologist Mikhail Gerasimov is quite revealing, showing the prince as intelligent, authoritative, cruel, and accustomed to limitless power, indomitable, and having an uncontrollable temper. His prominent cheek-bones are clearly those of his maternal grandfather, Ayub Khan of the Polovtsi.

Andrei's fatal mistake was ordering one of his brothers-in-law executed, for this revived long-dormant enmities. The frightened Kuchka clan, Andrei's wife included, decided to rid themselves of their old enemy. They bribed Andrei's servants and stole all the weapons from the prince's bed-chamber. Then after a round of drinking in the palace cellar to give them courage, the plotters groped their way up the stairs and burst into the defenseless prince's bed-chamber in a crowd. They tormented the helpless prince for a long time, wreaking their vengeance at last, then they stumbled back down to the wine cellar. However, the heavily wounded prince found the strength to crawl to the passageway at the staircase and call for help. Here, he was found by the boyars, who had followed the trail of blood from the bed-chamber. The boyars finished off the hapless prince and looted the palace. And thus ended the life of one of the most oustanding rulers and diplomats of Ancient Rus.

Through the north portal of the new cathedral, erected in the 18th century, you can reach the **museum** housed there. The museum contains archeological finds located during the excavations carried out at the fortress: stone female masks (the symbol of the Virgin Mary), fragments of carved capitals and other pieces of stone, and fragments of brightly painted majolica tiles. By the south wall of the fortress which was found during the excavations, the mighty circular stone piers that were the foundations of the cathedral of Andrei Bogoliubsky have been uncovered, revealing the location of this church.

On the present structures of the Bogoliubsky Monastery, the open 17th century **chapel** resting on four pear-shaped piers, which stands across from the Church of the Annunciation, attracts attention. It was erected in 1683, but was extensively altered during the restorations carried out in

1804. As excavations have shown, the tiny shrine stands on the site of the ancient Holy Canopy: in the earth below it, fragments of a round stone bowl on a three-stepped pedestal were found. Legend has it that when Prince Andrei paid the palace builders for their labor in silver, he drew the money from this bowl. On one of the stones is carved his coat-of arms, proving it the work of local craftsmen.

The enormous cathedral and the bell-tower, rising high above the other structures, were erected here in the mid-19th century.

The fortress of Andrei Bogoliubsky which stood, like the ancient fortress of Vladimir, on a high embankment once washed by the Klyazma River that has now receded from the monastery walls, having cut itself a new bed, is but a prelude to the most marvelous and perfect of all monuments of ancient architecture on the lands of Vladimir: the world-famous **CHURCH OF THE INTERCESSION ON THE NERL** (tserkov Pokrova na Nerli). The road to the church leads down Bogoliubsky Hill in the flood plain below.

The path winds for just over a kilometer through the hollow until it comes to a small grove beyond which the perfectly-proportioned single-domed church rises, reflected in the small lake that forms each year with the spring floods. The solitary church stands in the midst of a blooming meadow like a child of nature, sending the viewer into raptures of reflection on the noblest of motifs.

A great deal could be said about how the unnoticeable slant of the walls to the center creates the illusion of perspective from afar, and of the skillful division of the façades, of the increased height of the central apse, and other subtle techniques masterfully employed by the builders to give this church its uncommon lightness and airyness. But here on the flood plain at the confluence of the Nerl and the Klyazma, all our usual explanations and definitions, all our attemps to explain through elucidation of individual details the charm of this superb building seem quite unnecessary and out of place. Therefore, since the reader, nearing the end of his journey, is probably tired of all the belabored explanations and elucidations presented herein, we suggest that you simply contemplate this, the most perfect masterpiece of ancient Russian architecture to have come down to us without lingering on these pages for any explanation. No doubt, the reader would rather have a word about the history of this gem's creation in any case, for everything about it is quite unusual, beginning with the fact that it stands alone, far from any human habitation. But the moment you attempt to imagine this church not in the midst of nature but surrounded by other buildings, something of its charm is lost. From a technical point of view, it seems the church was placed in an absolutely miserable location – in the middle of a flood plain – but somehow it seems the building is floating on the water during the spring floods, and in the midst of the enormous winter ice floes, it is beautiful as at no other time of year.

The immediate reason for the erection of the church (in the space of a single summer!) was the death of the eldest son of Prince Andrei, Izyaslav, the heir to the throne of Vladimir, in the successful campaign of 1164 against the Volga Bulgars who were hampering trade relations between the Russians and the countries of the East and the Caucasus – or so the chronicles inform us in any case. Contemporary historians are more inclined to believe that the main reason for the building of the church at the confluence of the Nerl and Klyazma rivers, the gateway to the lands of Vladimir and Suzdal for those travelling by water, was visually to assert and enhance the might and power of the principality before all who happened to pass by: visitors to the city, ambassadors, and merchants from the East,

the Volga and the Oka. They feel that this was not originally a modest, intimate church, but looked rather a sumptuous imposing double-tiered mausoleum surrounded by a gallery. This point of view is supported by archeological excavations, but still it is sad to part, even in one's imagination, with the image of the solitary church as it is today, or to think that it might have undergone extensive alterations.

But nonetheless, such features as the female masks which make up a part of the rather modest decor of the façades, and which express such pain, grief, and empathy remind us first of all of the very personal nature of this monument. Thrice the figure of King David playing his psaltery appears on the façades, while birds – the ancient symbol of the Universe – and peaceable lions – the symbol of power and might – from whom predatory griffons are hiding in fear all listen to David's music, entranced. Both the appearance of the church and the symbolism of its carvings point to the idea that good will triumph over evil, to an ideal world in which there is love and harmony between man and nature, and to the fact that given the conditions and cares of life in those days, it made sense to take up Prince Andrei's call for peace and accept his plan for a single Rus, united under the authority of the Vladimir princes.

To understand how sincerely and insistently he strived to achieve that unity, it is sufficient to note that he boldly named his new church in honor of the Intercession of the Virgin and despite the risk of angering the clergy, he single-handedly proclaimed a new church holiday – Pokrov, or the Feast of the Intercession – to be celebrated on 1 October of each year. He took this decision without the consent of the Patriarch of Constantinople or even the Metropolitan of Kiev, an action which was clearly a sacrilege, and which might have led to the interference of the church hierarchs and a ban on the holding of services in all the churches through the principality, something which could have had grave consequences for the prince.

...But somehow, despite all the misfortunes and privations of war, the Church of the Intercession on the Nerl has come down to us as a testimony to the eternal ideas of peace, humanism, and harmony so dear to every Russian heart throughout the ages.

Historical and Architectural Monuments

Defensive Earthen Ramparts, 12th century – Kozlov Val in the center of the city
Cathedral of the Dormition, 1158-60, 1185-89 – 56 Ulitsa Tretyego Internatsionala
Bell-Tower of the Cathedral of the Dormition, 1810 – 56 Ulitsa Tretyego Internatsionala
Golden Gate, 1164 – beginning of Ulitsa Tretyego Internatsionala
Cathedral of St. Demetrius, 1194-97 – 60 Ulitsa Tretyego Internatsionala
Cathedral of the Dormition of the Princess's Convent – 15th-16th centuries, Ploshchad Pobedy
Monastery of the Nativity: walls and towers, Archbishop's Chambers, Seminary, Infirmary, 18th century – Ulitsa Tretyego Internatsionala
Church of the Nativity of the Virgin, 1649 – Ulitsa Tretyego Internatsionala
Church of the Ascension, 1724 – Ulitsa Shchedrina
Church of St. Nicholas-on-the-Waters at Galeya, 1732-35 – Ulitsa Verkhne-Kalininskaya
Church of St. Nikita, 1762-65 – Ulitsa Nekrasova
Church of St. George, 1784 – Ulitsa Krasny Profintern

Gubernia Office Building, 1785-90 – 58 Ulitsa Tretyego Internatsionala
Arcade, 1787-92 – Ulitsa Tretyego Internatsionala
Noblemen's Club Building, 1826 – Ulitsa Tretyego Internatsionala
Gymnasium for Boys, 1841 – Ulitsa Tretyego Internatsionala
Monument in Honor of the 850th Anniversary of the founding of Vladimir, 1958 – Lipki (Linden) Park, Ulitsa Tretyego Internatsionala

Bogoliubsky Monastery – Settlement of Bogoliubovo

Church of the Nativity of the Virgin, 1158-65, 1751-56
Staircase Tower, 1158-65
Refectory Church, 1683
Holy Canopy, 17th century
Archimandrite's House, 18th century
Monks' Cells, 19th century
Cathedral of the Dormition, 1866
Walls and Towers, 19th century
Church of the Intercession on the Nerl, 1165 – flood plain of the Klyazma River

Information for Tourists

Hotels
Vladimir – 74 Ulitsa Tretyego Internatsionala
Klyazma – 15 Sudogorodskoye Highway
Restaurants
Vladimir – at the Vladimir Hotel, 74 Ulitsa Tretyego Internatsionala
Nerl – 61 Ulitsa Tretyego Internatsionala
At the Golden Gate – 17 Ulitsa Tretyego Internatsionala
Traktir – 2 Ulitsa Stolyarova
Museums and Exhibitions
Historical Exposition – 64 Ulitsa Tretyego Internatsionala
Industrial Goods Exhibition – 47 Oktyabrsky Prospekt
Exhibition of Crystal, Laquered Miniatures, and Embroidery – Ulitsa Moskovskaya in the former Trinity Church
Picture Gallery – 850 Years of Vladimir Park
Old Vladimir Exhibition, look-out platform – Kozlov Val
Stoletov House-Museum – 3 Ulitsa Stoletovykh
Exhibition of Archeological Finds at the Church of the Nativity of the Virgin – settlement of Bogoliubovo
Stores
Univermag (Department Store) – 10a Ulitsa Moskovskaya
Souvenirs – 4 Ulitsa Gagarina
Khrustal (Crystal) – 4 Ulitsa Gagarina
Knigi (Books) – Ulitsa Tretyego Internatsionala
Theaters and Concert Halls
Lunacharsky Drama Theater – 4 Ulitsa Moskovskaya
Puppet Theater – 7 Ulitsa Gagarina
Taneyev Concert Hall – 7 Prospekt Lenina
Cinemas
Mir – 19 Ulitsa Frunze
Rus – 8 Suzdalsky Prospekt
Burevestnik – 29 Prospekt Lenina
Fakel – 20 Prospekt Stroitelei

Suzdal

Suzdal is a district center of Vladimir Region, located 195 km to the east of Moscow on the Gorky Highway. It is presently a museum-city which is part of the Vladimir-Suzdal History, Art, and Architecture Preserve.
Suzdal boasts an ensemble of 12th-19th century Russian architecture.

 Suzdal occupies a special place among the ancient Russian cities, for nowhere is the flavor of yesterday so clearly present as here in this tiny city which, as fate would have it, found itself far from factory smokestacks, railroad tracks, and large-scale construction projects which allowed it to come down to the present almost without alterations in its charming appearance which evolved over the course of eight centuries. Nowhere have such a large number of first-rate architectural monuments been preserved as here. Another remarkable fact about Suzdal is the organic fashion in which its architecture blends in with the natural surroundings: with flood plains, hills, spacious fields and the tiny Kamenka River. Strolling along the green streets with their multitude of tiny churches and gazing at the gardens surrounding the cozy, one-storey wooden houses, it is difficult to believe that in the 12th century, this was a capital city, considerably exceeding London in size and population.

It is not surprising that Suzdal attracts a never-ceasing stream of tourists – up to a million visitors annually. The former political, and subsequently, religious center of Russia has presently become a major center of tourism; here, all industrial development is forbidden by special decree as the entire city is a museum-preserve – the first one declared after the revolution, in fact – in which everything is subordinated to the booming tourist industry. But first, as always, a bit of history.

The most recent archeological excavations have shown that the first defensive earthen ramparts were dug in Suzdal at the beginning of the 11th century. In the chronicles, the city is first mentioned under entries for the year 1024 in connection with a rebellion of the lower strata of society, led by the pagan priests, against the upper strata. Suzdal, like the whole of northeastern Rus, began to flourish politically and economically during the reign of Vladimir Monomakh and reached its zenith under his son, Prince Yuri Dolgoruky. At the turn of the 11th century, Monomakh built the first stone cathedral to be erected in

hose parts in Suzdal and consecrated
t to the Dormition of the Virgin.
Unfortunately, this structure has not
come down to us.

In 1152, Yuri Dolgoruky trans-
erred the seat of his government to
uzdal and built his residence five
ilometers from the city in the village
f Kideksha. It consisted of a small
rooden fortress with a garret tower
nd a white stone church dedicated to
is ancestors, the brothers Boris and
ileb, the first saints of the Russian
rthodox Church.

Although Yuri's son, Andrei
ogoliubsky, moved the capital of the
rincipality to Vladimir, Suzdal con-
nued to grow by leaps and bounds in
he second half of the 12th century
nd became rich from trade and com-
erce. Suzdal was known far beyond
he borders of Rus, for it was visited
egularly by merchants from Europe
nd the East. The seizure and sacking
f Suzdal in February 1238 by the Tar-
ar Hordes brought innumerable
riefs and misfortunes to the resi-
ents of Suzdal as it did to the whole
f the principality. These cities were
ut down at the height of their golden
ge, putting an end to all stone build-
ng for the next three centuries, while
ulture, art, and the crafts took hund-
ds of years to recover from the blow.
A large number of monasteries
ppeared in Suzdal in the 13th cen-
ury, while by the 14th century, the
ity had recovered to a certain extent:
n opposition to the growing power of
Ioscow, the Suzdal princes formed
he Suzdal-Nizhny Novgorod Princi-
ality in the mid-14th century. This
ew principality had its capital in the
ity of Nizhny Novgorod (presently
orky) on the Volga, for this city was
rther from Moscow. Suzdal, in turn,
ecame a diocesan center. It was here,
1 1377, that the monk Lavrenty com-
osed the famous Lavrentian Chron-
le. In 1392, Suzdal was incorporated
to the Moscow Principality. In the
iddle of the 15th century, the local
rinces took advantage of the difficult
raits, in which Moscow found itself

to attempt a rebellion which would re-
establish their independence, but
Moscow Prince Vasily the Dark, who
was blind, put down the rebellion
harshly, and Suzdal left the political
arena once and for all, remaining but
one of the religious centers of the
Russian state.

In the 16th century, much stone
building was carried out in Suzdal, for
the most part, monasteries built
mainly with the funds of Moscow
Grand Prince Vasily III and his son
Ivan the Terrible. Many valuable
objects of enormous artistic value
accumulated in the monasteries'
sacristies. Although the population
was relatively small – in 1573, there
were slightly more than four hundred
households – there were an enormous
number of churches in the city: seven
in the Kremlin, not counting the main
cathedral, fourteen within the city
ramparts, and twenty-seven churches
at the various monasteries.

Even the dreadful calamities that
befell the town in the 17th century
when it was repeatedly invaded and
sacked could not stem the tide of the
energetic building campaign under-
taken by the townspeople. Between
1608 and 1610, it was raided several
times by the Polish and Lithuanian
interventionists. In 1634, it was devas-
tated during the forays of the Crimean
Tartars. There was a disastrous fire in
1644 which destroyed the settlement
adjoining the Kremlin, and a plague
which wiped out almost half of the
population in 1654-55. Despite all
these misfortunes, sturdy stone walls
were put up around the monasteries,
and one elegant church after another
appeared in the nearby settlements.
The building of stone churches was
resumed with fresh vigor after the
horrible fire of 1719 in which all the
wooden structures of the city
perished. A distinguishing feature of
that period was the paired churches
which were built: a large, richly deco-
rated church for summer services,
and next to it a smaller, simpler, heat-
ed building for use during the winter

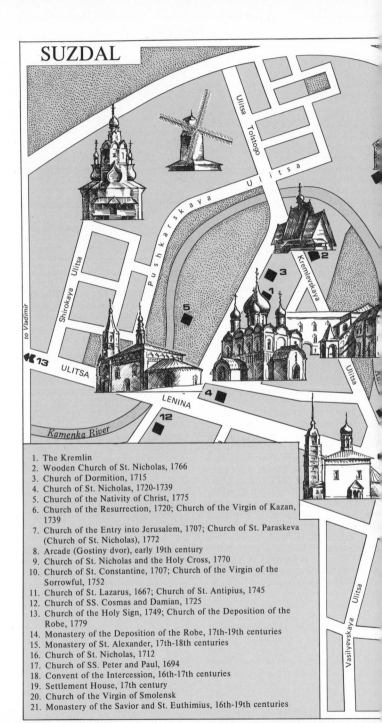

SUZDAL

1. The Kremlin
2. Wooden Church of St. Nicholas, 1766
3. Church of Dormition, 1715
4. Church of St. Nicholas, 1720-1739
5. Church of the Nativity of Christ, 1775
6. Church of the Resurrection, 1720; Church of the Virgin of Kazan, 1739
7. Church of the Entry into Jerusalem, 1707; Church of St. Paraskeva (Church of St. Nicholas), 1772
8. Arcade (Gostiny dvor), early 19th century
9. Church of St. Nicholas and the Holy Cross, 1770
10. Church of St. Constantine, 1707; Church of the Virgin of the Sorrowful, 1752
11. Church of St. Lazarus, 1667; Church of St. Antipius, 1745
12. Church of SS. Cosmas and Damian, 1725
13. Church of the Holy Sign, 1749; Church of the Deposition of the Robe, 1779
14. Monastery of the Deposition of the Robe, 17th-19th centuries
15. Monastery of St. Alexander, 17th-18th centuries
16. Church of St. Nicholas, 1712
17. Church of SS. Peter and Paul, 1694
18. Convent of the Intercession, 16th-17th centuries
19. Settlement House, 17th century
20. Church of the Virgin of Smolensk
21. Monastery of the Savior and St. Euthimius, 16th-19th centuries

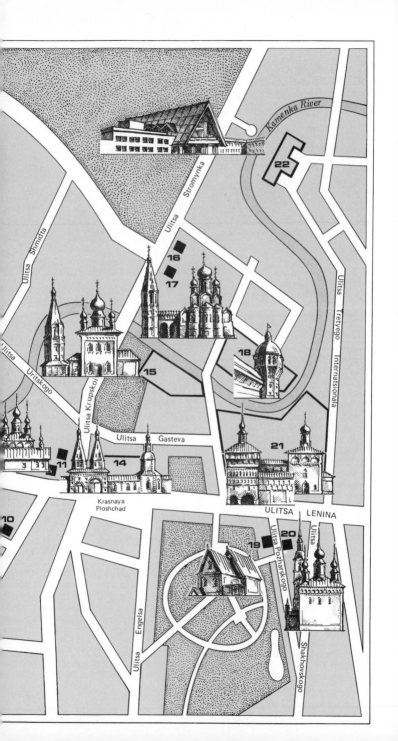

Architectural ensemble at Kideksha

months. During that period of active building in the settlement, structures which had been separate entities up to that point were united in complexes and ensembles in the town, the Kremlin, and the monasteries, the result of which was the integrated architectural whole visitors see today.

When the Vladimir Province was formed in 1796, Suzdal, which was made part of it, was allowed to retain its own coat-of-arms, a white falcon on a red and dark blue heraldic shield, rather than the rampant lion symbolizing the might and power of Vladimir. This exception was made for Suzdal alone among all the cities of the province in light of the services it had rendered in the past. Future events and developments seemed to pass Suzdal by, leaving it at the wayside of history. And by the end of the 19th century, Suzdal was but a provincial backwater town whose residents engaged in vegetable gardening and kept orchards.

Thus, the major architectural and artistic treasures of Suzdal have come down to us with insignificant losses. In an area of about eight square kilo-meters, over one hundred monu-ments of major architectural impor-tance are clustered, dating from different periods and still retaining their original forms. In this latter respect Suzdal has no equal; in its museum and exhibitions, priceless collection of fine arts and decorative and applied folk art are housed. Suzdal has been restored to its original state of beauty by the selfless labor of hundreds of restorers, architects, artists, and construction workers. But the fact that the city is now a museum and preserve has not deprived it of life and vigor: rather the city's existence has become far richer and much more interesting.

It is best to begin our tour of the compact city of Suzdal with the **FORTRESS OF YURI DOLGORUKY** erected in the 12th century in **KIDEKSHA.** All that remains of the royal estate from those days is the charming **Church of SS. Boris and Gleb** surrounded by a low stone fence. It was erected in 1152, the same year the Cathedral of the Transfiguration of the Savior appeared in Pereslavl Zalessky, and thus, they are the two

oldest extant buildings in the north-east of Russia. The two churches are the same in style, with a single dome, three apses, and a basic volume which is almost cubic. However, the dispro-portionately small dome of the pres-ent church strikes the eye: it appeared as the result of 17th century restora-tions, replacing the mighty, helmet-shaped original dome. At the same time, a new vault was erected, and a tent roof was added, while new, wider windows were cut into the walls, and the old narrow windows, which resembled loop-holes, were bricked up. These original windows are easily discernible even today. And thus, this ancient church acquired its present appearance. The simple, austere building has almost no decoration apart from a modest band of blind arcading (an element which was later brilliantly developed in the churches of Vladimir) and a row of ornamental brickwork. The church at Kideksha is an example of semi-rubble masonry, a practice common in that area.

Today, there is a **museum exhibi-tion** inside the church which allows the visitor to become acquainted with the fragments of frescoes from the end of the 12th century which once graced the interior of the building. It is believed that the woman depicted in the arched niche off the northern wall, is the wife of Yuri Dolgoruky, a Greek princess. The two horsemen on the southern wall are considered by some to be princes Boris and Gleb and by others to be mounted sorcer-ers.

The architectural ensemble at Kideksha is marvelously integrated, especially if one takes into considera-tion that it was built over the course of six centuries! It does not often hap-pen that builders are considerate and tactful with respect to the work of their ancestors. The elegant double-arched **Holy Gate** and tent-roofed **bell-tower** complement the austere exterior of the church. These two structures appeared at the end of the 17th century, and the small, cozy heat-ed **Church of St. Stephen** was built in 1780.

The road from Kideksha to the center of Suzdal leads out onto the main city square, the Torgovaya or Market Place Square, and from there along Kremlin Street (Kremlyovskaya Ulitsa) to the most ancient part of the city, the Kremlin. (No transportation is allowed in the city center, so you must go about on foot.) Like the fort-ress of Yuri Dolgoruky, the Kremlin is presently surrounded by a purely decorative wall, while some idea of the original mighty defenses can be gained from the earthen ramparts, presently cut through by streets.

The Kremlin consists of three buildings – an enormous cathedral with blue domes dotted with golden stars, a tent-roofed bell-tower, and the Bishop's Chambers attached to it by a lovely triple-arched gallery that serves as a passageway. The most ancient of these structures is the **Cathedral of the Nativity of the Virgin** (sobor Rozh-destva Bogoroditsy), commonly known as the Cathedral of the Nativ-ity. It has been ascertained from ancient documents that this cathedral was built from 1222 to 1225. In 1445, the upper tier of this tall, elegant building topped by a dome supported by a high drum resting on keel-shaped *kokoshniki,* collapsed. Later, the structure was pulled down to the band of blind arcading, and the upper part was rebuilt in 1528-30 of brick in a style that conformed to the canon of the times.

Some light on the original appear-ance of the Cathedral of the Nativity is shed by an 18th century work, *The His-tory of the Town of Suzdal,* written by sexton of the cathedral, Anany Fyodo-rov. This work states that the cathedral had three domes and that the interior was quite luxurious with its beautiful frescoes painted in 1233 (fragments of which have survived to the present), colorful majolica tiles, and valuable sacred utensils of silver and gold.

The Nativity Cathedral did not serve just the prince and his retainers: it was the first truly urban church, and this was

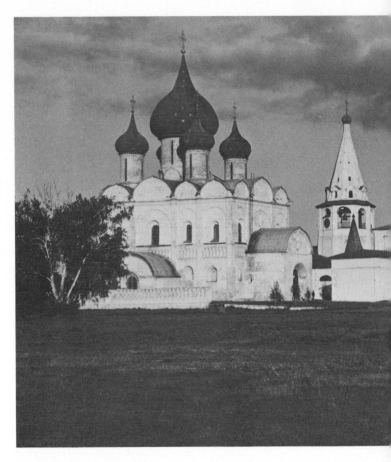

Suzdal. The Kremlin ensemble

reflected in its architecture. The church was not connected with the prince's quarters by a passageway, but rather had unusually large galleries to accommodate a large number of people. Moreover, the floral ornament which almost dominated the images of the saints in the murals was closer to the tastes of the common people.

When the church was reconstructed, it was given five domes, a feature which had become almost canonical after the quincunx Cathedral of the Dormition was erected in the Moscow Kremlin in the 15th century. So the brick of which the upper tier was built could not be distinguished from the porous tufa of the older part, the whole cathedral was whitewashed. In 1635, new frescoes were painted, and

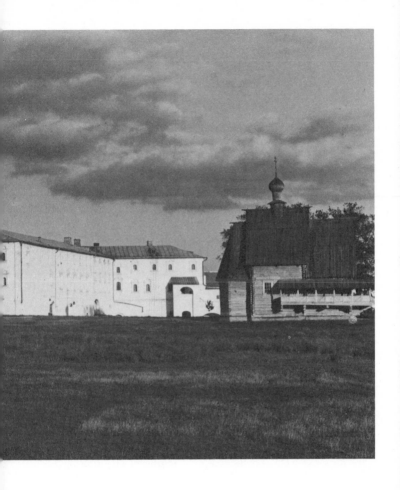

at the end of the 17th centuries, during modernization work, the galleries and balcony over the western porch were pulled down. The narrow windows were widened, and the numerous tombstones of the princes and bishops who had been buried here over the centuries were taken out of the church. Finally, in 1750, the church was crowned by large onion-shaped domes. The church was damaged repeatedly by fire, and at the beginning of the 17th century, it was looted by the Polish and Lithuanian invaders.

Despite all the alterations, the cathedral appears quite majestic after recent major restorations and is a beautiful monument of Russian architecture. The many details pre-

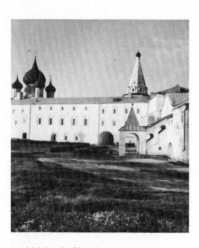

Archbishop's Chambers

Cathedral of the nativity of the Virgin.
Detail of the South portal

served in the ancient lower tier – the white stone sculpture and columned band of blind arcading with its rich ornamental carving, female heads and figures of lions on the pilasters, and birds and mythological creatures on the arches of the portals – allow us to imagine what this marvelous cathedral must have looked like originally in all its glory.

An idea of the luxurious original interior is given by two unique monuments of applied art of the 13th century – the Golden Gates of the southern and western portals. The gates were gilded in the following manner: first, a copper plate is 'burnished' (coated with black lacquer), after which it is covered with wax. The design is then etched into the wax in such a way as to scratch the surface of the copper plate beneath. A mixture of molten gold and mercury is then poured into the grooves. The mercury evaporates upon heating, leaving the gold fused to the surface of the copper plate. The result is a picture in shimmering gold on a black background. Each gate has two leafs and is divided into transoms by copper bars. On each

of these segments is a scene from the Bible. The magnificent copper masks of lions holding the heavy copper rings that served as handles in their jaws have also been preserved.

With the exception of a few insignificant fragments which remain from the murals of 1233 – the most interesting of which is the representation of two old men with stern, ascetic faces on the upper segment of the southern apse – the frescoes date back to 1635. Several of these frescoes are also worthy of attention, in particular a depiction of the Virgin on the vault of the northern porch, trumpeting angels on the west wall, and half-length portraits of the apostles on the north wall. There are joyful icons in simple settings of gilded copper in the enormous but rather austere iconostasis which dates back to the end of the 17th century.

There is an interesting collection of lanterns used in church processions in the cathedral, including the largest known one of its kind, which is shaped like a quincunx cathedral.

The **Archbishop's Chambers** are an ensemble of buildings which took

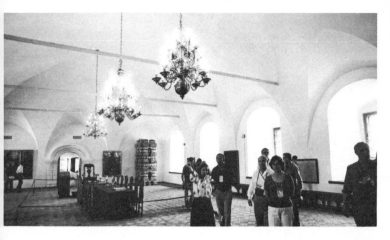

In the Cross-Vaulted Chamber–the main reception hall of the Archbishop's Chambers

shape from the end of the 15th to the beginning of the 18th centuries and comprised a whole series of religious, residential, formal and husbandry premises. The chambers acquired their present appearance at the end of the 17th and the beginning of the 18th centuries during the extensive building campaign conducted by Metropolitan Illarion. At that time, the new wing was built with its well-known formal **Cross Chamber,** a vaulted hall over 300 square meters in area without a single pillar – something previously unheard of in Russian architecture. At this time, a complex system of passageways, staircases, and galleries was built to connect everything into a single unit, including the most ancient, southeastern segment of the Bishop's Chambers and its Refectory Church. The result was a unique ensemble which has come down to us almost in its original form. True, after the head of the See moved to Vladimir in 1799 and a seminary was set up and housed in the Chambers, a large number of alterations were made, the pulling down of the remarkable vault of the Cross Chamber, for one. However, it has been restored to its original appearance.

Presently, on the lower floor, which was once used for husbandry purposes, a Refectory Restaurant featuring many tasty Russian dishes prepared and served in the traditional way has been housed. And the bedchambers of the heads of the monastery, the Cross Chamber, the bell-tower and the refectory church house a fascinating **museum.** The entrance hall will acquaint visitors with the steps taken to preserve historical and cultural monuments in this country from the first days of Soviet power until the present. The long series of rooms that comprise the Archbishop's Chambers contains an exposition dedicated to the history of the city as well as examples of old furniture, chandeliers, wall lamps, domestic utensils, and china. By the way, the founder of Russian china manufacture, Dmitry Vinogradov, friend of the great 18th century Russian scholar Mikhail Lomonosov, was born in Suzdal. The refectory church boasts a large collection of icons and ancient

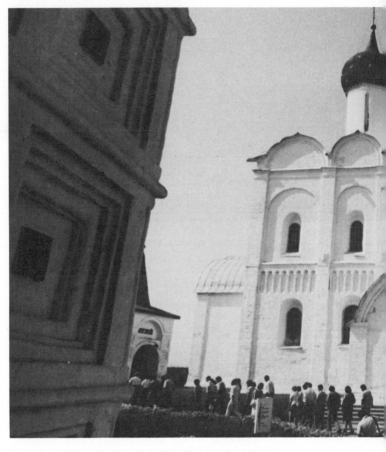

In the Suzdal Kremlin Cathedral of the Nativity of the Virgin

religious paintings produced by the Rostov-Suzdal school.

The particulars of this school were discussed in the chapter devoted to Rostov whose museum has an excellent collection of these works. The Suzdal collection consists of 13th-17th century icons from monastery sacristies, the churches of Vladimir and Suzdal, and nearby villages.

The earliest icon in the exhibition, *The Maximovo Virgin,* was painted for the central cathedral of Vladimir – the Cathedral of the Dormition – in 1299 and is impressive in scale of conception, as well as in its soft, fluid outlines. The 14th century works are notable for the emphasis placed on expression, for their energetic portrayals and even intensity of the faces.

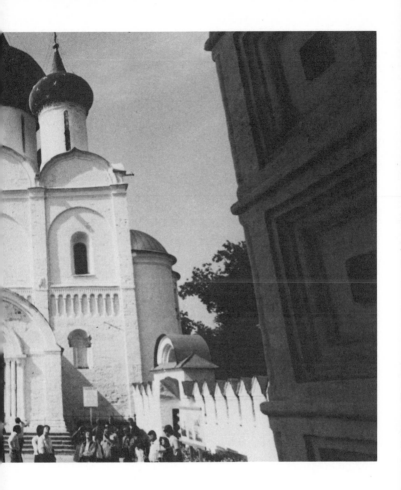

This is typified by the icon *Virgin Eleusa* from the Convent of the Intercession in Suzdal.

Icons of the 15th and 16th centuries, a time when icon-painting flourished in Suzdal, create an entirely different impression. One of the best icons of this time is *The Intercession* from the 15th century with its subtle color scheme, lyrical images, and attention to the individual nature of the spiritual world of the person. By the 17th century, the strong influence of the Moscow school is felt.

The majestic **Cross Chamber** makes the most striking impression in the Suzdal Kremlin. The entrance, with its elegant tent-roofed porch covered with shiny green glazed tiles, faces the western door of the Cathe-

Kremlin. A covered gallery with arches

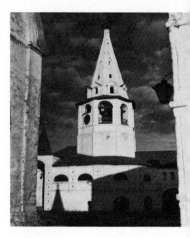

Cathedral Bell-Tower

dral of the Nativity. Truly a match for the Cross Chamber itself is the wide formal staircase leading to the second floor residence of the presiding bishop. The interior of the chamber has been restored according to a 1788 description, and the oaken parquet of the floor has been laid to resemble brickwork. In the center of the enormous room stands a long table at which the hierarchs of the see discussed their affairs. The unusually lovely and intricate tiled stoves (18th century) in the corners of the chamber are especially worthy of note. The stoves – one in dark blue tints and the other in brown – are themselves masterpieces of architecture and pottery: each of them is composed of five tiers and reaches a height of three and a half meters. Each is made of 150 tiles painted with unrepeated sagely or ironic pictures and aphorisms which form figured colonettes and open arches. There is another such stove in the living quarters. We should note that Suzdal was a center for the production of such glazed tiles as grace these lovely stoves. The museum exposition contains examples of local colored glazed ceramic-ware of the 17th century.

The cathedral bell-tower is joined to the Archbishop's Chambers by an elegant triple-arched gallery at the level of its second tier. This gallery was restored after scrupulous study of archeological evidence, documents, and descriptions written by that passionate Suzdal patriot, scholar and restorer Alexei Varganov, to whom the city is indebted for the resurrection of many of its architectural monuments.

The impressive octagonal body of the tent-roofed **bell-tower** was built in 1635, and at the time, it was the tallest structure in the city. Even now, this bell-tower is one of the major landmarks in the panorama of the town. In the 17th century, a chiming clock which marked not just the hours and quarter-hours but the minutes as well was installed.

There is one more monument on the ancient territory of the Kremlin, and it is the **wooden Church of St. Nicholas,** moved here in 1960 from the village of Glotovo. It serves as a bridge to the next stop on our tour,

the **MUSEUM OF WOODEN ARCHI-TECTURE OF PEASANT LIFE** directly opposite the Kremlin across the Kamenka River. This church from Glotovo (1766) was erected in place of a wooden church that burned down in the 17th century.

Fire is the main reason so many thousands of marvelous examples of ancient Russian wooden architecture which fit organically into their natural surroundings have not come down to us. To save those which have survived by some miracle, the Soviet Union began to organize open air museums in various parts of the country. Ancient monuments are brought to these museums from surrounding far-flung regions and carefully restored or reassembled. Suzdal is the center to which such structures are brought in Vladimir Region.

The church from Glotovo, known as a church, is quite unusual since it takes its roots from the simplest type of peasant hut found in northern Russia, but which has all but disappeared from the central regions. It is curious that this type of construction is common in the small heated (or winter) stone churches of Suzdal. The Church of St. Nicholas looks quite picturesque, resting on a high basement and surrounded by open galleries.

The path from the Kremlin to the open air museum crosses a small wooden bridge that spans the Kamenka, now overgrown with water-lilies and grass. **The Church of the Transfiguration** (Preobrazhenskaya tserkov, 1756) brought from what was once the most ancient Suzdal monastery, that of St. Demetrius in the village of Kozlyatevo, proudly raises its shingled dome and catches the eye immediately. The interior of the church and iconostasis are quite interesting to visitors.

The **Church of the Resurrection** (1776), but two decades younger than its neighbor, brought from the village of Potakino, is worth taking a look at for its slender bell-tower and the special method in which the log frame-

work has been constructed to keep moisture from penetrating to the interior of the church.

The examples of peasant huts and out-buildings and farmsteads brought from various places are of great ethnographic value: there is a **19th century house of a peasant of middle income** and a two-storey **house with elaborate carving dating back to the mid-19th century which belonged to a prosperous peasant.** In each of the houses, tourists are greeted by a peasant woman dressed in a long, embroidered Russian sarafan. The interiors of the houses have been completely restored down to the last detail and utensil: there is a large Russian stove, a bench for the head of the family and another for the women, a simple handloom on which the peasants spun sackcloth, and a variety of kitchen utensils. Behind the houses is a chimneyless bathhouse. The various sheds and husbandry buildings round out the impression of peasant life: there are two enormous wind mills, barns, granaries on long piles, and a deep, covered well with a huge windlass.

With the multitude of domes and tent roofs vying for attention in Suzdal, it simply would not occur to the visitor that the best sights are hidden from view in the depression of a water-meadow, the quiet of which is disturbed only by the song of grasshoppers.

Such is the **CONVENT OF THE INTERCESSION** (Pokrovsky monastyr, Ulitsa Pokrovskaya) which rises from the meadow like a wedding cake on a green plate, framed by a sharp bend in the Kamenka River.

The Convent of the Intercession was founded as a place of banishment for high-spirited, strong, energetic women who loved life in all its vigor and were frequently quite extraordinary. This unhappy tradition of banishment which gave the convent its ill-fame was begun by Moscow Grand Prince Vasily III whose wife Solomonia Saburova bore him no heirs. (This remarkable woman has already been mentioned in

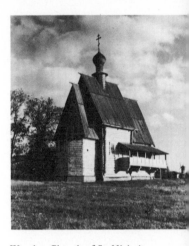

Wooden Church of St. Nicholas

the chapter on Zagorsk under the section on tapestry.) So Vasily decided to divorce Solomonia and send her to a convent. To obtain permission for such an unheard-of deviation from church canon, the prince showered the church authorities in Byzantium and at the Mount Athos Monastery with gifts and made generous donations to the construction work being carried out at Suzdal's Convent of the Intercession, which he had chosen as the place of seclusion for his wife. Then, after a special enquiry into the barrenness of Solomonia, he received permission to divorce her, and in 1525, she was forced to take the veil. Then Vasily was free to marry the Polish beauty, Helena Glinska, who became the mother of the future Ivan the Terrible.

There is a curious story connected with the stay of the energetic and intelligent Solomonia in the convent. Legend has it that after she had taken the veil, she bore a son, Georgi (George), but had to feign the death of the child to save his life. Supposedly this very Georgi became the famous brigand Kudeyar, who robbed the rich to give to the poor.

For centuries, this was considered but a beautiful legend until in 1934, next to the grave of Solomonia Saburova in the basement of the Cathedral of the Intercession was found a tiny wooden coffin with a small white stone grave marker. Inside the coffin was a doll in a silk shirt.

Ivan the Terrible followed in his father's footsteps and banished his fourth wife Anna Vasilchikova to this convent. And thus, the Convent of the Intercession became a house of tears and place of confinement in which many high-born women and girls who had fallen into disfavor bemoaned their bitter fates to the end of their days.

A tarmac road leads from the museum of wooden architecture to the Convent of the Intercession, but it can also be reached by following the river, which allows the visitor to enjoy the beautiful natural surroundings of Suzdal and have a lovely panorama of the city, for from this side, the entire town seems to rest in the palm of one's hand. There are the white buildings of the Kremlin surrounded by the ancient earthen ramparts; to the left, the architectural ensemble of churches grouped around the Market Place Square, and in the center, the tall bell-tower of the Convent of the

Museum of Wooden Architecture and Peasant Life

Deposition of the Robe. To the left in the distance are the red walls and towers of the Monastery of the Savior and St. Euthimius.

According to legend, the Convent of the Intercession was founded following the miraculous escape from death in 1364 of Prince Andrei whose boat was caught in a storm on the Volga as he was travelling from Nizhny Novgorod to Suzdal. However, nothing remains of any structures from those ancient times, for stone building was not conducted then. The present lyrical and intimate ensemble, the pastoral appearance of

which is in no way reminiscent of the river of tears shed over needlework by those so unfortunate as to be shut up there, took shape between 1510 and 1518, and served as a model for the architectural development of the city for the next century.

The Gateway Church of the Annunciation (Blagoveshchenskaya tserkov, 1518) above the Holy Gate which serves as the main entrance to the convent is quite interesting with its two side-chapels and arched gallery. Like the main cathedral of the con-

vent, that of the Intercession, this church has three domes, but the small side-domes rest not on the main body of the church: rather they are above the side-chapels. And another unusual detail: this tiny church has four miniature apses in place of the usual three.

In the pure, noble, monumental forms of the **Cathedral of the Intercession** (Pokrovsky sobor) – which also served as a mausoleum for the high-ranking ladies shut away here – the influence of pre-Mongolian traditions in architecture is clearly evident. The raised open gallery immediately under the band of blind arcading topped by *zakomari* is an unmistakable sign of the golden age of the Vladimir-Suzdal architectural school.

The cathedral has three domes, but in comparison with the mighty central dome, the lateral ones look like toys. The church is surrounded on three sides by a light, airy gallery – a feature unusual for Suzdal. This cathedral was unquestionably designed by an extremely talented master capable of balancing the rather ascetic form of the whole with the detailed ornament of the gallery.

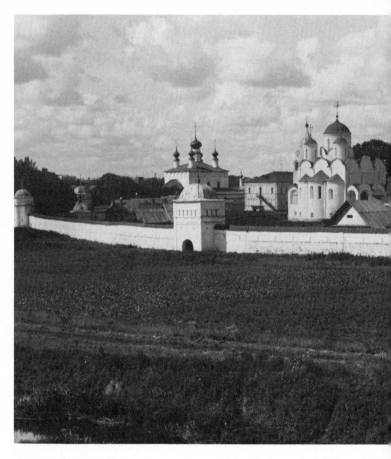

Convent of the Intercession

In the 18th century, a double-arched passageway at the level of the second tier of the cathedral was erected to connect it to the tent-roofed bell-tower, the lower two tiers of which served as a mausoleum. Erected at almost the same time as the cathedral, the kinship of these two structures is revealed by the analogous vertical beads spaced about the two tiers at intervals. The upper part of the tower and the hipped roof were erected in the 17th century.

Built in 1551, the **Refectory Church of the Conception of St. Anne** (tserkov Zachatiya Anny) is one of the biggest architectural enigmas in all of Suzdal. The building is really quite extraordinary. The two-storey, gable-roofed structure has a broad band of red dia-

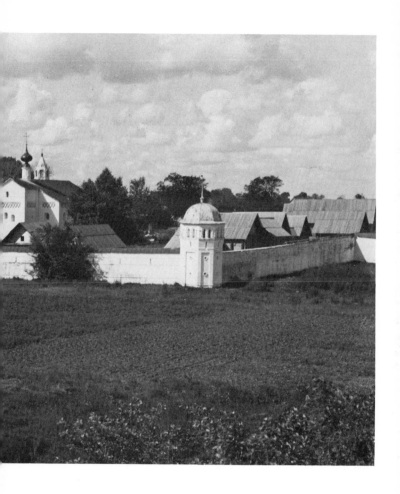

nonds in relief on a white back-
ground which runs the whole length
of the wall just under the cornices. An
unusual type of brickwork was
employed in the construction of the
walls and vaults, and the design of the
adjoining three-tiered, tent-roofed
bell-tower is uncommon as well. For a
number of reasons, scholars tend to
think that this church was built by a
Polish architect. This seems entirely
possible in light of the fact that it was
built during the reign of Ivan the Ter-
rible in memory of his daughter Anna
whose mother was the Polish beauty
Helena Glinska.

The elongated one-storey build-
ing in the southwestern corner of the
monastery by the Holy Gate is the
late-17th century **court chamber,** a

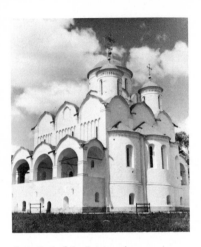

Cathedral of the Intercession

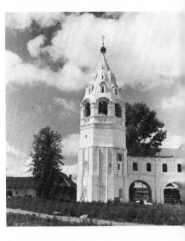

Cathedral Bell-Tower

type of building intended for the conducting of the monastery's administrative affairs as well as for enquiries by the ecclesiastical court, abolished in the first quarter of the 18th century by Peter the Great whose sweeping reforms greatly curtailed the powers and rights of the monasteries and convents. Therefore, very few buildings of this type remain. During recent repairwork, the structure was restored to its original appearance, and an exposition, the Interior of the Court Chamber, has been opened there.

Another interesting **exposition** has been opened in one of the wooden houses on the convent's grounds. This is the **interior of a convent house** of the late-18th to mid-19th centuries, based on old descriptions. It consists of two cells: that of the nun and that of the novice who attended her. In the other half of this house is an exhibition of **Linen Embroidery from the 19th and Early-20th Centuries** which features samples of embroidery on bed linens, towels, and dinner napkins which once brought the convent hefty profits, since they were much-sought-after by the well-to-do from nearby cities.

Not long ago, an entire street of wooden houses in which the nuns lived were restored on the monastery grounds. These cottages are now part of a **hotel complex.**

Near the convent walls are two monuments worthy of note which we shall treat of here, since they were directly related to the monastery. The large, five-domed **CHURCH OF SS. PETER AND PAUL** (1694) and the small, single-domed **CHURCH OF ST. NICHOLAS** (1712) are the first example of the paired summer-and-winter churches which later became quite characteristic of Suzdal architecture. The Church of St. Nicholas is known for the fact that Peter the Great's first wife, Evdokia Lopukhina, who fell into disfavor and was forced to take the veil and enter the Convent of the Intercession, had the side-chapel added in honor of her son, Tsarevich Alexei, the heir apparent.

In the Church of SS. Peter and Paul is a singularly interesting exhibition of **carving and painting on wood**, the most valuable exponent of which

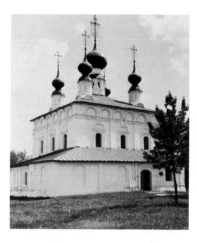

Church of SS. Peter and Paul

the *Jordan Canopy*, a unique example of church requisites and Russian folk art, made at the end of the 17th century by craftsmen from the Bishop's Chambers and the Convent of the Intercession. The tradition of erecting such wooden tents above the ice hole at which the water was blessed during the winter feast of the Epiphany came from Moscow. The canopies, often referred to simply as 'ordans', from the River Jordan in which, according to the Gospels, Christ was baptized by John the Baptist, existed in many other Russian cities. But the Suzdal canopy is the only one to have come down to us. This large wooden structure consists of 260-odd carved details; it is square in shape with domes and crosses at the corners. The painting on the canopy, in which floral motifs and intricate colorful designs are prominent, is quite striking and cheerful. Another valuable monument of carving and painting – a set of 17th century Holy Doors – is on display here.

From the low-lying Convent of the Intercession, the brick walls and towers of the **MONASTERY OF THE SAVIOR AND ST. EUTHIMIUS** (Spaso-Evfimiev monastyr) on the high, steep bank of the opposite side of the Kamenka (Ulitsa Lenina) seem impregnable. And so they are. This fortified monastery can be reached by following the narrow path leading across a plank bridge along the edge of the winding precipice up to the monastery walls, or by driving down the main thoroughfare of the city – Lenin Street (Ulitsa Lenina). The 1,200-meter wall reinforced by twelve stout towers, built in 1664, is a masterpiece of fortification architecture and one of the most fascinating monuments of Suzdal. The enormous, 22-meter-high **entrance tower,** decorated with rows of ornament not repeated elsewhere in the structure, is easily the equal of the main gates of the Goritsky Monastery in Pereslavl-Zalessky, the most elegant of all Russian fortification works.

From the *Life* of the first father superior of the monastery, Euthimius, it is known that he founded the monastery in 1352. In the 15th century, the monastery was granted vast lands and thousands of serfs. In gen-

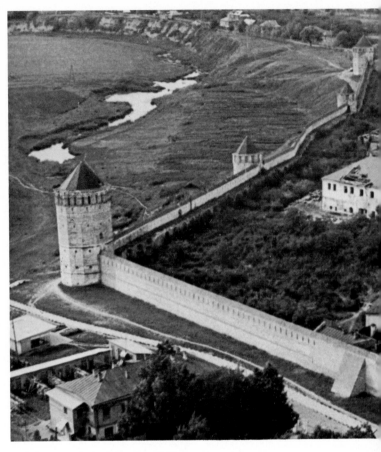

Monastery of the Savior and St. Euthimius

eral, the enrichment of the monastery was greatly facilitated by the discovery of the relics of Euthimius, who had been canonized by the church, in 1507. In the same year, the monastery's first stone building was erected – a church over the grave of Euthimius, and the first stone building to go up in the city after the 13th century Church of the Nativity. Naturally, such a tiny church could not lon serve as the main cathedral of such powerful monastery, and so in 1594 the enormous cubic four-piered quincunx **Cathedral of the Transfiguration of the Savior** (Spaso-Preobra zhensky sobor), was built onto th smaller church, which was thereb rendered but the southern side-cha pel (St. Euthimius's) of the large

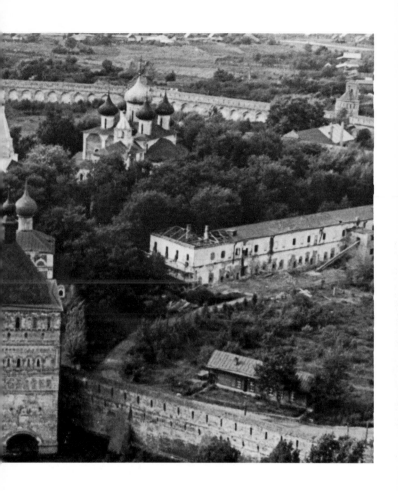

structure. The two buildings are united architecturally by a band of blind arcading.

When you enter the monastery via the entrance arch, you find yourself in a small inner courtyard facing the 16th-17th century Gateway Church of the Annunciation (Blagoveshchenskaya tserkov), the façades of which are richly decorated with festive plat-bands and a cornice with a row of balusters. It is thought that in ancient times, the church was crowned not by a dome, but by two tent roofs. Only after passing through the entrance arch under the church do you find yourself before the massive, gleaming white Cathedral of the Transfiguration, the architecture of which was clearly influenced by that of the

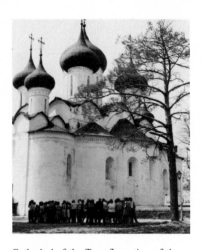

Cathedral of the Transfiguration of the Monastery of the Savior and St. Euthimius

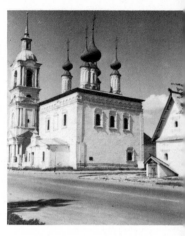

Church of Virgin of Smolensk

Cathedral of the Dormition in the Moscow Kremlin. The multitude of side-chapels give the building a rather squat and ponderous appearance. As you near the cathedral, you will be able to make out the large fresco of *The Transfiguration* on the façade. The frescoes on the interior and exterior of the cathedral were first painted in the 16th century, and an excellent mural executed in 1669 by an artel of artists from Kostroma (already familiar to the reader) headed by Gury Nikitin and Sila Savin can be seen inside.

Near the cathedral is the grave of famous commander, Prince Dmitry Pozharsky (died 1642), a native of Suzdal who, with Kuzma Minin, a village elder from Nizhny Novgorod, raised a volunteer corps and liberated Moscow from the Polish-Lithuanian interventionists in August 1612. A monument to Minin and Pozharsky stands in Moscow's Red Square, and a **bust** of Dmitry Pozharsky stands at the entrance to the monastery.

The rather flat, wall-like **belfry** (16th-17th centuries) is similar to the bell cotes of the Rostov Kremlin and the Monastery of SS. Boris and Gleb. Its oldest section – the tower that formed the original church-under-the-bells – (tserkov pod-zvony) which served simultaneously as a church and a bell-tower – dates back to the first half of the 16th century.

With its altar wall facing the cathedral courtyard stands the lovely, elegant tent-roofed **Refectory Church of the Dormition** (Uspenskaya tserkov, 1525), with its two rows of shingled *kokoshniki,* the oldest tent-roofed church to have come down to us. The aspen shingles of its domes gleam like silver in the sunlight.

To the south of the Church of the Dormition stands the two-storey Chambers of the Father Superior (16th-17th centuries) in which an **exhibition, Six Centuries of Books,** has been opened. Some of the books here are very large, weighing up to twenty pounds, and have ornate chased silver covers. Many of the manuscripts and early printed books here are works of art in their own right, such as the hand-written altar copy of the

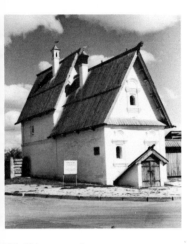

17th-18th century house

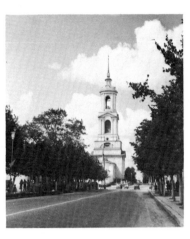

Prepodobenskaya Bell-Tower

Gospels from the end of the 17th century in a cover made by engraver Afanasy Trukhmensky of the Armory Chamber of the Moscow Kremlin. This Gospel was reputedly the gift of Sophia (Peter the Great's sister) to the Cathedral of the Nativity in Suzdal.

The impregnability of the monastery's walls, erected in 1664, was never put to the test, for Suzdal was not attacked by enemy forces after the Polish and Lithuanian invaders were driven out. At the end of the 18th century, a wing in the monastery was made into a state prison, the head warden of which was the hegumen of the monastery. In the first quarter of the 19th century, a special building with a high wall and exercise yard was erected to house the prison. Presently, the **exhibition,** *Inmates of the Monastery Prison,* operates here.

The prison, which operated until 1905, was used mainly to incarcerate persons who had committed so-called crimes "against the faith" – defrocked priests, atheists, those who criticized church dogma or rituals, Old Believers, or sectarians. In addition to a large col-lection of padlocks, handcuffs, fetters, and other paraphernalia, this former prison whose stone vaults are chilly even in July has a collection of documents which reveal the conditions in which the prisoners lived. Here is one dated 1849-50: "Many people imprisoned in the Monastery of the Savior and St. Euthimius have been held for many years... Some are detained for twenty years and more, and no one has paid them any attention since the time of their imprisonment."

The nearby Infirmary Church of St. Nicholas (1669) presently houses an **exhibition of Russian decorative and applied art of the 18th and 19th centuries** known as *The Golden Treasury.* The collection of minor plastic arts is particularly interesting with its masterpieces based on traditions originating in Byzantium: a Byzantine jade icon of the Archangel Michael, a gate icon carved in stone with a representation of St. Panteleimon the Healer, and a Deesis of black stone.

Among the examples of tapestry displayed here are some marvelous pieces, such as the **pall** from the tomb

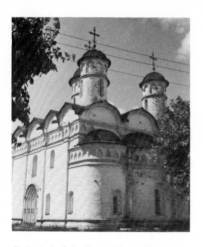

Cathedral of the Deposition of the Robe

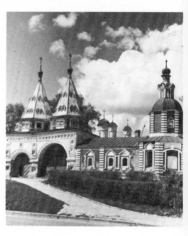

Holy Gate of the Cathedral of the Deposition of the Robe

of Yefrosinia of Suzdal executed by Solomonia Saburova (16th century), *The Savior at Ubrus* (16th century), the pall from the tomb of Yuri Vsevolodovich, and an 18th century stole.

The east side of the cathedral courtyard is framed by the long building of the **Monks' Cells,** the lower storey of which dates back to the 17th century, while the upper storey was added in the 19th century. Presently, the **Folk Art Museum of the Russian Federation** is housed here. Works by amateur painters and folk craftsmen who continue the traditions of the past are on display. Hundreds of articles carved from wood or bone, or shaped from birch bark, as well as hand-made rugs, embroidery and weaving attest to the inexhaustible talent of our people.

On the other side of Lenin Street (Ulitsa Lenina) across from the Monastery of the Savior and St. Euphimius stand a pair of churches: the **SUMMER VIRGIN OF SMOLENSK** (1696-1706) and **WINTER ST. SIMEON'S** (1749) **CHURCHES.** The Virgin of Smolensk Church (Smolenskaya) is similar to the Church of

SS. Peter and Paul, differing only in the intentional contrast of the large, massive cubic volume of the main body of the church and the tiny, intricate details: the slender, elongated drums of the five domes, the twelve small *kokoshniki*, the crenelated brickwork, and the pointed balusters.

On the same street (Ulitsa Lenina) is located one of the most interesting secular structures of Suzdal, a **SETTLEMENT** *(Posad)* **HOUSE** from the end of the 17th and beginning of the 18th centuries which features an exposition of a typical household of moderate means of the second half of the 18th century when this was the home of the owner of a bakery and tavern. The stone house consists of two sections of different heights, each of which has its own steep gable roof. In this extremely simple type of building, elements common to Russian wooden peasant houses are present. Such stone houses are extremely rare, this being the only one in Suzdal and surrounding parts. This unique house boasts over 150 original articles of 18th century everyday use: clay, copper, and wooden tableware, a cup-

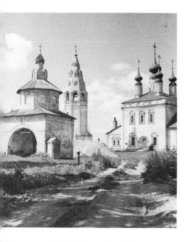

Monastery of St. Alexander Nevsky

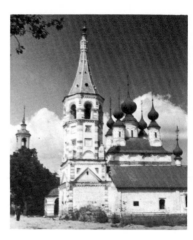

Church of St. Antipius and its Bell-Tower

board, a chest, benches, the cheap, primitive pictures printed from linden moulds which enjoyed wide polularity at the time, account books, and icons.

Not a single Russian city, with the exception of Moscow, had so many monasteries as Suzdal, where their number reached about fifteen. Very few have survived to the present in the excellent state of the two described in this book, but there are other brilliant gems in the "necklace of Suzdal monasteries" which deserve our attention.

There is no need to hunt for the **MONASTERY OF THE DEPOSITION OF THE ROBE:** the spire of its enormous bell-tower is visible from any point in the city. The monastery occupies the highest plot of land in the city and boasts the tallest structure as well – the seventy-meter **Preobodenskaya Bell-Tower.** Its longest wall opens onto Red Square (Krasnaya Ploshchad) and Lenin Street (Ulitsa Lenina).

However, a single glance at the Holy Gate of the monastery is enough to convince anyone that the tallest

building is far from the most interesting. The Holy Gate was built in 1688 by local craftsmen Ivan Mamin, Andrei Shmakov, and Ivan Gryaznov. The asymmetrical, double-arched gate is surmounted by two lovely octagonal tent roofs with charming tiny onion-shaped domes. The geometrical designs and crenelated brickwork contrasted with glazed tiles in a striking color combination of maroon against a flat white surface are particularly effective, making the gates a masterpiece of 17th century architecture.

The fascinating **Cathedral of the Deposition of the Robe** (Rizopolozhensky sobor), built in the first half of the 16th century, is the oldest structure in the monastery. It vaguely resembles the Cathedral of the Intercession with its smooth, almost plain façades and three domes. Since the cathedral has no pillars, the domes are quite light, but their drums are extremely elongated, even divided into two tiers, which makes them resemble minarets. During restoration, the helmet-shaped domes were once again shingled, as in days of old.

234

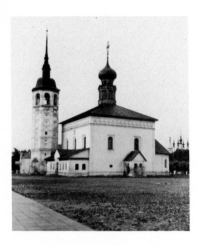

Church of the Resurrection

This building lacks the band of blind arcading so typical of Suzdal architecture, but has instead a frieze of pentagonal double-sectioned niches. On the western side of the cathedral, part of the gallery built around the whole church at the end of the 17th century, simultaneously with the construction of the Holy Gate, has survived. The differing architectural tastes of the various eras can be seen quite distinctly: the intricate designs of the gallery stand out in sharp and pleasant contrast to the bare walls of the cathedral.

The enormous Empire-style **bell-tower,** erected between 1813 and 1819 – probably in honor of the victory over Napoleon – under the supervision of local stone-mason Kuzmin, is in many senses too large and out of proportion with the rest of the tiny town. But still, for Suzdal, it has become the dominating structure which unites all its disparate architectural ensembles into a single whole. At a height of forty meters, a **viewing platform** has been built. Not long ago, as at the Convent of the Intercession,

a **hotel** has been opened in its 19th century buildings.

Right next to the Monastery of the Deposition of the Robe is a singularly lovely structure – the only one left from the Trinity Monastery – its 18th century **Holy Gate**, which looks out onto Lenin Street. The influence of Moscow baroque is clearly felt in its elegant proportions – a rare instance in Suzdal, with its devotion to ancient Russian architectural traditions.

Not far from the Monastery of the Deposition of the Robe on the high bank of the Kamenka across from the Convent of the Intercession in the meadow below stands the **MONASTERY OF ST. ALEXANDER** (Ulitsa Gasteva), which is much older than either of the two. It was founded in 1240 by Alexander Nevsky and was known as the Great Laura in days of old. Three buildings from the end of the 17th and beginning of the 18th centuries have survived here.

Built in 1695 with funds provided by Tsarina Natalya Naryshkina, Peter the Great's mother, the **Church of the Ascension** (tserkov Vozneseniya

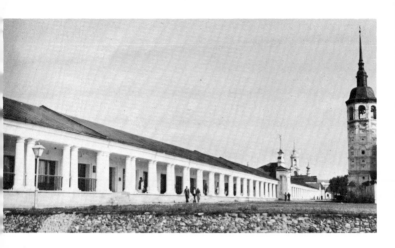

Shopping arcade

Khristova) is similar to the Church of the Virgin of Smolensk with its contrasting massive cubic body and delicate, intricate ornamentation. Here, however, the details are slightly larger than those of the other church, and the domes are bigger as well. The heated northern side-chapel of the Church of the Ascension served as its winter church.

The austere, ascetic monastery **bell-tower** topped by a high tent roof stands on the very bank of the Kamenka. The two structures are gracefully united by the Holy Gate, for its form reflects the austerity of the bell-tower and the joie de vivre of the church.

In the 18th century, there was a stone church in Suzdal for every few dozen people. Even today, the question arises, 'Why so many?' For surely, there could have been no practical reason why the city had such a large number of churches. Could it be that the residents of Suzdal were fanatically religious? No, not at all: it was not so much a matter of zealousness as tradition and a love of beauty which had very deep roots. In

the old days, each street had to have its own tiny wooden church. Then, when this church burned down or became dilapidated with the passage of time, a new church was built in place of the old one, and generally, the icons and other sacred utensils were brought there from the old one. This tradition continued down through the centuries, and therefore, at the end of the 17th and in the 18th century, when stone churches began to spring up like mushrooms after a rain, these were not new churches, but simply new stone buildings to replace the old wooden ones. They were built on exactly the same site and retained the name of the old church.

During this, Suzdal's most prosperous period, the main commissioners of churches were the merchants and artisans, with their particular needs and tastes, who had recently become prominent. These people staunchly adhered to the architectural forms of patriarchal Rus. We have mentioned more than once that in the provinces, baroque and other new styles never caught on, the more so in Suzdal, which opposed all manner of innovations, including those

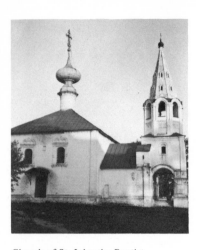

Church of St. John the Baptist

in the realm of art. This was particularly manifested in the anti-Petrine sentiments which resulted from his banishment of Evdokia Lopukhina, his first wife, to the Convent of the Intercession. Therefore, the parish churches of Suzdal retained the traditional cubic form, but due to the rich imaginations and inexhaustible inventiveness of the builders, no two churches here are alike.

From Holy Gate of the Monastery of the Deposition of the Robe to the Market Square (Torgovaya Ploshchad) runs Old Street (Ulitsa Staraya) which boasts a pair of churches – the summer Church of St. Lazarus (Lazarevskaya tserkov, 1667) and the heated Church of St. Antipius (Antipievskaya tserkov, 1745). Its bell-tower is obviously of earlier construction. The quincunx **CHURCH OF ST. LAZARUS** is one of the oldest parish churches in the city. The transformation of the ancient *zakomari* from a structural element of wooden architecture into the purely decorative *kokoshniki* is evident. They are still relatively large, but, emphasized by the cornice, are clearly ornamental

like the band of decorative tiles on the façades and the blind arcading on the drums of the domes.

The **CHURCH OF ST. ANTIPIUS** is quite simple: a low, elongated rectangular body crowned by an elegant dome and a fine decorative crest of open metalwork along the ridge of the roof. Entirely unlike this austere church is its brightly decorated **bell-tower**, one of the most colorful buildings in the whole city. The geometrically patterned tower in which the bells are suspended serves as the base which supports the high concave tent roof – a type found only in Suzdal – with its three rows of windows. The tasteful combination of maroon, cream and white make the bell-tower a distinctive structure which cannot be confused with any other in town.

Another pair of churches lies within the boundaries of the 13th century settlement ramparts. These are the summer **CHURCH OF SS. CONSTANTINE AND HELENA** (tserkov Konstantina i Yeleny, 1707) and the winter **CHURCH OF OUR LADY OF THE SORROWS** (tserkov Bogomateri vsekh skorbyashchikh radost,

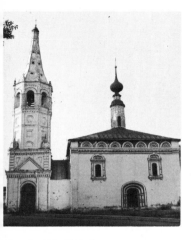

Church of St. Nicholas

Church of the Dormition

1787). The former is presently the only working church in the city and is notable because at the beginning of the 19th century, a classical style porch with three two-columned porticoes was built on to the western side.

Richest of all in architectural monuments is the Market Place Square, the central structure of which is the **CHURCH OF THE RESURRECTION** (tserkov Voskreseniya Khristova, 1720). As the main church in the center of town, this sanctuary had to live up to a great number of expectations. For that reason, the flattened cube of the building (by that time, the most popular shape for the basic volume of a church) has plain, smooth white walls almost totally without decoration. Even the windows have no platbands, but are splayed into the walls, which are broken only by a band of miniature keelshaped *kokoshniki* and tiny balusters. Its builders seem to have designed such a church in tribute to the traditions of old. But in contrast, the tall, slender, tent-roofed bell-tower is richly decorated with green and polychrome tile insets and sharply pro-

filed geometrical niches and recesses.

At present, the church houses the **exhibition of Russian Decorative Wood Carving.** Among the exponents are carved boards that decorated houses in the 19th century featuring representations of lions, sirens who protected domestic peace and security, female guardian spirits, and other characters from folk tales which became the favorite subjects in the decoration of old Russian wooden houses.

The ordinary domestic utensils of the Russian peasants displayed here are proof that the simplest articles became wondrous objets d'art in the hands of skilled folk carvers. Beauty and perfection of design in articles of everyday use surrounded the peasant from the cradle to the grave, from the bottoms of distaffs of the 18th and 19th centuries to the wooden implements for washing and ironing covered all over with geometrical designs, and the famed carved cookie boards.

One look at these cookie boards will explain why Russian biscuits or cookies looked as if they had been

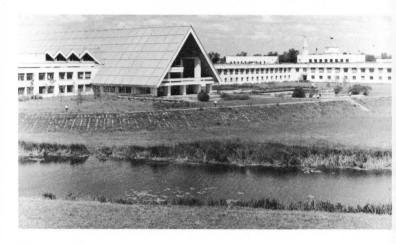

Main Tourist Complex

stamped from molds: dough rolled out in a thick layer over a board was imprinted with the rich designs-in-relief which ranged from geometrical patterns to representations of birds, animals, or even architectural motifs. Each city had its own favorite designs for cookie boards.

This exhibition will also acquaint the visitor with the religious carving and sculpture of the area. The most ancient object in this part of the collection is a 16th century Crucifix.

The most significant example of secular architecture in Suzdal is the shopping **ARCADE** (Gostiny dvor) which runs along the western edge of Market Place Square. It was built in the classical style between 1806 and 1811 and features a striking row of white columns. Even today, this is the city's main shopping center.

The **CHURCH OF ST. JOHN THE BAPTIST** (tserkov Ioanna Predtechi) on Lenin Street right next to the ancient Kremlin rampart and the **CHURCH OF ST. NICHOLAS** (Nikolskaya tserkov) quite nearby were both built in 1720 after a devastating fire which destroyed all the

wooden buildings in Suzdal. It is quite in order to compare these buildings which, despite their proximity, reveal the inexhaustible richness of imagination of the local craftsmen in creating variations upon the basic theme of a single-domed church, the main body of which consists of a flattened cube, complemented by a tent-roofed bell-tower.

It is better to begin this comparison with the **Church of St. Nicholas** which features an entire series of techniques later used quite successfully in Suzdal and many other places. The vertical proportions of the various volumes of the church from the chancel, to the rectangular volume of the main nave, to the spire of the bell-tower are quite organically integrated. This subtle rhythm emphasizes the row of *kokoshniki* which appear on the church and the bell-tower at exactly the same height. The Church of St. Nicholas is one of the most ornate structures in the city: its portals, platbands, and elongated drum with two tiers of archlets are elaborately decorated. The ornamentation of the concave tent-roofed bell-tower

s even more lavish. Moreover, the degree of lavishness increases with each successive tier. While the base is relatively simple, the octagon surmounting it is graced with rows of *kokoshniki*, rectangular recesses, octagonal niches, and polychromatic glazed tile insets.

A few dozen meters away on the other side of the earthen rampart stands the **Church of St. John the Baptist**, in which the ever-present *kokoshniki* are conspicuously absent as is the decorative cornice, while the platbands are quite simple. The bell-tower is the same height as the church and counterbalances it, a technique more common to the 16th century than the 18th. The mode of architectural expression employed here is geometric rather than decorative: the building appears massive and monolithic with the mighty pillars of the porch, the rectangle surmounting them, and the octagon of the bell-tower, all of which can be inscribed into cubes of equal volume. The height of the severe tent roof of the bell-tower is exactly double the cross-section of the base. It is as if the builder was attempting to prove that the ruler is far from the worst of tools in the hands of a skilled craftsman, in no way inferior to the compass or the chisel. Then as if to assert that he could work as well with the latter two, he decorated the otherwise restrained façade of the church with a magnificent portal, one of the finest in the city.

Unfortunately, within the framework of this book, we are unable to elaborate upon all the superlative architectural monuments of Suzdal. So in conclusion we will say a few words about a small sanctuary not far from the Church of St. John the Baptist — the **CHURCH OF THE DORMITION** (Ulitsa Kremlyovskaya). Erected in the second half of the 17th century, the church was remodelled in 1715, and might not be worthy of close scrutiny if not for one thing: its close proximity to the Kremlin — an 'official' location which determined the 'official' style in which it was built — Moscow (Naryshkin) Baroque — and its tiered composition which is extremely rare in Suzdal. However, the scroll design of the platbands and the fringe-shaped cornice are rather restrained in comparison with the rich, plastic ornamentation characteristic of baroque.

Suzdal's future lies in its past — in the unrepeatable atmosphere of antiquity which permeates it. And city planners who must take into account the comfortable accommodation of tourists have not forgotten this. Therefore the new buildings are designed so as not to disturb the charm of the old. Severe contemporary lines must not be allowed to clash with the more ornate grace of the old. Therefore, when the **MAIN TOURIST COMPLEX** — the best in all of Russia — was built, it was spread out along a bend in the River Kamenka. Various services are provided for guests: a concert hall and cinema, a sauna and swimming pool, a bar, and a pinball arcade. A comfortable **motel** provides accommodations for those who come by car.

We would also like to take the liberty of suggesting a few of the more interesting dishes from the traditional Russian cuisine available at the local eating places housed in old buildings, the interiors of which have been remodelled. First, there is the Refectory (Trapeznaya) in the 17th century Bishop's Chambers at the Kremlin and then there is the early 19th century Arcade (Gostiny dvor) in the shopping Arcade at the Market Place Square. We suggest that you try Bishop's Fish Soup (*ukha arkhiereiskaya*), Bishop's hors d'œuvres (*zakuska po-arkhiereisky*), Russian Soup (*pokhlyobka po-russky*), Meat Merchant-Style (*myaso po-kupechesky*), pancakes with caviar (*bliny s ikroi*), or pickled mushrooms (*solyonye griby*). One dish outdoes the other, and many are served in piping hot clay pots right from the oven.

The pride of Suzdal's tables is its fine *myedovukha* — honeyed vodka or mead — made from unrefined honey. This is something you should be sure to try!

Two more notes to give you a better picture of the regard in which Suzdal is held. In 1977, the fifth General Assembly on Architectural Monuments and Tourist Spots, previously held in such cities as Paris and Rome, was convened in Suzdal. In 1981, for its outstanding contribution to international tourism, preservation of cultural monuments and their use in the interest of tourism, Suzdal was awarded the annual prize of the International Travel Commentators Association, the **Golden Apple.** Thus, Suzdal joined the ranks of such cities as York, the ancient capital of England, and Sarajevo, the Yugoslavian city, the town of Melnik and Rilsky monastery in Bulgaria.

Historical and Architectural Monuments
The Kremlin

Earthen Ramparts, 11th century
Cathedral of the Nativity of the Virgin, 1222-25, 1528-30
Archbishop's Chambers, 15th-18th centuries
Bell-tower, 1635
Wooden Church of St. Nicholas from the village of Glotovo, 1766
Church of St. Nicholas, 1720
Church of the Nativity of Christ, 1775

Kideksha Estate in the Settlement of Kideksha

Church of SS. Boris and Gleb, 1152
Holy Gate, end of the 17th century
Bell-tower, end of the 17th century
Church of St. Stephen, 1780

Convent of the Intercession — Ulitsa Pokrovskaya

Cathedral of the Intercession, 1510-14
Cathedral Bell-Tower, 1510-15, 17th century
Gateway Church of the Annunciation, 1518
Refectory Church of the Conception of St. Anne, 1551
Court Chamber, 17th century
Walls and towers, 16th-18th centuries

Monastery of the Savior and St. Euthimius — Ulitsa Lenina

Cathedral of the Transfiguration, 1507-11, 1594
Refectory Church of the Dormition, 1525
Belfry, 1530, 1691
Father Superior's Chambers, 16th-17th centuries
Gateway Church of the Annunciation, 16th-17th centuries
Walls and towers, 1664

Monks' Cells, 17th-19th centuries
Infirmary Church of St. Nicholas, 1669
Prison, 1767
Grave of and Monument to Prince Dmitry Pozharsky

Monastery of the Deposition of the Robe — Ulitsa Lenina

Cathedral of the Deposition of the Robe, 1st half of the 16th century
Holy Gate, 1688
Walls and towers, 17th century
Prepodobenskaya Bell-Tower, 1813-19
Holy Gate of the Trinity Monastery, 18th century

Monastery of St. Alexander — Ulitsa Gasteva

Church of the Ascension, 1695
Bell-Tower, 1695
Holy Gate, end of the 17th and beginning of the 18th centuries

* * *

Church of St. Lazarus, 1667 — Ulitsa Staraya
Church of St. Antipius, 1745 — Ulitsa Staraya
Church of SS. Peter and Paul, 1694 — Ulitsa Pokrovskaya
Church of St. Nicholas, 1712 — Ulitsa Pokrovskaya
Church of SS. Kosma and Damian, 1696 — near the Main Tourist Complex
Church of St. Andrei Bogoliubsky, 1696 — near the Main Tourist Complex
Settlement (Posad) House, end of the 16th–1st half of the 17th century — Ulitsa Lenina
Church of the Virgin of Tikhvin, end of the 17th century — izluchina Kamenki
Church of SS. Boris and Gleb, end of the 17th, 18th centuries — western outskirts of the city
Church of the Nativity of John the Baptist, 1703 — izluchina Kamenki
Church of the Epiphany, 1775 — izluchina Kamenki
Church of SS. Constantine and Helena, 1707 — Torgovaya Ploshchad
Church of Our Lady of the Sorrows, 1787 — Torgovaya Ploshchad
Church of the Entry into Jerusalem, 1707 — Torgovaya Ploshchad
Church of St. Paraskeva (Pyatnitsa), 1772 — Torgovaya Ploshchad
Church of the Dormition, 2nd half of the 17th century, 1715 — Ulitsa Kremlyovskaya
Church of the Virgin of Smolensk, 1696-1706 — Ulitsa Lenina
Church of St. Simeon, 1749 — Ulitsa Lenina
Church of St. John the Baptist, 1720 — Ulitsa Lenina
Church of the Resurrection, 1720 — Torgovaya Ploshchad
Church of the Virgin of Kazan, 1739 — Torgovaya Ploshchad
Church of SS. Kosma and Damian, 1725 — Ulitsa Lenina (Yarunov Hill)
Church of the Sign, 1749 — Ulitsa Lenina
Church of the Deposition of the Robe, 1777 — Ulitsa Lenina
Church of St. Elijah the Prophet, 1758 — near the river Kamenka
Church of St. Nicholas and the Holy Cross, 1770 — Torgovaya Ploshchad
Shopping Arcade, 1811 — Torgovaya Ploshchad

Information for Tourists

Hotels
Main Tourist Complex — northwest edge of the city, branch at the Convent of the Intercession
Restaurants
Main Tourist Complex Restaurant
Pokrovsky — in the Refectory of the Convent of the Intercession
Trapeznaya — in the Bishop's Chambers of the Kremlin
Gostiny dvor — Torgovaya Ploshchad
Pogrebok — 6, Ulitsa Kremlyovskaya
Kremlin
Exhibition: Leninist Policy Concerning the Preservation of Cultural and Historical Monuments
Exposition: The History of Suzdal
Exhibition: Old Russian Painting
Interior of the Cross Chamber
Museum of Wooden Architecture and Peasant Life
Interior of the Wooden Church of the Transfiguration
Interior of a house of a peasant family of moderate means (mid-19th century) from the village of Ilkino
Interior of a house of a well-to-do peasant family (mid-19th century) from the village of Log
Interior of a wind-mill
Convent of the Intercession
Office and Court Chamber
Convent House of the late-18th-mid-19th centuries: interior of the cells and the Exhibition: Linen Embroidery from Suzdal
Monastery of the Savior and St. Euthimius
Interior of the Cathedral of the Transfiguration
Museum of Folk Art of the Peoples of the Russian Federation
Museum of Russian Decorative and Applied Art of the 18th and 19th Centuries
The Golden Treasury
Exhibition: Inmates of the Monastery Prison
Exhibition: Six Centuries of Books
Monastery of the Deposition of the Robe
Panorama of the city from the viewing platform in the Prepodobenskaya Bell Tower
Other Exhibitions and Expositions
Exhibition of Russian Decorative Wood Carving (Church of the Resurrection, Torgovaya Ploshchad)
Exhibition of Peasant Garb (Church of St. Nicholas and the Holy Cross, Torgovaya Ploshchad)
Exhibition of Painting on Wood (Church of SS. Peter and Paul)
Interior of a settlement (posad) house of the 17th and early-18th centuries, Ulitsa Lenina
Interior of the Cathedral of SS. Boris and Gleb at Kideksha
All museums are open from 10.00 a.m. to 5.00 p.m.
Stores
Department Store, Books, Beriozka, Souvenirs — Shopping Arcade on Torgovaya Ploshchad
Suzdalskaya Lavka (souvenirs) — 3 Ulitsa Lebedeva (near the Kremlin)
Concert Hall, Cinema, Sauna, Swimming Pool — on the premises of the Main Tourist Complex
Garage — at the edge of the city from the direction of Vladimir

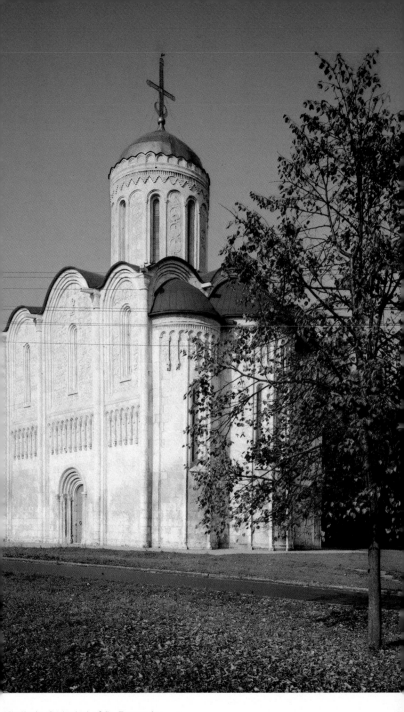

Vladimir. Cathedral of St. Demetrius

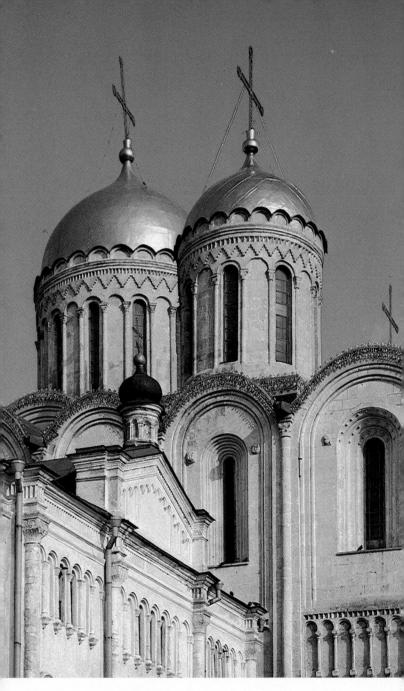

Vladimir. Cathedral of the Dormition

Cathedral frescoes by Andrei Rublev

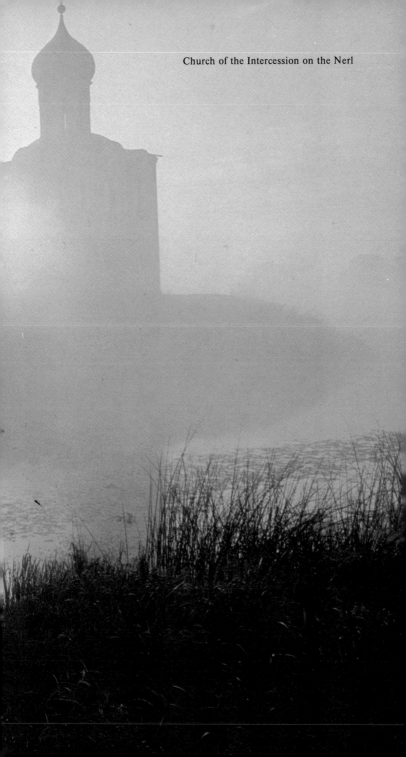

Church of the Intercession on the Nerl

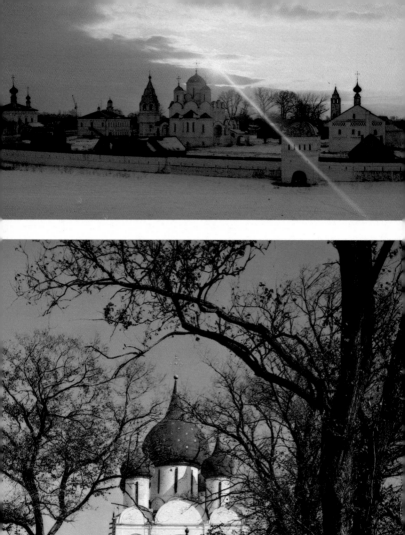

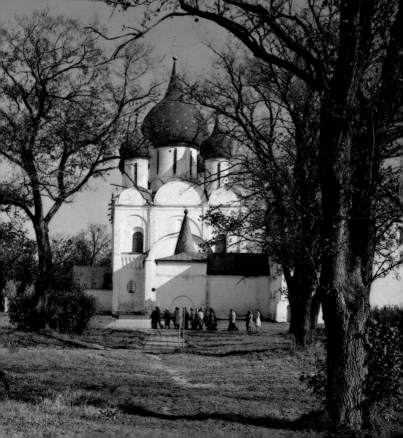

Suzdal.
Convent of the
Intercession

Holy Gate of the
Cathedral of the
Deposition of the
Robe

Cathedral of the
Nativity of the
Virgin in the
Kremlin

Belfry of the
Monastery of the
Savior and St.
Euthimius

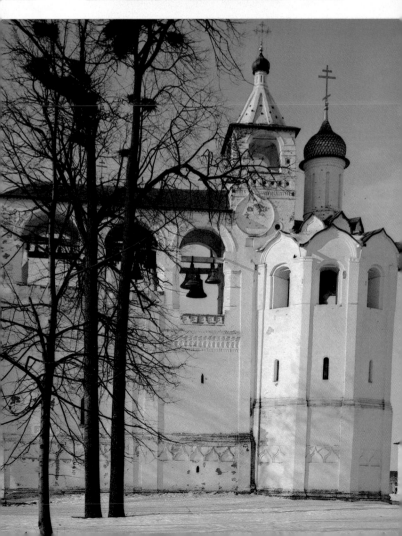

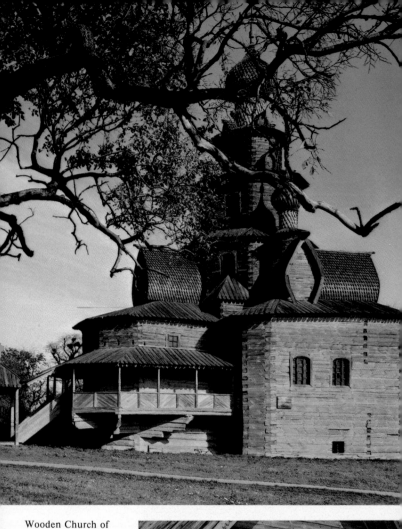

Wooden Church of
the Transfiguration

At the Museum of
Wooden Architecture
and Peasant Life

Bon Voyage!

The Russian land is very hospitable, and tourists from abroad can be assured of the courteous ministrations of Intourist, the organization which deals with foreign tourism in our country. To make the best use of all the possibilities available, we suggest that you purchase a packaged tour for your visit to the USSR which includes stops at cities of interest to you from one of the Intourist offices in your country or from a travel agent which offers tours to the Soviet Union. Information about available tours can also be obtained from any Soviet trade representative.

As in any country, there are certain laws and customs in the USSR which should be observed to avoid problems or awkward situations: for example, the tourist must have a valid passport with all the necessary visas, and the tourist who comes by car must have the proper documents for his automobile and a valid international driver's license. Autotourists should not deviate from the approved route without the prior consent of Intourist. Hard currency should be exchanged only at the branches of the Bank for Foreign Exchange (Vneshtorgbank). Bathing suits should be worn only on the beach, and so forth.

As a rule, all questions concerning the availability of additional services can be quickly resolved with the assistance of the Intourist guide accompanying your group, while individuals travelling alone can refer to the service bureau at any Intourist Hotel.

Automobiles may be rented at the border crossings and in any major city of the USSR. The rules of the International Convention on Motor Traffic are in effect in our country, and all the road signs and traffic signals conform to its statutes. The speed limit is 60 km/h in town and 90 km/h on intercity highways. At most filling stations, 93 octane gasoline is available, while those on major thoroughfares sell 93 octane regular and 95 octane super. Gas stations may be considerable distances apart, so be sure to bring a gas can along in case you run out.

Road maps will be issued at the border. Those who wish to travel by car in winter should be experienced at driving on icy, snowy roads, for given the moderate continental climate of the central regions of European Russia, snowfalls and icy roads are common from November to April. You should also dress warmly and bring a wind-proof coat, a hat, and lined boots. The summers in this part of the country are generally mild or warm, but occasionally hot.

Each large city and major highway will have a special garage where you may have your automobile repaired. Since occasionally, accidents do occur, it is advisable to insure your automobile with Ingosstrakh, the offices of which are noted on your road map. In addition, in many countries, it is possible to buy insurance for car and driver for a trip to the USSR from the international firm Europe Assistance. Medical care short of hospitalization is provided free of charge to tourists, but there is a fee for hospitalization.

This is about all you need to know in general, so now we will proceed to how to choose a route. Needless to say, this depends on the amount of time you wish to spend in the Soviet Union, as well as your personal inclinations. Intourist offers a wide range of organized tours for those interested in visiting the ancient Russian cities described in this book. Keeping these cities in mind, you can choose the most convenient itinerary of those offered by Intourist:

Russian troika

No. 4-2. Minsk — *Smolensk* — Moscow — Novgorod — Leningrad. Bus, 9 days
No. 4-4. Leningrad — Novgorod — *Kalinin* — Moscow — *Smolensk* — Minsk Bus, 12 days.
No. 4-6. Moscow — *Kalinin* — Leningrad. Train, 8 days.
No. 4-13. Moscow — *Suzdal* — Moscow — *Kalinin* — Novgorod — Leningrad — Petrozavodsk — Leningrad. Bus, train, 15 days.
4-15. Moscow — *Suzdal* — Moscow. Bus, 8 days.
No. 4-16. Moscow — *Suzdal* — Moscow. Bus, 6 days.
No. 4-17. Moscow — *Yaroslavl* — Moscow — *Suzdal* — Moscow — Leningrad — Novgorod — Leningrad — Kiev — Moscow. Bus, plane, 20 days.
No. 4-21. Moscow — *Suzdal* — Moscow. Bus, 8 days.
No. 4-22. Leningrad — *Kalinin* — Moscow — *Smolensk* — Minsk. Bus, 9 days
No. 4-25. Leningrad — Novgorod — Moscow — *Smolensk* — Minsk. Bus, 1 days.
No. 4-26. Minsk — *Smolensk* — Moscow — Novgorod — Leningrad. Bus. 1 days.
No. 4-27. Moscow — *Suzdal* — Moscow — Novgorod — Leningrad. Bus, train 10 days.
No. 4-28. Moscow — *Yaroslavl* — Moscow — *Suzdal* — Moscow — Novgorod — Leningrad — Pskov — Kaliningrad. Bus, train, 15 days.
No. 4-33. Leningrad — Novgorod — Moscow — *Smolensk* — Minsk. Bus, 8 days
No. 4-36. Leningrad — *Kalinin* — Moscow — *Smolensk* — Minsk. Bus, 10 days
No. 4-38. Leningrad — Novgorod — *Kalinin* — Moscow — *Smolensk* — Minsk Bus, 11 days.
No. 4-39. Minsk — *Smolensk* — Moscow — *Smolensk* — Minsk. Bus, 9 days.
No. 4-40. Minsk — *Smolensk* — Moscow — Orel — Kiev — Lvov. Bus, 11 days
No. 4-41. Lvov — Kiev — Orel — Moscow — *Smolensk* — Minsk. Bus, 11 days
No. 4-43. Moscow — *Suzdal* — Moscow. Bus, 8 days.
No. 4-48. Moscow — *Yaroslavl* — Moscow. Bus, 6 days.
No. 4-58. Minsk — *Smolensk* — Moscow — Novgorod — Leningrad. Bus, 10 days.
No. 4-82. Moscow — *Suzdal* — Moscow — Leningrad — Kiev — Moscow. Bus, plane, 14 days.
No. 4-86. Leningrad — Novgorod — Leningrad — Moscow — *Suzdal* — Moscow — *Yaroslavl* — Moscow. Bus, plane, 15 days.
No. 4-95. Moscow — *Suzdal* — Moscow. Bus, 7 days.

Tourists should not be puzzled that such cities as Zagorsk, Pereslavl-Zalessky, Rostov, and Vladimir are not listed as separate stopping points. Since they are day, rather than overnight, trips, excursions to these cities are arranged from Moscow, Yaroslavl, and Suzdal and are included in the itineraries listed. Tourists will have comfortable, roomy buses at their disposal.

Which is the best season for a trip to the USSR? That depends on the individual, for each season has its merits. Of course, those who do not bear cold weather well would do better to come in the warmer months, although the buildings of the ancient cities described herein are particularly lovely against the background of white, snow-covered fields and streets. For those who are not afraid of the cold, we wholeheartedly recommend a visit to Suzdal during Christmas vacation, for in that city, from 25 December to 5 January, the Russian Winter Festival is held each year. Tourists come for a three-day visit, each of which will be filled with vivid impressions.

One of the three days will be devoted to an excursion to Vladimir. Then guests will enjoy the performances of folklore ensembles, the Vladimir philharmony and the Russian folk ensemble, *Rus*.

Snow houses are built on one of the squares; a large fir tree is decorated, and

merry performances are held under it with guest appearances by Grandfather Frost (the Russian Santa Claus) and his helper, the lovely Snow Maiden, as well as the Snowman, Lazybones Emelya, and other characters from folk tales. Traditional performances by bands of mummers are the order of the day. The Petroushka Puppet Theater gives performances, and dances around the Christmas Tree with maskers, amusing games, concerts, and lots of folk traditions are organized. The audience also takes part in the fun: they have tugs-of-war, relay races with buckets full of water, trying not to spill any, and attempt to climb a pole with a prize at the top. Beverages, tea, and bagel-like rolls are sold right in the square.

The Festival program includes troika rides at Kideksha, after which each guest will be treated to a shot of vodka and caviar with bread and butter. To top it all off, a festive table with traditional Russian dishes prepared according to ancient recipes awaits the hungry guests. Bliny — Russian pancakes served with various toppings and fillings — are always a part of this banquet. During the festival, a multitude of souvenirs and keepsakes of the city can be had.

There are some nice features of the summer season here as well: you can relax and sunbathe, swim, or go fishing.

As for Russian nature, it is beautiful at any season. Great Russian poet Alexander Pushkin drew inspiration from the reddish-gold tones of autumn. "I love a storm in early May..." exclaimed another Russian poet, Fyodor Tyutchev. Nikolai Nekrasov, with whom the reader became acquainted at the estate of Karabikha near Yaroslavl, wrote ecstatic lines about winter. Russian artists loved all the seasons, each in its own way, and left many marvelous pictures of the natural surroundings at every conceivable time of year. Like nature itself, the ancient cities of central Russia are lovely at any time — just as they are always hospitable and cordial.

REQUEST TO READERS

Raduga Publishers would be glad to have your opinion of this book, its translation and design and any suggestions you may have for future publications.

Please send all your comments to 17, Zubovsky Boulevard, Moscow, USSR.

ИБ № 1572

Редактор русского текста *М.М. Державина.*
Контрольный редактор *А.А. Кафыров.*
Художник *Э.М. Симанович.*
Художественный редактор *А.П. Купцов.*
Технический редактор *С.Ф. Сизова, Е.И. Скребнева.*

Сдано в набор 30.10.84. Подписано в печать 5.12.85 г. Формат 84×108/32. Бумага мелованная. Гарнитура „Таймс Нью Роман". Печать офсетная. Условн.печ.л. 13,44. Усл. кр.-отт. 44,63. Уч.-изд.л. 19,85. Тираж 16830 экз. Заказ. № 00691. Цена 2 р. 40 к. Изд. № 1296.
Издательство „Радуга" Государственного комитета СССР по делам издательств, полиграфии и книжной торговли.
Москва, 119859, Зубовский бульвар, 17.

Типография А/О Курсииви
Хельсинки, Финляндия